CW01431059

FROM BISHOP TO WITCH

DAVID GENTILCORE

From bishop to witch

The system of the sacred in early modern Terra d'Otranto

Manchester University Press

Manchester and New York

distributed exclusively in the USA and Canada by St. Martin's Press

Copyright © David Gentilcore 1992

Published by Manchester University Press
Oxford Road, Manchester M13 9PL, UK
and Room 400, 175 Fifth Avenue, New York, NY 10010, USA

Distributed exclusively in the USA and Canada
by St. Martin's Press, Inc., 175 Fifth Avenue, New York, NY 10010, USA

British Library Cataloguing-in-Publication Data
A cataloguing record for this book is available from the British Library

Library of Congress Cataloging-in-Publication Data
Gentilcore, David.
 From Bishop to witch : the system of the sacred in early modern
 Terra d'Otranto / David Gentilcore
 p. cm.
 Includes bibliographical references and index.
 ISBN 0-7190-3640-2
 1. Otranto Region (Italy)—Religious life and customs.
 2. Catholic Church—Italy—Otranto Region.
 3. Occultism—Italy—Otranto Region. I. Title.
 BX1548.074046 1992
 306.6′0945′753—dc20 91-44695

ISBN 0 7190 3640 2 *hardback*

Printed in Great Britain
by Biddles Ltd, Guildford & King's Lynn

CONTENTS

ACKNOWLEDGEMENTS

This book reconstructs the complex of ritual behaviour and attitudes towards the sacred of a Mediterranean society over the two hundred and fifty years following the close of the Council of Trent (1563), using sources like episcopal court records and trials for the canonisation of local saints. It explores the close relationship that existed between orthodox Church ritual and unofficial lay ritual, with the hope of establishing some sort of religious model. I am indebted to a number of people for their stimulus and encouragement during its preparation. First of all, I should like to thank Peter Burke and Bob Scribner for their supervision throughout the thesis stage and their continuing support as I endeavoured to make it suitable for publication. John Bossy and John Henderson assisted at this latter stage with enthusiastic comments and criticism. Revisions were made during the first year of a Wellcome Trust research fellowship, held at the Cambridge Wellcome Unit, and I should like to take this opportunity to express my gratitude to the Trust.

My thanks to Giovanni Romeo in Naples for first suggesting the episcopal trial records as a possible source for my research – when the Inquisitorial records in Naples proved unavailable – and for clearing up some ambiguities regarding the functioning of the tribunals. I am also indebted to Maria Gabriella Rienzo and don Michele Miele for their guidance during my Naples 'phase'.

Helpful advice during the Apulian stages of research came from various sources: don Salvatore Palese of the Molfetta seminary and Bruno Pellegrino, Francesco De Luca and Francesco Gaudioso of the University of Lecce. Once I had decided on the Salentine peninsula as the focus of my research – a decision based partly on its well-ordered diocesan archives – local archivists proved unfailing in their willingness to encourage and facilitate my work: don Raffaele De Simone and don Carmine Maci (Lecce), don Vittorio Piccinno (Gallipoli), Prof. Antonio Benvenuto (Oria), Prof. Rosario Jurlaro (Brindisi) and don Emilio Mazzarella (Nardò). I am also grateful to the staffs of the Vatican Archives and the Archivium Romanum Societatis Iesu.

Friends in Cambridge were more than willing to provide a sounding board for my ideas, as well as sharing their own: Trevor Johnson, Maria José Del Río and Nick Griffiths. A special word of appreciation to Fabiana Gagliani, who suffered accounts of my research difficulties and frustrations with patience, and with her feet firmly on the ground enabled me to keep things in perspective. Her first-hand knowledge of the subject matter meant that she became something of a sounding-board for my theories and findings, while serving as a reminder that the

subjects of my research, though surviving only on dusty and sometimes crumbling and illegible documents, were first and foremost people, with their own very human needs and worries.

And a final word of thanks to my parents, for their support in every possible way. To them I lovingly dedicate this book.

David Gentilcore
Cambridge, June 1990

LIST OF ABBREVIATIONS

Archivio della Curia Arcivescovile, Brindisi — A.C.A.B.
Archivio della Curia Arcivescovile, Lecce — A.C.A.L.
Archivio della Curia Vescovile, Gallipoli — A.C.V.G.
Archivio della Curia Vescovile, Nardò — A.C.V.N.
Archivio Diocesano, Oria — A.D.O.
Archivium Romanum Societatis Iesu — A.R.S.I.
Archivio Segreto Vaticano (Rome) — A.S.V.

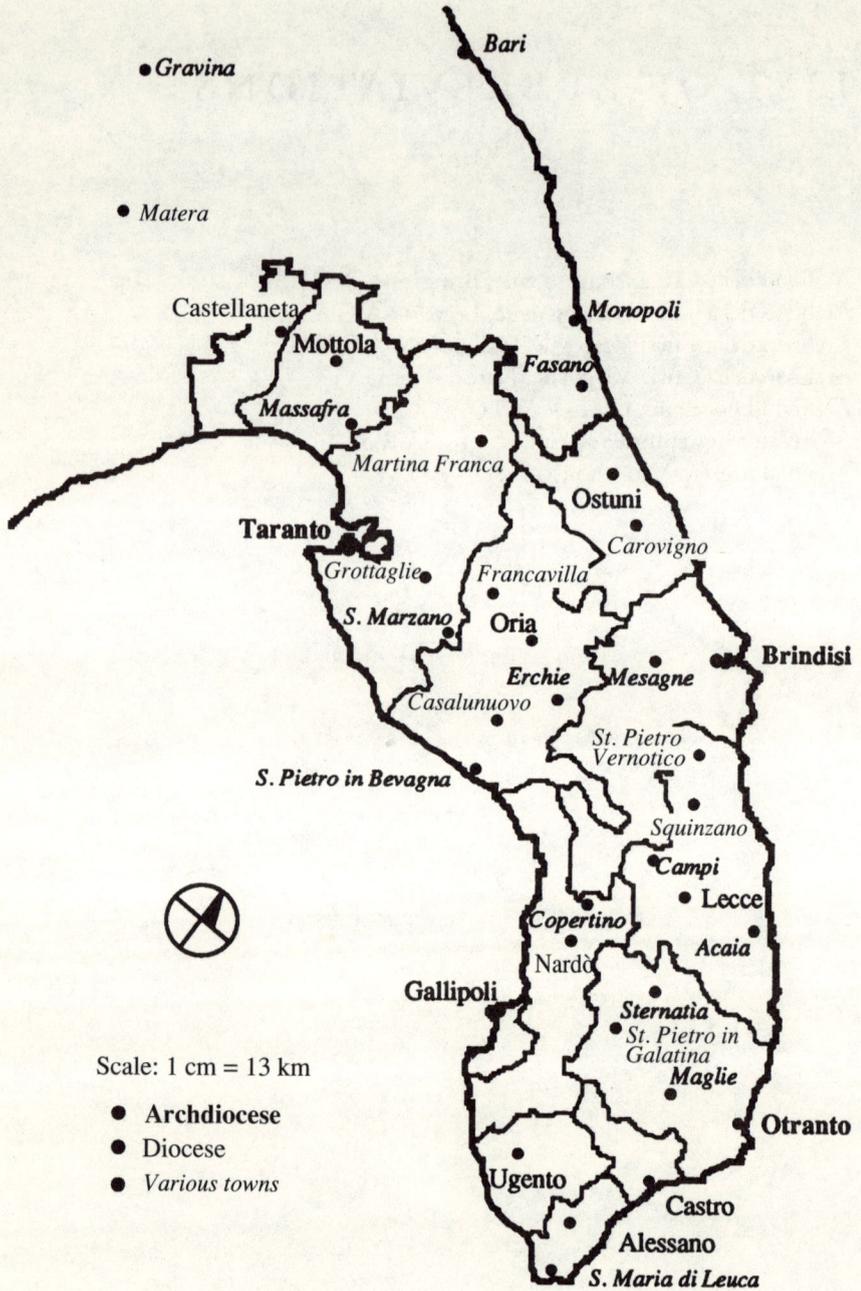

The dioceses of Terra d'Otranto

Introduction

In 1935 the doctor, painter and writer Carlo Levi was banished from his native Turin to a small village in Basilicata because of his opposition to Fascism. Nine years later he published an account of his experiences in this impoverished and remote part of Italy, calling it *Christ Stopped at Eboli*. The town of Eboli is just south of Salerno, formerly the last point on the rail line in the direction of the mountains of Basilicata, providing a metaphor for the furthest penetration of Christian civilisation:

> 'We're not Christians,' they say. 'Christ stopped short of here, at Eboli.' 'Christian' in their way of speaking means 'human being', and this almost proverbial phrase that I have so often heard them repeat may be no more than the expression of a hopeless feeling of inferiority... But the phrase has a much deeper meaning and, as is the way of symbols, this is the literal one... Christ never came this far, nor did time, nor the individual soul, nor hope, nor the relation of cause to effect, nor reason, nor history... The seasons pass to-day over the toil of the peasants, just as they did three thousand years before Christ; no message, human or divine, has reached this stubborn poverty.[1]

The book had quite an impact in the post-war period, highlighting as it did the great misery of southern Italy, the *Mezzogiorno*, which seemed to have persisted from time immemorial. The view might be regarded as a mid-twentieth-century version of the opinion put forth by generations of northern European Protestant scholars and travellers, who saw in southern Italy a land only superficially touched by Christianity. Catholicism as practised there had more in common with the religion of the pagans than that of the Bible, they suggested. Such views were conditioned in large measure by the Grand Tour, whose writers rarely ventured south of Naples, focusing their romantically-tinted sights at 'picturesque' feasts like San Gennaro and the Madonna della Piedigrotta. Yet Levi's account was not the result of such superficial observation, but of first-hand experience during the year he was banished there. Levi's peasants are stripped of their romantic, 'noble savage' accoutrements, laying bare the sad economic reality of their meagre, bestial existence.

Levi notwithstanding, later studies of ecclesiastical history and popular

religion have shown that Christ did *not* stop at Eboli. This will become clear in the course of this book, which explores what I have chosen to call the 'system of the sacred' in early modern Terra d'Otranto, a province in the south-east corner of the Kingdom of Naples, corresponding to the present-day Salentine peninsula of southern Apulia. Southern Italian society did participate in Christian civilisation. It is a matter of determining the extent of this participation and its forms, and of locating what are often stereotyped as 'magical' beliefs and 'southern Italian religiosity' in this more general picture. This kind of mediation between levels of culture and the need to take a more global look at the activities of *homo religiosus* are crucial building blocks in understanding the social history of the Counter-Reformation in Italy. Whether we are discussing the Catholic or the Counter-Reformation, the key aspect is reform, in particular as process, revealing the innate tensions between different levels of society. This can only be accomplished by placing the research within a larger time-span than that usually adopted by historians, and so this study will take in the period from the end of the Council of Trent in 1563 to the 1818 concordat between Naples and the Papacy. By way of introduction to the book, this chapter will explore the kinds of themes that have been dealt with by a wide range of scholars and the theoretical issues involved.[2]

First and foremost is the discussion concerning 'popular religion' and its place in socio-religious history. Both words in the expression have created confusion and differences in opinion, so that it has become, to quote Carlo Ginzburg, 'one of the most ambiguous terms in the historiographical lexicon'.[3] An interpretation that has dominated research in Italy has been that articulated by Gabriele De Rosa. He asserts that popular religion has relatively little to do with class because the devotions and forms of piety associated with it were shared by the entire people of God, lay and clerical, literate and illiterate. Rather, he stresses the gap that existed between a 'magico-sensitive' pagan–Christian form, composed of the 'rural classes' and the local clergy, and a positive, institutional Catholic piety which the various reforming bishops attempted to introduce in the wake of the Council of Trent. However, for De Rosa religion is distinct from other forms of culture because its functions were perceived as real rather than as 'simply ritual'. He therefore posits a clear qualitative difference between a belief in the evil eye and spells, on the one hand, and prayer on the other, so that in his view 'we should commit an outrage in reducing magic, witchcraft and faith in grace into the same category'.[4]

The risk of this approach lies in accepting as popular religion only those ritual forms accepted by the Church. This means adopting the opinions of the reformers, by repeating their theoretical positions against what they

defined as superstition, ignorance, pagan, and so on.[5] Historians have too often described as popular religion those aspects of the ritual system which the ecclesiastical authorities sought to disqualify, merely employing a different vocabulary. Yet it is absurd to posit a 'popular religion' perpetually opposed to that of the Church hierarchy and to recognise it only in the presence of beliefs, cults and practices which deviated from orthodoxy. To remedy this Ginzburg suggests returning religious practices to their wider context of the *culture folklorique,* and singling out the specific social categories and cultural contacts to which we refer.[6] Similar is Roger Chartier's suggestion that we should approach the identification of certain cultural types not from objects supposedly characteristic to a certain group but from the relation each group has with shared objects and practices.[7]

The focus of much recent work has been on christianisation and popular piety within a context of eclesiastical history, gradually switching the traditional emphasis on institutions to people and their actual practices. Italian historians have traditionally felt more at ease with those sources owing much more to their specific diocesan origin: episcopal visitations, *ad limina* relations and Church synods. The visitations in particular have been studied to good effect in terms of the pastoral activity of reforming bishops throughout the South and the obstacles they encountered.[8] They can also reveal much about the social, economic and urban history of the diocese, as Umberto Mazzone and Angelo Turchini have suggested.[9] Yet the more historians rely on visitations for the study of the changing religious situation the more the source's limitations become evident. They are useful in suggesting the religious practices present in a diocese as perceived by its bishop, but this means discussing popular 'unorthodox' beliefs only in terms of something to be christianised and reformed rather than as part of a cohesive, though open, system of belief. We must therefore be wary of simply repeating their attitudes by using the visitation as some objective ethnographic document. The other two sources of the diocesan 'trinity', the *ad limina* relations sent by bishops to Rome and the decrees of Church synods, have similar strengths and weaknesses, affecting the kind of history that is written.[10] In making such descriptions and decrees the sole focus of research, the scholar runs the risk of repeating the mistake of nineteenth-century folklorists in separating particular customs and rituals from the wider behavioural system. This limitation can best be remedied by employing the diocesan records in concert with other sources, as we shall see.

The ecclesiastical records point to four categories of religiosity, as seen from the vantage point of officialdom: the proposed (e.g. models of saintliness), the prescribed (the sacraments), the tolerated (popular reli-

gious drama) and the proscribed (superstitions and impiety).[11] Although these categories could shift over time, with what was proposed or tolerated in the 1600s being proscribed two centuries later, and vice versa, they give us the impression of tension between ruling and subordinate classes, centre and periphery, resulting in change and compromise on both sides.

Practices condemned by the Church usually had a different meaning for the participants from the one interpreted or perceived by the clergy. This sometimes resulted in a form of cultural disintegration or 'deculturation', as we shall see with regard to the phenomenon of tarantism. When it involved a dominant and a receiving culture the process was invariably one of acculturation. For Italy the term negotiation might be more apt, since it implies a separation and distinction between cultures, without making the gulf too great, which would render dialogue impossible.[12]

The usefulness of the term negotiation lies in taking account of the active role of the subordinate classes of society in creating their own patterns of behaviour and ritual expression. Such is the case with popular healing rituals and the formation of local shrines. At the same time, it can account for the positions of relative weakness that generally characterise the process. In the context of Counter-Reformation Italy, according to Adriano Prosperi, religion becomes a force of control and restraint: a question of power, where the 'simple' are encouraged not to stray from their own condition, a limit that was not just cultural but increasingly social as well.[13]

Another way in which this struggle manifested itself was in the clash of interests between local and centralised authority. It applies to De Rosa's discussion of the capitular clergy's opposition to episcopal reforms, as we shall see below, and, on another level, to Neapolitan opposition to the introduction of the Spanish Inquisition within the kingdom. Using a similar model, William Christian has developed the concept of 'local religion' very successfully with regard to community vows to certain saints and the growth of new shrines, often in rural areas in apparent rejection of parochial authority.[14] While this is ideally suited to the nature of his research on sixteenth-century Spain, the limitation is that 'local' is a relational concept, and it is often difficult to ascertain when central, institutional authority ends and local demands begin. It can be useful none the less in characterising certain specific expressions of belief and their social setting in the reform process.

In the Kingdom of Naples religious reform took longer than elsewhere, a fact that has kept historians much occupied during the last few decades. This particular situation has been explained in part by the relatively poor

quality of the local clergy, who as the local representatives of orthodoxy were responsible for the success or failure of the Tridentine reforms. This, in turn, was due to the general absence of seminaries, frequent non-residence of bishops, isolation and poverty, as well as often sour relations with the Religious Orders and confraternities. But the primary cause has been identified as the *chiesa ricettizia,* the organisation of the local clergy into collegiate churches.[15] According to this structure, clerics were required to be natives of the diocese, who together elected their own archpriest or rector. As Francesco De Luca has shown for eighteenth-century Lecce, this meant that they were jealous of their own rights and privileges, especially when confronted with episcopal authority, which they did their best to oppose or obstruct.[16] Because of the economic and legal privileges of being an ecclesiastic their numbers soared throughout the kingdom during the seventeenth and eighteenth centuries. Indeed many clerics took only first orders so as to gain the advantages of the religious life without assuming any of the responsibilities.[17]

This determined the character of the local clergy, to the detriment of reform and pastoral care. Yet we must be wary of regarding the clergy as simply an ignorant, homogeneous mass, resisting episcopal reform and shirking their parochial duties. Although it represents one aspect of the reality, it tells us little of the ecclesiastics themselves and their place and role in society. Luciano Allegra has instead identified the struggle as one between the ruling and subordinate classes over the control and administration of the sacred, with the priest occupying the role of mediator, balancing the wishes of his flock with the demands of religious orthodoxy.[18] This crucial role was also manifest in the priest's occasional use of the Church sacramentals alongside popular, lay healing rituals. We shall return to the concept of mediators below.

Into this breach went missionaries like the Jesuits, who referred to southern Italy as 'the Indies of down here', considering missionary work there to be analogous to the evangelisation of Asia and the Americas. An important source for the study of their activity are the mission accounts and annual letters, even though they tend to give centre stage to their successes, whilst playing down, if not ignoring, the world of popular culture that they were reforming. In the process, there was no head-on clash between cultures. Instead, the missioners attempted to modify local beliefs by substituting an orthodox custom for one considered unorthodox or inappropriate, such as religious drama or the Forty-hours devotion for Carnival.[19]

In the understandable absence of useful data on what the missioners were reforming (understandable, because the records were not kept for the

delectation of future historians), the real points of interest become how the Jesuits and other Orders actually conducted their missions and the degree of impact they had on local society.[20] We know that communities were often whipped into a fury of devotional activity during the mission. But, although confraternities and Marian congregations were frequently founded as part of the mission, it is very difficult to determine their long-term impact. Considering that a permanent system of pastoral care and education were required after the missioners left, it is not surprising that a few days' activity did not bring about a radical change in religious orientation. Changes in piety did occur, although not in the way the missioners might have hoped for, with people absorbing the emotional aspects of the introduced devotions, while largely ignoring the admittedly meagre and superficial doctrinal content. Maria Rosa has even concluded that the devotions encouraged by the Jesuits were responsible for much of the theatricality and emotional nature of modern southern Italian religiosity.[21]

Like the parish priest described by Allegra, the missionary priest can also be seen as something of a socio-cultural mediator. The concept of mediators has become an important tool in analysing the relations between different levels of society in post-Tridentine Italy. One example of this approach has been the study of religious congregations and confraternities, which were crucial in the spread of new forms of piety amongst the laity. Louis Châtellier has shown how Jesuit Marian congregations throughout Europe adapted to local situations and traditions, while at the same time putting Counter-Reformation devotions into practice and giving the laity a voice in how they were performed and enabling them to set an example for the wider community.[22] However, it would be misleading to see the lay Christian brotherhoods as specifically 'popular'. In Italy they were frequently founded at the behest of the local ecclesiastical authorities and were usually controlled by the Religious Orders.[23] Nevertheless their success was a response to the local lay devotional and ceremonial needs, unfulfilled within the diocesan or parochial reality. As we focus on their membership and organisation, as well as their devotions and charitable activities, it is important that we should not lose sight of the wider complex of ritual beliefs and practices of which they were a part.

If much of the social history of Catholic reform after the Council of Trent is about the processes of mediation and negotiation, we have another confirmation when we study the as yet little explored field of Church-sponsored remedies for malady and misfortune, and the priests and friars called to administer many of them. The range of sacramentals and 'ecclesiastical remedies' is vast, including prayers, the rosary, blessed

articles, *brevi,* benedictions, gospel readings, canonical exorcisms, processions and pilgrimages. Owing to their crucial importance in dealing with crisis situations, they tended to characterise religious observance, as well as spawning many lay variants which sought to satisfy the constant demand for access to sacred power. These lay interpretations often found their way into popular healing rituals. Part II of the book will explore the rationale that was involved in selecting from the myriad of possible cures available – lay as well as ecclesiastical – and how successful the Church was in enforcing the use of its own orthodox remedies.

Because the Church insisted that only its remedies were admissible, the pressure on priests to use the techniques at their disposal was greater than ever before. This was compounded by the widespread conception of the ecclesiastic as an intermediary between heaven and earth, sacred and profane, who was therefore a potential healer par excellence. For this reason, priests and friars were constantly being sought out to perform orthodox Church healing and protective rituals, as well as unorthodox ones. The pressure put on the priest by those who considered his powers parallel to those of the wise woman meant that the rituals as performed often crossed the line into unorthodoxy.[24] And the fact that many clerics were not fully able to distinguish between the two meant that they occasionally ended up before the episcopal courts. This was particularly true of exorcism, in increasing demand as the Church stressed diabolical disease causation. Here it is useful to compare canonical and extra-canonical varieties, to learn under what circumstances exorcisms were performed, how and by whom.[25] It is an example of the plurality of healers coming up against the Tridentine Church's attempts at reform and control.

The Church also advocated 'self-help' remedial forms, of which the rosary is the most interesting example. What began as a tool of meditation was soon transformed into a ritual article with sacred powers of its own, which could be multiplied by touching it to the corpse of a saint or other sacred object.[26] The rosary came to assume a very real material as well as sacred presence, like holy water and oil, powder scraped from the walls of shrines, images and statuettes of saints, all of which could also be employed in popular healing rituals. The Church could accept and even encourage such practices as manifestations of piety as long as they were not utilised in what it considered to be an unorthodox fashion.

The same held true for pilgrimage. Research here has been orientated around the object or focus of the experience, whether it be a miraculous image or the placing of an ex-voto at a shrine in response to a vow. For Giovanni Battista Bronzini the ex-voto is an expression of faith, though

one that is inspired not by Christian hope but by the mechanical certainty of a magical rite – an automatic bargain which the patron (the saint) cannot refuse his or her client (the devotee).[27] Little work has been done by ethno-historians to shed light on the actual pilgrimage experience itself, along the lines suggested by Victor and Edith Turner.[28] However, one worthy contribution in this regard is Annabella Rossi's ethnological study of local pilgrimages among the poor of the South, carried out during the early 1960s.[29] She observed pilgrims who wore special habits and went to the shrine on foot, where they performed penitential acts of self-abasement, like beating their breasts and dragging their tongues along the chapel floor. Originally spread by Jesuit and Redemptorist missioners, such devotions are now frowned upon by the Church authorities, an example of the transition from proposed to proscribed activities. But such friction between levels of society is nothing new. The Church authorities after Trent were increasingly suspicious of new developments in shrine formation, not unlike its guarded stance regarding the events in Medjugorje (Yugoslavia) today. What is clear is the often ambivalent attitude of orthodoxy towards pilgrimage, the initiative for which often comes spontaneously from below. This is compounded by its peripheral nature in relation to the liturgical system and the apparent capriciousness of the pilgrim in deciding to visit a given shrine at a particular time.

The tension between Church authorities and devotees in the formation of Marian shrines reflected a local need for sacral objects in the countryside – and the Church's desire to regulate and supervise devotion to miraculous images. Many shrines started out as images with a reputation for healing that was later substantiated by legends detailing their miraculous discovery and numerous cures. Paola Vismara Chiappa has studied miraculous images and shrine formation in the archdiocese of Milan during the eighteenth century. She devotes much attention to the typology of miracles and the social origins of those healed who gave evidence at the ecclesiastical investigations, and concludes that lay piety of the 1750s was more restrained than that of the previous century and closer to that of the clergy.[30]

We should err however in ascribing a restricted popular character to the cult of saints, since it usually has more to do with the *vox populi* in the Christian sense of the entire people of God. For this reason sanctity is best studied in its diocesan context, enabling us to see the saints' cults not as 'popular appendages' but as an integral part of society. This requires something of a sociological perspective. Since saints are saints for other people – their devotees – and are therefore more or less 'constructed', we must look at who these other people are, according to Pierre Delooz. Peter

Burke has suggested the existence of saintly sterotypes. New individuals had to fit established roles and models, and were perceived as similar to other holy men and women already recognised as saints.[31]

The canonisation processes are ideal for this purpose. Here witnesses were examined on the divine merits of the 'servant of God' in question. Through them we are able to perceive a real sense of devotion and the role of the healing and other virtues which is often lacking in the stereotyped hagiographic literature. The creation of the office responsible for canonisation, the Congregation of Rites and Ceremonies, in 1588 favoured the diffusion of cultural models of sanctity, but it also limited their sphere by taking the initiative for saint-making out of local control and prohibiting public cults for uncanonised people. In utilising the processes, Jean-Michel Sallmann suggests that instead of taking either a hagiographic or condescendingly agnostic approach to the testimony, we must probe the meaning that the 'representations of sanctity' had for the witnesses and their communities.[32] The predominance of clerics and professional people as witnesses contradicts the idea that a popular following meant primarily 'superstitious peasants'. Despite varying levels of income and education, witnesses continually cited miracles as proof of a saint's heroic virtue, rather than stemming from it, as theologians viewed the matter. Even saints of undoubted spirituality like the Jesuit Bernardino Realino, active in Lecce, were frequently regarded as saints because of their healing abilities. His letters were kept by his devotees as examples of his piety, but were mentioned in the trials as relics used to heal all sorts of afflictions.[33] Such facts are important to bear in mind when considering the meaning of 'popular' in the expression 'popular religion'.

Most revealing of the tensions between the local need for sources of sacred power and the ecclesiastical authorities are those cases dealing with those holy men and women whom we might call 'saints-in-waiting' and 'failed saints'. The former are those who had not yet made the grade and are still awaiting full recognition by the Church. The latter are those who have been examined by the Inquisition or the local bishop and found wanting, accused of either diabolical connections or fakery. As we shall see, the case of Giuseppe da Copertino – first accused of diabolical magic but later canonised – suggests that the magic–religion distinction, and hence the acceptability for canonisation, is really the expression of different levels of power. A contest which the Church invariably won. Unsuccessful candidates for sainthood like Angela Mellini of Bologna and Alfonsina Rispola of Naples have been studied with this in mind.[34] Because both holy women were tertiary or house nuns – in a no-man's land between secular and religious – their chances of ecclesiastical recognition

were almost non-existent, even when they sought to follow already well-trodden paths to sanctity. Indeed even full-fledged nuns could have difficulties, since the Church after Trent adopted a wary stance with regard to mysticism and miracles.[35]

It would be impossible to describe the system of the sacred in any of the Italian states without the records of the local offices (or representatives) of the Inquisition and the episcopal tribunals. Since H.C. Lea's comment that the presence of the Holy Office in Naples was superfluous, given the absence of heretics combined with the regular activity of the Church courts, more recent research has explored the Inquisition's activity in greater detail.[36] Like the records of the canonisation processes just discussed, those of the Inquisitorial and episcopal courts have the advantage of being the closest we can come to a direct source for a region where most of the populace was unable to read or write and so has left few traces. Through the trials people seem to speak to us directly – as in an oral source – of their social relationships, economic hardships, sacred rituals, fears and anxieties, and so on. Yet there are pitfalls. The witnesses' depositions are often brief, repetitive and formulaic. Furthermore they are rarely the exact words as uttered by witnesses, but versions translated into Italian as taken down by the clerk (and sometimes summarised as well), from the dialect testimony given by most witnesses. Of course, we must also account for the pointed questioning of the inquisitor or judge, the nervousness and possible animosity of the accused, plaintiff and witnesses – to say nothing of the often long spells of imprisonment and occasional use of torture during the course of the trial.

Trials for 'magic and superstition' – acts which the Church believed drew their power from a tacit or expressed pact with Satan – can tell us much about lay forms of ritual healing, popular and learned magic, diabolical witchcraft. With the help of other sources we can reconstruct the social, behavioural and ritual contexts in which they operated. There has been the tendency to dwell on the distinction between magical and religious rituals according to the way they were supposed to work: that is, depending on whether a given act had a mechanical efficacy (considered magical) or relied on the intervention of the divine (therefore religious). However, given that so-called magical invocations often gained their efficacy through recourse to saints, and that many religious rituals and devotions were assumed to have automatic effectiveness, it is difficult to maintain this distinction. They are still useful as descriptive terms, although not as categories, and rather than attempt such distinctions in this book, I have regarded the healing rituals, for example, as part of a wider cultural complex, in communication or overlapping with orthodox Ca-

tholicism (in the form of the sacramentals) and official medicine.

Where disease causation is not human in origin, such as in the southern Apulian phenomenon of tarantism, the healing rituals are of a different sort. Ernesto de Martino's unsurpassed (but untranslated) 1961 work on the subject portrays tarantism as a form of musical exorcism, enabling people ritually to express and come to terms with 'crises of existence'.[37] De Martino combined contemporary ethnological and psychological analysis with both the comparative and the regressive methods of ethno-historical research. Using written sources from the ancients through to medical treatises and episcopal visitations, he identified tarantism as stemming from the mystery cults of the Magna Graecia, before it was christianised by association with St Paul, as both the cause and cure of the malady. A long process of 'deculturation' began as a result of ecclesiastical efforts to control the cult during the nineteenth century, and continues today.

Ethnography such as de Martino's can be invaluable to the historian, combining as it does an acute sense of change over time and an awareness of all the phenomenon's ramifications as only research conducted with living subjects can give. It must be said, however, that Italian ethnography still owes much to the positivistic and romantic themes of Giuseppe Pitrè. But, as with the voluminous work of the nineteenth-century Sicilian folklorist, the sheer detail of the data collected and presented, independent of its methodology, can be employed to illuminate the historian's own sources from earlier periods. More recent contributions to the field known in Italy as the 'history of popular traditions' have revealed much about the social context and workings of ritual healing, and its relationships to beneficent and maleficent magic.[38]

Fortunately, the inquisitorial trial records are being consulted by increasing numbers of historians, allowing us to come to a more accurate understanding of court procedure than that provided by the treatises of demonologists. The Roman and Spanish Inquisitions took the diabolical element in popular magic much less seriously than related campaigns elsewhere in Europe. The root cause of what the tribunals labelled 'superstition' was ignorance and not satanically inspired evil. Mary O'Neil's article on the Inquisition's attitude towards love magic is a good example of what can be done with the trial records to shed light on the invocations and conjurations (variously known as *orazioni* and *scongiuri*) which formed a crucial part of rituals of healing and ceremonial magic, and, more significantly, to attempt to single out the circumstances under which people were prepared to approach and/or accuse a cunning man or woman.[39] In this sense, our analytical technique has taken a step forward. The fact of an accusation before the court is as important as the docu-

ment's purely ethnographic content, as when a woman accuses a man or procuress of having illicitly administered a love philtre to her as a means of justifying a socially unsuitable relationship. And, as this example demonstrates, we must keep in mind that an accusation before the court does not necessarily equal an actual occurrence, though the fact of an accusation may be just as revealing of the social fabric and tensions.

This theme is taken up by Jean-Michel Sallmann in a detailed study of a Neapolitan trial containing elements of both popular and learned magic.[40] Using the single trial in a qualitative manner, he approaches the accusation and testimony in terms of elaborated aggression. He is also correct in asserting the independence of the source as an ethnographic document, in the sense that quantitative variations in the numbers of accusations need have no relationship to the amount of magic 'practised' in a given area or to changes over time. Despite relying on a too limited sample of documents, Sallmann's study is useful in suggesting the close links between popular and learned (or élite) magic at the local level in the Kingdom of Naples, even though the former was a female and the latter a male field of endeavour. In learned magic, whose practitioners were largely clerics and *civili* (the professional class of doctors and lawyers), practical books of spells like the *Sword of Moses* (for curing maladies) and the *Key of Solomon* (for obtaining buried treasure) circulated. Learned magic was by far the greater threat as far as the Counter-Reformation Church as concerned, despite – or because of – the number of ecclesiastics involved in it. Not only did it have a more clearly expressed cosmology than popular magic, but the powers obtained through demons established it as a rival to organised religion.

The courts also tried women for the specific crime of diabolical witchcraft, said to result from an 'expressed' pact with the devil and accompanied by night flight to the sabbath gathering. The important question for historians in the study of witchcraft is to separate demonological myth from actual practice, and determine its relationship to other popular beliefs, particularly with regard to the sacred.

In Italy, in contrast to northern Europe, a witch-hunt as such only took place in some Alpine and subalpine areas, even though women suspected of witchcraft were tried throughout the peninsula and in Sicily. Like the Spanish Inquisition, the Roman offices of the Inquisition tended to treat its witches as a variety of female *illusa*: not powerful and feared, but stupid and misguided.[41] This went hand in hand with the Inquisition's concern for procedural propriety, rare use of torture and assigning little weight to the denunciations made by previously accused witches.[42] The Inquisition's relative leniency was combined with a war on 'superstitious healing'

during the final two decades of the sixteenth century, as discussed in a wide-ranging study by Giovanni Romeo.[43] Although probably not a conscious strategy, it helped to diffuse the perceived threat of witchcraft, since these magical activities were considered to be the reverse side of sorcery or *maleficium* (accusations of which culminated in the witch-craze in many areas of northern Europe). Romeo also seeks to demonstrate the extent to which the exorcism was a growth industry during the same period. Because exorcism could be employed against both suspected witch and victim to chase away demonic influences, it served as a further escape valve for the perceived witchcraft threat. This is all placed in the context of increasing Church control – the author calls it 'clericalisation' – after Trent. As part of this, the Holy Office asserted its authority over 'religious' offences, appointing its own inquisitors (instead of depending on Dominican and Franciscan friars as in the past), through whom it was able to exercise more direct control over the episcopal courts.

There is still much to be learned about witchcraft at the local level, especially if we analyse the trials and accusations from both 'above' and 'below', as we have suggested in the context of the closely related trials for beneficent and maleficent magic. How were people's beliefs influenced by the trial procedure? A useful example can be found in Carlo Ginzburg's study of the Friulian cult of the *benandanti*, whose members 'went out' at night to do battle with witches in order to defend the harvest.[44] Ginzburg demonstrates how the beliefs of the *benandanti* were transformed over the course of several centuries through interaction with the inquisitorial judges into those of standardised diabolical witchcraft, leaving only vague traces of earlier beliefs. This process of diabolisation also occurred in Sicily, according to Gustav Henningsen's illuminating study of the *donni di fuora*, a Sicilian fairy cult whose members were reputedly organised into companies that went about visiting houses at night to heal people and bestow prosperity. Interestingly enough, soon after 1600 the accounts of the ritual celebrations of these *donni* were turned into straightforward witchcraft accounts as a result of the inquisitors' 'monkish fantasies'.[45]

In areas like the Terra d'Otranto where there was no persecution to speak of, the central question should be: why did people look to the courts for protection from wise women rather than turn to traditional remedies against their activities? It was not due to changing socio-economic pressures, because such structures remained largely static, as we shall see in chapter one. It seems as if the episcopal courts of the Kingdom of Naples came to be perceived as a last-ditch solution to the threats of the wise woman, partly because this suited the people's own needs and partly because the Church stressed that such sorcery was the devil's work which

only the Church possessed the force and authority to counter. For example, absolution in confession often depended on the denunciation of one's own or a neighbour's offences, and occasionally this would lead to trials before the episcopal courts. And as Richard Horsley has suggested, a witchcraft accusation was all the more plausible against someone who already had a reputation as a wise woman.[46] Nevertheless, most trials *began* as charges of specific malefice, which were believed to lie behind a particular disease or misfortune, rather than as charges of diabolical witchcraft. Wise women were tolerated as a necessary evil – on the principle that *qui scit sanare scit destruere* (who knows how to heal also knows how to harm) – as long as they did not overstep certain limits. How the accused women came to terms with the further accusations of diabolical witchcraft directed at them by the courts is the subject of chapter 8.

Following this review of recent research into aspects of popular religion in the Italian South it is appropriate to suggest ways forward. The first stumbling block is clearly one of definition and orientation. This can be overcome by exploring the relationships of particular ritual beliefs and practices to one another and to the more general process of reform undertaken following the Council of Trent. In doing the research we must not take our sources – whether they be pastoral visitations, missionary relations or trial records – at face value, using them as if they were the field-notes of an équipe of anthropologists, for they were written with very different ends in mind. We would also risk simply repeating the ortho-dox–unorthodox distinction of the reformers. But neither should this frighten us off: even the most subjective sources, the diocesan 'trinity' of visitation, *ad limina* relation and synod, can furnish valuable background information regarding the role and condition of the Church at the local level.

It is this local reality which will be the main focus of this book, enabling us to consult the maximum number of sources over the longest period of time, to trace change and continuity. For this reason I have chosen the Terra d'Otranto. It is compact enough to have its own distinct identity, yet large enough to present different historical and social realities (and, in Lecce, it had the second city of the Kingdom of Naples, in terms of post-Tridentine ecclesiastical development). Its fluctuating though essentially stagnant economy and unchanging social character during the early modern period calls out for a *longue durée* analysis. At the same time, however, we should be aware of similar processes throughout (especially) Catholic Europe, making frequent use of comparative analysis.

I shall be focusing on the ecclesiastical trials (and, to a lesser extent, the canonisation processes) as the most useful source in the study of attitudes

towards the sacred because of their relative directness and wealth of detail. In following this path I am aware of the pitfalls, but I think these can be avoided by seeing the trial records in their institutional and social context, and by exploring the different motives of all the actors: judges, witnesses, plaintiffs and defendants. This local reality can be reconstructed, at least in part, by combining the variegated source materials at our disposal. As for periodisation, I shall begin with the close of the Council of Trent in 1563, after which time most of our sources make their first appearance, and end with the 1818 conordat between the Kingdom of Naples and the Papacy, which formally altered many of the ecclesiastical structures.

Where does this leave us? Most important, I think, given the fragmentation of much of the research carried out, is to take a more global view of the subject. It may be helpful to view religion as a ritual *system*, made up of individual 'signs' or 'symbols',[47] which offer various means of gaining access to sacred power so as to provide protection and maintain personal equilibrium. As we shall see, these signs operate in patterned ways, often overlapping and competing with one another, forming what Robert Scribner has called an 'economy of the sacred', 'an ordered structure of relationships with the sacred, encompassing persons, places, times and things.'[48]

Alphonse Dupront has also made some interesting suggestions in this regard, though there is no room for maleficent magic in his conception of the sacred. He divides religion into that of liturgically-structured everyday life, the 'extraordinary' (such as pilgrimages and miracles) and the 'cryptic' (para-liturgical and magical elements), and notes its importance in providing therapeutic 'mental mechanisms' against the threats of the 'irrational'.[49] In a world where everything is linked, the legendary – image narratives and apparitions, for example – represents the irruption of the sacred into the everyday and the momentary disciplining of the anarchic forces of the cosmos. Dupront is correct in emphasising the importance of gestures and actions in the solicitation of supernatural power, like crossing oneself, kissing a relic, kneeling before an image. These form part of what he has termed the 'sacralities': situated at the 'boundaries where human weakness and hope seek, amidst a constraining existential tension, the certainty of the all-powerful or more often dramatically the courage to live.'[50] Although his research has emphasised worship – often in popular forms which the ecclesiastical authorities have tried to control or correct – his comments could be extended even further to include all the ritual forms which sought to tap sacred power, in both its divine and diabolical manifestations. For, as sacred and profane co-existed in the popular mentality, so did divine and diabolical.

We must step back from our sources and observe how the system's various elements functioned, overlapped, competed. In early modern Terra d'Otranto there were different levels of society all participating in the sacred system, but to varying degrees and stressing its different elements and structures, as we shall see. How to isolate these? I have chosen to focus on the protagonists in this rich and multi-layered story. Through them we can explore the many signs – at least the most representative – and observe how they functioned in the societal context. We begin with a general survey of the geographical area under consideration, as an introduction to the economy, demography, settlement patterns and other structural features which did much to characterise the particular existential needs that the sacred system sought to satisfy. Next, we turn to the Church, as a body the single most important element and one which sought to appropriate, regulate and standardise religious belief and practice after the Council of Trent. Its institutions and reforms – its vain attempts to establish a monopoly over access to and interpretation of the sacred – form a backdrop to the study of the ritual actions and actors that follows in Part II.

Here, we see the sacred system in action, confronting life-threatening crises of malady and misfortune. The origin or causation of disease determines the form of cure, encompassing a pool of ritual figures: the priest, wielder of Church sacramentals and representative of the so-called 'ecclesiastical medicines'; the wise woman, practitioner of lay, popular healing rituals; and the saint, dispenser of miracles and favours. All provided channels to sacred power, able to restore order to daily life, and all were used by patients and victims in a pragmatic search for relief, despite attempts by the ecclesiastical authorities to define what was orthodox and permissible.

But sacred power was ambivalent and unpredictable: what could heal could also harm. So too with the demonic, equally a part of the system, through which treasures could be found, spells cast and even grace obtained. We shall explore the relationships between the activities of the sorceress (representing popular magic) and the necromancer (representative of learned or élite magic) at the local level, before turning to the characteristics of diabolical witchcraft and the Satanic pact. The devil makes his appearance gradually in Part III, and even when he does assume a major role – regarding witchcraft – he remains for much of the population the trickster of folklore, with whom bargains are struck and just as easily broken.

The *longue durée* of the book allows us to explore what is constant in the sacred system and what changes and evolves in this province on the

periphery of Catholic Europe during the early modern period. Through a discussion of the actors involved – from bishop to witch – we shall be able to pinpoint the system's key elements and characteristics, as well as the overall changes and developments that took place during the early modern period. The overlap between clerical and lay is revealed, as are the exchanges and tensions between centre and periphery. The emphasis, however, is on similarities, on the shared values, needs and fears of all members of society, over which hovers the Church, attempting to define, regulate and reform access to and attitudes towards the sacred.

NOTES

1 Carlo Levi, *Christ Stopped at Eboli*, trans. F. Frenaye (London, 1948), 1-2.
2 For an expanded version of this introduction, see my 'Methods and approaches in the social history of the Counter-Reformation in Italy', *Social History,* XVII (1992), 73-98.
3 Carlo Ginzburg, 'Premessa giustificativa', introduction to *Quaderni storici,* XIV (1979), 383.
4 Gabriele De Rosa, 'Religione popolare o religione prescritta', in *Chiesa e religione popolare nel Mezzogiorno* (Bari, 1979), 6.
5 Dario Rei, 'Note sul concetto di "religione popolare"', *Lares,* XL (1974), 264-80.
6 Cf. Ginzburg, 'Stregoneria, magia e superstizione in Europa fra Medioevo ed età moderna', *Ricerche di storia sociale e religiosa,* IX (1977), 119-33, and Jean-Claude Schmitt, '"Religion populaire" et culture folklorique', *Annales. E.S.C.,* 31.5 (1976), 941-53.
7 Roger Chartier, 'Culture as appropriation: popular cultural uses in early modern France', in S. Kaplan (ed.) *Understanding Popular Culture.* (Berlin, 1984), 229-53.
8 Gabriele De Rosa, 'Storia e visite pastorali nel Settecento italiano', in his *Feudalità, clero e popolo nel Sud attraverso le visite pastorali del '700* (Naples, 1969), 69-90.
9 Umberto Mazzone and Angelo Turchini, *Le visite pastorali: Analisi di una fonte* (Bologna, 1985).
10 Cf. Bruno Pellegrino, 'L'archidiocesi di Taranto nei secoli XVII e XVIII attraverso le relazioni degli arcivescovi', Pellegrino, ed. *Terra d'Otranto in età moderna* (Galatina, 1984), 67; and Cleto Corrain and Pierluigi Zampini, *Documenti etnografici e folkloristici nei Sinodi Diocesani italiani* (Bologna, 1970), 5-7.
11 Ginzburg, 'Premessa', 394-5.
12 Peter Burke, 'A question of acculturation?', in *Scienze, credenze occulte, livelli di cultura: Convegno internazionale di studi.* (Florence, 1982), 197-204.
13 Adriano Prosperi, 'Intellettuali e Chiesa all'inizio dell'età moderna', in *Storia d'Italia. Annali IV: Intellettuali e potere.* Turin, 1981, 159-252.
14 William Christian, *Local Religion in Sixteenth-Century Spain* (Princeton, 1981), 177-80.
15 Gabriele De Rosa, *Vescovi, popolo e magia nel Sud* (Naples, 1982), 36-8.
16 Francesco De Luca, *La diocesi leccese nel Settecento attraverso le visite pastorali: Regesti* (Galatina, 1984), 20-4.
17 Cf. Rosa Martucci, '"De vita et honestate clericorum": La formazione del clero meridionale tra Sei e Settecento', *Archivio storico italiano,* CXLIV (1986), 423-67; and Mario Rosa, 'La Chiesa meridionale nell'età della Controriforma', *Storia d'Italia. Annali IX: La Chiesa e il potere politico dal Medioevo all'età contemporanea* (Turin, 1986), 293-345.
18 Luciano Allegra, 'Il parroco: un mediatore fra alta e bassa cultura', *Storia d'Italia. Annali*

 IV: Intellettuali e potere (Turin, 1981), 807.

19 Adriano Prosperi, '"Otras Indias": Missionari della Controriforma tra contadini e selvaggi', in *Scienze, credenze occulte, livelli di cultura: Convegno internazionale di studi.* (Florence, 1980), 206-34.

20 For example, Maria Gabriella Rienzo, 'Il processo di cristianizzazione e le missioni popolari nel Mezzogiorno: Aspetti istituzionali e socio-religiosi', in G. Galasso and C. Russo, eds. *Per la storia sociale e religiosa del Mezzogiorno d'Italia.* I (Naples, 1980), 441-81; Elisa Novi Chavarria, 'L'attività missionaria dei Gesuiti nel Mezzogiorno d'Italia tra XVI e XVII secolo', in ibid. II (1982), 159-85.

21 Mario Rosa, 'Strategia missionaria gesuitica in Puglia agli inizi del Seicento', in his *Religione e società nel Mezzogiorno tra Cinque e Seicento* (Bari, 1976), 267.

22 Louis Châtellier, *The Europe of the Devout: The Catholic Reformation and the Formation of a New Society,* trans. J. Birrell (Cambridge, 1989).

23 Christopher Black, *Italian Confraternities in the Sixteenth Century* (Cambridge, 1989), 280.

24 Allegra, 'Parroco', 897; cf. Mary O'Neil, '*Sacerdote ovvero strione*: ecclesiastical and superstitious remedies in 16th century Italy', in S. Kaplan, ed. *Understanding Popular Culture.* (Berlin, 1984), 53-83.

25 Giovanni Levi, *Inheriting Power: The Story of an Exorcist,* trans. L. Cochrane (Chicago, 1988), especially chapter one.

26 Mario Rosa, 'Pietà mariana e devozione del Rosario nell'Italia del '500 e '600', in his *Religione,* 217-43.

27 Giovanni Battista Bronzini, '"Ex voto" e cultura religiosa popolare', *Rivista di storia e letteratura religiosa,* XV (1979), 3-27; but see Bernard Cousin, 'Devotion et société en Provence: Les ex-voto de Notre-Dame-de-Lumières', *Ethnologie Française,* VII (1977), 121-42.

28 Victor and Edith Turner, *Image and Pilgrimage in Christian Culture* (Oxford, 1978).

29 Annabella Rossi, *Le feste dei poveri* (Bari, 1971).

30 Paola Vismara Chiappa, *Miracoli settecenteschi in Lombardia tra istituzione ecclesiastica e religione popolare* (Milan, 1988), 162.

31 Gabriele De Rosa, 'Pertinenze ecclesiastiche e santità nella storia sociale e religiosa della Basilicata dal XVIII al XIX secolo', in *Chiesa e religione popolare nel Mezzogiorno* (Bari, 1979), 48-101; Pierre Delooz, 'Towards a sociological study of canonised sainthood in the Catholic Church', in S. Wilson, ed. *Saints and their Cults* (Cambridge, 1983), 189-216; Peter Burke, 'How to be a Counter-Reformation saint', in *The Historical Anthropology of Early Modern Italy* (Cambridge, 1987), 48-62.

32 Jean-Michel Sallmann, 'Image et fonction du saint dans la région de Naples à la fin du XVIIIe siècle', *Mélanges de l'Ecole Française de Rome,* 91.2 (1979), 827-74.

33 Mario Gioia, 'Per una biografia di san Bernardino Realino, S.J. (1530-1616): Analisi delle fonti e cronologia critica', *Archivum Historicum Societatis Jesu,* XXXIX (1970), 7-8.

34 Luisa Ciamitti, 'Una santa di meno: storia di Angela Mellini, cucitrice di Bologna (1667-17 –)', *Quaderni storici,* XIV (1979), 603-39; and Giovanni Romeo, 'Una "simulatrice di santità" a Napoli nel '500: Alfonsina Rispola', *Campagnia sacra,* VIII-IX (1977-8), 159-218.

35 Such is the case of the nun studied by Judith Brown, *Immodest Acts: The Life of a Lesbian Nun in Renaissance Italy* (Oxford, 1986).

36 H.C. Lea, *The Inquisition in the Spanish Dependencies* (New York, 1908), 97. For a more recent overview, see Gustav Henningsen and John Tedeschi, eds. *The Inquisition in Early Modern Europe* (Dekalb, 1986).

37 Ernesto de Martino, *La terra del rimorso: Contributo a una storia religosa del Sud* (Milan, 1961).

38 To cite but three, Alfonso Di Nola, *Gli aspetti magico-religiosi di una cultura subalterna italiana* (Turin, 1976); Annamaria Rivera, *Il mago, il santo, la morte, la festa: Forme religiose nella cultura popolare* (Bari, 1988); and Tullio Seppilli, ed. *Le tradizioni popolari in Italia: Medicine e magia* (Milan, 1989).

39 Mary O'Neil, 'Magical healing, love magic and the Inquisition in late sixteenth-century Modena', in S. Haliczer, ed. *Inquisition and Society in Early Modern Europe.* (London, 1987), 88-114.

40 Jean-Michel Sallmann, *Chercheurs de trésors et jeteuses de sorts: La Quête du surnaturel à Naples au XVIe siècle* (Paris, 1986).

41 William Monter, 'Women and the Italian Inquisitions', in M. Rose, ed. *Women in the Middle Ages and the Renaissance* (Syracuse, 1986), 85.

42 John Tedeschi, 'Inquisitorial law and the witch', in B. Ankarloo and G. Henningsen, eds. *Early Modern European Witchcraft: Centres and Peripheries* (Oxford, 1989), 83-118.

43 Giovanni Romeo, *Inquisitori, esorcisti e streghe nell'Italia della Controriforma* (Florence, 1990).

44 Carlo Ginzburg, *The Night Battles: Witchcraft and Agrarian Cults in the Sixteenth and Seventeenth Centuries*, trans. J. and A. Tedeschi (London, 1983).

45 Gustav Henningsen, '"The Ladies from Outside": an archaic pattern of the witches' sabbath', in B. Ankarloo and G. Henningsen, eds. *Early Modern European Witchcraft: Centres and Peripheries* (Oxford, 1989), 191-215.

46 Richard Horsley, 'Who were the witches? The social roles of the accused in the European witch trials', *Journal of Interdisciplinary History*, IX (1979), 689-715.

47 For an anthropological approach, see Clifford Geertz, 'Religion as a cultural system', in his *Interpretation of Cultures* (New York, 1973), 87-125.

48 Robert Scribner, 'Cosmic order and daily life: Sacred and secular in pre-industrial Germany', in his *Popular Culture and Popular Movements in Reformation Germany* (London, 1987) 1.

49 Alphonse Dupront, 'De la "religion populaire"', in his *Du sacré: Croisades et pèlerinages. Images et langages* (Paris, 1987), 419-66.

50 'Sacral et sacralités', in ibid., 89.

PART I *Spaces, structures, rhythms*

The setting:
early modern Terra d'Otranto

While a census of the inhabitants of Lecce was being conducted in the vicinity of Porta Rudiae in 1781, the trial records for twenty-five episcopal court cases were discovered in the possession of a local shopkeeper. When questioned, the shopkeeper admitted to using the papers to wrap his wares for the clientele, not realising their importance since he was unable to read. He and other shopkeepers in the area had been offered the papers the previous Christmas, and again at Carnival, by Francesco Cazzetta, *cursore* (messenger and guard) at the episcopal court, so that the latter could buy bread. Trusting Cazzetta and believing his story that he had come on behalf of the curia to dispose of scrap paper from the archive, the shop-keeper accepted his offer of five *grane* per *rotolo* of paper.[1] In his deposition the impoverished Cazzetta testified that he was aware of the gravity of his offence but was forced to commit it out of sheer desperation.

> This year is one of such great penury, well known to everyone, because of the great scarcity of foodstuffs...so that I saw myself and my family consumed by hunger, which counsels every disorder and excess, even to probity itself. I resorted to all possible expedients in order to find some assistance, but I could find no way out.

Then he had the brilliant idea of selling some archival papers to the shopkeepers. Unable to read, he deemed the papers of little importance. In his own words: 'I never considered it a great crime, believing that the said papers present in the Archive, so covered with dust and all withered up because of their great age, could no longer be of any use.'[2] The curia managed to recover some of the trial records and Cazzetta was released.

Besides suggesting reasons for the disappearance of archival documents – one of many vicissitudes experienced by the religious archives of the Terra d'Otranto – the above case serves as an introduction to one of the important themes of both this chapter and the book as a whole: poverty. But more than just a lack of means and resources, it was the very fragility of human life which so influenced the sacred system to be explored. In order to understand better these underlying structures, which remained more or less constant throughout our period, and their effects on belief,

this chapter will briefly introduce the geographic, economic, demographic and sociological features of the Terra d'Otranto. I do not want to suggest that these environmental structures *determined* the make-up of the sacred system. Rather, they helped to shape its contours, and can help us understand why the main configurations of the sacred system remained so constant throughout the early modern period.

THE ENVIRONMENT

In order to explore the man–nature relationship we must begin with a word about the geography and environment. The province of Terra d'Otranto, can be divided into three major areas: (i) the northwest, composed of the *murgia* (limestone table mountain) of Matera, the *murgia* of Martina Franca, the Francavilla–Latiano plain, and the plain south-east of Taranto; (ii) central Salento, composed of the Lecce plain; and (iii) southern Salento, composed of the Nardò–Gallipoli plain, the Otranto plain and the cape of S. Maria di Leuca.[3]

North-west and central Salento were characterised by the large peasant agglomerations typical of Mediterranean settlement patterns, often referred to as agro-towns, with *masserie* scattered throughout the countryside and some dispersed settlement.[4] While the *murgia* of Matera was given over to cereal cultivation and pasture, that of Martina Franca and the nearby Francavilla-Latiano plain was more developed, the expansion of cereal cultivation balanced by tree crops, including olives as well as fruit trees, and market gardens. Olive growing tended to predominate in the area of Ostuni–Brindisi–Lecce–Gallipoli, with an area of grain growing in the plain around Taranto; but even in these areas there was a mixing of arable lands with tree crops (vines predominant among the latter). This meant a greater variety than in the two provinces to the north, Terra di Bari and Capitanata.[5] Aside from typically Mediterranean products like wheat, olive oil and wine, other cereals were cultivated in the province, especially barley, as well as saffron, cotton, linen, silk and citrus fruits. To the south of Gallipoli–Otranto, the third area of the province, structures were somewhat different, due in part to poorer soil. Here landholdings were smaller, given over to polyculture largely to satisfy local needs, and the settlement pattern consisted of small scattered villages. Even the episcopal centres of Ugento, Alessano and Castro were but villages, with populations of 151, 161 and fifty-one hearths, respectively, in 1561, at the beginning of our period.

This basic geography was to be important in conditioning demographic patterns and local agricultural strategies over the next 250 years. Although

overall the period was one of stagnation and even decline for the province, it was not constant, nor the same everywhere. Models of political instability and economic backwardness are not particularly useful in helping us to understand the Kingdom's economy, for a lack of change is often the result of continual action and reaction, of local strategies on the part of merchants and farmers to preserve the status quo.[6] For instance, the sparsely inhabited lands to the south-east of Taranto were settled by local lords, making use of groups of Albanians fleeing the Turkish invasions; the importance of the port of Gallipoli led to a replanting of olive trees, the city's main export; while the years of the Restoration witnessed the ongoing expansion of some traditional products, like grapes and cotton, and the introduction of new ones, like tobacco. Moreover the peasant village, although a closed society, was not motionless. Residents left for the cities and larger towns to find work (or beg), or went to other rural areas to work in the *masserie* as fixed seasonal labourers. At the same time, shifts in feudalism occurred, as the peasant became more of a direct subject of the king and less of the baron, at least politically. Although weakened as individuals, the barons closed ranks to form their own class, resulting in a tightening of the feudal regime, until abolished by the French in 1806.[7]

These fluctuations do not alter the fact that landholding patterns remained relatively constant throughout the period, while the institutional and legal framework prevented any large-scale transformation from subsistence to commercial agriculture. Land was subject to a multiplicity of rights and powers vested in different agents, and the entrenchment of much of the peasantry into share-cropping tenures encouraged a way of life which was closed in on itself, limiting the impact of outside developments.[8] Indeed, *ancien régime* social and economic structures remained largely intact as the Kingdom joined the newly-unified Italian state in 1860. Even the resurgence which began in the mid eighteenth century was more apparent than real: higher yields and demographic expansion were not necessarily signs of an expanding economy. The methods of cultivation – a peasant could cultivate only 3.5 hectares with his own arms, while the use of a team of oxen would have achieved up to 10 hectares – town-country relations and the great poverty of the mass of peasants remained unchanged.[9]

ECONOMIC AND DEMOGRAPHIC PATTERNS

A close link can be traced between demographic behaviour and agricultural types. Grain cultivation tended to encourage high birth rates sensitive to market fluctuations, wine and fruit production was equally affected

by price changes but birth rates were low, while a third type, seed and tree crops, tended to be immobile and were not so affected by the market.[10] The third type corresponds to the polyculture of southern Salento, characterised by little demographic change during the course of our period. Its stagnancy and inward-looking nature enabled it to withstand the years of economic crisis begininning in the 1590s, exacerbated here by continuing Turkish incursions; but it was the worst affected by the long-term decline of the seventeenth century, becoming increasingly marginalised with vast expanses of uncultivated land by the mid-1700s.

The rest of the province was much more open and thus more sensitive to outside economic developments, and this is reflected in greater population fluctuation. The impression of the seventeenth century is one of overall decline. The population of the capital, Lecce, fell from 6,167 hearths in 1561 to 3,300 just over one hundred years later.[11] And this despite the fact that the city was spared the calamitous plague of 1656. The entire province, not to say the Kingdom of Naples, was adversely affected by the shift of world commerce away from the Mediterranean and towards the Atlantic. As a result, according to Immanuel Wallerstein, the Kingdom became part of an increasingly underdeveloped periphery,[12] reduced to exporting raw materials (like grain and olive oil) and semi-finished goods (like silk), and importing manufactured products. Even within the Kingdom, the relationship of the provinces to the capital was almost 'colonial'. Because of the victualling legislation Naples consumed vast amounts of grain, the payment for which, instead of finding its way back into the provincial economies, was absorbed by the capital in the form of goods and services provided for the court, absentee landowners, government officials and merchants.[13] The survival of early modern Naples depended on the continuous in-flow of funds – taxes, rents, feudal dues – from the provinces. Only Church property was a countervailing force, clerical structure (see chapter two) ensuring the Church's role as a mainstay of the local and provincial economy. The Church leased much of its land in small garden plots and extended credit to local farmers. But even this apparently beneficial activity, rather than solve economic problems, tended to perpetuate them, by allowing for peasant survival but preventing self-sufficiency and economic development.[14]

Like much of the Adriatic side of the Kingdom, the Terra d'Otranto had a low population density, particularly after the 1590s which witnessed a period of long decline. This was compounded by the absence of urban centres of importance – aside from Lecce – to bring about mercantile activity in the surrounding areas. Grain prices, for example, varied widely from town to town throughout the province, suggesting a variety of local

markets and lack of commercial organisation.[15] There was no adequate network of rivers, and the presence of stagnant water – the threat of which increased as population declined – reduced the area of cultivable land and marginalised whole strips of territory into marshland.[16] Nor was there a decent infrastructure of roads to aid in communication. What did exist – the royal *cammini* linking Apulia to the capital – reflected trading patterns and the interests of political and economic forces which controlled agricultural production, ensuring the transport of vital grain and food supplies to the capital.[17] Lecce was well connected to Naples by road (via Bari, Foggia, Bovino and Avellino), although up to Bovino it was a natural road rather than a *strada di fabbrica*, that is, carriageable by all means of transport. Aside from the secondary roads leading to Otranto, Gallipoli and Taranto (the *cammini traversi*), the rest of the province was poorly served, a situation which only began to change in the nineteenth century. As a result, much had to be transported by ship, with all the delays and dangers – including Turkish and Venetian piracy – that this incurred.[18]

To return to the theme with which we began this chapter. The poverty of the peasantry meant a diet consisting largely of vegetables, primarily pulses, and wild plants like field chicory and thistle, along with bread.[19] But according to Paolo Mattia Doria, writing in 1713, 'the wretchedness of the peasants is such that only during the most serious and extreme diseases do they touch wheat bread: usually they feed themselves with maize bread and herbs seasoned with salt and oil. Of meat and other foods, they have not even the idea.'[20] In the Terra d'Otranto the 'bread of the poor' was made of barley, although constant shortages of wheat and the demands of the capital meant that the consumption of barley bread was quite widespread during the early modern period.[21] The resulting general state of malnutrition amongst much of the population meant that even minor diseases could kill over a period of days if not hours, to say nothing of the epidemics and pestilences which periodically decimated the population. According to one scholar, 'paltry grain yields, meagre olive harvests, infestations of *bruchi* and the wide diffusion of epidemic diseases, typhus and smallpox above all, constitute the frame of reference within which series of sudden deaths are able to develop.'[22] And even for those who could afford their services, physicians were not of much help, given their inability to diagnose and treat successfully most of the period's diseases. (Although physicians were not unaware of their limitations, as we shall see in chapter 5.) The precarious condition and weakness before disease helps explain the apparent desperation of patients in seeking cures for their afflictions, a theme we shall explore in greater detail in Part II.

Famine was a frequent visitor. A year of dearth every three or four was

considered acceptable, or at least normal. When they followed one an-
other in close succession famine was the inevitable result.[23] Peasant society
focused its thoughts and hopes on the moment of the harvest. The period
leading up to the harvest, and of the harvest itself, was therefore one of
great existential tension. One could never be sure of the harvest until it was
in, as flooding in winter could give way to drought and the desiccating
south wind (the *scirocco*) in summer. The Mediterranean was always on
the verge of famine, and 'a few changes in temperature and a shortage of
rainfall were enough to endanger human life'.[24] The sacred system at-
tempted to confront the manifestations of this anxiety both at the time of
the harvest – by the tarantism ritual, for instance (chapter 3) – and
throughout the year, by means of liberating calendrical festivals, like
Carnival and saints' feasts, and apotropaic rituals like rogation processions
and the more *ad hoc* exorcisms and conjurations.

In the Kingdom of Naples the decline of the seventeenth century was
most clearly demonstrated by the revolts of 1647–48, which shook the
capital and the provinces. Compounding a general anti-Spanish sentiment
– Spain's fiscal policy saw Naples as a source of quick income – were years
of drastic inflation, famine, rapid currency depreciation and a public debt
which brought many *università* (municipalities) to the brink of bank-
ruptcy.[25] As early as the 1590s tensions were manifested by increased
banditry throughout the Kingdom, in the Terra d'Otranto as elsewhere.
Sporadic raiding and robbery held captive many provincial towns:
Martina Franca, Locorotondo, Carovigno, Taranto, Scorrano, Palag-
giano, Gallipoli and Ugento.[26]

By 1647 much of the Kingdom was in open revolt. Although they
followed the lead of the capital to a certain extent, the *moti* in the terra
d'Otranto – notably in Martina Franca and Nardò – were directed more
towards the heavy feudal demands of the local lords (Duke Francesco
Caracciolo and Count Giovan Girolamo Acquaviva, respectively), than
Spanish fiscal policy.[27] In Martina the crowds took advantage of the duke's
absence to occupy the castle and form a band to search for the ducal
governor. On the other hand, there were no disturbances in the towns of
Francavilla, Oria and Casalnuovo because Prince Michele Imperiale – to
whose fief the towns belonged – had temporarily declared an 'immunity
from the gabelle'[28]. Other revolts were more directly antifiscal, whilst still
involving a strong element of local dispute. In the port city of Taranto the
principal participants were the *marinai*; this was also the case in Brindisi,
where crowds imprisoned both the archbishop and the royal governor. In
Grottaglie the Jesuits, to whom most of the local dues went, were chased
from the town. In Lecce, in contrast, local uprisings were quickly con-

tained by the clergy, organised and armed by Bishop Luigi Pappacoda and dispatched to the city's 'trouble spots'.[29] Pappacoda also sought to mediate between the people of the city and the viceroy's representative in the province, Francesco Boccapianola. He was less successful in mediating between the people of Nardò and their count, Acquaviva, who restored order in his domain by executing numerous *popolani*, several nobles and four ecclesiastics suspected of being involved in the disturbances. In fact, the period following the crushing of the uprisings favoured the landowning aristocracy, who took advantage of the climate of destabilisation and the power vacuum to acquire new rights (or reinforce old ones) and new lands.[30]

Having described the general picture for the province let us now turn to those areas which will form the basis for the discussion of the sacred system, to be presented in the chapters which follow. In the Introduction we suggested the importance of also utilising more 'direct' sources for the research, in particular the criminal trial records of the episcopal tribunals, most accessible (as of 1986–87) at the diocesan archives of Lecce, Gallipoli and Oria. This allowed for research in the three different areas which made up the Terra d'Otranto, each with its own characteristics, as discussed above. In Lecce, we have the undisputed centre of the province, in religious, political and cultural terms; in Gallipoli, a maritime centre of the south, whose livelihood was due to the international trade in olive oil, crucial to the economy of the entire province; and in Oria, a diocese representative of the mixed agriculture of the plain, composed of large agro-towns, most notably Francavilla.

LECCE

Lecce exercised hegemony over the Terra d'Otranto not only because it was the province's capital – and thus the seat of royal power, with the tribunal and other offices of state – but because of its role in cultural and religious leadership. With the possible exceptions of Naples and Aquila, no other city in the Kingdom was comparable to this 'church–city' of the Counter-Reformation, with an importance over the diocese and the province out of proportion with its modest size.[31] The strong feudal presence in the province gave its lay barons and ecclesiastical proprietors rising incomes as prices increased during the economic 'crisis' of the last few decades of the sixteenth century and the first two of the seventeenth. This coincided with a period of intense urbanisation in the city, where land-based wealth was poured into the construction of new buildings in the baroque style – what has been called the 'pietrification of wealth'.[32]

The first half of the sixteenth century had seen the expansion of the city walls, work on the castle, the rebuilding of the Ospedale dello Spirito Santo and the enlargement of the Udienza (tribunal). However, it was the second half of the century which saw the construction of new palaces by the nobility, the building of new churches, the restructuring of convents and monasteries, the demolition of unused or ruined religious edifices and the putting up of new houses by the Religious Orders inhabiting the city with ever increasing density. The buildings of the newly arrived Jesuit and Theatine Orders triumphed, both materially and symbolically, over those previously occupied by the Greeks and the Jews.[33] During the period from the mid-1500s to 1620 the number of the city's monastic buildings more than doubled, many belonging to reformed branches of the Franciscan family: Observants Minor (1566), Capuchins (1570), Reformed Observants Minor (1588) and Alcantarines (1610).[34] The architectural fashions of the so-called *barocco leccese* then radiated outwards to other provincial centres, which in turn influenced styles in smaller communities.

Yet, as mentioned above, the city was affected by wider developments, and its population began to decline between 1620 and 1630. Building in the city all but ceased, until the second phase of the baroque. This began with the reconstruction of the cathedral in 1658 in gratitude for the city's having been spared the plague of two years earlier. Despite this impressive period of sacred and secular building, lasting until about 1710, the city's financial fortunes had already begun to decline. It was becoming clear that the 'wealth' of the ecclesiastical structures was based on a system of benefices and pious bequests, as we shall see in chapter 2. Later increases in population remained but slight, and by the end of our period the decay of Lecce into a lesser centre of the Mezzogiorno was already visible, though it continued to be the province's most important city. When the traveller Richard Keppel Craven visited it in 1820 he described the city as appearing all but deserted of people, its population being only half of what it could 'commodiously admit'.[35]

The success of Lecce, and its subsequent decline, also influenced the smaller towns of the diocese. In describing them, Keppel Craven noted that 'each boasts of a handsome church, capacious and well-built houses, and a broad paved street'. Although he found their uniformity monotonous, he admitted that it testified to 'the existence of a certain degree of affluence and industry among the inhabitants.'[36] While in a major centre like Lecce land-based wealth formed the basis for the construction of a network of churches and monasteries, in the smaller rural centres the focus was on the parish church – with altars paid for by donations – as well as a few scattered churches and chapels, each with its own income-generating

parcel of land.[37] The population make-up of these towns was determined
by the proximity and attraction of Lecce. Nobles were noticeable by their
absence, having chosen to reside in Lecce (or Naples). Artisans made up
only 18 per cent of the population, compared with over a third in Lecce,
and even they would have derived most of their income from some plot of
land in their possession.[38] Their most important link was still with the soil,
and there was no sense of belonging to a separate class, a bourgeoisie. The
bourgeoisie was only to become a factor in the Kingdom's political
economy after 1806, with the abolition of the feudal system under the
French.[39] Generally, just over one fourth of family heads would have
owned no land, earning money as salaried farm labourers (*braccianti*),
while another quarter owned just a small parcel, though not enough for
self-subsistence, despite the variety of produce.[40] At the bottom of the
scale, mendicants and cripples – like the nobles – were attracted to Lecce,
making up 4.31 percent of its population (whereas in the towns they
represented a mere 0.18 percent).[41] But whatever the class, whatever the
wealth, all these people depended ultimately on the land and its fruits for
their livelihood, however meagre.

GALLIPOLI

Gallipoli, on the other hand, owed its continued existence to trade,
although even here it was agricultural produce – olive oil – that was
handled. While Lecce looked inland, Gallipoli, on a promontory, looked
out to the sea. Although much of the coastal land from the cape up to near
Gallipoli was insalubrious marsh, in common with vast stretches through-
out the province, the administrator and reformer Giuseppe Ceva Grimaldi
noted in 1818 that the city's 'territory is fertile and the citrus fruits abound
and perfume the air', while its commerce 'rendered it populous and rich'.[42]
Much of the olive oil exported from the Kingdom – in the 1760s over a
third – was shipped from the port of Gallipoli, most of it going to North
Sea and Baltic countries.[43] As of the mid-seventeenth century the English
had their own consul there, who designated himself a 'public trader of the
city'.[44]

 Although the trade in olive oil was highly commercialised, the bulk of it
was in the hands of a small group of Neapolitan merchants and agents of
foreign merchant houses and was carried primarily by English shipping, so
that profits were not greatly returned to the local economy. Furthermore,
because the barons possessed rights over the pressing of olives and derived
income from the use of their presses as well as a tax of one third on the
fruit, the industry was rendered immobile. A sign of its stagnation was the

difficulty experienced by such reformers as Giovanni Presta in introducing much-needed reforms in the manufacturing process, despite some success in Calabria.[45] Despite this stagnation, trade was busy throughout our period shielding the city from the worst effects of the economic crisis and providing the stimulus for the province's limited recovery during the second half of the eighteenth century.

ORIA

The third and final area under consideration is the diocese of Oria, consisting mainly of the Francavilla–Latiano plain, described above. The area's population was stable during the seventeenth century when the rest of the central and northern parts of the province was in decline. It was largely spared the incursion of marsh and wasteland which, as we have said, characterised other areas, such as the adjacent diocese of Brindisi. But in one other feature it was typical of the province: its episcopal see did not differ greatly, quantitatively or qualitatively, from the other centres of the diocese.[46] Indeed, the principal town of the diocese was Francavilla, half-way bewteen Taranto and Brindisi. For someone like Alessandro Kalefati, used to the cultural life of Naples, appointment as bishop of Oria in 1781 was something of a shock, and he prolonged his move 'from the Capital to some desolate Province' for two years.[47] His remorse continued, though he eventually overcame it by busying himself with diocesan affairs and his own antiquarian interests.

> I am placed in a lovely locale truely through divine mercy: but after thirty years of life spent in Naples, it seems to me that I am on a country vacation. Accustomed to the big world, in the midst of many friends and *belles-lettres*, I feel as if I have been abandoned by everyone and forced to unlearn... If you have academic and literary news, *extra academiam* and world-wide, give them in charity to me, a poor tenant farmer, toiling on a parcel of land.[48]

This feeling of being 'in the country' was no doubt due to the impact of being transferred from the bustling chaos of Naples to the collection of peasant agglomerations, or agro-towns, which constituted the basic settlement pattern of his diocese and, indeed, much of the rural South. The fourteenth-century decline in population had contributed to the rise of these concentrated, closed localities as marginal settlements were abandoned. The resulting resurgence of marshland and malaria, as well as the danger of these vast stretches of open country, then tended to keep people in the towns, with only fortified *masserie* dotting the countryside.[49] The agglomerations also persisted for various other reasons. The town square –

whether in a large centre like Lecce or in a tiny community – served as a labour market for the salaried farm work so important to the local economy. These day-labourers generally felt no intrinsic attraction to the land, sharing local perceptions whereby the town was equated with qualities like 'urbanity' and *civiltà* and the countryside with backwardness.[50]

In fact, these 'peasant towns' are towns only in appearance. The town–country distinction was more apparent than real: the country was overwhelmingly present in the towns, reflected in the urban structures and the forms of buildings, the paucity of non-agricultural activities and the prevailing values and sensibilites of the inhabitants.[51] In terms of the sacred system, it meant that the needs and values of town and country were virtually indistinguishable. And the face-to-face nature of even the largest centres is frequently apparent in the depositions of witnesses before the episcopal courts. Gossip circulated in the main square, enabling the inhabitants to keep abreast of events. Indeed the village-like atmosphere of snooping neighbours, where people began to gather at the first sign of a disturbance or irregular occurrence, was a fact of life in all Otrantine communities, regardless of size.

The rural aspects of life conditioned the way people perceived time and space. In a sacred sense time was divided up by the ringing of church bells, bringing a daily rhythm to town and village life. The year was liturgically ordered according to saints' feasts and other calendrical festivities (like Carnival), which also provided a guideline for carrying out agricultural activities. Space was delineated by a sacred geography of shrines and healing springs, and was defined by parish or communal boundaries and the distances one could travel on foot, accentuating the local, self-sufficient nature of lived religious experience.[52] In agricultural terms, times of the year were defined by the fruits being harvested, as when a deponent located events 'during the time of the figs'. It also affected concepts of space. In a 1778 trial over the boundaries of a market garden, the gardener determined that the plot was smaller than it had previously been, 'because...I noticed that the days of labour did not correspond to the days usually needed to cultivate a garden.'[53]

The dominant feature of a largely unchanging, stagnant economy, despite minor fluctuations, held tight in a feudal grip, charaterised the Terra d'Otranto in our period. The fragility of human life, exacerbated by widespread malnutrition, economic hardship and frequent famine and epidemic, is another constant. These basic structures influenced the sacred system in profound ways, as we shall see in the chapters that follow. If there was any change in the early modern period, slight though it was, it

took place in the mid eighteenth century when the economy seemed to improve and population increase. The vast majority of the population was perhaps little affected by this upswing, at least directly. But as Church incomes rose, local bishops were able to find money to build seminaries in their dioceses, if not always to run them. This was accompanied by increasing desires to reform the clergy and the means to do so. Some reforms were ushered in by the concordat of 1741, although more profound changes had to await the 'French decade' of Joseph Bonaparte and Joachim Murat, and the Restoration concordat of 1818. As we shall see in our discussion of organised religion in the province (chapter 2), it was the second half of the eighteenth century which saw the ecclesiastical reforms of the Council of Trent beginning to make a noticeable impact.

This did not, of course, spell the end for the extra-ecclesial elements of the sacred system – though with the rise of the bourgeoisie in the nineteenth century, they became increasingly relegated to the lower echelons of society. For the small landholders, tenant farmers and day-labourers life continued pretty much as before. Despite the abolition of feudalism in 1806, the basic economic and agricultural structures were still intact, as was the mentality that went with it. Before the Church could successfully reform and educate the humblest members of its flock, it had to reform itself, in many ways captive to the same structures and equally shaped by them. It is to this process, and its effects on religious life in the Terra d'Otranto, that we now turn.

NOTES

1 A *grana* was the lowest unit of currency (100 *grane* =10 *carlini* =1 ducat), while a *rotolo* was equal to 891 grams.
2 Deposition of Cazzetta, 'Contro Francesco Cazzetta, *cursorem curiae* ', Lecce, 1781, A.C.A.L., *Giudicati criminali*, no. 776.
3 Cf. Pasquale Villani, 'Documenti e orientamenti per la storia demografica del Regno di Napoli nel Settecento', *Annuario dell'Istituto storico italiano per l'età moderna e contemporanea*, XV-XVI (1963-4), especially 51-9.
4 The *masseria* was an estate orientated towards the intensive cultivation of grain worked by seasonal wage labour.
5 Maria Antonietta Visceglia, *Territorio, feudo e potere locale* (Naples, 1988), 126.
6 John Marino, *Pastoral Economics in the Kingdom of Naples* (Baltimore, 1988), 11.
7 Aurelio Lepre, *Storia del Mezzogiorno d'Italia. I: La lunga durata e la crisi* (Naples, 1986), 50 and 63.
8 Patrick Chorley, *Oil, silk and Enlightenment. Economic problems in XVIIIth-century Naples* (Naples, 1965), 12.
9 Gérard Delille, *Agricoltura e demografia nel Regno di Napoli nei secoli XVIII e XIX* (Naples, 1977), 142.
10 Ibid., 37.
11 Cf. Visceglia, *Territorio*, 70-92 for population tables.

12 Immanuel Wallerstein, *The Modern World-System. II: Mercantilism and the Consolida-tion of the European World-Economy, 1600-1750* (New York, 1980), 146-7.

13 Chorley, *Oil*, 14. For a study of the spending habits of the aristocracy resident in Naples, see Gérard Labrot, *Baroni in città* (Naples, 1979).

14 Giovanni Tocci, 'Per un nuovo studio dell'economia agricola salentina nella seconda metà del Settecento', *Critica storica*, VI (1967), 62.

15 Paolo Macry, *Mercato e società nel Regno di Napoli* (Naples, 1974), 143-4.

16 Cf. Christiane Klapisch-Zuber, 'Villaggi abbandonati ed emigrazioni interne', in *Storia d'Italia. V: I documenti*, I (Turin, 1973), 316.

17 Angelo Massafra, 'En Italie Meridionale: Déséquilibres régionaux et réseaux de transports du milieu du XVIIIe siècle à l'unité italienne', *Annales E.S.C.*, 43 (1988), 1049. Cf. Francesco Caracciolo, 'Vie di comunicazione e servizio postale nel Regno di Napoli tra XVI e XVII secolo', *Ricerche di storia sociale e religiosa*, II (1972), 213-28.

18 Antonio Calabria, *The Cost of Empire: The Finances of the Kingdom of Naples in the Time of Spanish Rule* (Cambridge, 1991), 11-13.

19 Cf. Carmelo Turrisi, *La diocesi di Oria nell'Ottocento* (Rome, 1978), 73.

20 M. Schipa, 'Il Regno di Napoli descritto nel 1713 da P.M. Doria', *Archivio storico per le province napoletane*, XXIV (1889), 335; cit. in Macry, *Mercato*, 80.

21 Visceglia, *Territorio*, 319.

22 Mario Spedicato, 'Demografia, economia e società a Carmiano alla fine dell'antico regime', in Spedicato, ed. *Chiesa e società a Carmiano alla fine dell'antico regime* (Galatina, 1985), 74. *Bruco* was a generic term, referring to various grubs and caterpillars.

23 Lepre, *Storia*, I, 67.

24 Fernand Braudel, *The Mediterranean and the Mediterranean World in the Age of Philip II*, trans. S. Reynolds (London, 1975 edn.), I, 243-4.

25 Cosimo Damiano Fonseca, 'La Terra d'Otranto da Lepanto a Masaniello', in Fonseca, et al., *'Barocco' leccese: Arte e ambiente nel Salento da Lepanto a Masaniello* (Rome, 1979), 7. Revolts also took place in other parts of Europe at this time – Paris, Catalonia, Portugal, England – but those in Naples had the least impact, burning themselves out 'like a straw fire', in the words of Fernand Braudel, 'L'Italia fuori d'Italia. Due secoli e tre Italie', *Storia d'Italia. II: Dalla caduta dell'Impero romano al secolo XVIII* (Turin, 1974), p2233.

26 Eliseo Danza, *Tractatus de pugna doctorum* (Montefusco, 1636), 154-5; cit. in Lepre, Sto*ria*, I, 217-18.

27 Giovanni Caramia, 'Pagine di storia martinese: il Seicento', in M. Paone, ed. *Studi di storia pugliese in onore di Giuseppe Chiarelli*, III (Galatina, 1974), 366.

28 Aurelio Musi, *La rivolta di Masaniello nella scena politica barocca* (Naples, 1989), 205.

29 Visceglia, *Territorio*, 292-3.

30 Fonseca, 'Terra d'Otranto', 8-10.

31 Mario Rosa, 'Geografia e storia religiosa per l'"Atlante storico italiano"', in his *Religione e società nel Mezzogiorno* (Bari, 1976), 61. The idea of the 'church–city' was suggested by Giulio Cesare Infantino in his *Lecce sacra* (Lecce, 1634), which dealt with the city's 'sacred space' and was modelled on Caracciolo d'Engenio's *Napoli sacra*, published in Naples ten years earlier.

32 Rosa, 'Geografia', 61.

33 The Jesuits deprived the Greek-rite community of its church of S. Niccolò to make way for the College, while the site chosen for the Theatines in 1584 was that of the former ghetto.

34 Rosa, 'Geografia', 62; Fonseca, 'Terra d'Otranto', 12.

35 Richard Keppel Craven, *A Tour Through the Southern Provinces of the Kingdom of Naples* (London, 1821), 135.
36 Ibid., 146.
37 For the example of Carmiano, in the diocese of Lecce, see Bruno Pellegrino, 'L'ulivo e l'aldilà. Devoti, messe e clero A Carmiano nel XVII secolo', in Spedicato, *Chiesa e società*, especially 87-90.
38 The figures are based on the 1748 cadaster studied by Francesco Gaudioso, 'Testamento e devozione. Il caso di Lecce fra i secc. XVII–XIX', in his *Testamento e devozione* (Galatina, 1986), 56.
39 Lepre, *Storia*, II, 106-7.
40 Spedicato, 'Demografia', 52-7.
41 Gaudioso, 'Testamento', 56.
42 Giuseppe Ceva Grimaldi, *Itinerario da Napoli a Lecce e nella provincia di Terra d'Otranto nell'Anno 1818* (Naples, 1821; reprinted with an intrdocution by E. Panareo, Cavallino di Lecce, 1981), 44-5.
43 Chorley, *Oil*, 26.
44 Visceglia, *Territorio*, 158.
45 Chorley, *Oil*, 172. Presta was the author of *Degli ulivi, delle ulive e della maniera di cavar l'olio* (Naples, 1794). Cf. Giacinto Donno, 'Giovanni Presta: medico ed insigne olivicoltore del Settecento', in *Studi di storia pugliese in onore di Nicola Vacca* (Galatina, 1971), 171-97.
46 Of the thirteen dioceses that made up the province, Lecce was the exception to this general rule. The case of Gallipoli is also somewhat singular, because the diocese consisted of just the town and its immediate vicinity.
47 So he wrote to his friend and fellow cleric Pasquale Baffi, archiepiscopal librarian in Naples, on 1 July 1783. Gino Rizzo, *Settecento inedito fra Salento e Napoli* (Ravenna, 1978), 39.
48 Letter to Baffi, 4 July 1783, cit. in ibid, 38.
49 Klapisch-Zuber, 'Villaggi', 316. Cf. Anton Blok, 'South Italian agro-towns', *Comparative Studies in Society and History*, II (1969), 495.
50 Ibid., 128. For the important concept of civiltà in such communities, see Sydel Silverman, *Three Bells of Civilization* (New York, 1975). Although the study deals with a hill town in central Italy, the concepts are relevant to the South as well.
51 Giuseppe Galasso, 'Gli insediamenti e il territorio', in his *L'altra Europa. Per un'antropologia storica del Mezzogiorno d'Italia* (Milan, 1982), 57.
52 Cf. Alphonse Dupront, 'Ethno-histoire et anthropologie religieuse', in his *Du sacré: Croisades et pèlerinages. Images et langages* (Paris, 1987), 81.
53 'Contro Rvdo Francesco Melicore', San Pietro in Lama, 1778, A.C.A.L., *Giud. crim.*, no. 830.

2 *The local Church:*
organised religion following the Council of Trent

In 1775 the missionary priest Giuseppe Jorio was able to denounce

> the horrible disorder that there is in the towns and cities, in which one sees where thirty, where forty, where fifty, where a hundred priests, and of these not even the tenth part attends to the spirit and to study. And although most of them may not be scandalous, one still sees clearly that they are either lazy or all preoccupied with the interests of their own houses, and if they occasionally participate at church, they do it for pure advantage and without any edification of the people.[1]

Why was this the case more than two hundred years after the Council of Trent? This chapter will attempt to account for this situation and explain what it meant for the sacred system as a whole. To do this we shall focus on the institutionalised or formal aspects of the sacred system in early modern Terra d'Otranto in terms of the pace and effects of Tridentine reform, examining the sometimes troubled relationships between centre and periphery. The reforming measures undertaken after 1563 brought to the fore tensions between bishop and clergy, Church and state, regular and secular clergy, all of which to some degree affected the rest of the sacred system in the province, and so will serve as a backdrop to the chapters which follow. I want to argue that organised forms of devotion, which provided for the sacramental aspect, were only a part of the entire ritual complex, existing alongside ways of sensing and approaching the supernatural which originated from below, responding to local needs and traditions.

In the first two centuries after the Council of Trent the weakness of the parish structure in the Terra d'Otranto and, more generally, in the Kingdom of Naples, made for a complex mixture of elements which seem to be in open competition for men's souls. As we shall see in the following two chapters, the secular clergy, mired down in a system of benefices, saw its role usurped by the reformed Religious Orders, whilst the laity turned increasingly to confraternities in a quest for a devotional routine. However, before discussing the condition and image of the clergy it is necessary to discuss Church structure and the means of reform which the bishops had at their disposal, like visistations, synods and their own tribunals.

Following an analysis of the quality of the local clergy we shall explore the other features which characterised organised religion during this period: the role of the seminaries, enduring structures like will-making, the latinisation of the Greek Church and the attempted reform of the carnivalesque. The following chapter will explore those aspects of organised religion that sought to put the proposed reforms of Trent into practice: the internal missions and the religious brotherhoods.

LOCAL ECCLESIASTICAL STRUCTURES

As mentioned in the Introduction, southern Italian religious historiography has rightly concentrated on the clergy as both the main object of and the main impediment to reform after Trent. The primary reason for this was the corporate structure of many church and cathedral chapters, known as *chiese ricettizie*. Of the 3,734 parishes in the Kingdom of Naples 1,087 were *ricettizie* (that is, just under a third), with the highest concentration stretching in a band from Molise in the north to the Terra d'Otranto in the south. In fact in the latter province just under seventy per cent of the parishes were *ricettizie*.[2] By definition it consisted of a college of ecclesiastics who were required to be natives of the community, living on a common patrimony and collectively exercising the cure of souls, although in practice this was usually delegated to one or more members of the chapter. As such, it differed from the parish structure in several important ways, including the administration of income and benefices,[3] and came to dominate the life of smaller dioceses where the cathedral was the community's only parish. Its corporate structure rendered it closed to outsiders and change. This included the bishop, whose jurisdiction was confined to spiritual matters and who consequently found it difficult to undertake large-scale reform of the local clergy.[4]

The bishop could intervene only when a dispute within the collegial ranks resulted in a lawsuit being pleaded before the episcopal tribunal. This occurred in Gallipoli in 1628 when, according to the archpriest, the cantor assigned readings to some lower dignitaries during the office in celebration of the feast of St Agatha, skipping the more senior priests. As a result, several ecclesiastics almost came to blows, leaving their choir stalls in a rage in the middle of the service. The event was simply a manifestation of a deeper dispute – which seems to have begun with the posting of a defamatory bill against the archpriest – affecting the chapter, with several clerics throwing stones at the archpriest's window late one night. Whatever the trouble, Bishop Consalvo de Rueda (1622–50) was unable to bring

about any improvement in relations and resorted to an ineffectual excommunication 'against all those who make notices, pasquinades, bewitchments [*magariate*], and other defamatory actions against any person whomsoever'.[5] Yet whatever their internal divisions, members of a collegial church would go to great lengths to keep a cleric from outside the community from entering, as when a petition was circulated among the ecclesiastics of the city to prevent the participation of D. Silvestro Valiano, from nearby Parabita, in the diocese of Nardò. So quick were the seventy-five ecclesiastics to sign that they neglected to read the fine print (or so they alleged), which the promotor fiscal noted was full of abuse, insults and lies directed at the outsider.[6]

The top of the local religious hierarchy was still plagued by the frequent non-residence of bishops. This could be due to disagreements with local authorities or feudal lords, or because the bishops were also called to political or diplomatic service as members of noble families. Throughout the period from 1545 to 1714, a minimum of one-quarter of the Otrantine bishops were of noble origin, high with respect to the adjacent provinces of Terra di Bari and Capitanata, many of whom were veritable functionaries of the Spanish crown. Only two-thirds of the bishops resided in their dioceses until they died, although the proportion rose throughout the period, to three-quarters in the years 1651 to 1714. Furthermore, over half of the bishops appointed, by papal or royal nomination, were of Neapolitan or Spanish origin, exacerbating tensions with the loyal, home-grown clergy.[7] Papal and episcopal nepotism continued in some areas, like Nardò, dominated by bishops from the ducal family of Acquaviva d'Aragona for most of the sixteenth century, during which time a series of vicars were delegated to ensure the cure of souls, although they lacked the authority and means to govern effectively.[8] Those bishops who *did* undertake the reforming route came up against a wall of abuses and resistance, with the result that diocesan synods often became meaningless and repetitive, provincial councils but a memory and pastoral visitations irregular and difficult to carry out.[9] In his *ad limina* relation of July 1592 the archbishop of Taranto, Lelio Brancaccio, excused himself for not being able to organise a diocesan synod or provincial council, 'because of the continual lawsuits and disputes with his chapter and clergy'.[10] And where synods and councils were celebrated and visitations undertaken it was then a matter of enforcing the resulting decrees. When two ecclesiastics were arrested in Gallipoli for bearing arms, Bishop de Rueda asked one of them if he remembered the recent synod. The accused admitted to being present at the synod but, strangely enough, did not remember any prohibition against carrying weapons.[11]

THE EPISCOPAL TRIBUNALS

The bishops, of course, were not totally helpless when confronted with clerical and lay offences within their dioceses. They did have one instrument at their disposal, the records of which provide the ethno-historian with much of his material: the episcopal tribunals. The trial records of these courts will feature throughout this chapter and those that follow, so at this juncture it is fitting to focus on the institutional and social side of the tribunals by way of introduction. This must be carried out despite the lack of general studies on their activities in the dioceses of the Kingdom of Naples.

Until their suppression by Napoleonic law under Joachim Murat, king of Naples between 1806 and 1815, the episcopal courts had jurisdiction over offences which affected the Church and its property in any way. This included offences involving ecclesiastics, illicit magic and the possession of prohibited books. They had jurisdiction over laymen in matters of faith, heresy, sacramental offences, polygamy, matrimonial causes and those involving benefices and pious legacies. The 1741 concordat between the Kingdom and the Holy See stipulated that the episcopal courts were empowered to proceed 'according to the discipline of the Church and Canon regulations, with only spiritual penalties as well as of censure, against public and scandalous sinners, and specifically against profaners, adulterers, keepers of concubines, usurers, blasphemers and the like.'[12] Despite this agreement there were continual disgreements between Church and state, primarily regarding ecclesiastical exemptions of person and place (as we shall see below). The secular courts also objected to the relative leniency of the ecclesiastical courts, which they felt undermined their effectiveness. As a response to the habit of sentencing murderers to exile or payment of a fine in lieu of prison or service in the galleys, the secular authorities ordered the bishops 'that in future they must not nor can they absolve such delinquents by means of a pecuniary settlement'.[13] We shall examine a related controversy in chapter 8 over the prosecution of offences regarding witchcraft and the satanic pact, where the episcopal courts were accused by the secular authorities of being not only lenient but overly slow in their proceedings.

The episcopal courts put great emphasis on procedural propriety – which no doubt accounts for their slowness – the result perhaps of inquisitorial representatives. Rather than have a tribunal of its own, in the Kingdom of Naples the Inquisition was only permitted to operate through the episcopal courts, serious cases occasionally being transferred to Rome, though it seems that a more common practice was for the bishop or his

vicar-general to seek counsel from the cardinal inquisitors in Rome as to how best to proceed.[14]

Exemplifying this propriety was the attitude of the courts towards heresy. Here it was important for the court to ascertain intent, for the act had to be wilfully done in contempt of the Church for it to qualify. Yet it was not always possible for the court to discover a heretic's motives, as a Gallipoli trial of 1681 demonstrates. It involved a cooper of the city who, since his return from military service in Messina (presumably at the revolt of 1674), had eaten meat during Lent and spoken out repeatedly against the Church and Our Lady in his shop and in public, getting into arguments with his fellow coopers. The reaction of deponents was that Antonio Roccio was mad. For this reason the archpriest did not even attempt to correct his opinions,[15] while another priest suggested to Roccio that he have himself medicated and bled.[16] Because of his alleged insanity the court was unsure as to how to proceed with the case. The final document before a copy of the records was sent off to Rome consisted of a declaration made by various 'dignitaries, canons, parish priests, priests and confessors', which stated that Roccio had seemed devout when he first returned from the war, undertaking penances, fasts and abstinences. But he soon began to utter 'idle talk' (*vaniloquio*) on spiritual matters because he had read several books (but which ones?) without adequately understanding them, while being convinced that he understood them better than other people. Then, the document continues, Roccio's mind began to fail. One day he stripped and gave his clothes to a beggar and ran into the city, 'where he did many things like a madman', such as walking in the sun without a hat.[17] Finally, despite the treatment of doctors, he completely lost his mind in prison. Unfortunately we do not know Rome's response to this curious case. It would be interesting to know, for example, whether the accusation of insanity was an attempt by the local clergy to keep the heresy from spreading.

The episcopal courts did most of their business in private. Loose allegations were not permitted and witnesses made their depositions under oath. Records of the proceedings were shown to the accused and his or her lawyer – with the names of witnesses for the prosecution deleted – so that they could prepare a proper defence and assemble their own witnesses. Moreover, to identify charges stemming from personal animosity the accused was asked to provide the names of people whom he or she regarded as enemies or who might wish him ill.[18] It is not always easy for the historian to identify the plaintiff's motives in pressing charges. In most of the trials we must await their outcome, 'when the play of the parties is finally revealed, in order to reconstruct the intentions which led to the

trial'.[19] Nor can we posit a direct link between patterns of accusations involving religious offences and a developing orthodox religious sensibility among the faithful in response to Tridentine reform. A specific accusation was generally the outcome of social tensions and soured relations, 'sign of a precise desire to cause someone harm, rather than a response of faith in the face of behaviour which might offend Christian sensibility.'[20]

Two other features must be borne in mind when interpreting the accusations. First of all, the mediation of priests and confessors. Absolution in confession was often made dependent upon an appearance before the episcopal court, to denounce either oneself or another offender. Hence the common use of the expression 'for the relief of my conscience' or 'scruple of conscience' by plaintiffs. The victim of an offence might also seek guidance from his or her parish priest or denounce a suspected offender to him. For this reason the priest can be seen as a mediator not only between different levels of culture but between the plaintiff and the episcopal court as well. This may have given increased authority to the figure of the priest; but it may also be that he was frequently a pawn in the personal disputes of others.

A second important aspect of the workings of the episcopal tribunal is the figure of the promotor (or procurator) fiscal. It was he who presented the charges to the court and established the list of criminal accusations and the text of the questions to be put to the witnesses for the prosecution. A specialist in canon law and theology, often drawn from the ranks of cathedral canons, he was well equipped to analyse the testimony and give advice. However, the work and contribution of these consultants rarely appears in the trial records – they represent another unknown in the trial's course – and it was the bishop or his vicar-general who pronounced sentence and determined punishment.

The promotor fiscal was also assigned the responsibility of policing ecclesiastical behaviour in the diocese, and in this capacity cases began with his own denunciation of the accused. This is exemplified by a 1702 Gallipoli trial against a cleric for going about at night without clerical dress, carrying a prohibited weapon and shouting lewd things into the houses of several women. In his accusation, the promotor fiscal declared that 'while walking at night by order of the Most Illustrious Monsignor [the bishop], so that no scandal of priests took place at night in the city', he came across the accused committing the offences and decided to press charges.[21] In this way the promotor fiscal could augment the bishop's fragile hold over his clergy which depended on the episcopal tribunal for enforcement. In a more general sense, the tribunal provided the bishop with an instrument of reform which supplemented the often ineffectual

means of visitation and synod. Indeed bishops sometimes took advantage of a particular case to issue general proclamations regarding correct clerical behaviour and obedience to episcopal authority.

CONDITION OF THE CLERGY: QUALITY

In dire need of reform was both the quality and the quantity of the local clergy. The former was a problem that reforming bishops throughout Europe were forced to confront in the years after Trent. The Council sought to reform those ecclesiastics primarily involved in the cure of souls, to turn them into a body of specialists and functionaries, increasingly conscious of their new role in the daily administration of the sacred at the parish level. In order to bring about this change a drastic modification in clerical behaviour was required. The episcopal visitations have provided us with a long list of the clergy's shortcomings: gambling, card-playing, womanising, keeping concubines, drinking in taverns, lending money at usurious rates, dressing like laymen, smoking in church, owning and reading forbidden books, performing illicit magic, carrying weapons, dancing and masquerading during feasts and Carnival. The synodal decrees and edicts sought to correct such failings.

At this stage, the decrees 'de vita et honestate clericorum' were largely limited to discliplinary problems – defining what an ecclesiastic could and should not do – with the only positive norms regarding liturgical activity, such as the correct manner of celebrating mass and administering the sacraments.[22] These were common abuses and, for reasons that we shall shortly explore, difficult to eradicate. For instance, there was the so-called 'hunter's mass' (*messa da cacciatore*), celebrated with lightning speed and irreverence by the priest.

Two years after the Council of Trent, in which he participated, Giovanni Bovio, archbishop of the Brindisi–Oria diocese, conducted an exemplary visitation (a model, alas, not often followed). During his visit to Francavilla, double the population of Brindisi, he was informed of nine clerics who kept concubines, including the archpriest himself, who could barely read and write and was considered so incompetent that Archbishop Bovio interviewed the cantor instead regarding the state of worship within the town.[23] In the village of Guagnano, according to the archpriest there, there were often no priests to celebrate mass or perform extreme unction and many could barely read and could not understand Latin. One such priest was Selvaggio Tafuro – one of four keepers of concubines – who admitted to being the father of six children.[24] Accusations for sexual offences perpetrated by clerics – from illicit relations to rape – continue to

be made before the episcopal courts in Gallipoli and Lecce well into the mid eighteenth century, and there is no reason to suppose that these two courts are in any way exceptional. For instance, Rev. Fabio de Leone, a priest at the cathedral in Gallipoli, was accused of having sexual relations with a servant girl in 1750. A man reputed to be a friend of his noted that on top of this de Leone 'is a great blasphemer, since much to the scandal and amazement of the entire neighbourhood he has blasphemed many times and in many circumstances the blood of Christ and the souls of God and other saints, such that the said neighbourhood calls him a most unworthy priest'. De Leone had had a dispute with his mother Caterina over her sacking of the servant, but it was also part of a larger dispute. According to Caterina's godmother, it was said that 'on no account should he have become a priest; and he himself blasphemes his mother for making him become a priest despite the fact that he in no way wanted to be one'.[25]

In the extenuating circumstances used to account for de Leone's relations with the servant girl – that he had not wanted to be a priest in the first place – two aspects of clerical shortcomings in the years after Trent are demonstrated: continuing low rates of clerical celibacy and the presence of those without any vocation. With regard to the relatively high number of priests in Taranto who had children, it has been suggested that the cause lay not only in the slow pace of reform but also in the fact that many parishes bordered on Greek-rite communities and were influenced by them. Latin-rite priests with children were ordinarily accepted by their communities as long as they continued to perform the rites of supplication and exorcism required of them.[26] The suggestion is intriguing, given the presence of Greek-rite communities throughout the Terra d'Otranto: Albanian settlements near Taranto, Slav and Levantine settlements in Brindisi and vicinity and the Greek-speaking area known as *Grecia* between Gallipoli and Otranto. The memory of the Greek rite may have continued to influence the behaviour of the Latin-rite clergy in Gallipoli, for instance, where the last funeral conducted according to the Greek rite was in 1513.[27] Yet as interesting as the connection is, it is all but impossible to document, short of having a suspect cleric admit that he had assumed it perfectly acceptable to do as the neighbouring Greek-rite priests did. The accusations involving ecclesiastics tend to reveal other attitudes and tensions within the community.

From the frequent condemnations of clerical misbehaviour in the pastoral visitations and ecclesiastical trials it is difficult to know which is the rule, the licentious priest or the virtuous cleric. However, unlike the priest who acts as cunning man (see below, chapter 5), the priest who kept a concubine and had children was generally conscious of sinning, knowing

that it was forbidden. In making this observation Luciano Allegra has noted that few ecclesiastics made 'spontaneous' confessions (that is, of their own free will) before the episcopal tribunals. Most were denounced by one or more accusers for their misdeeds, if not by the community as a whole.[28] It would seem that the community was generally quite tolerant of clerical misbehaviour. That is, until some fact or dispute caused it to turn against him, producing long litanies of offences, going back many years in their accusations and depositions. What single event or misdeed could cause such a change in sympathies, putting an end to the community's previous tolerance?

In a 1739 case Marina Pizzuto, six months pregnant, accused Rev. Pasquale De Mitri of having raped her.[29] However, the details of the depositions which follow reveal at least a limited consent to sexual relations on her part: De Mitri had met her through a procuress and would bring Pizzuto two loaves of bread as payment for his twice-weekly visits. There is little doubt that her poverty was at the root of the affair, for she was described as living in a ground-floor room, selling fans and doing occasional domestic service to support herself (she later worked for De Mitri as well). Seeing herself pregnant and abandoned by De Mitri – apparently unwilling to support her or the child – she pressed charges against him. By the time De Mitri testified Pizzuto had died giving birth, and the infant girl was placed in the care of a wet-nurse. Asked by the court if he had any enemies (who might be accusing him out of sheer animosity), De Mitri replied evasively, 'Who can remember them now?' And when he was then asked by the court to comment on the detailed testimony against him, contradicting his own version, and how all the deponents could have lied, placing their souls at risk, he replied: 'If you knew in Gallipoli where especially the low people take offence for nothing, you would not ask me this... Their own consciences will see to it, so many are the false testimonies that are made in this world, and there are people who for money will do whatever you want.'[30] De Mitri was sentenced to exile, and a declaration requested the sale of some of his goods so that the *monte di pietà* could pay the wet-nurse for the care of the child. The trial comes to an end with him petitioning from prison, where he had been locked up following his return to Gallipoli and the alleged rape of a young girl in his service.

As in the accusations and trials involving *maleficium* and witchcraft, the subject of Part III, we can observe the point where inter-community relations went wrong, often upon the refusal of one party to play by the accepted rules. Cases of the sort involving sexual relations between ecclesiastics and poor, helpless women are all too frequent. A twenty-five-year-old widow of Gallipoli, Leonarda dell'Orgio, when asked by the court if

she could pay the wet-nurse for the care of her child, born out of relations with Rev. Giovanni Cozza, was forced to reply: 'I am a poor beggar, and dying of hunger; how could I have the money to pay a wet-nurse? Rather it is because of this poverty that this disgrace has happened to me.'[31] She was not the only woman to resort to (or be tricked into) sexual relations with the promise of financial support or marriage (since clerics in minor orders could marry). Dell'Orgio's case is also typical in two other respects. First, charges were made only when a child resulted and had to be cared for, or when a cleric in minor orders had reneged on his promise of marriage: not simply out of remorse or a wish to have a sinful ecclesiastic chastised. This worked because the court usually punished the guilty cleric by making him provide for the woman and the upbringing of her child. Reparation could also take the form of marrying the woman or providing for her dowry. Second, the guilty ecclesiastic was not usually a rich, well-connected townsman taking advantage of a poor, helpless woman, but was, in fact, generally only marginally above the woman in economic terms. In both the cases we have mentioned the accused possessed no benefices or legacies according to episcopal visitations.[32] Of course, it is possible that many such cases never reached the courts, having been successfully mediated beforehand by a confessor. The carnal violence would be 'compensated' by a suitable increase in the woman's dowry, agreed upon by the woman's custodian-father and the seducer.[33]

As such cases would seem to suggest, accusations of any form of clerical misconduct should be examined carefully. The fact that a group of people charge a certain priest with drinking, gambling and womanising does not necessarily mean that such behaviour was not tolerated in ecclesiastics. There are occasions when an accumulation of misdeeds breaks the tolerance of the parish or community concerned. Likewise, it could result from the priest's arrogant treatment of his parishioners and his flagrant disregard of their wishes and community standards, setting them against him.

It would be untrue to say that the faithful were universally unaware of what should constitute the behaviour of the Tridentine *buon parroco*. But it is only with the mid eighteenth century that they seem to become more adamant about it and less tolerant of misbehaviour, although further research is still necessary before we can draw any firm conclusions. In a 1752 trial the witnesses, who all signed their depositions, knew what was expected of a priest. When asked specifically by the court, one deponent replied: 'I know that the life and habit of a priest consists of mass, office, church and worship, and not walking always in the squares, day and night.'[34] On the other hand, Rev. Ferdinando di Strudà could still play cards with (uneducated) laymen without being the cause of scandal; until,

that is, he began cheating and in the ensuing tussle was told that he should go home and recite the office, since the tavern was no place for him.[35] Clerical misbehaviour could bring about different reactions within the same community, as when the unlettered peasant Pasquale Calà referred to the long-standing sexual relations of a parish priest as common knowledge, so much so that 'it isn't really talked about any more'.[36] But it nevertheless continued to be the source of much scandal for other townspeople, including the town's *sindaco* Saverio de Carlo. Lest we suggest that it was simply a matter of the educated being more in tune with the demands of Tridentine reforms, other illiterate deponents echoed the scandal felt by one witness, when she said:

> He [the accused priest] celebrates mass in the first hours after dawn and immediately goes out into the country, to the aforesaid estate [*massaria*], performing the most vile jobs, like ploughing, hoeing, cutting wood, pruning vines and selling produce, without ever attending to the offices of the Church and the edification of the public.[37]

Indeed Tridentine reforms could be *too* successful, in the sense that they could lead to reactions not intended by the Church. In 1801 the people of Acaia (in the diocese of Lecce) could no longer tolerate the womanising – which had resulted in several pregnancies – and drunkenness of Rev. Lazaro Pellè. One witness said, 'the population [is] scandalised by it, being a small town and everything is easily found out.' As a result of Pellè's misbehaviour, and despite attempts by another priest to persuade inhabitants to the contrary, no one attended his masses because 'his sacrifice was reputed to be a sacrilege'.[38]

Knowledge of Church expectations regarding clerical behaviour also meant that the mention of clerical misdeeds could function as a form of character assassination. When confronted with the many accusations of clerical misbehaviour the ethno-historian must determine origins and motives, in order to decide which priests formed the norm and which deviated from it. A 1763 case decided at the episcopal court of Lecce would seem to suggest that illiteracy among clerics was by now the exception. When a priest demanded that Rev. Nicola Bianco should show him the chapter accounts, Bianco was enraged and ridiculed him, calling him 'an ass, an ignorant animal...you don't know how to read or write!' And to the other priests he shouted, 'Bring me some paper to show that he cannot write.'[39] As interesting as it is to come across a priest in the second half of the eighteenth century who is unable to read or write, the isolated fact is of relatively little value. It is only known to us because Bianco lost his temper and shouted at the other priest, causing 'scandal' to those in the church at

the time, who could hear every word.

None the less, taking other sources like the visitations into account, we can hypothesise about the gradually improving quality of the clergy in terms of the most basic requirements of literacy and behaviour, accompanied by an increase in people's expectations, especially from the mid eighteenth century onwards. Why did this improvement take such a long time to realise? We have already suggested that the clergy's corporate structure made it difficult to reform, exacerbated by the fact that the bishops were often perceived as outsiders. Even the best efforts of the reforming bishops were confronted with one nagging reality, the overwhelming absence of seminaries for the education and formation of priests. In this the Terra d'Otranto was in no way exceptional: the diocese of Paris – a city of 400,000 with 472 parishes in its immediate vicinity – had no seminary before 1696.[40]

SEMINARIES

Cardinal Reginald Pole was responsible for much of the work behind the decrees of Session XXIII of the Council of Trent which dealt with the founding and operation of the *seminaria*. But while the construction of a seminary was made obligatory for all bishops, with the exception of those in charge of poorer dioceses, attendence by future ecclesiastics was not made mandatory and one could proceed to the priesthood much as before. In the dioceses of the Terra d'Otranto the major difficulty to overcome was the lack of financial resources, income for the building's construction and the maintenance of students being in short supply. The Council and many later synods had made allowances for this by providing for a system of percentages to be drawn from ecclesiastical benefices, but this proved impossible to enforce, given the opposition of the collegial churches.[41] Thus Nardò, which had a school for aspiring ecclesiastics (run by the Benedictines) when it was elevated to a diocese in 1413, was only able to build a seminary in 1674 when a local doctor left money to the Church.[42] Several other Otrantine bishops were eventually able to overcome financial difficulties. The construction of the Lecce seminary was initiated by the Theatine bishop Michele Pignatelli (1682–95) and completed in 1709. It functioned throughout the eighteenth century, though it experienced serious difficulties during the vacancies of 1771–92 and again from 1797 to 1818, because of the revolutionary disturbances and the turmoil of the 'French decade'. Also in operation during the eighteenth century, though not without often grave financial difficulties, were the seminaries of Oria, Brindisi and Taranto. Those founded in mid-century were Gallipoli

(1740), Otranto (1750), Ostuni (1750s) and Ugento (1752), although the latter apparently closed when its founder, Bishop Mazza, was transferred elsewhere. At the end of the eighteenth century five out of the thirteen dioceses in the Terra d'Otranto still did not have working seminaries: Alessano, Castro, Ugento, Mottola and Castellaneta.[43]

Compounding the financial difficulties was the shortage of qualified teachers, so that some bishops were forced to turn to the Religious Orders for personnel. This had the effect of accentuating the rift between regular and secular clergy, as the former filled the gap left by the absence of a strong parish structure. The Oria seminary, for example, was largely run by the missionary priests of St Vincent de Paul. The employment of qualified regular clergy was not a possibility in every diocese and well into the eighteenth century most priests were not instructed and trained in seminaries but in various schools, public and private. For instance, a significant contribution was made by the four *scuole pie* of the Piarist Order, such as the one at Campi, founded by Marquis Giovanni Enriquez in 1628.[44] And those seminaries that did exist could often not afford to take in all those who wanted to become ecclesiastics. Nor were they primarily pastoral in orientation, admitting day students and providing instruction for large numbers of lay pupils, not destined for ecclesiastical careers.

One of the most widely read spiritual authors of the eighteenth century, St Alfonso de' Liguori, suggested that it was better not to have or to close a seminary than to maintain one which was poor or badly organised. In such seminaries strict discipline and supervision of the pupils was often lacking and scandals occurred, so that 'angels enter the seminaries, and in a short time they become demons'.[45] Furthermore, 'ordinarily speaking, there are more evils and scandals in the seminaries than the bishops know about, who perhaps are generally the least informed'.[46] The episcopal trials would seem to support the idea that many seminaries were not yet any different from other schools and were a long way from being able to encourage a better quality of clergy. But as cases only reached the bishop if the rector or prefect was unable to deal with the problems, it is difficult – once again – to assess what the norm might have been. For instance, the prefect of the Gallipoli seminary was inable to stop Carnival masquerading and theatricals (one of the pupils had dressed up like a woman for the performance of a *comediola*, or sketch) or do anything about finding him on several occasions with another pupil, 'lying in the same bed'.[47] They did not benefit from the prefect's 'punishments, nor do they advance in their studies, because they do not want to study in the least'. But according to other seminarians, the prefect himself was at fault, leaving the seminary to play cards, and doing nothing to hide his attraction to one of the boys,

threatening those who knew not to tell anyone, and poking his hands with scissors to simulate scabies so that the rector would grant him leave.[48] In fact, one gets the impression that the prefect might have engineered the accusation against the two boys in order to protect himself by directing suspicions elsewhere.

Aside from the suggested homosexual acts, the pranks, skits and rowdy behaviour were not untypical of seminary life, difficult to correct because of the presence of many pupils not intended by their parents for the priesthood. Conditions like these meant that the seminaries, whether because of the lack of them or their poor quality, were something of a missed opportunity in attempts to bring about the much needed reform of the clergy. Throughout the seventeenth century and for much of the eighteenth, until the reign of Charles of Bourbon (1734–59), the number of ecclesiastics in the Kingdom of Naples increased steadily. This caused worry both for a Church bent on implementing Tridentine reforms and for a state seeking to limit clerical immunities and privileges.[49] At the same time the Church wanted to lose none of its power and influence. The jurisdictionalists of the capital were only too aware of the controversy, although they tended to lump it together with the Church's overall wealth and rapaciousness. For Pietro Giannone the high number of ecclesiastics went hand in hand with the wealth of the monasteries which profited out of the hard times of the first half of the seventeenth century by amassing land and wealth.

> There needs not a more flagrant instance, to make it plainly appear, that by how much greater the misfortunes and calamities of the people are, so much the more do the riches of the churches and monks increase, than what happened in our Kingdom in the time of its greatest misery and destruction; for at such times, more than at others, miserable mortals, having recourse to God and the saints, or returning thanks for the evils they have escaped, or begging that greater may not befall them, are more moved than ever to share their riches with the churches and priests.[50]

CONDITION OF THE CLERGY: QUANTITY

By any standards numbers of ecclesiastics were high. A census conducted in the mid seventeenth century reveals that out of a total of 58,597 ecclesiastics in the Kingdom, 7,684 resided in the Terra d'Otranto.[51] According to Cesare d'Engenio's *Descrittione del Regno di Napoli*, which gives population figures from the 1669 cadaster, the number of hearths in the province was 41,980, meaning that in simple numerical terms there was an average of just over eighteen clerics for every one hundred hearths,

along with the Terra di Bari the highest ratio in the Italian peninsula.[52] What might at first seem advantageous to the pastoral care of the population was in fact quite the contrary when we consider the actual number of ecclesiastics involved in the cure of souls. Of the 7,684 clerics not even half were fully-ordained priests (they made up 48.95 per cent). The rest consisted of clerics in minor orders (39.35 per cent), deacons and sub-deacons (3.57 per cent) and attendants (8.13 per cent), which included married clerics, oblates and episcopal messengers and guards, as well as the so-called *diaconos selvaticos*, tonsured attendants to whom were entrusted modest tasks of church maintenance or marginal religious duties. Moreover the census did not include the regular clergy, enclosed nuns, seminary pupils, functionaries of episcopal curias and the members of capitular and collegial churches.

The high number of ecclesiastics was closely related to the exemptions and immunities they enjoyed. Aside from fiscal exemptions on all ecclesiastical property, they benefited from the following types of privileges: the *canone*, by which anyone who harmed a cleric could be excommunicated; the *foro*, by which a cleric could not be judged by a lay tribunal without permission of the ecclesiastical authorities; the *esenzione*, which guaranteed immunity from military service and other civil functions not deemed in keeping with the clerical state; and the *competenza*, by which a clerical debtor could not be deprived of that property necessary to maintain him decently.[53] Such privileges were enjoyed not only by priests and deacons but by clerics in minor orders as well. This included married clerics (who, however, were deprived of any benefices obtained, unless they took a vow of chastity or received papal dispensation) and the *diaconos selvaticos*. The epsicopal *cursori* ('messengers') also benefited. They served the bishops as guards and undertook the arresting of suspects and escorting of witnesses for the episcopal tribunals, the only clerics permitted to carry weapons.

Entry into the clerical state was linked not to ordination but to tonsure (that is, the taking of first orders). It was the tonsure that defined someone as an ecclesiastic, and he could remain at that level, without ever intending to seek ordination into the priesthood. Because of this and the fiscal and legal exemptions enjoyed, the clerical state was an attractive prospect. For this reason minor clerics often outnumbered priests in the Kingdom, sometimes by as much as two or three to one. In the mid seventeenth century, for example, Lecce had 404 clerics to its 154 priests and deacons, while Gallipoli had 203 clerics to its 139 priests and deacons, although generally the Otrantine ratios of clerics to priests and deacons were more evenly matched.[54]

Questions of ecclesiastical immunity and jurisdiction not only pit-

ted the Church against the state, but clergy against bishop. In addition, bishops were all but impotent with regard to the regular clergy, whose offences came under the jurisdiction of the various Orders. Lay brothers, associated with a monastery but not following its full rule, could constitute a grey area. Jurisdictional disputes between the bishops and the secular authorities often centred on the right of sanctuary in holy places, contested at a higher level between the king and the papacy. But they also concern the economic exemptions. In 1723 the bishop of Gallipoli, Oronzo Filomarini, threatened the governor of the city, Juan de la Cruz, with excommunication when the latter had one of the bishop's guards arrested for not surrendering the toll of half a *rotolo* of fish for his boat. Bishop Filomarini pointed out to the adamant governor that since the boat was ecclesiastical property and the guard a cleric under episcopal jurisdiction, the governor was exceeding his authority in arresting the man.[55] But perhaps the most serious dispute occurred in Lecce over the clerical exemption from the tax on flour. Owing to this exemption the clergy possessed thirty mills, against the three belonging to the city, and they could mill large quantities of grain for their families and friends tax-free, resulting in a clandestine trade. The city authorities, seeing a greater burden of the tax fall upon their shoulders as a result, complained to the viceroy, who had the clergy's mills demolished. Bishop Pignatelli, after seeking reparations for the damage to no avail, placed an interdict on the city and diocese (1711). The viceroy responded by banishing the bishop from all territories of the Kingdom, and a compromise was only reached eight years later, ending the interdict, but in no way resolving the matter or easing tensions between Church and state.[56]

BENEFICES, LAY BEQUESTS AND WILLS

Clerical numbers were also high because of the system of benefices, which at the same time formed part of family strategies to maintain control over wealth. Benefices and chantries provided the family with a means of having its cake and eating it: property was willed to the Church as a means of providing masses for the souls of the deceased, while the family retained the *ius patronatus* (right of patronage) over the appointing of a chantry priest, thus providing an income for future family ecclesiastics, which functioned as a sort of dowry for entry into the clerical ranks. The family was able to benefit from the social, economic and political prestige that the bequest *ad pias causas* brought whilst keeping control over goods and property formally left to the Church. Hence the saying 'Blessed is the

house with a tonsured priest'.[57] In effect, the perseverance – indeed proliferation – of this structure was an obstacle to Tridentine reform, helping to keep alive collegial churches and cathedral chapters by supporting numerous ecclesiastics not responsible for the cure of souls, while at the same time institutionalising and legitimating the interference of the laity through rights of patronage.[58] Even the important position of cathedral canon could become hereditary, family members encouraged into the priesthood in order to keep it in the family.[59]

The high numbers of churches, chapels and altars was in part the result of this combination of family strategy and devotion, a phenomenon which increases in importance from the mid seventeenth century.[60] Bequests in the form of farmland and olive orchards supported much of the local clergy, and as these increased the clergy became more numerous. By way of example, with the proliferation of bequests to the Church during the seventeenth century the number of ecclesiastics in the town of Carmiano (diocese of Lecce) increased from nine in 1594 (an archpriest, three priests and five clerics) to thirty-two in 1694 (an archpriest, sixteen priests and fifteen clerics).[61] Just as land was the most secure investment in life, so in death it appeared the surest means of providing for one's eternal rest, since the income deriving from it ensured the perpetual saying of masses.

The 1741 concordat between the Kingdom of Naples and the Papacy sought, among other things, to bring about clerical reform by restricting the number of people exempt from duties and taxes, and by promoting a renewal of ecclesiastical behaviour through the ordination of only the worthiest. Previous attempts to reform the clergy had come up against the closed nature of local society, requiring legislative pressures.[62] By limiting the taking of minor orders, regulating family patrimony and limiting access to the priesthood to those with a secure income the numbers of ecclesiastics in the Kingdom declined progressively during the second half of the eighteenth century. Yet in attempting to ensure an end to the general poverty of the clergy, which had previously forced it to seek additional benefices and money from ecclesiastical functions,[63] the concordat was not entirely successful in making clerics any less worldly. Many continued to depend on their families for the patrimony to provide the necessary income, meaning that families continued to use the ecclesiastical career for their own ends, and thereby consolidating the clergy's links with the land.[64] The dependence on the land and its fruits for their survival meant that clerics often neglected their pastoral duties, while impeding the formation of the *buon parroco*, distinct and separate from his flock. Throughout the early modern period they continued to share many

of the values, attitudes and sensiblities of the society around them, as will become clearer in chapter 5.

For their part, the wills – generally the means by which wealth and property were donated to the Church – demonstrate the devotional needs of the community throughout the period. Regarded by the Church as an essential means of salvation for those with property, the source tells us only the story of the more privileged classes. But even here, with a relatively stable population (occasionally declining), there is a noticeable increase in will-making during the eighteenth century, according to Francesco Gaudioso.[65] The devotional formulas which opened the wills usually contained a series of 'recommendations': first to God, then to the Virgin (rarely to Christ), particular saints (including patrons) and, occasionally, the guardian angel (a devotion introduced by the Jesuit missions). The emphasis of these recommendations is consistent in wills drawn up either by a notary or by the testator himself.[66] There is, however, some indication that the notaries may have mediated to some degree in this the will's introductory section. Wills drawn up by the notary Nicola Fanuli of Galatone (diocese of Nardò) between 1700 and 1731 made use of the same devotional formulas, regardless of the class of testator.[67] Notaries were trained to regard this as a fundamental part of the will's structure and advised that it was a mortal sin to make a record against the liberty of the Church (punishable by excommunication), attesting to the close ties between the notarial profession and ecclesiastical structures.[68] Moreover, witnesses to the drawing up of the will were often ecclesiastics, contributing to the Christian character and content of the will, perhaps sharing this role with confessors.

Interestingly enough, the devotional formulas do not change substantially or fall into desuetude until they were abolished by the Napoleonic reforms of 1808. This absence of any notable trend of dechristianisation is reinforced by the consistency of mass requests throughout the period, not affected by the Napoleonic legislation. In Lecce and diocese, requests for masses are present in the vast majority of wills, the only change being a gradual shift away from more elaborate devotions (perpetual and high masses) to simpler and less ostentatious forms (low masses). This trend seems to begin during the second half of the eighteenth century, both in Lecce and in the smaller centres of the diocese.[69]

THE GREEK CHURCH

One of the foremost concerns of several Otrantine bishops was the assimilation or latinisation of the Greek-rite comunity, related in their minds to

the elimination of heterodoxy. Although the bishops tended to downgrade Eastern Orthodoxy in their dioceses by referring to the Greek 'rite', there was in fact an organised ecclesiastical structure, a legacy of the Byzantine period, still in occasional contact with Constantinople.[70] A Greek clergy was present in thirty-seven dioceses in the Kingdom of Naples, eight of which were in the Terra d'Otranto: Alessano, Altamura (part of the province until 1663), Brindisi, Lecce, Nardò, Otranto, Taranto and Ugento. The fall of Otranto in 1480 and the destruction of monastic centres by the Turks did not extinguish Greek civilisation in the region. The 1607 visitation of the Otranto archdiocese by Archbishop de Morra mentioned the presence of Greek clergy in thirteen communities, including twenty-two clerics in Soleto and twelve in Calimera, for a total of ninety-nine ecclesiastics.[71]

Their high numbers, perceived as one more threat to the bishops' attempts at control and reform, were combined with their relative poverty, lack of education and general state of abandon. Archbishop de Corderos of Otranto, writing to Cardinal Santoro in 1580, considered the entire Greek-rite clergy to be in a constant state of sin, since they lacked the proper books and were unable to recite the office. He concluded that 'the abuses and insolences of the Greeks in this province, and not less their great ignorance, are so many and so great and so continuous that only some angelic spirit could bear it'.[72] Archbishop Brancaccio of Taranto was even more adamant with regard to the Albanian communities in his diocese, attempting to impose the Latin rite under the guise of correcting clerical abuses.[73] In visitations to the Albanian hamlets in 1577–8 he prohibited the Greek-rite custom of administering communion to infants, forbade husbands from remarrying if their wives were caught committing adultery and affirmed that no priest could be ordained by a Greek-rite bishop without first being approved by him or his vicar. Moreover he insisted that the Latin version of confirmation be employed and prohibited Latin and Greek clergy from celebrating mass in one another's churches.[74]

Despite official tolerance of the Greek rite and the appointing of an ordaining bishop for the Greeks of Italy in 1595 by Pope Clement VII (though subject directly to papal authority), the tendency in the Terra d'Otranto was to abolish Greek survivals in areas of Italian predominance and gradually suppress the Greek rite in mixed localities, replacing it with the Latin rite. For this reason the Greek clergy of San Pietro in Galatina (archdiocese of Otranto) had to petition Archbishop de Capua in 1570 to allow them to appoint a new cantor, following the death of the previous one. In Lecce, with its own Greek parish, a Greek priest was charged with performing a baptism according to the Greek rite of a child of Latin (that

is, Italian) parents, but was pardoned because it was performed in an emergency.[76] Often the nearby Latin-rite populations reacted severely to the Greek-rite presence (coaxed by whom?), turning the dispute into a confessional conflict. In Soleto the Latin community wrote a petition in 1583 against the archpresbyter and the Greek clergy to the effect that they should immediately convert to the Latin rite. The town of Calimera was fortunate in being able to hang on to its Greek rite longer than most; until 1663, that is, when its protopapas was assassinated and its parish archive burnt to the ground.[77]

The Greek presence and tradition in the Terra d'Otranto – both Byzantine and classical – manifested itself in various aspects of the sacred system. We have already suggested possible influences on the Latin clergy and in chapter 6 we shall see how Greek monasticism contributed to Marian image narratives. Mourning customs also reflected this presence, and bishops and missionary priests throughout the region, in their attempts to enforce religious orthodoxy, were faced with the need to christianise a ritual fundamental to the people's view of the sacred and the way they interacted with it. As in the rituals of healing we shall be exploring in chapter 5 which allowed people to counter and come to terms with crises of existence caused by malady and misfortune, so in the death of a loved one, 'the risk of not being able to go beyond that situation, of remaining fixed and polarised in it' consituted a kind of 'second death', which the hired mourners, dirges and keening of the funeral lament were meant to overcome.[78] The hired mourners were known in Terra d'Otranto as *rèpute* or *reputatrici* from the dirges they led, which consisted of a ritualised dialogue with the deceased, dwelling on his or her qualities and exploits while expressing the anger and great loss caused by his untimely death.

This form of 'protective discourse', where the hired mourner led the others into paroxystic states of keening and self-mutilation (not unlike the demonstrations of penitence to be discussed in the next chapter), was condemned by the Church as antithetical to the Christian ideology of death.[79] Dirges collected in the previous century in the Terra d'Otranto, as well as in Basilicata and Calabria, contain no reference to Jesus, the Virgin Mary, the saints, or resignation to pain and death and the hope of a better life after death. Instead rebellion and protest in the face of death are the dominant *topoi*.[80] The Byzantine Church had attempted to replace the dirges and invocations with psalms, hymns and prayers, and put an end to the self-mutilation and man-centred outlook of the ritual. Otrantine Catholic bishops did likewise, hoping to latinise the laity as they were then latinising the clergy. In 1654 Archbishop Raynos of Brindisi ordered

priests to set the example by processing with the bier into the church in an orderly and restrained manner, chanting psalms.[81] Bishop Pappacoda of Lecce forbade mourners at funeral services from disturbing the singing of psalms by excessive 'bitter weeping', under pain of expulsion from the church.[82] And in 1664 the Oria synod, referring – among other things – to the custom of placing various herbs and possessions on the corpse before burial, declared that

> the wailing and clamour of relations shall cease, women shall not beat their breasts, tear out their hair, or throw things on the bodies of the deceased or into tombs, and everyone shall abstain from songs [*cantilenas*]... Similarly, we prohibit panegyrics and discourses in praise of the deceased to be made in church, permitting only discourses on the deceit of the world and the wretchedness and vanity of human life.[83]

As the Church discovered, it was not enough to prohibit, especially when there was virtually no diocesan and parochial structure of teaching and supervision. The Jesuit missioners, whose strategies will be explored in the next chapter, made some general attempts to reform the custom by converting the more respectable families, whom, the Jesuits hoped, the rest of the community would soon imitate. In Sicily, for example, where mourners 'cry, scream, howl, and with their hands tear out their hair, beat their breasts, rend their faces', the missioners encouraged the bereaved of one important family not to call in the hired mourners and avoid any uncomposed grief. At first the family of the deceased was abused for not showing its affection and loss in the usual way, but soon their example was widely followed, if we are to believe the Jesuit report.[84] However, despite the best efforts of the Church, these mourning customs – like the ritual of tarantism to be discussed in chapter 4 – survived into the contemporary era, albeit in a somewhat acculturated form.

The overall lack of a well prepared clergy meant that some of the bishops' best efforts had little effect, for the bishops depended on the clergy for parish-level supervision and enforcement of their decrees. During most of the early modern period the campaign against *maleficium* and other forms of what the Church regarded as 'superstition' made little impact. Episcopal concern for the faithful – especially those living away from the major centres and under the control of pastors who were very much like them in way of life and mentality – had to wait until the worst clerical habits had been eliminated. It was only in the late eighteenth century that bishops began to request in their visitations that archpriests should ensure religious instruction in their communities. They were to teach the Gospel especially to *campagnuoli*, making sure that 'it was not so

long as to cause boredom', according to Bishop Spinelli of Lecce. He also instructed the priests who celebrated mass in the rural chapels to have 'the Christian acts read to the countrymen and instruct them in Christian doctrine.'[85] Likewise, the *padri spirituali* of the various congregations were requested to give catechistic instruction to the confrères instead of sermons.[86]

Bishop Kalefati of Oria also expressed concern over doctrinal ignorance throughout his diocese. In his 1783 visitation he was told the following by the archpriest of Ceglie, Rev. Vincenzo Carlucci:

> a large number of people live in the *masserie*, who on feast days are content to hear mass in some rural chapel, or else by coming to the churches in town. They pass the remainder of the day with their families either doing lighter tasks than on working days, or in an idle way, neither the fathers nor the sons listening to the catechistic instruction. Hence there is extreme ignorance among the ranks of men, especially in the countryside. This should be remedied with an increase of [pious] works.[87]

This suggests none the less that the situation had changed for the better in the course of just over two hundred years, even if there was still ample room for improvement, and strong variation from diocese to diocese. A basic parochial framework was being laid down, it was now a question of winning the hearts and minds of people. A case in point: the battle to enforce a concept of sacred time and space – that is, the Church's concept of sacred time and space – was not easily won. Activities during Carnival and feast days continued to pose difficulties for the authorities.

THE PERSISTENCE OF THE CARNIVALESQUE

Episcopal visitations, first concerned with doctrinal ignorance among the clergy, eventually turned to aspects of behaviour which they considered unsuited to the clerical state. In 1654 Archbishop Raynos of Brindisi decreed that during Carnival ecclesiastics 'must not go about at night wearing masks, dancing, throwing leather clippings, scraps, mud or any other filthy things, or go about at night singing, or uttering immodest words through the windows of houses.'[88] The Brindisi synod of nine years later also condemned the participation of clerics in 'the detestable invention that they call "the wolf", which in substance is none other than the making public of defamatory bills with falsified and masked voices: knocking at the doors of houses and causing noise in the streets'.[89]

Insults and satire were commonplace during Carnival. A priest charged in 1749 with insulting a man's wife and singing rude songs about her, defended himself by saying that 'during Carnival, by universal custom, no one takes offence at insults'. He added that 'if the person [the victim] is taken into consideration, it concerns a vile common woman, wife of a porter, rabble of the people'.[90] So much for the christianisation of Carnival! The insults he sung into her window were the stereotypical ones of the period, making them all the more difficult to verify. He called her a 'pockmarked whore / public and practised' ('puttana buzzerata, / puttana pubblica e provata'), with the refrain 'fig, fig, / a penny a pound...' ('ficu, ficu, / a grane due il rotolo, / e cucurocù'), the meaning of which witnesses were reluctant to tell the court, for the fig symbolised a woman's genitals, suggesting that she sold her honour at a low price. The *cucurocù* was part of a standardised refrain, around which the verses would be extemporised.

The clergy, like the rest of the population, continued to pen defamatory notices (*libelli diffamatori*, sometimes referred to as 'pasquinades'), sing mocking rhymes and perform satirical plays or sketches (*comediole*) during Carnival and feasts. Cases involving written insults were more serious than those dealing with oral ones as far as the episcopal tribunals, and their secular counterparts, were concerned. Not only did the former appear more premeditated and less spontaneous than the latter, but 'the permanence and publicity of writing, in this semi-literate culture, made it a powerful weapon against an individual's honour.'[91] In fact, the Lecce synod of 1663 decreed the offence to be punishable by excommunication, but to little avail.[92] In 1768 a defamatory bill was posted at the town hall (*sedile*) of Novoli, and the ecclesiastic Liberato Parlangeli was charged with writing it. At first he did not admit to being the bill's author (though he later did), but was able to enlighten the court as to its contents. Its fourteen verses ridiculed the habits of Leonardo Mazzotta, a sixty-year-old man who had taken a young woman as his wife, only to tire of her several months later and send her home to her parents. He then fell in love with her more than ever, and continually spied on her, looking through doors and windows at all hours.[93] Of the few verses that have come down to us – Mazzotta's brother cut the bill into pieces, and deponents could only recite a few lines to the court, saying that they had immediately stopped reading once they realised the bill's nature! – the bill had much in common with the charivari, which was aimed primarily at punishing certain disapproved forms of love.[94] It is difficult to ascertain how much the townspeople shared Parlangeli's desire to ridicule Mazzotta, since witnesses remained less than outspoken on the matter of the bill, and it is possible that Parlangeli bore his victim a personal grudge.

The insult often took on the form of a charivari, especially in response to a perceived sexual transgression. Decrees against this phenomenon often refer to the singing of *cantilenas* or defamatory words before the doors and windows of 'honourable people'.[95] The Church's prosecution of the offence was part of its effort to reform clerical conduct and, more generally, to gain control of the sacrament of marriage (see below, chapter 7). When the ecclesiastic Abramo Russo was accused of having 'composed and made public' a satirical song during Carnival, which called into question the honour of several notables of Carmiano, he defended himself – or rather, his lawyer did – by saying that for it to have been 'libellous' it would have had to be written down and then posted in a public place.[96] Since his eighteen stanzas were only sung – reminding us of the high memory capacities of oral culture – they were at worst 'light verbal insults'. But *because* they were sung their impact was arguably even greater. Composing and singing such satirical songs, often extemporaneously, was an integral part of rural culture, especially during the harvest. In this case, the entire *'canzone'* was written down for the court from the dictations of two people 'who knew it and perhaps sang it'.[97] One woman, when asked if she could identify the song's verses, said she knew it by heart 'for having heard it recited many times in public by various people'.[98] Indeed it seems to have created quite a sensation, being sung out in the fields and orchards, for another witness deposed: 'When I went into the country to gather olives with my father I would hear, from near and far, a new song sung by the other women.'[99] The defence lawyer, fishing for possible angles, argued that a bill had to be clearly understood by everyone for it to be libellous, and since the 'non-vulgar people' of Carmiano habitually used Italian, the verses – composed in dialect – could not be construed as libellous. Despite the point's dubious validity, dialect being understood by all natives, the case ends at this point and the final sentence is unknown to us.

Such ritual insults were also common on feast days, despite Church attempts to enforce its ideas regarding sacred time. To this end the Gallipoli synod of 1661 decreed that 'no mimes, actors, jesters or mountebanks perform comedies, stories or any other theatrical spectacle, or set up dances or games.'[100] But a major summer feast was too good an occasion to pass up, so on the feast of Our Lady of Purity (27 July) several ecclesiastics and laymen put on a comedy satirising the love affair involving a woman of the city, in which 'many excessive things [*spropositi*] were said against the said woman and her family'.[101] And just over thirty years earlier the feast of Our Lady of Canneto in the city had been the occasion for a comedy satirising the royal judge's 'mani malati' (a reference to theft or corruption). Performed in the courtyard of a house belonging to a city

nobleman, the sketch was linked to a defamatory notice posted near the cathedral at about the same time.[102]

Besides sacred time, the Church also had its ideas about sacred space to enforce. Some progress was no doubt made in this direction. Early in the period, depite the emphasis visitations put on the 'dignity' of ecclesiastical buildings, they did not differ much in nature and wealth from the surrounding village buildings. In fact, they continued to be locales of intense sociability, related to play and business, as well as to worship (much as they had been in the Middle Ages).[103] In the towns and Church centres things were already beginning to change with the widespread impact of the baroque: ecclesiastical buildings were constructed and adorned with precious objects in keeping with the sacred rites of the Tridentine liturgy. The ripple-effect had its beginning and focus in Lecce, as we noted in the previous chapter, spreading to other centres in the province. Even the smaller communities in the Lecce diocese had church and chapel altars dedicated to such Counter-Reformation saints as Carlo Borromeo, Francis de Sales, Vincent de Paul, Aloysius Gonzaga and Vincent Ferrer.[104] And the same was true throughout the Terra d'Otranto.

Yet it was a slow process. Over one hundred years after Trent Otrantine episcopal visitations were still concentrating on the (often disastrous) material state of religious buildings, the clerico-pastoral situation having to take a secondary place. This was not untypical for the Kingdom of Naples, given the number of Church buildings – major and minor – in dire need of repair. The 1660 visitation of Bishop Montoya de Cardona noted the habit of women to go up into the vaults of the churches of S. Giuseppe and S. Giorgio to lay out their washing to dry,[105] suggesting an almost medieval nonchalance about the mixing of sacred and profane. The same goes for behaviour during mass. A Lecce priest, charged with causing a disturbance because of his bad habits 'on the solemn days of indulgence [when] all the women and young girls go to make their confessions',[106] was defended by one deponent Oronzio di Marchi. He noted that the discord in church was caused by his anger in order to 'amend either the restlessness of the women in church, or the little respect shown by the men in church'.[107]

The behaviour of one eighty-year-old Gallipoli priest (1762) can only be described as carnivalesque:

> Having seen him myself [another priest testified] many times, while we were in the choir on recent occasions and in the past few days, leave the choir during the divine offices, and go looking for people in the church in order to jeer and

mock, saying senseless things with great irreverence... He has become a laughing stock, since these people consider it permissible to tickle him in the posterior parts, and he shows signs of enjoying it. He does not even have repugnance in deriding the very words of the sacred psalms during the recitation of the divine office, especially in the place of the psalm 'Laudate Domini [*sic*] de coelis', in the little verse which begins 'Beasts and all cattle' [verse 10, Psalm 148], appropriating with derision and jest first one and then another of the said words. Likewise, whenever some office for the deceased is celebrated, he never lets the opportunity pass to apply the *Requiem eternam* to various people by raising his hand and making the sign of the cross first towards one and then towards another of the people who are taking part,[108]...in jest [according to another priest], making the sign of the cross with two fingers of his hand to form a horn.[109]

We are certainly a long way from the *buon parroco* ideal of the Counter-Reformation. However, as discussed above, we have no way of knowing for certain how typical such behaviour was. It may be that conduct tolerated before was now increasingly the subject of correction by colleagues and contemporaries. Interestingly enough, the only layman who commented on the behaviour of the accused was not scandalised in the least by it when asked so by the court (more like the good-natured fun of a dirty old man). Indeed he remarked without condemnation that often when they walked on the bridge into Gallipoli 'and when some woman would pass by, he [the accused priest] would make some gesture of amazement – oh, look at her! – and then ask me who she was, and we would have a good laugh; nor do I know if he is a scandalous priest'.[110]

In this chapter the focus has been on those elements of the sacred system coming under the general rubric of organised religion. The overall impression is one of very slow change, due in particular to weaknesses within the diocesan and parochial structures. Even two hundred years after the Council of Trent the picture seems largely unchanged. But there were important movements of Tridentine reform that did have some success in transforming local society, and it is to those that we now turn.

NOTES

1 Giuseppe Jorio, *Il vescovo consolato* (Naples, 1775), 170; cit. in Rosa Martucci, '"De vita et honestate clericorum": La formazione del clero meridionale tra Sei e Settecento', *Archivio storico italiano*, CXLIV (1986), 435.

2 Mario Rosa, 'Storia socio-religiosa del Mezzogiorno', in his *Religione e società nel Mezzogiorno tra Cinque e Seicento* (Bari, 1976), 153.

3 Antonio Cestaro, 'Per la storia della parrocchia nel Mezzogiorno nell'età moderna e

contemporanea', in his *Strutture ecclesiastiche e società nel Mezzogiorno* (Naples, 1978), 226.

4 Cf. Francesco De Luca, *La diocesi leccese nel Settecento attraverso le visite pastorali* (Galatina, 1984), 19-22.

5 'L'Arciprete D. Michele de Velandia ricorre contro i reverendi D. Nicola Spicolizzi, D. Stefano Roccio et D. Giovanni Mazzucci', 1623, A.C.V.G., *Processi penali*, no. 5/1. See the discussion of defamatory bills below, under 'The persistence of the carnivalesque'.

6 'Contro D. Sebastiano Megha per infamia nella persona di D. Silvestro Valiano', 1701, A.C.V.G., *Proc. pen.*, no. 2169.

7 Mario Rosa, 'Diocesi e vescovi del Mezzogiorno durante il viceregno spagnolo: Capitanata, Terra di Bari e Terra d'Otranto dal 1545 al 1714', in B. Musca, ed. *Studi storici in onore di Gabriele Pepe* (Bari, 1969), especially 656-72.

8 Cf. Salvatore Palese, 'Vescovi di Terra d'Otranto prima e dopo il Concilio di Trento. La vicenda dei vescovi della famiglia Acquaviva di Nardò', *Rivista di scienze religiose*, I (1987), 78-187.

9 Cf. Mario Rosa, 'Geografia e storia religiosa per l'"Atlante storico italiano"', in his *Religione e società*, 32.

10 A.S.V., *Rel. vis. ad lim.*, 734A; cit. in Michele Miele, 'Gli atti dei concili provinciali dell'Italia meridionale in epoca moderna', *Annuarium historiae conciliorum*, XVI (1984), 413.

11 'Contro l'Abate Ferdinando Venneri ed il Chierico Domenico Rappatito per asportazione d'armi', 1633, A.C.V.G., *Proc. pen.*, no. 1821.

12 Section VI, 'Cause, e delitti ne' quali i Giudici Ecclesiastici potranno procedere contro de' Laici', *Foedus Regium et Pontificium. Trattato di accomodamento tra la S. Sede e la Corte di Napoli*, 1741. In Lorenzo Giustiniani, *Nuova collezione delle Prammatiche del Regno di Napoli* (Naples, 1804), V, 282-327.

13 Section III, 'Immunità personale', ibid.

14 John Tedeschi, 'Inquisitorial law and the witch', in B. Ankarloo and G. Henningsen, eds. *Early Modern European Witchcraft: Centres and Peripheries* (Oxford, 1989), 114.

15 Deposition of Rev. Nicolò da Siena, 'Contro Antonio Roccio per parole ereticali', 1681, A.C.V.G., *Proc. pen.*, no. 2738.

16 Deposition of Rev. Leonardo Salina, ibid.

17 Behaviour of this sort was evidently not restricted to mad dogs and Englishmen.

18 Cf. Tedeschi, 'Inquisitorial law', 83.

19 Giovanni Romeo, 'Per la storia del Sant'Ufficio a Napoli tra '500 e '600: Documenti e problemi', *Campania sacra*, VII (l976), 39.

20 Ibid., 69.

21 'Contro il Chierico Giuseppe Antonio Perez per cattiva condotta', 1702, A.C.V.G., *Proc. pen.*, no. 1789.

22 Cf. Maurilio Guasco, 'La formazione del clero: i seminari', in *Storia d'Italia. Annali IX: La Chiesa e il potere politico dal Medioevo all'età contemporanea* (Turin, 1986), 645.

23 'Acta Sanctae Visitationis, Habitae in Metropolitanae Ecclesia Brindisina et Uritana Ab Archiepiscopo Jo. Carolo Bovio, 1565', A.C.A.B., *Sante visite*, fols. 522v–523r.

24 Ibid., fol. 277r. The priests who admitted to acts of 'illicit magic' are discussed in chapter five.

25 Deposition of Antonio Ragno, 'Contro Fabio De Leone sacerdote di questa Cattedrale per maltrattamenti alla propria madre', 1750, A.C.V.G., *Proc. pen.*, no. 2926. For a discussion of family strategies regarding the priesthood, see the discussion of legacies and benefices below

26 Pietro Stella and Giovanni Da Molin, 'Offensiva rigoristica e comportamento

demografico in Italia (1600-1860): natalità e mortalità infantile', *Salesianum*, XL (1978), 34-5.

27 Cf. Zacharias Tsirpaulis, 'Memorie storiche sulle comunità e chiese greche in Terra d'Otranto (XVI sec.)', *La Chiesa greca in Italia dal'VIII al XVI secolo*, II, in *Italia sacra*, no. 21 (Padua, 1972), 851.

28 Luciano Allegra, 'Il parroco: un mediatore fra alta e bassa cultura', *Storia d'Italia. Annali IV: Intellettuali e potere* (Turin, 1981), 915-16.

29 'Contro R.do De Mitri per stupro commesso nella persona di Marina Pizzuto', 1739, A.C.V.G., *Proc. pen.*, no. 2632.

30 Deposition of Rev. Pasquale De Mitri, ibid.

31 'Contro Sac. Giovanni Cozza per immoralità', 1706, A.C.V.G., *Proc. pen.*, no. 989.

32 For Pasquale De Mitri, 'Santa Visita Personale, Mons. filomarini', 1735, fol. 12; and for Giovanni Cozza, 'Visitatio Episcopi Philomarini de anno 1714', fol. 106, both in A.C.V.G., *Sante visite*.

33 Giorgia Alessi, 'Il gioco degli scambi: seduzione e risarcimento nella casistica cattolica del XVI e XVII secolo', *Quaderni storici*, XXV (1990), 828.

34 'Contra Sac. Creti de Creti e Sac. Bonaventura Citignola per cattiva condotta', 1752, A.C.V.G., *Proc. pen.*, no. 1731.

35 'Contro Crescenzio Pico', Acaja, 1771, A.C.A.L., *Giud. crim.*, no. 825.

36 Deposition of Pasquale Calà, 'Contro Rvdo Giuseppe de Matteis', Vanze, 1792, A.C.A.L., *Giud. crim.*, no. 840.

37 Deposition of Donata Montinara, ibid.

38 'Contra Rvdo Lazaro Pellè', Acaia, 1801, A.C.A.L., *Giud. crim.*, no. 826.

39 'Contra Rvdo Nicola Bianco', Campi, 1763, A.C.A.L., *Giud. crim.*, no. 819.

40 Jean Delumeau, *Catholicism between Luther and Voltaire*, translated by J. Moiser (London, 1977), 28. In support of his thesis that the religious revival began to be felt in France only during the second half of the seventeenth and the beginning of the eighteenth centuries, he also notes that regular pastoral visitations for the Paris diocese begin only after the Fronde of 1648–52.

41 Guasco, 'Formazione', 656.

42 Emilio Mazzarella, 'Per la storia degli istituti di formazione per gli ecclesiastici in Puglia: il seminario di Nardò (1674)', in M. Paone, ed. *Studi di storia pugliese in onore di Giuseppe Chiarelli*, III (Galatina, 1974), especially 505-12.

43 Salvatore Palese, 'Seminari di Terra d'Otranto tra rivoluzione e restaurazione', in B. Pellegrino, ed. *Terra d'Otranto in età moderna* (Galatina, 1984), especially 117-24.

44 Karen Liebreich, 'The contribution of the Piarist Order to popular education in the seventeenth century', unpublished Ph.D. thesis, University of Cambridge, 1985-6, 295.

45 Alfonso de' Liguori, 'Regolamento per i seminari', in *Opere ascetiche di S. Alfonso Maria de' Liguori*, III (Turin, 1880), 865; cit. in Guasco, 'Formazione', 671.

46 De' Liguori, 'Riflessioni utili ai vescovi', *Opere ascetiche*, 865-6; cit. in ibid., 671.

47 'Contra seminaristi Carlo Patitari e Luigi Arendi, per atti illeciti', 1795, A.C.V.G., *Proc. pen.*, no. 2002.

48 Depositions of Antonio Paglialonga and Luigi Stajano, ibid.

49 Cf. Martucci, 'Formazione del clero', 456.

50 Pietro Giannone, *The Civil History of the Kingdom of Naples*, trans J. Ogilvie (London, 1729), II, 793.

51 'Reassunto del numero de' Preti del Regno', A.S.V., Arm. XXXV, vol. 59, *Collectanea scriptuarum diversarum Neapolis usque ad annum 1709*, fols. 280r-330v. Cf. Pasquale Sposato, 'Dati statistici sulla popolazione civile ed ecclesiastica nel Viceregno di Napoli tra la prima e la seconda metà del Seicento', *Annali della scuola speciale per archivisti e*

bibliotecari dell'Università di Roma, V (1965), 115-76 and VI (1966), 33-86.

52 Cesare d'Engenio, *Descrittione del Regno di Napoli, diviso in dodeci provincie...* (Naples, 1671), 214-22. Cf. the table in Sposato, 'Dati statistici', 52-5.

53 Martucci, 'Formazione del clero', 443.

54 'Reassunto', in Sposato, 'Dati statistici', 52-55.

55 'Minaccia di scomunica', 1723, A.C.V.G., *Scomuniche*, no. 29.

56 Cf. Emilio De Giorgi, *L'interdetto contro la città e la diocesi di Lecce (nelle cronache e documenti del tempo)* (Lecce, 1984).

57 In the dialect of Nardò: 'Iata a quedda casa a ddo nc'è na chirica rasa'. Mazzarella, 'Istituti di formazione', 497.

58 Antonio Ciuffreda, 'I benefici di giuspatronato nella diocesi di Oria tra XVI e XVII secolo', *Quaderni storici*, XXII (1988), 40.

59 Mazzarella, 'Istituti di formazione', 497.

60 Salvatore Palese, 'Per la storia religiosa della diocesi di Ugento agli inizi del Settecento', in M. Paone, ed. *Studi di storia pugliese in onore di Giuseppe Chiarelli*, IV (Galatina, 1976), 326.

61 Bruno Pellegrino, 'L'ulivo e l'aldilà: Devoti, messe e clero a Carmiano nel XVII secolo', in M. Spedicato, ed. *Chiesa e società alla fine dell'Antico Regime* (Galatina, 1985), 90-1.

62 Mario Spedicato, 'Indicazioni sul reclutamento del clero leccese nella seconda metà del XVIII sec. attraverso l'esame dei patrimoni sacri', *Archivio storico pugliese*, XXIX (1976), 271.

63 Martucci, 'Formazione del clero', 450.

64 Spedicato, 'Indicazioni', 277.

65 Francesco Gaudioso, 'Un'inchiesta sul testamento di Terra d'Otranto (secoli XVII–XIX)', in B. Pellegrino, ed. *Terra d'Otranto in età moderna* (Galatina, 1984), 197.

66 Gaudioso, 'La devozione in Terra d'Otranto tra XVI e XIX secolo: evoluzioni e permanenze', in his *Testamento e devozione* (Galatina, 1986), 15-19.

67 Ibid., 26.

68 According to the manual written by Giacomo Dragonetti (of Melpignano, in the diocese of Otranto), *Appunti sul notariato e sulla stipula dei contratti* (Naples, 1788), cit. in Gaudioso, 'Devozione', 33-4.

69 Gaudioso, 'Testamento e devozione: Il caso di Lecce fra i secoli XVIII e XIX', in *Testamento*, 72-3.

70 Vittorio Peri, 'Chiesa latina e chiesa greca nell'Italia postridentina (1564-1596)', *La Chiesa greca in Italia dal'VIII al XVI secolo*, I, *Italia sacra*, no. 20 (Padua, 1973), 281-2.

71 Tsirpaulis, 'Memorie', 853-857.

72 Cit. in Peri, 'Chiesa greca', 314,

73 Vittorio Farella, 'I decreti sinodali dell'arcivescovo Lelio Brancaccio relativi ai greco-albanesi del tarantino', in M. Paone, ed. *Studi di storia pugliese in onore di Giuseppe Chiarelli*, II (Galatina, 1973), 665.

74 'Visitatio casalium Tarantinae diocesis Archiepiscopi Brancacii de anno 1577', Archivio Diocesano, Taranto, *Sante visite*, fol. 475. Cit. in Farella, 'Decreti', 673.

75 Tsirpaulis, 'Memorie', 851.

76 It was at night and the unbaptised infant was dying, risking limbo. 'Contra Rvdo Gabriele De Orazio', Lecce, 1688, A.C.A.L., *Giud. crim.*, no. 758.

77 Tsirpaulis, 'Memorie', 856 and 862. In the town of Galatone (diocese of Nardò) the elimination of the last traces of the Greek hierarchy within the chapter was celebrated, physically and symbolically, by the construction of the church of the Crocifisso in the years 1622-5. Mario Cazzato, 'Architettura religiosità popolare: osservazioni e documenti in margine alla ricostruzione della chiesa del Crocifisso di Galatone', *Sallentum*, VIII (1985), 33-53.

78 Ernesto de Martino, *Morte e pianto rituale dal lamento funebre antico al pianto di Maria* (Turin, 1975 edn.), 5.

79 It was periodically condemned in the classical world as well, sometimes for sumptuary reasons and sometimes because it was feared that the induced state of frenzy might incite mourners to revenge or hostility. Cf. Margaret Alexiou, *The Ritual Lament in Greek Tradition* (Cambridge, 1974), 21–2.

80 Cf. the discussion in H.F. Tozer, 'The Greek-speaking population of southern Italy', *The Journal of Hellenic Studies*, X (1889), 11-42.

81 'Visitatio pastoralis ab Archiepiscopo Brundisino Laurentio Reinosso, 1654', A.C.A.B., *Sante visite*, fol. 725r.

82 'Prima Santa Visita di Mons. Luigi Pappacoda, 1641', A.C.A.L., *Sante visite*, IX, fols. 350v–351r.

83 'Synodus Diocesana Ecclesiae Oritanae ab Ill.mo et R.mo D.no Fratre Raphaele De Palma...1664', A.D.O., *Sinodi*, fols. 228-9.

84 'Lettera quadrimestre' of Rev. Angelo Sibilia, Catania, 17 September 1560, A.R.S.I., *Ital. Episc.*, cit. in Tacchi Venturi, *Storia*, I, 330–1.

85 'Prima visita pastorale di Mons. Salvatore Spinelli, 1792', A.C.A.L., *Sante visite*, no. 191, fol. 40v and no. 196, fol. 42v.

86 'Visita...Spinelli, 1792', A.C.A.L., no. 196, fol. 42r.

87 Mons. Alessandro Kalefati, 'Visitatio Personalis', 1783–4, A.D.O., *Sante visite*, fol. 27.

88 'Visitatio...Reinosso', A.C.A.B., fol. 682r.

89 *Sancta Tridentina Synodus ad Praxim, seu Decreta et Constitutiones Synodales Sanctae Ecclesiae Metropolitanae Brindisinae* (Venice, 1663), 84.

90 'I coniugi Ippazio Gianfreda e Lazara Leo contro D. Onofrio Tornese, D. Sancio Andronico ed il chierico Emanuele Paparone per ammirazione ed insulti', 1749, A.C.V.G., *Proc. pen.*, no. 2798.

91 Peter Burke, 'Insult and blasphemy in early modern Italy', in *The Historical Anthropology of Early Modern Italy* (Cambridge, 1987), 99.

92 *Secunda Synodus Dioecesano*, 117.

93 Deposition of Liberato Parlangeli, 'Contra Chierico Liberato Parlangeli', Novoli, 1768, A.C.A.L., *Giud. crim.*, no. 801.

94 Reconstructed from various jumbled testimony, the verses must have gone something like this: 'Leonardo Mazzotta / belluccha spennata / cicileu e pescia causi / muccusu e tabaccusu / mette lu nasu ad ogni pertusu / fa la sentinella in mezzo alla piazza' (translation: 'Leonardo Mazzotta / skinned sturgeon / smells of shit and pisses his pants / dirty with snot and tobacco / pokes his nose into every hole / stands and waits in the middle of the square').

95 Christiane Klapisch-Zuber, 'The "mattinata" in medieval Italy', in her *Women, Family and Ritual in Renaissance Italy*, trans. L. Cochrane (Chicago, 1985), 268-9. cf. Marzio Barbagli, *Sotto lo stesso tetto* (Bologna, 1984), 412-13, and Martin Ingram, 'Ridings, rough music and mocking rhymes in early modern England', in B. Reay, ed. *Popular Culture in Seventeenth-century England* (London, 1985), 166-97.

96 'Contra Chierico Abramo Russo', Carmiano, 1778, A.C.A.L., *Giud. crim.*, no. 871.

97 Deposition of Pietro Lecciso, ibid.

98 Deposition of Maria Falli, ibid.

99 Deposition of Eugenia Rizzo, ibid.

100 *Constitutiones Synodales Editae in prima Diocoesana Synodo Gallipolitana...Ab Illustrss. ac Reverendiss. Domino D. Ioanne Montoya De Cardona Episcopo Gallipolitano* (Naples, 1661), 27.

101 'Contro alcuni ecllesiastici per parole ingiuriose, insulti ed oltraggi all'indirizzo di Domenico Tornese ed Isabella Cataldi', 1723, A.C.V.G., *Proc. pen.*, no. 2826.

102 'Contra il chierico Paolo Creddo per libello diffamatorio', 1690, A.C.V.G., *Proc. pen.*, no. 1640.

103 Torre, 'Consumo delle devozioni', 183.

104 'Visita...Spinelli, 1792', A.C.A.L., no. 191, fol. 16r; no. 195, fol. 15r; and no. 197, fol. 5v.

105 'Visita Pastorale di Mons. Giovanni Montoya de Cardona, 1660', A.C.V.G., *Sante visite*, fol. 121.

106 Opening denunciation by four priests and eight laymen, 'Contra Rvdo Pasquale Mangè', Aquarica, 1734, A.C.A.L., *Giud. crim.*, no. 866.

107 Deposition of Oronzio di Marchi, ibid.

108 Deposition of Rev. Giacinto Chirello, 'Contra Sac. Maurizio Sogliano per indisciplinatezze e disonestà', 1762, A.C.V.G., *Proc. pen.*, no. 2599.

109 Deposition of Rev. Giuseppe de Matteis, ibid. The 'horns', made by pointing the index and little fingers of the hand, was (and is) a typical gesture of derision, the sign of the cuckolded husband. It also doubled as an all-purpose conjuration.

110 Deposition of Antonio Tornese, ibid.

Missioners and confrères:
movements of reform

The absence of an effective parish structure and the dominance of a collegial clergy, occupied in the dense network of benefices lying at the basis of numerous churches and chapels, left a large gap in orthodox religious life. This gap that was increasingly filled by the Religious Orders. They were often invited by local communities, who sometimes paid for the construction of a monastery or residence. The establishment of the Jesuits in Lecce (1573), for example, was quite an event, uniting as it did the two factions dividing the city, who together donated 300 gold *scudi* for the purchase of a house. When, the following year, the Jesuits sent Bernardino Realino, already renowned in Naples as a holy man, he was welcomed in the city by a cavalcade of notables, including religious and secular authorities. It no doubt seemed a remarkable event 'to the women who peered from the towers to discern him and from the windows to observe him, and to the other men who waited for him in the streets'.[1] Meanwhile, just to the south, Bishop Fornari of Nardò requested the Jesuits to conduct missions in his diocese, as well as seeking the foundation of a college.[2] Such was the contribution of the internal missions to the sacred system in the Terra d'Otranto, as elsewhere in the peninsula, that one scholar has identified them as the 'most characteristic and important' phenomenon of Italian religious history in the seventeenth century.[3] After discussing missionary activity in the province, we shall turn to the related role of the religious brotherhoods – congregations and confraternities – as movements of Tridentine reform within organised religion.

MISSIONS: THE JESUITS

For more than two centuries the missions were a crucial aspect of religious life, not only because the *Mezzogiorno* was one of their particular concerns, but because they partially succeeded in breaking down the divide between centre and periphery. Scipione Paolucci sought to demonstrate that the mission in the Kingdom of Naples was 'little inferior to the vocation of the Indies: after being deprived of the hope of shedding one's blood there for

the Faith, here the toils are not fewer, and the task is perhaps greater.'[4] According to Adriano Prosperi the *topos* of 'the Indies' had its origins in attempts to transfer the crusading impulse of missionary energies into the internal regions of Europe, but meant that missioners tended not to distinguish the specific situations which they faced. For this reason the reader of their relations and annual letters must be wary of taking them at face value because of the frequent recurrence of certain stereotypes, such as the people's complete ignorance of God and the sacraments.[5] Likewise, in the missionary tradition, they tended to glorify achievements, conversions, miraculous occurrences, without telling us much about the objects of their activity. Their work in the peripheries of southern Italy to evangelise and christianise 'the Indies of down here' brought about changes in devotion, though not always in the ways intended by the missioners, as local people sought to make the missioners' messages fit in with their own beliefs. To understand this process of negotiation, and its importance to the system of the sacred, we must first explore the aims and strategies of the various missionary groups, beginning with the Jesuits, the most significant.

Jesuit missioners generally conducted urban missions during the winter and rural missions during the summer. Each mission lasted for eight or nine days, relying on its intensity and extraordinary character in the lives of villagers to bring about repentence. They were in fact styled by the missioners as 'raids' (*missioni scorriere*). On arrival at the mission site, the missioners met with the local clergy, confraternity superiors and area notables, in order to ensure their good will and support. Then, to inform the community of their arrival, the Blessed Sacrament was carried in procession to the church chosen for the exercises, where it would remain exposed for the duration of the mission. The villagers or townspeople were invited to attend a sermon at which the intention of the mission would be announced. The first instruction was held at dawn the next day, before the peasants left for the fields, explaining the commandments and the need for penance and confession. During the afternoon catechetical instruction was given to the children. Evening sermons were a fundamental feature of the missions, as were penitential devotions (for the men) and confessions of the whole population. The Jesuits would seek to institute at least one Marian congregation (depending on the area's population) before closing the mission with penitential processions, as a final act of expiation.[6]

The most vivid and dramatic elements of the mission were made up of the preaching and processions. The preachers – 'sacred orators' and 'itinerant men of God'[7] – constructed their terrorising eloquence out of emotive metaphors, figurative language, studied presentation and delivery. Draw-

ing both from the Bible and recent events, they would dwell upon plagues, epidemics, cataclysms and the imminence of death in order to instil a fear of God and the sufferings of hell and bring about repentence.[8] The Jesuit preachers, exemplified by Paolo Segneri, characterised the age, for 'probably no century looked more disconsolately at this world by the light of the other; on no other age has Hell exercised such a spasmodic and obsessive attraction–repulsion as in the seventeenth century'.[9] To bring images of eternal infernal suffering to life for the villagers, the preacher might employ a human skull as a prop while discussing the fragility of life, or mortify his flesh with a rope or singe it with a candle. Some of the faithful might participate in this mortification during the sermon, slapping themselves or beating themselves with stones or ropes, increasing the atmosphere of tension and anxiety. The relationship established between preacher and faithful in this sacred performance would be further developed by the burning of playing cards, ribbons and obscene and forbidden books. Such events naturally assumed great importance in the life of the community.

During the mission the men were encouraged to perform penitential devotions and exercises of self-discipline inside the church, while the women – in a typical exclusion of women from the public sphere – were encouraged to pray and perform acts of contrition at home. The women would often remain outside the church, 'and while the men beat themselves, these women scream with tears and loud groans mercy from God', according to the report from a 1618 mission in Basilicata.[10] The final penitential procession entailed the participation of all men from the community, rich and poor alike, performing the same acts of contrition. As Novi Chavarria notes, this unity of gesture not only helped to ease community tensions and frustrations. The ritual was also exorcistic in nature, seeking to eliminate or allay the pains of hell and the fear of death and the beyond by recourse to an analogous system of self-inflicted punishment.[11] According to the report from a 1630 mission in the hinterland of Lecce, 'those who beat themselves with iron chains, far from turning red with a lot of blood, actually turned white as their bones were revealed through lacerated flesh.'[12] Like the other rituals which attempted to provide access to sacred power, and which together constituted the system of the sacred, the penitential procession expressed and took on the suffering of the individual, liberating him or her from the precariousness and anguish associated with crises of existence – disease, misfortune, the imminence of death – and providing a means of hope and reintegration into society. In the city of Lecce itself that year there was a general communion of 17,000 people, accompanied by acts of charity and peni-

tence, to placate the wrath of God. Such was the impact of the mission that it was even reported in the city's chronicle.[13]

The Jesuits also introduced or helped spread other forms of devotion during the course of their missions. One was the 'rosary of the five wounds of Jesus' introduced throughout the Terra d'Otranto and Terra di Bari by missions from the college of Lecce beginning in the 1660s. They were also responsible for the 'Slaves of the Virgin Mary': seven men chosen from among the community who processed in chains to the church, the leader holding a crucifix, where they prostrated themselves before the altar, seeking forgiveness for their sins and dedicating themselves to the Queen of Heaven. Aside from encouraging the cult of the guardian angel, the 'good death' and the use of the rosary, other devotions reflected the Jesuits' strategy of accommodation. This meant replacing practices they considered unorthodox – the result of (what they regarded as) ignorance and superstition – with more orthodox customs. Certainly the principle of 'substitute rather than destroy' had a long history in the Catholic Church. The Jesuits themselves were using it to great effect in their overseas missions.[14] Whereas in foreign lands this meant adapting oneself to the environment one was attempting to evangelise, in Europe the Jesuits had the advantage of authority and power and were christianising what they regarded as inferior examples of the same (or similar) culture. For this reason there was little attempt to understand or appreciate specific aspects of the local culture on the peripheries of Europe, as there was on the overseas missions. On the other hand, they did not display a direct aggression towards the culture, or compile a list of 'popular errors' for the benefit of the secular clergy (as did reforming bishops like Carlo Borromeo and Gabriele Paleotti), but seem instead to have operated on a case-by-case basis, replacing an unorthodox custom with an orthodox one.[15]

In this way the celebrations of Carnival, May Day, St John's Eve and other feasts, which the Jesuits and the Counter-Reformation in general considered illicit and un-Christian, were replaced by processions and religious theatre, and exercises of piety like the Forty-hours devotion. Indeed we might regard the processions discussed above as the utilisation of the carnivalesque dimension of popular culture – being a sort of *grande mascherata* – which the missioners directed towards penitential ends.[16] By means of such substitutions the Jesuits attempted to apply Tridentine reforms, taking religious initiative away from the laity. For instance, the first time the Forty-hours devotion was 'staged' during Carnival was at Macerata in 1556, to lure responsible citizens away from a comedy which the Jesuits considered impure and obscene. To achieve this they exposed the Blessed Sacrament 'with a beautiful and unusual *apparato* of lights and

decorations',[17] and such was their success that by the end of the century it was practised at all Jesuit colleges and houses during Carnival. As in this case, the Jesuit strategy was first to approach the élites, reforming their practices and gaining their support and favour, before moving on to the lower echelons of society, who they felt would begin to imitate the example set by their 'betters'.[18]

In the same way the Jesuits began their activity in the cities, acquiring social and cultural prestige, before spreading out into the countryside. The centre for the Jesuits in Apulia was their college at Lecce, upgraded from a religious house to a college in 1583, which achieved something of a working routine by the 1630s, when it had an enrolment of 400 pupils.[19] They put great emphasis on the establishment of teaching colleges throughout their area of operations, especially regarding attempts to change the attitudes and culture of the young. It was from the Lecce college that the Jesuits established their network of activities and intitutions. It was here that they founded Marian congregations and then launched charitable works into the city's prisons and hospitals. And it was the Lecce college that served as a base for the missions, the aim being to set up residences in various mission locations, eventually transforming them into colleges, if the conditions were right for teaching and the cultural, religious and social integration of the Jesuits into the civic context. Taranto became first a residence (1617) and then a college (1624) in this way. It was intended that it should cover the strip of land along the Ionian Sea, since missions from the Lecce college focused on the Adriatic coast, not generally penetrating further inland than Nardò, although they were known to make forays as far inland as Matera. Further north in the province, in the absence of a college at Brindisi,[20] the rural residences of Torre Santa Susanna and Sava (both in the diocese of Oria) became important focal points, sending out small groups of missioners, complementing the work of the missionary stations set up at Ostuni and Casalnuovo.[21]

The letters written by the Jesuit missioners, triumphalist in tone,[22] describe great successes: entire villages assembling for confessions and mass, feuds ended, conversions of sinners and hardened criminals, competition for giving alms, the re-establishment of civic morality, as well as other miraculous events. Let us limit ourselves to one example, involving the missioner Francesco Guerrieri, a native of Lecce.[23] According to the miracle narrative, in 1592 a woman in the province of Otranto (we are not told where) was accused of having dishonoured her family, for which her brothers wanted to kill her. She hid and, being innocent, she beseeched the Virgin Mary, who answered her prayer by telling her not to worry and that 'tomorrow a priest will come from the Society of Jesus, for the

spiritual aid of this people, whom you will quickly meet. After having recounted your danger and innocence to him, you will tell him on my behalf to direct you, to the best of his capability, and secure your safety.' The next day Guerrieri arrived and, after hearing the woman's case and receiving divine illumination, placed her under the care of a pious matron of the town. Then, by miraculous intervention of the Virgin, the brothers' murderous wrath cooled and the woman was able to return home.[24] The narrative demonstrates the extraordinary nature of missions in the lives of the local people and the emotive impact they must have had. It also exemplifies the missioners' tendency to welcome and even elaborate on such accounts – there are numerous examples in the relations and annual letters – in the same way that legends recounting the discovery of miraculous images were developed (see below, chapter 6).

Despite the frequency of such occurrences – or perhaps because of it – we must ask ourselves what kind of long-term impact the Jesuit missions may have had on local religiosity. Although religious behaviour was affected by the emotionalism of their preaching, penance and mass confessions, it is doubtful that any profound changes in consciousness occurred. More likely, the devotional forms superficially introduced were taken on and assimilated, though stripped of much of their doctrinal context and message or else transformed to fit the local ritual system. Such was the case with the rosary, which had gone from being a tool of meditation to a devotional article with all the powers of a relic. Townspeople often followed the missioners for miles, kissing the fringes of their habits, or touching their rosaries to them, in order to imbue the rosaries with the sacred power which they believed the missioners possessed.[25] In addition, some of the penitential forms introduced by the missioners survive to this day in the form of local, unofficial processions during Lent and Easter, although the 'analogy with Christ' through the penitent's suffering and shedding of blood has taken on the meaning of a salvific rite and an affirmation of strength.[26] Such apparently spontaneous lay practices were already in existence several years after the expulsion of the Jesuits from the Kingdom (1767) and their suppression by Pope Clement XIV (1773), as we know from a 1779 Neapolitan document condemning them.[27]

By the second half of the eighteenth century the Jesuit-style mission was already beginning to face criticism from intellectual and ecclesiastical circles, which believed that the combination of emotive piety and terror of God engendered by the missioners did more harm than good. In 1745 the cleric and archivist-librarian Ludovico Antonio Muratori, educated at the Jesuit college in Modena, wrote:

I have known women who, on the occasion of a clamorous sacred mission, have become insane, so that it then took much effort to restore them to normal. Oh, those unfortunates [the missioners], who do not pay attention to the great wrong they commit to God our sublime master, the most loving, merciful Master that could ever be imagined, who – knowing the present state man is in, that is, a fallible and sinful creature – pities us, tolerates us, and anxiously waits until we, repenting our faults, beg forgiveness, in order to put us back in his grace and embrace us as his beloved children.[28]

Clearly, the Enlightenment was bringing with it a new concept of God. At the same time, the Jesuit missions were becoming increasingly identified with rural as opposed to urban areas. It might be interesting to explore how the other missionary Orders and congregations active in the Terra d'Otranto conducted their missions, and how strategies evolved as the nineteenth century approached.

OTHER MISSIONARY ORDERS

Even before eighteenth-century changes in attitudes, other Orders were pursuing a different course. In contrast to the Jesuit missioners the Congregation of the *Pii Operai*, founded at Naples in 1602, forbade its missioners from employing exterior demonstrations of penitence. Pietro Gisolfo's *Instruttione* for the Congregation (1674) suggested that a crucifix and a few well-chosen words were enough to bring about repentance, and that the penances favoured by other orders were not for him.[29] Likewise, the Congregation of the Fathers of the Mission (or Lazarists) founded by St Vincent de Paul in France (1625), chose not to adopt the so-called penitential mission of the Jesuits, preferring a catechetical style that stressed doctrinal teaching to bring about a re-orientation of the faithful towards orthodox religious behaviour.[30] Their missions lasted longer than those of the Jesuits: at least two weeks in the smallest communities and up to one month in larger ones, and the presence of two or three missioners allowed them carefully to confess the entire population. In the first week of the mission they would seek to establish a charitable society (*compagnia della carità*) in the community. Although their sermons stressed the themes common to the baroque – fear of death, divine wrath and final impenitence – they relied on the intrinsic nature of the themes to being about repentance rather than using external and emotive techniques to cause a quick psychological impact. And while the Jesuits staged macabre penitential processions, the Lazarists conducted the 'procession with angels', consisting of young girls and unmarried women.[31]

However, the two missionary groups most active in the Terra

d'Otranto, the Congregation of the Apostolic Missions and the Congregation of the Most Holy Redeemer (the Redemptorists), can be said to belong ostensibly to the Jesuit tradition. For instance, during the evening sermons given by the Apostolic Fathers, a line of priests would unexpectedly process towards the altar, covered in ashes, crowned with thorns, ropes about their necks and skulls in their hands, weeping. The preacher was then given a rope with which he would then proceed to whip them. Occasionally, before beginning his sermon, the preacher would approach the altar on his knees, licking the floor in self-abasement.[32] In efforts to eliminate what they saw as superstition, they instituted the 'damning of witches and sorceresses', which was conducted after the evening sermon by a priest in a dark habit, in almost complete darkness, with 'the usual rite of the tolling of the knell'.[33] They also favoured the penitential processions of the Jesuits.

This is not to say that the Apostolic Fathers were not open to new developments, for they put increasing emphasis on sound catechistic teaching and attempts to strengthen parochial and diocesan structures, which their activity was meant to aid rather than substitute. The Fathers were reminded not to create trouble with the local clergy, while confessors were instructed to treat the local clergy with respect, addressing them by their titles and never substituting themselves for the local confessors.[34] They stressed a kind of preaching that would be within everyone's comprehension, using the local dialect if necessary, while composed in sober language and drawn from Scripture. The Congregation's urbane and learned character was crucial in their desire to help create a theologically-trained clergy, necessary to fortify the parish structure. Success in this regard, however, had to await the nineteenth century.

In the Terra d'Otranto this achievement was shared with the Redemptorists, founded by St Alfonso de' Liguori in 1732, but did not reach fruition until the years following the concordat of 1818 signed between King Ferdinand I (restored to the throne of the newly-named Kingdom of the Two Sicilies) and Pope Pius VII. De' Liguori was aware of the risk that after the missioners had departed and the emotion of the mission had subsided and the fear of divine punishment faded, the people would return to their old ways, whereas those tied to God by love would persevere.[35] Despite this new emphasis, the transition away from the Segneri-influenced missions of the Jesuits was a slow one, with Redemptorist sermons continuing to give the macabre free range.

'Already I am aware, most beloved people [went a sermon suggested by Ludovico Altarelli], that the sermon on death has not made any impression

upon you whatsoever this evening, so that you remain with a heart harder than a boulder, your eyes dry and unmoved. Do you know what I want to do this evening? I want to let another preacher come up on to the pulpit this evening, your countryman, but who has come from another world, and I want to give you the sermon on death from him...' And having said that, [the preacher] will take a lighted torch and say to the people: 'Go! Before that other preacher comes, seek forgiveness from Jesus Christ, yes!, run to Mary Most Holy.' And in the meantime, he will take a skull of death and turn it about with the lighted torch before it; and afterwards he will make a dialogue of questions between him and the skull, keeping in mind however that when he speaks to the skull he will turn to the people. Be it also noted that the response, which he himself will give to the people on behalf of the skull, will be given throughout in a third tone or peroration.[36]

In many ways it is to the Redemptorists that the Jesuit missionary mantle was passed, continuing as they did 'the work begun by the Jesuits, spreading a facile and exterior piety, in which the display of the processions and the emotions stirred by the sermons had an essential part'.[37] Theirs was a piety at once influencing and influenced by local concepts of the sacred, a world which de' Liguori knew intimately. As tangible reminders of their missions the Redemptorists distributed blessed rosaries, crosses and the so-called *abitini di Maria* (little cloth pouches, worn about the neck or sewn into clothes to protect the wearer).[38] These were believed to possess thaumaturgic powers, analogous to the protection and recourse to the sacred provided by the *brevi* (canonical and extra-canonical) and various forms of saints' relics to be discussed in Part II (below).

The Redemptorists, like the Apostolic Missioners, were slightly more methodical than the Jesuits in their approach. They carried out what they termed a 'renewal', returning to the locale for a few days four or five months after the initial mission. They established numerous houses throughout the Kingdom in order to maximise their efforts. In addition, they were consistent with other eighteenth-century missionary Orders in acting as a force of calm and stability. Bishops had long used missions to restore spirituality to their dioceses, as when Bishop Fabrizio Pignatelli of Lecce requested missions following the Interdict.[39] They could also be trusted to bring an end to natural calamities, where the ecclesiastical remedies of the local clergy had failed. But now, because of the accentuated politico-religious orientation, they could even be relied upon to suppress upheavals. The activity of the missioners was increasingly called upon beginning with the revolutionary troubles of 1799. In this year Bishop Cimino of Oria requested permission for missions, and obtained eight Redemptorists who went about the diocese for six months, preach-

ing the word of God, obedience to ecclesiastical and secular authorities, respect for the crown and its laws, and peace among the people.[40]

The turn of the century witnessed increased missionary activity, which was further accentuated during the Restoration, and the establishment of a new missionary community. Along the lines of the Redemptorists, it was called the Congregation of the Most Precious Blood. According to Guido Verucci, it contributed to an 'evolution towards a more fervent piety, more popular, but also more facile, more exterior, a manifestation of religiosity naturally present from the seventeenth and eighteenth centuries but which becomes prevalent during the nineteenth.'[41] It was during the second half of the eighteenth century, and even more during the nineteenth, that the missions began to show fruit. They began to have an impact on the forms of religious practice and succeeded in establishing a new relationship between the clergy and the faithful. They were able to restore a social function to Church institutions and, in particular, over the long term, to the parish.[42] Their simple but fundamental message had been to ensure that the faithful practised their religion 'correctly', according to Tridentine norms. But it was a message that stressed practice and devotions at the expense of belief and knowledge of the faith, and so its effect on the local belief system was somewhat muted. During the period under consideration in this book, then, we can certainly notice inroads regarding such things as an at least partial acquaintance with correct religious practice, especially amongst the educated classes. However, the themes to be discussed in the chapters that follow were only slightly effected by this, as we shall see.

Although the long-term impact of the Jesuit missions in particular has been called into question, they did make one lasting and profound contribution to the local system of the sacred, in the form of Marian congregations (or sodalities) and lay confraternities. The Jesuits were not alone in establishing these pious brotherhoods, but they provided a significant impetus to their foundation. The spread of the brotherhoods throughout the Kingdom met local needs for intimate devotional groups left unsatisfied by a parochial structure which remained weak until well into the nineteenth century. As such, they provided an important means of introducing Tridentine reforms and devotions to the laity, complementing the activities of the missioners.

JESUIT MARIAN CONGREGATIONS

The Jesuit Marian congregations began within the colleges but soon spread beyond, accepting 'respectable' members of society, both clerical

and lay. At first they accepted women, and brought together noble and bourgeois, merchants and artisans; but by the 1590s separate sodalities were formed for priests, in line with Tridentine expectations regarding the separate character of the clergy. At the same time, mixed congregations came into disfavour, with the Jesuits adapting and accommodating themselves to a society which saw women as inferior before the law and represented in public by their father or husband. The sodalities became spatially distinct – those with married members from unmarried, educated from uneducated – each having its own chapel.[43] The Marian congregations in Lecce, based at the Jesuit college, numbered six: one for noblemen, one for priests, one for *civili* (members of the professions), one for elder pupils of the College, one for younger pupils and one for 'students' (those who studied outside the college but would take examinations there). In addition, there were two oratories, for elder and younger artisans respectively.[44] The Jesuit network of congregations, oratories and conservatories (for girls) was expanded from the 1590s onwards, through missionary activity, so that they became a characteristic and relatively permanent sign of Jesuit passage through the diverse areas of the Kingdom, from urban centres to the smallest rural communities.[45] As early as 1607 there were fifty-six congregations and oratories in the Kingdom, with a total of 4,633 members: together, Terra di Bari and Terra d'Otranto had thirteen, for a total of 752 members.[46]

Congregations could influence religious life over the long term in a way that the missions alone could not. The missioners were only too aware of this, and instituting a congregation was an important part of each mission. One mission account praises

> the foundation of congregations in each town, which is the greatest good that they could ever have, because through the participation in the Sacraments, exhortations and discplines all the good achieved during the missions can be maintained, and God must be blessed for the perseverance of such congregations, which in every place, and today in almost all of this province, are seen to have the most beautiful vessels and buildings, obtained through the piety of the brothers.[47]

Although the directors of the local congregations were chosen by Jesuit superiors without consultation of (lay) members, they did provide the laity with an important role, in terms of providing a Christian example to the community through piety and charitable works, teaching catechism and encouraging 'correct' beliefs in others: roles that had previously been limited to the clergy. Members sometimes accompanied the Jesuit missioners on their missions, participating in processions, singing litanies

to the Virgin, listening to sermons, going to confession, performing acts of penance, preparing themselves for communion and giving alms. In short, demonstrating how best to follow a mission and benefit from it.[48]

But the congregations and confraternities of the Counter-Reformation also possessed an internal 'missionarism'. In fact, it is this quality that most differentiates them from their medieval forebears. Lay sermons were replaced by clerical sermons and spiritual advice, and the feasting and entertainment which were part of medieval conraternities went into decline. The Tridentine missionarism was manifested in a religious drive to create a liturgical and sacramental consciousness within the brotherhoods, coupled with an increased awareness of the plight of one's neighbour and the need to harmonise with the activities of the clergy. It is particularly evident in the brotherhoods created by the Jesuits themselves. Their statutes, rather than emphasising aspects of administration, reveal the religious, devotional and charitable aspects of the association.[49] Indeed they were treated as devotional literature, to be read frequently by and to members.

Let us look briefly at what were probably typical statutes for a Jesuit congregation. The congregation of S. Anastasio, later S. Francesco Xaverio, was founded in the hamlet of Tuturano (diocese of Brindisi) in 1740, during a mission, by the indefatigable missioner Onofrio Paradiso (1704–61).[50] Typical of such hamlets – its population was 250 in 1795 – Tuturano had had no religious brotherhood before that time. The statutes themselves recognised that it was a farming community and that the congregation's members were peasants. Every day, before going out to the fields, members were to hear mass, or at least stop in a church to pray before the Blessed Sacrament. An ordinance also reinforced the universal prohibition from working on feast days, which peasants were notorious for ignoring – if episcopal visitations are anything to go by – particularly during the intense and busy harvest period. And, regarding the harvest, members were instructed to avoid using 'dishonourable words' during work in the fields, a time of gossip and satirical work songs (as we saw in the previous chapter).

We are reminded of the extent to which such congregations sought to instil the values of the Counter-Reformation into the daily lives of the faithful. Many of the ordinances for the S. Atanasio congregation seek to inflence religious practice, putting forth the confrères as models of baroque religiosity. On waking each morning the confrère was to thank God for his bounty and dedicate the day's work to him, and in the evening he and his family were to recite the rosary together. He was to go to confession followed by communion once a month. He was not to swear,

play cards, make music or sing in the streets, masquerade during Carnival or visit the house of his betrothed before they were wed (a reminder of Church attempts to reform marriage customs). Members were also encouraged to keep an eye on one another to ensure obedience to the statutes and report shortcomings to the prefect. Punishment consisted of acts of penitence during meetings of the congregation. If offences were considered more serious and the confrère incorrigible, he would be expelled from the congregation and his name would be burned in public to the sound of the death knell. Expulsion symbolically consigned the soul to the flames of hell: the member would no longer be able to depend on the masses and prayers of his confrères for the repose of his soul.

The statutes written for the small congregation of S. Anastasio were a simplified version of the more elaborate and detailed ones written by the Jesuits for their larger urban congregations and confraternities. It is by studying the latter that the full religious and social impact of the lay brotherhoods can be understood. The statutes of the congregation of the Santissima Annunciazione of Lecce are a case in point. Written by the saintly and learned Jesuit Bernardino Realino in 1582, they discuss every aspect of the congregation's activity, from personal devotions to public acts of charity. The general aims of the congregation are clearly stated:

> Each of the brothers, in accordance with the direction of the fathers of the Society of Jesus, is to attend with all diligence first of all to his own spiritual assistance and that of his family, and then with the same diligence dedicate himself to the benefit of his neighbours in works of mercy, and particularly in lending assistance to the naked poor of the city.[51]

The confrère was to pursue his own 'spiritual assistance' through 'both mental and oral prayer, participation in the Blessed Sacraments, attending to the acquisition of the virtues, with some exercise of mortification, according to the direction and orders of the congregation's priest'.[52] This religious routine of prayers and devotions gave shape to the devotee's day, week and year. Indeed the practice of morning prayer, evening examination of conscience, fortnightly confession, frequent communion and religious retreats eventually became accepted devotional models, if not actual practices, in the wider community. The stress on quantity could lead to formulaic devotion – that is, form over substance. But the profusion of images and symbols in the devotions provided a sort of theatrical action, which allowed the confrère actually to enter inside and participate in the process of salvation. For this reason, according to Louis Châtellier, it would be wrong to consider baroque piety in this regard as simply exterior and frivolous, for, in the routine of the devotee, time, space, words and

action assumed a sacred character.[53] The contribution of the congregations to the spread of such frequent and public devotions – by no means unique to the Jesuits, and in common with baroque piety – lay in their very number and influence.

The Santissima Annunciazione was to meet every Satuday evening (except Easter Saturday) and every Sunday morning, as well as the principal feasts of the Lord (Circumcision, Epiphany, second and third days of Easter, second and third days of Pentecost, Holy Trinity) and Our Lady (Conception, Nativity, Purification, Annunciation, Visitation, Assumption) and the feasts of the Apostles, All Saints and the Nativity of St John the Baptist. It was during these meetings that the congregation sought to put its dedication as a Christian brotherhood into practice. All members were addressed alike as 'brother'; no other titles were used. Meetings consisted of a quarter of an hour of prayer and meditation, on some point from either their catechism booklet or the day's gospel, followed by a sermon. Then the prefect noted the confrères who were absent, failings and offences were discussed, penances given and works of charity for the week assigned. The meeting was brought to a close with prayer. In addition, on the first Sunday of the month each member chose a particular saint as his 'advocate' by a lottery process, to whom he was to dedicate himself for that month. As he approached to be handed the slip of paper on which was printed the saint's name, the confrère was to kneel 'and say which saint he had the past month, the virtue which he had to practise, and for whom he had to pray, at the same time accusing himself of any negligence or other failing committed, and asking for penance.'[54] Members who were to be away for a protracted period of time were to continue to obey the congregation's rules and devotions as much as possible, pray for its spiritual growth and write at least twice a year giving news of themselves, to which the confraternity was duly to respond.

At the same time, congregations and confraternities also devoted themselves to a wide range of charitable activities in the wider community. These 'works of mercy' included feeding the hungry, clothing the naked, housing wayfarers, visiting the sick and those in prison, dowering orphans and poor girls and burying the dead. The performance of any of these was a means of acquiring grace, 'a wholly efficacious rite that communicated with God even as it relieved the physical discomfort of one's fellow Christian'.[55] Each brotherhood tended to have its specialisation. As we have seen, the Santissima Annunciazione of Lecce sought to clothe the naked. The prefect was to have one delegate in each quarter (*pettaggio*) of the city who 'will be responsible for dressing one naked person each month'. The delegate was to visit the pauper being selected in order to

ensure that 'he is of honest and good reputation in his neighbourhood; second, that because of his nakedness he is worthy of such alms'. The clothes were to be paid for solely out of alms gathered by confrères in the city.[56]

In addition, two brothers would be delegated each week to visit the prisons, and two to visit the hospitals. The aims here were a mixture of consolation and conversion. The confrères visiting the prisons might seek to reconcile debtors with their creditors or speed up the cases of prisoners through the courts, while at the same time introducing devotions like the saying of litanies or donating catechism booklets. Those visiting the sick were to bring food, make beds and talk to the patients, 'treating of the fruit that is obtained from sickness and tribulation, which function like the flailing to separate the good grain from the straw, or the dust from clothes'. They should give the patients 'some blessed grain, rosary, images or similar devotions, that console and help the soul with the benefit of indulgences and holy reminders'. Visitors, stressed the statutes, were not to interfere and respect the wishes of hospital staff; while those visiting the prisons were not to compete with the work being done by the Gonfalone (literally, standard or banner) confraternity.[57]

In the Kingdom of Naples the 'devotional system' of the congregations also included involvement in pious works like the *monti di pietà*,[58] catechism teaching and clerical formation, in those areas lacking seminaries. The *monti* were a crucial part of their philanthropic activity, directed primarily towards saving the souls of the confrères and those of the 'deserving poor' whom they helped. The *monti di maritaggio* allowed savings to be made for dowries and funded a limited number of dowries for poor or orphan girls. The *monti frumentari* lent seed and capital to farmers at a modest rate of interest. So important were their activities that several of the *monti* weathered the economic difficulties of the seventeenth century and later developed into full-fledged banks. If a 1795 geographical dictionary of the Kingdom of Naples is anything to go by, the distribution of the *monti* in the Terra d'Otranto was a haphazard and variable affair, though towns of over 2,500 inhabitants often had at least one of the types.[59] But there is no hard and fast rule. While the capital Lecce had only one *monte di pietà*, the considerably smaller Castellaneta, with a population of 5,000, had five *monti frummentari* and one *monte di pietà*. And while a major centre like Francavilla (population 12,000) had one *monte di pietà*, the nearby town of Locorotondo (diocese of Ostuni, population 4, 270) could boast of four.

CONFRATERNITIES

Like the missions which they sometimes assisted, the Marian congrega-
tions set up by the Jesuits throughout the Terra d'Otranto provided a
source of social stability, while being able to adapt to new circumstances.
Many congregations survived the expulsion of the Jesuits, often by re-
forming into confraternities. Confraternities also existed alongside the
congregations, possessing many of the same traits and performing similar
functions within the local system of the sacred. In Novoli, besides two
congregations, the Jesuits also founded the confraternity of Santa Maria
Mater Domini, and we know of many other confraternities they initiated
in the smaller centres of the Lecce diocese.[60] In fact, the difference between
congregation and confraternity is largely semantic, and usage has blurred
the distinction still further. For at least one sixteenth-century Jesuit,
however, a congregation was unlike a confraternity in that it did not have
its own gown (*sacco*), standard or chapel, and its members did not ususally
accompany the dead to burial.[61]

The Jesuit missioners also revived confraternities that had fallen on
hard times or had ceased to exist. This seems to have been a relatively
widespread phenomenon in the Terra d'Otranto, in part due to the
unreliability of confraternity financing. But perhaps their major contribu-
tion in this regard was the sponsoring of confraternities of the Santissimo
Sacramento which, as its dedication would suggest, stressed eucharistic
devotion. Through the eucharist these confraternities, located in towns
and villages throughout the province, featured devotions involving the
entire community, in this way eventually becoming rooted in the religious
life of the parish, as the following example shows. When the Jesuit
Onofrio Paradiso set up the confraternity in Lecce (1740), he organised its
members into four units, each responsible for one of the city's parishes.
One of their responsibilities was to leave their houses, bearing torches,
whenever the priest went out to take the viaticum to a dying person, as an
escort for the Blessed Sacrament.[62] Such was the impact of this practice on
popular sensibilities that in 1792 Bishop Spinelli decreed that women
should not accompany the viaticum at night, remaining at home instead,
placing a candle in the window as a sign of devotion.[63] The integration of
this confraternity into communities and its importance to the parish fabric
resulted in its being exempted from the suppression of confraternities
brought about by the Napoleonic 'Legge Italica' of 1807.

The Religious Orders were also involved in the founding and running
of confraternities. The Dominicans, for example, encouraged Marian
devotion through their confraternities of the Rosary. Along with the

confraternities dedicated to the Santissimo Sacramento it was the most widespread in the province. But the sometimes ambiguous nature of surviving records can lead to confusion in this regard. The Carmelites, for example, were active in instituting confraternities dedicated to Our Lady of Mount Carmel. Yet the historian is often unable to distinguish between confraternities bearing this dedication that were founded by the Order, those of Marian confraternities erected in Carmelite churches and those erected in churches not pertaining to the Order.[64]

The foundation of confraternities was not however a one-way street. In fact, the dedication of such brotherhoods to particular devotions is another example of where centre meets periphery in the sacred system. This is the case when introduced devotions suit local sensibilities, such as the devotion to Our Lady of Sorrows (the *Addolorata*), spread by the Order of the Servants of Mary (Servites). The pain of Mary, suffering in solitary silence, was shared by the entire community, and her mourning became its mourning. This devotion complemented the local sense of the tragic, of *thanatos*, which survived in the mourning rituals we explored in the previous chapter. The introduction of this devotion in the mid eighteenth century, to cite but one example, resulted in the confraternity of S. Domenico – founded by the Domincans at Taranto in the previous century and situated in their church there – altering its dedication to that of S. Domenico e l'Addolorata.[65] The province's many brotherhoods dedicated to the Addolorata were largely founded after this time, during the nineteenth century.

In Lecce as elsewhere the confraternities were concentrated in the churches of the various Orders. Like the city's Marian congregations, they were organised according to social status. Thus the Theatines sponsored one for noblemen (the Crocifisso) and one for artisans (the Anime del Purgatorio). The Carmelites founded a branch of the widespread S. Maria del Carmine and another specifically for artisans (the Agonizzanti). Minor confraternities included Sant'Eligio, made up of farm workers, and San Giuseppe, sponsored by the Minor Observants for the carpenters of the city. Noble confraternities consisted of two based at the cathedral – the Sacramento and the rich and powerful Santa Maria del Popolo – and the Gonfalone, based at the church of Santa Maria della Carità.[66]

The larger the community the more compartmentalised its devotion; the reverse was true of small towns and villages. Thus the confraternities present in smaller communities were not generally based on occupation, tending to be mixed. Whereas in big towns and cities the Santissimo Sacramento brotherhood was often made up only of professionals and notables, in the villages membership was open.[67] This was true in the

diocese of Ugento, composed of relatively small dispersed settlements, or *casali*, where the membership lists show a mixture of literate (35 per cent) and illiterate (65 per cent), according to those able to sign their names.[68] However, the thirty-one confraternities of the diocese did differ from one another in size and wealth. Some were linked with the mother confraternities in Rome – able to draw upon extensive incomes for their devotions and ceremonies – others managed to survive on alms collected in the streets, and some were in dire penury.[69]

It was only at the end of the eighteenth century that the Terra d'Otranto's confraternal network reached a substantial degree of uniformity, in organisational and devotional terms, in part the result of government legislation beginning in 1742. The eighteenth century witnessesed the greatest growth of confraternities. By 1795, according to Francesco Sacco's *Dizionario geografico-istorico-fisico* (Naples, 1795), even many of the smallest communities in the province supported at least one confraternity, while the principal cities had at least ten or fifteen. There seems to have been an average of one brotherhood per 1,000 inhabitants. Lecce (with 15,000 inhabitants) had sixteen confraternities, Taranto (17,000) likewise, while Gallipoli (12,000) had ten. The most popular were the devotionally-orientated confraternities of the Santissimo Sacramento, present in 35 per cent of Otrantine communities, and that of Santa Maria del Rosario, present in 34 per cent. The Immacolata was present in 29 per cent of communities. Not surprisingly, confraternities with Marian dedications, including the Rosario and Immacolata, accounted for more than half (53.4 per cent) of all confraternities, consistent with Marian predominance in wills and other expressions of devotion to the sacred pantheon (see chapter 6). What is intriguing is the high number of dedications with only a few exemplars, suggesting that they were named after local patron saints or devotions. Many are Marian – Santa Maria della Neve, della Stella, di Costantinopoli – while others reflect Counter-Reformation devotions: S. Francesco de Sales, S. Vincenzo Ferreri, S. Carlo.[70]

If we can begin to count the number of congregations and confraternities in the province, determining their respective membership is quite another matter. Christopher Black has suggested for Italy as a whole that 'a quarter or a third of the adult male population in significant urban areas were confraternity members at some time in their lives', though the ratio was lower in smaller towns and rural areas.[71] Certainly the numbers were nothing like those of early modern Spain, led by the town of Zamora, with a remarkable ratio of one brotherhood for every fourteen households.[72] However, numbers pure and simple can be misleading. We must bear in mind such things as variation between active and passive

membership, fluctuation during an individual's lifetime and membership in more than one confraternity, to say nothing of brotherhoods which were inactive or bankrupt.[73]

Given their sometimes precarious state, how did the brotherhoods contribute to the reform of organised religion? There is little doubt that they made an important contribution to the spreading of Counter-Reformation devotions. One is less sure of their success in providing a network of organised charity, especially outside the cities. We need to know more about their day-to-day operations, from finances to membership rolls. The confraternity statutes present us with an ideal picture; what about actual practice? Clearly, as with any organisation, the reality was never as efficient and harmonious as the statutes alone make out.

Episcopal court records can be useful in supplementing the data offered by the statutes. Disputes sometimes centred on jurisdiction, where they tended to come under the heading of seemingly petty difficulties between religious and secular clergy. In 1687 the vicar-general of Gallipoli and 'a multitude of priests' blocked the procession of the Dominican confraternity of the Rosary, forcing them back to the Dominican church, apparently because confrères were wearing medals from their necks but no habits, according to the vicar-general.[74] Disputes occurring within confraternities are more revealing. For instance, the statutes of the Santissima Annunciazione warned that voting during meetings was a time of potential discord within the congregation. It suggested that members 'seek to proceed without passion and give their vote with every liberty and rectitude of intention; not having regard for anything other than the service of God Our Lord and the common good of the congregation'.[75] Just such a dispute occurred within Latiano's (diocese of Oria) Confraternita dei Morti in 1746. When it was proposed that the Blessed Sacrament be exposed in their chapel on the first Monday of each month and that priests should say a mass for the souls in Purgatory, the Rev. Andrea Nardelli refused to enter a vote. When he was told that his vote would be annulled, he directed his wrath at the confraternity's prefect, Giovanni Leuzzi, shouting that Leuzzi had never been elected and did not do his job. Nardelli's name was removed from the table of voters, but confraternal justice was not enough for the enraged Leuzzi. In his accusation before the episcopal court, he accused Nardelli of causing scandal to the other brothers by his insolence, and alleged that Nardelli went out masquerading during Carnival and had had relations with a girl resulting in her getting pregnant. Once his reputation had been restored, Leuzzi withdrew his charges, because, in his words, 'it is the obligation of a Christian to forgive'.[76]

Other trial records do, however, remind us of the devotional and pious nature of the confraternities. In 1695 the confraternity of the Anime del Purgatorio (Souls of Purgatory) of Gallipoli, made up of porters, brought charges against the preacher Rev. Francesco Mega. It seems that the accused was giving a paid sermon to the confrères and their families during the Forty-hours devotion, and had chosen as his subject 'Meditation on a damned soul'. However, in the course of it he gave so many examples of the 'the blasphemy which the damned souls make' against the Trinity, the Blessed Virgin and Paradise, that his 'entire sermon consisted of such blasphemy'. The women began 'calling to Jesus and Mary, because they didn't want to hear such blasphemy', but Mega only responded by insulting them, so that many left the church in disgust. When Mega went to the confraternity prefect for his fee, he was given only the standard 'charity' of thirty *carlini*. Mega – a cathedral canon and doctor of theology – went into a frenzy, shouting for all to hear that he sold his sermons at a high price, worth far more than the basic donation he was being offered. The confraternity concluded the accusation against him by calling for his licence to preach to be withdrawn, saying that a preacher should set an example and preach simply the word of Christ for the benefit of the faithful.[77]

Important as the congregations and confraternities were to local devotion and lay involvement, they were not 'popular' in any absolute sense. I have included them in Part I of the book because of their role in organised religion. First of all, they were generally sited either in the parish church or in the church of a Religious Order. Furthermore, we have seen how the Jesuit congregations were controlled by the superiors. The statutes of the Santissima Annunciazione state specifically that the congregation's priest, assigned to it by the rector of the Jesuit college, was to have 'supreme authority over the direction and government of the congregation and of the individual brothers'.[78] As Angelo Torre has noted, the foundation of the brotherhoods 'is always requested by the ecclesiastical authorities through the preaching and missionary activity of the Religious Orders, primarily with the goal of providing for the material managment of the parochial structure by the care and maintenance of the altars, or else with a purely devotional intent'.[79]

At the same time, the success of confraternities responded to local lay devotional and ceremonial needs. Through the dedications of their altars, the collective public rituals they celebrated and the charitable activities they undertook, the congregations and confraternities acted as mediators for the Church-sponsored devotions of Tridentine catholicism. At the present state of our knowledge of confraternity activities in the Terra

d'Otranto it is impossible to ascertain just what the laity's role was in their day-to-day running. Lay intiative, for example, may have been more pronounced in those strictly local confraternities dedicated to a particular saint or devotion.[80] The founding of confraternities by laymen is a late phenomenon here, but one destined to become more important during the course of the nineteenth century, following the suppression of the Religious Orders in 1806.[81]

The reform of ecclesiastical structures – parishes, seminaries, clergy and so on – which had taken so long to get under way, suffered a further setback during the revolutionary period and the years of French rule with which the nineteenth century began. From 1799 to 1815 many dioceses in the Terra d'Otranto were without bishops, exemplifying the air of uncertainty that persisted until the concordat of 1818. During the 'French decade' the Kingdom experienced policies drawn directly from France. Religious Orders were suppressed, seminaries closed or given military and civil uses, traditional clerical functions like the chantries and colleges reduced or eliminated, the system of benefices undermined and confraternities all but eradicated. The reforms were traumatic. They adversely affected all of the so-called *luoghi pii*, from hospitals to the *monti di pietà*, so crucial to local religious life and welfare. The suppression of the monasteries hit the countryside particularly hard, for they had traditionally supplied the rural populace with many of its preachers, confessors and missioners, as we have seen.

But there were benefits. The secular and regular clergy were finally brought closer together, as secular priests were forced to take on many of the latter's functions and many regulars joined the secular clergy, accentuating a process which had begun in the previous century.[82] Gone – or almost – were the sinecured priests, those who, having celebrated mass or recited the office, had no other obligations.[83] The net effect was the new centrality of the parish in religious life and the importance of the parish priest, now distanced from lay interference and patronage, and firmly under the control of the bishop. Only in the years after 1818 did it become possible to exercise, through the parish, 'in the country as in the city, a capillary religious control of the mass of the faithful'.[84] The penetration of the Church into the countryside meant that many of the beliefs and practices condemned as 'errors' and 'superstitions' were pushed more and more to the margins of the sacred system. Of course, they continued to exist (as they continue to exist today) and play a role in the way people interpreted the sacred and gained access to sacred power, but in increasingly 'deculturated' and minor forms, and among gradually more restricted levels of society.

In the chapters that follow we shall explore a few examples of this process of cultural disintegration which occurred primarily as a result of ecclesiastical pressure. But for most of the period under examination the overall shape of the sacred system remained constant, though there were shifts within it. In this and the previous chapter we have dealt with organised ecclesial structures and the reforms which eventually came to some sort of fruition. Yet success was limited. It might be argued that only those Church sacraments corresponding to biological rites of passage – baptism, extreme unction and deathbed confession – formed an important part of the religious mentality of the average Christian. As Richard Trexler puts it, 'the procession was important, not confirmation. To *see* the host was a matter of great emotional excitement; to eat it was an occasional, secondary religious requirement. To speak with and trust an image was common; to confess to a priest was not.'[85] We might add that countering marriage magic was crucial, not the actual religious ceremony; the healing power of the saint more important than his exemplary life. We shall now turn to the more *ad hoc* or spontaneous and pragmatic elements within the system, liturgical and para- or extra-liturgical. From ritual conjurations, sacramentals and saints, representing the divine aspect of the sacred, to sorcery and witchcraft, representing the diabolical.

NOTES

1 Francesco Schinosi, *Istoria della Compagnia di Giesù, appartenente al Regno di Napoli* (Naples, 1711), 286.
2 Ibid., 395.
3 Carlo Ginzburg, 'Folklore, magia, religione', *Storia d'Italia. I: I caratteri originali* (Turin, 1972), 656.
4 Scipione Paolucci, *Missione de' padri della Compagnia di Giesù nel Regno di Napoli* (Naples, 1651), in the dedication to 'the holy apostle of the East, Francis Xavier'. Cit. in Adriano Prosperi, '"Otras Indias': Missionari della Controriforma tra contadini e selvaggi', in *Scienze, credenze occulte, livelli di cultura: Convegno internazionale di studi* (Florence, 1982), 218.
5 Ibid., 213 and 217.
6 For a detailed description of Jesuit missionary procedure, see Elisa Novi Chavarria, 'L'attività missionaria dei Gesuiti nel Mezzogiorno d'Italia tra XVI e XVIII secolo', in G. Galasso and C. Russo, eds. *Per la storia sociale e religiosa del Mezzogiorno d'Italia*, II (Naples, 1982), 159–185.
7 The expressions is Piero Camporesi's, in *La Casa dell'eternità*, (Milan, 1987), 43–4.
8 Novi Chavarria, 'L'attività', 167–8.
9 Camporesi, *Casa*, 46.
10 'De missione facta in Basilicata, relatio 25 Junii 1618', A.R.S.I., *Historia Provinciae Neapoletanae*, 73, fol. 113v.
11 Novi Chavarria, 'L'attività', 181.
12 'Pro litteris annuis anni 1630', A.R.S.I., *Prov. Neap.*, 73, fols. 257v–258v.

13 Andrea Panettera, 'Notizie della città di Lecce', reprinted in Appendix to *Rivista storia salentina*, 1905, 37.

14 Cf. Jonathan Spence, *The Memory Palace of Matteo Ricci* (London, 1984).

15 Prosperi, 'Missionari', 226-9.

16 Ginzburg, 'Folklore', 659.

17 Nicolò Orlandini, *Historiae Societatis Iesu prima pars* (Rome, 1615), 540. Cit. in Pietro Tacchi Venturi, *Storia della Compagnia di Gesù in Italia, narrata col sussidio di fonti inedite*, I (Rome, 1950 edn.), 240–1.

18 Prosperi, 'Missionari', 231–2.

19 Mario Rosa, 'Strategia missionaria in Puglia agli inizi del '600', in his *Religione e società nel Mezzogiorno tra Cinque e Seicento* (Bari, 1976), 265.

20 A college at Brindisi was founded only in 1753, fourteen years before the expulsion of the Society from the Kingdom by King Ferdinand IV.

21 Giovanni Barrella, *La Compagnia di Gesù nelle Puglie* (Lecce, 1941), 71 and 73.

22 Cf. Rosa, 'Strategia', 246.

23 A renowned scholar, Guerrieri (1558-1629) was celebrated by Torquato Tasso in a sonnet which began: 'You have the name Guerrier [warrior], of a warrior the genius' (Schinosi, *Istoria*, 130). All the more fitting, then, that he should have participated in the missionary 'raids'.

24 Schinosi, *Istoria*, 130.

25 For example, 'Punti principali occorsi nelle Missioni', 1646, A.R.S.I., *Prov. Neap.*, 74, fol. 215v.

26 Novi Chavarria, 'L'attività', 181.

27 'Interdidctum sacrae passionis mysteriae exprimere', Naples, 4 May 1779, in Lorenzo Giustiniani, *Nuova collezione delle Prammatiche del Regno di Napoli* (Naples, 1803-5), IV, 276.

28 Ludovico Antonio Muratori, *Della forza della fantasia umana* (Venice, 1753 edn.), 119.

29 *Instruttione per ben Missionare del P.D. Pietro Gisolfo dei Pii Operai* (Naples, 1717 edn.), 195; cit. in Gabriele De Rosa, 'Linguaggio e vita religiosa attraverso le missioni popolari del Mezzogiorno nell'età moderna', in his *Vescovi, popolo e magia nel Sud* (Naples, 1983 edn.), 206.

30 Luigi Mezzadri, 'Le missioni popolari della Congregazione della Missione nello Stato della Chiesa (1642-1700)', *Rivista di storia della Chiesa in Italia*, XXXIII (1979), 18

31 Maria Gabriella Rienzo, 'Il processo di cristianizzazione e le missioni popolari nel Mezzogiorno. Aspetti istituzionali e socio-religiosi', in Galasso and Russo eds., *Per la storia sociale e religiosa*, I, 466.

32 Known as the *strascino*, this practice was adopted by penitents of all kinds and was practised until very recently in local pilgrimages (see chapter 4, under 'Pilgrimage'). It is an example of something which has been frequently classed as 'popular piety' being in fact a survival of a whole range of practices introduced by the Church centuries earlier because it suited local needs and means of expression.

33 Archivio Storico Diocesano, Naples, *Apostoliche Missioni*, 31, fol. 132; cit. in Rienzo, 'Processo', 478.

34 Marcello Semeraro, *Le Apostoliche Missioni* (Rome, 1980), 35.

35 De' Liguori, 'Selva di materie predicabili, istruzioni per le missioni...', *Opere ascetiche*, III, 253; cit. in De Rosa, 'Linguaggio', 211. De' Liguori had been with the fathers of the Apostolic Missions for a time, before being encouraged to found his own missionary community.

36 From a manuscript collection of sermon guides by the Redemptorist Ludovico Altarelli, Archivium Sancti Gerardi, College of Materdomini, Naples, 1/B; cit. in De Rosa,

'Linguaggio', 215. De Rosa dates the collection from the period of the Bourbon restoration.

37 Ginzburg, 'Folklore', 662.

38 The *abitini* have survived into the present day throughout the *Mezzogiorno*, as extra-liturgical talismans worn by infants and young children to protect them from maleficent magic. Cf. Ernesto de Martino, *Sud e magia* (Turin, 1966 edn.), 36–8.

39 Barrella, *Compagnia*, 79, note 12.

40 Carmelo Turrisi, *La diocesi di Oria nell'Ottocento* (Rome, 1978), 331–2. The Lazarist missioners were also kept busy during this period, operating from their houses in Oria and Lecce.

41 Guido Verucci, 'Chiesa e società nell'Italia della Restaurazione (1814-1830)', *Rivista di storia della Chiesa in Italia*, XXX (1976), 67–8.

42 Roberto Rusconi, 'Predicatori e predicazione', *Storia d'Italia. Annali IV: Intellettuali e potere* (Turin, 1981), 1011.

43 Louis Châtellier, *L'Europe des dévots* (Paris, 1987), 30–2.

44 Barrella, *Compagnia*, 67.

45 Rosa, 'Strategia', 165.

46 'Catalogo di tutte le Congregationi delle B.ma Vergine che sono in ciascheduna Casa e Collegio della Compagnia di Giesù della provincia di Napoli fatto nel mese di luglio, 1607', A.R.S.I., *Neap.*, 72, fols. 109r–112v.

47 'Relatione di XIV missioni fatte nella Provincia di Otranto nel 1666 da' Padri della Compagnia di Giesù del Collegio di Lecce', A.R.S.I., *Prov. Neap.*, 76 I, fol. 28r–28v.

48 Châtellier, *Europe*, 35–6.

49 Pasquale Lopez, 'Le confraternite laicali in Italia e la Riforma cattolica', *Rivista di studi salernitani*, II (1969), 183 and 197.

50 'Regole per la congregazione eretta sotto il titolo di S. Anastasio sotto la protettione del SS. Crocifisso, e di S. Francesco Xaverio in Tuturano tempore missionis peractae per Reverendum Padrem Honfrium Paradjso Societatis Iesu in mense Ianuarij 1740', reprinted in Appendix to Rosario Jurlaro, 'Le confraternite della diocesi di Brindisi in età moderna: Prime indagini', in Liana Bertoldi Lenoci, *Le confraternite pugliesi in età moderna: Atti del seminario internazionale di studi*, Fasano, 1988, 489–91.

51 'Regole comuni della Congregatione della Santissima Annonciatione della Beatissima Vergine nel Collegio della Compagnia di G.I.E.S.U. nella magnifica città di Lecce', reprinted in Appendix to Lopez, 'Confraternite', 210.

52 Ibid.

53 Châtellier, *Europe*, 54.

54 'Regole...SS. Annonciatione', 228.

55 Maureen Flynn, *Sacred Charity: Confraternities and Social Welfare in Spain, 1400–1700* (London, 1989), 48.

56 'Regole...SS. Annonciatione', 219–20.

57 Ibid., 221–2.

58 Pawnshops or funds administered by laymen, which provided small, short-term loans and often supported institutes of beneficence like hospitals and conservatories. A *monte* could also be established as a form of pious bequest, its activities depending on the will of the testator.

59 Francesco Sacco, *Dizionario geografico-istorico-fisico del Regno di Napoli*, four vols. (Naples, 1795), lists the Kingdom's towns and their attributes in alphabetical order.

60 Cf. Rosa, 'Geografia', 68

61 Christopher Black, *Italian Confraternities in the Sixteenth Century* (Cambridge, 1989), 24.

62 Châtellier, *Europe*, 229.
63 'Prima Visita Pastorale di Mons. Salvatore Spinelli, 1792', A.C.A.L., *Sante visite*, no. 196, fol. 3r.
64 Liana Bertoldi Lenoci, 'Le confraternite pugliesi in età moderna', in Bertoldi Lenoci, *Confraternite pugliesi*, 109.
65 Carmela D'Errico, 'L'istituzione confraternale della città di Taranto (secc. XVI–XX)', in Bertoldi Lenoci, *Confraternite pugliesi*, 452.
66 Rosa, 'Geografia', 67.
67 Bertoldi Lenoci, 'Confraternite', 120.
68 Salvatore Palese, 'Le confraternite laicali delle diocesi di Ugento nell'epoca moderna', *Archivio storico pugliese*, XXVIII (1975), 166.
69 'Visitatio pastoralis habita pro universa dioecesi Uxentina a R.mo D.no D. Thoma De Rossi', 1741, Archivio Diocesano, Ugento, *Sante visite*, I. Cit. in Palese, 'Confraternite', 145.
70 Of confraternities dedicated to saints, St Joseph predominated (10 confraternities), followed by St Anthony of Padua (5) and St John the Baptist (4).
71 Black, *Confraternities*, 270.
72 Flynn, *Sacred Charity*, 17.
73 We know even less about confraternities for women in southern Italy, and which confraternities had mixed membership. Where women did belong, they were generally restricted to passive participation. The Jesuit Marian congregations were usually segregated, as we have seen.
74 'Contro il Capitolo della Cattedrale per aver disturbato la processione fatta dai Domenicani di M. SS.ma del Rosario', 1687, A.C.V.G., *Processi penali*, no. 1457.
75 'Regole...SS. Annonciatione', 212.
76 'Informatio contra Sacerdotem Andrea Nardelli', 20 November 1746, Latiano, A.D.O., *Processi criminali*.
77 'Contro il Rev.do Francesco Mega per scandali dati nella Confraternita delle Anime del Purgatorio', 1695, A.C.V.G., *Proc. pen.*, no. 2586.
78 'Regole...SS. Annonciatione', 232.
79 Angelo Torre,'Il consumo di devozioni: rituali e potere nelle campagne piemontesi nella prima metà del Settecento', *Quaderni storici*, XX (1985), 188.
80 Cf. the discussion in Black, *Italian Confraternities*, 68-78.
81 Bertoldi Lenoci, 'Confraternite', 115.
82 Verucci, 'Chiesa e società', 40.
83 Toscani, 'Il reclutamento del clero (seccli XVI–XIX)', *Storia d'Italia. Annali IX: La Chiesa e il potere politico dal Medioevo all'età contemporanea* (Turin, 1988), 614.
84 Rusconi, 'Predicatori', 1011.
85 Richard Trexler, 'Florentine religious experience: The sacred image', *Studies in the Renaissance*, XIX (1972), 34.

PART II *Ritual responses to malady and misfortune*

The priest:
ecclesiastical remedies and their variants

The focus of Part II will be on what might described as extra-liturgical, non-orthodox, spontaneous lay responses to malady and misfortune in a constant attempt to order daily life. In order to put such rituals into their proper context, we shall first explore those 'remedies' offered by the Catholic Church and which were also widely used in the Terra d'Otranto. These remedies – the sacramentals (*sacramentalia*) – often found their way into lay healing rituals, influencing the ways in which people atempted to tap the power of the sacred. This part of the book will thus examine how these various forms of healing (for that is when they were most used) interacted and overlapped, and why we can regard what the Church divided into orthodox and unorthodox, divine and demonic, as part of the same system of beliefs and practices.

Following the Council of Trent ecclesiastical alternatives were increasingly stressed as the only acceptable method of combating *maleficium* (in all its various manifestations) and possession. According to the seventeenth-century Theatine Tommaso Delbene, there were ten ecclesiastical remedies against demons and their works, which he listed in order of importance: faith, baptism, confession, the Eucharist, exorcism, holy water, relics, the sign of the cross, the names of Jesus and Mary, and prayer.[1] Delbene puts great trust in faith and the sacraments to keep the devil at bay, but this must have been small consolation to pious men and women who suddenly found themselves victims of a spell or even possession. And although the sacraments of baptism and the Eucharist occasionally figure in the records as means of countering such things, it is the sacramentals Delbene mentions which were generally relied upon. Where a ritual was believed to be at the cause of a malady, as in the case of sorcery, only a like ritual could combat it. This is the key to the importance of the sacramentals and why they have such a crucial role in the sacred system, both in their orthodox form and in their lay interpretations.

The classic exorcist manuals of the period, the Observant Minor Fra Girolamo Menghi's *Compendio dell'arte essorcistica* (1576) and *Flagellum daemonum* (1577), are even more specific on how negative supernatural

forces like sorcery and possession could be combated by these *remedia ecclesiae,* rendering the inquisitorial witch-hunt an almost superfluous solution to the problem.[2] Menghi (1529-1609) categorically condemned all healing techniques which worked by means of an expressed or tacit pact with the devil. All such activities and beliefs were defined as superstitious and illicit. So, if one were the victim of an evil spell (*maleficium*), it was not to be undone by counter-magic, for this was to attempt to counteract evil by evil means, but by the orthodox remedies available. According to Menghi, more than adequate protection from such acts was provided by

> the continuous invocation of saints, that is, reciting litanies; sprinkling oneself with holy water; taking exorcised salt through the mouth; carrying a blessed candle on one's person on Candlemas day; or a blessed palm or olive branch on Palm Sunday; by this licit practice man is greatly protected from these *maghe*.[3]

These ecclesiastical remedies are known as sacramentals, minor rites and benedictions, the efficacy of which was not automatic (like the sacraments) but depended on the situation and the officiating priest. Unlike the mostly personal, lay conjurations to be discussed in the next chapter, the 'sacramentals were closely linked to the church's liturgy, for the benedictions usually took place during, or in conjunction with, a liturgical situation of a more regular kind.'[4] They were related to or signs of the sacraments, but they derived their power or sanctifying grace not *ex opere operato* as did the sacraments, but *ex opere operanti,* through the action of the person using them. In terms of the sacred system, they were in many ways analogous to the popular healing rituals in providing a means of order and psychological security through access to sacred power. One of the official liturgical books of the Church, the *Rituale Romanum,* contained ceremonies not only for the blessing of water, palms, candles, church bells and images, but also those for the blessing of houses, crops, the marriage bed, as well as exorcisms against insects and storms.[5] These rites were ideally suited to an essentially agrarian society like early modern Terra d'Otranto. The Roman Ritual was originally commissioned by Pope Gregory XIII in 1575 and was officially promulgated by Paul V in 1614. Before that time many separate compilations for the use of clergy had been in circulation, resulting in a great variety of rituals, sometimes conflicting with one another in content.

Whereas the protagonist of the following chapter will be the *magara* or wise woman, this chapter will focus on the priest, as the person who administered the sacramentals. But it is also appropriate to deal with the laity, as those who made regular use – and sometimes misuse, as the

Church saw it – of the ecclesiastical remedies. We shall begin with the most spontaneous and accessible to the laity, forms of prayer.

FORMS OF PRAYER

The most obvious weapon against misfortune as far as the Church was concerned was prayer, and emphasis on prayer formed part of its attempt to reform and eliminate unorthodox practices. Thus the Brindisi synod of 1623 extolled the priests of the diocese to 'teach the faithful the worship of God, and to have recourse to Him, and the Blessed Virgin and all the saints, since they are intercessors between us and God, and to recite prayers and frequent the sacraments for all tribulations, infirmities and difficulties'.[6] Certainly, the effectiveness of prayers had never been put into question, for, as will be observed, they were a crucial part of many healing rituals, both in their orthodox form (recited in groups of three) and in the less orthodox form of *orazioni.* Indeed it was precisely the force attributed to the mere repetition of sacred words that led to abuses, such as those reported by Dorotea Rossi to the episcopal court of Oria in 1742. Among other women, she denounced Cicemaria Pugna of Taranto, who combined the power of prayer and the force of sacred space by reciting a Paternoster and an Ave Maria on each step of the church of San Nicola while descending them. At the bottom step Pugna would recite a certain *canzona* (Rossi did not reveal its contents) and, as she had told Rossi, 'the Saint with the two towers and a purse at his chest would come out, and you had to snatch it [the purse] quickly and run away'.[7] Interestingly enough, the saint in question (most likely St Nicholas of Bari, whose purse symbolised – rather ironically, in this case – his acts of charity) is not identified by name, indicating that the images and their symbols might not always have been enough in instructing the illiterate in matters of faith.

Of course, the Church sought to encourage prayer of a more orthodox nature. The use of prayer is mentioned hardly at all in the ecclesiastical trials, perhaps because it was such an obvious form of relief, and accusations were made only after much more ritualistic techniques had failed. Perhaps, too, victims never knew whether their prayers were being heard. In the case of Carmina de Tomaso of Oria the exception may prove the rule. This twenty-year-old lay nun was being tormented by a neighbour, Giustina Quaranta, who not only wanted to develop an intimate friendship with her (which de Tomaso at first refused), but asked her to accompany her on the witches' sabbath. At each further refusal de Tomaso's father was taken ill, and de Tomaso wondered whether she

should denounce Quaranta as a witch to the court. De Tomaso knelt before a paper image of the 'Venerable servant of God Sister Rosa Maria Serio', praying to her 'in the form of the said image'. Feeling helpless and confused, she beseeched her: 'I pray you to knock if I have to denounce the said Giustina so she'll be arrested; if not, don't knock for me.' In her denunciation she told the court that 'as many times as I prayed that, so did she knock [on the wall] with loud blows'.[8] Moreover, she also prayed that Quaranta would no longer come over to visit her; and, sure enough, the next day Quaranta told de Tomaso's sister that she would visit no more. But the effect was temporary and her threats resumed so de Tomaso finally resolved to denounce her.

We also know that not all people's prayers were considered to be of equal efficacy. Holy men and women (some future saints) were frequently asked to pray on behalf of a devotee, for they were presumed to have closer contacts with the sacred and could serve as mediators (see chapter 6). Wise women may have fulfilled the same function. The aforementioned Giustina Quaranta apparently had a reputation in this regard, for she was accused of having accepted payment in exchange for her prayers to various saints on behalf of her clients.

Another devotion encouraged by the Church which assumed its own popular configuration was the recitation of the rosary. Introduced and spread by the Dominicans, the practice was given a great boost by the victory of Lepanto, which occurred on the day traditionally dedicated to Our Lady of the Rosary (7 October 1571).[9] At first, devotional literature tended to emphasise the necessity for meditation on the mysteries of the rosary, but within fifty years it was being described as well-defined ritual, and the indulgences, confraternities, processions and masses associated with it were being stressed, as was the correct manner of reciting it. In 1627 a treatise written by a Dominican, Arcangelo Caraccia, attempted to bring about a wider diffusion and popularisation of the rosary by proposing a greater emphasis on its iconography, 'because they [the images] are the letters of the ignorant and uneducated who do not know how to read'.[10] As if in response to this, an image of Our Lady of the Rosary located in Guagnano (diocese of Brindisi) was being recognised as a source of miracles, and a legend circulated to explain its origins, no doubt with the encouragement of local Dominicans. In 1450, so the legend went, a bull went astray in the dense scrub outside the village, and when it was finally tracked down three days later it was found kneeling with a rosary clenched between its teeth. Unable to remove the rosary or free the bull, the cowherds cut away the brush and found an image of Our Lady of the Rosary painted on an old wall. The parish priest ordered the image

removed but, in a *topos* common to shrine legends, this proved impossible and so a chapel was built on the site. It soon became the focus of local pilgrimages and numerous miracles (involving mouth pains – suitably enough – and storms), and a small settlement grew up around it which eventually became part of the village.[11]

In actual practice, devotion and recitation of the rosary were tied to popular interpretations of sin, disease and death. In a way analogous to drawing from the powers of sacred words, the repetitive and formulaic prayers making up the rosary were found to be effective in ways not approved by the Church. One young woman of Oria recited a particular rosary 'for those executed by hanging'. Apparently, 'this rosary had to be recited with one's hands behind one's back, in the dark, and without turning around, since by turning around the person reciting it would see the hanged men's heads with their tongues hanging out'. The woman in question made the mistake of turning around and saw the hellish scene.[12] The rosary's material power vis-à-vis the sacred meant its occasional use in sorcery as well, as when Elisabetta Trippa of Latiano (diocese of Oria) accused a *magara* of giving her husband a certain rosary which had prevented them from consummating their marriage.[13]

Even more revealing is the fact that, like other devotional articles the keeping of which was encouraged by the Church, from palm branches and holy water to saints' images and relics, the rosary began to take on a material life of its own. In part, this was due to Dominicans like Caraccia, who claimed to have introduced the devotion of 'the blessed roses of the rosary' from Spain, using it against the devil's snares and in curing patients of malignant fevers.[14] From being a tool of meditation and prayer the rosary became a holy object in its own right, capable of miraculous feats, like the relics of saints. Rosaries were touched to the corporeal relics of saints, taking on the powers of the relics. The Jesuit missioners were believed to be possessed of such sacred power that the faithful touched their rosaries to them. When the body of Masaniello – the popular hero of the 1647 insurrection in Naples – was laid out in the Church of the Carmelites, masses of people came to touch their rosaries to his body and tear his hair out to keep as relics, as if he had been a saint. The people even claimed deathbed miracles: 'that he had opened his eyes, perspired, and that moving his hands, he had taken a rosary and held it tightly to himself'.[15]

Such behaviour was not limited to pseudo-saints in the city of Naples. When the founder of the Jesuit College in Lecce, Bernardino Realino, lay on his deathbed in 1616, a crowd assembled outside his room. Despite the posting of guards, according to another Jesuit present, 'the crowd broke

down the door of the College, and ran to the said father's room, where he lay dying. Everyone kissed his hands and feet; everyone touched him with their rosaries, as one would touch the relics of a saint'. The witness did not condemn this form of devotion when he testified at the initial canonisation inquiry in 1623. Far from it. He noted that its adherents were drawn from all classes, as was devotion to the deceased:

> What surprised me and made me believe that blessed God wanted the said priest to be so honoured and venerated, was that not only did simple and devout people assemble to perform these actions, but prelates too, as I have said, and almost all the city's doctors and physicians, who number perhaps sixty, Cathedral canons and ecclesiastics, teaching fathers and preachers of the Order of St Francis, the Carmelites, Observants and other Orders; and everyone kissed the hands and feet of the said ailing priest, touched him with their rosaries and tried to have something of his.[16]

Such devotion was perhaps the reverse side – or the logical extension – of the piety encouraged by the Confraternity of the Rosary, as described by its spiritual director, Calisto da Missanello, in his *Regola e constituzioni* of 1627. According to this, the Confraternity was to teach Christian doctrine to families as a way of supplementing catechistic instruction at the popular level. Moreover, and this was presumably its primary aim, it was to encourage evening or serotinous recitation of the rosary before an image of the Virgin, as part of familial devotion.[17] The Confraternity itself was exceedingly popular, as noted in chapter three, spreading to even the smallest of villages in the Terra d'Otranto. So much so that Pope Clement VII attempted to limit the proliferation of more than one in the same place.[18]

The Confraternity's efforts in encouraging the recitation of the rosary seem to have been effective, for the devotional practice even comes to light in the criminal trials – usually silent on matters such as devotion. In one case, Antonio Cocciolo, a shoemaker of Squinzano, was reciting the rosary one evening with members of his family – as was their custom, he says – when his youngest daughter came in and told him of a fight in the town. In a similar case in another town, the family of Antonio Rao decided it was better to continue reciting 'la corona della Beatissima Vergine' rather than take a glimpse at the fight taking place next door.[19]

The above remedies, prayer and the rosary, would most probably have been the first reaction to disease and misfortune, although it is difficult to be sure. It is also difficult to determine just how efficacious people considered prayer when used on its own as a means of problem-solving. Where a disease was considered the result of sorcery or the evil eye, the

result of human actors, and not due to natural or divine factors, then prayer could not successfully combat it: one's best bet was to seek out the actor involved. Prayer and *maleficium* operated on different wavelengths. The strength of prayer lay largely in its protective and preservative effects, akin perhaps to the wearing of an amulet. In this respect, it possessed a ritual apotropaic function similar to the action of crossing oneself. This latter action, so much a part of 'popular religion' today, was in fact widely encouraged by the Church as a form of protection against satanic forces. Rev. Giuseppe Bottaro, third dignity of the collegiate church of Francavilla, recounted that he crossed himself over the heart at the frightening sight of two of the town's wise women.[20] The Brindisi synod of 1623, which had recommended prayer, also declared:

> And because in this city and diocese the sorcery of the magical arts is so very widespread: we exhort by the Lord that all the subjects of our diocese, of both sexes, repeat the sign of the cross above every edible thing, especially at the beginning of meals, and for every other action, since the sign of the cross is rendered so very salubrious through the action of grace. They should also keep holy water at home, where it can be used devoutly for chasing away demons and all their tricks and agents.[21]

SACRAMENTAL OBJECTS

Most homes would have contained devotional images and other religious articles, such as the holy water suggested above. They were meant to protect the house and household from harm, deriving their power from interaction with the sacred. Images, whether in the form of cheap prints of saints (such as Sister Rosa Maria Serio) or statuettes, gave a direct link to the saints themselves. For this reason, women accused of satanic witchcraft were known to despise them. Giustina Quaranta, spotting a statuette of St Francis of Paola on a side-chair in Carmina de Tomaso's house, knocked it over, cursing 'this damned monk' (*monaco fottuto*). And when she saw several saints' images on the walls, she commented that they were 'like so many spies'.[22]

In another case, Caterina Patrimia admitted to being a witch (that is, going to the sabbath) but denied ever having practised sorcery. Five years later the promotor fiscal of the court came to her defence, arguing that her reputation as a witch had developed only after her incarceration. Furthermore, not only was she a pious woman, going to mass frequently and fulfilling her Easter obligation; but when her house was searched no witches' oil had been found, nor other objects of the craft. In fact, they found only articles of devotion: images of Christ and the saints, vials of

holy water, and a 'collage' of sacred relics. A true witch, who had made a pact with the devil, would not have been able to tolerate their presence.[23]

In the next chapter it will be seen how such holy articles were frequently employed in popular healing rituals; but equally effective cures could be obtained from one who had direct access to divine power – the priest. The Catholic Church regarded the sacramentals as important tools for healing the sick, and simple blessings, the reading of prayers and parts of the gospel over the patient and the dispensing of handwritten *brevi* were among the clergy's legitimate healing activities.[24] The *breve* was a slip of paper on which was written the names of the Trinity or words from the gospel and worn on the person as a means of protection. It could also take the form of an *agnus dei*, a wax medallion made from paschal candles (although the word is also used by the unlettered to mean a small pouch containing holy objects). Such 'devotions' were widely distributed to the faithful during the internal missions and by confraternity members visiting the hospitals and prisons, as we have seen. Even someone like Ludovico Antonio Muratori, professing a new religious sensibility, defended the use of religious medals, rosaries, *abitini*, *brevi*, *agnus dei* and images.[25] He was only critical when, because of ignorance or excess, otherwise praiseworthy devotions became reprehensible and superstitious. Noteworthy is his use of the term 'superstitious': not in the sense of something which gains its power or efficacy through the devil, but in the sense of an exaggerated or misdirected piety.

Because of the reputed sacred power of these sacramental objects they were often used and applied by the laity in ways not approved of by the ecclesiastical authorities; though, as we shall see, the clergy often reacted with a sort of grudging tolerance, that is, when they were not themselves guilty of the same offences. Ecclesiastical theory and practice tended to diverge, as the local clergy faced the pressures of their parishioners. Officially, at least, the Church was adamantly opposed to non-approved uses of blessed objects, as the following two examples from the diocese of Ugento show. In 1645 a diocesan synod condemned the misuse of blessed oil, water and salt, as well as the use of altar cloths and images in the healing of the sick. Apparently, an image was placed under the patient's head, while the cloth was used to wipe off perspiration. It was the fact that the objects were taken from the altar which made the actions reprehensible. Seventy-five years later priests were warned not to use the linen cloth outside the baptism rite, suggesting that ritual articles be kept in church at all times and destroyed if they had been employed for 'superstitious' purposes.[26] The fact that the warnings were issued against ecclesiastics suggests the sort of problems Church reformers were up against.

ECCLESIASTICS AND HEALING

A common sacramental permitted to the clergy was the sign of the cross made by the priest over the patient and the gospel reading (referred to as 'segnare' and 'leggere/cantare il vangelo sopra').When Vittoria de Arrico's newborn son took ill and was unable to suckle following a dispute she had with the midwife, she first took him to the archpriest of the village who chanted the gospels over the sick infant. According to de Arrico's testimony, when he reached the part of the ritual where he said 'Giuseppe Pascale, suck your mother's milk', the infant did. None the less, the archpriest identified both parents as having been bewitched.[27] In another deposition, Colonna Calò told the court that her orphaned nephew had been bewitched by the same *magara*, Antonella Seppi, and was ill as a result. The archpriest diagnosed the boy's condition and read the gospels over him, 'and in this way he was cured and freed from the said spell'.[28]

This trial against Antonella Seppi, to which we shall turn again in the next chapter, is very revealing in the way it combines recourse to both wise women and ecclesiastics, in order to treat maladies of a presumed maleficial origin. The clerical 'healers' of the village were its archpriest and a Capuchin friar, Fra Gregorio Lupo. It was the latter who treated Isabella di Nitto with a series of 'blessings, holy baths and readings'; and when he had to return to his monastery, the archpriest had taken over and continued the treatment. And it was Lupo who recognised the impotence of Laura de Lorenzo's son-in-law as being the result of *maleficium* and chanted gospels over the unfortunate couple several times, without success. They refused to go to Seppi for a cure, considering it sinful (though not denying that it might have proved effective).[29] However, the groom's mother had no such qualms, and went to Seppi for a *breve,* which also proved ineffective: in which case recourse to the ecclesiastical court was a last resort, almost an ultimate remedy.[30]

The *breve* was used by both priest and wise woman, showing us once again how the worlds of 'popular' and 'orthodox', 'lay' and 'clerical', keep overlapping, the boundaries between them blurring. Indeed in Friuli one woman's *brevi* and spells were so successful that she was given permission to practise by a local priest, after she had cured his fever. It was said 'that people went to her with as much devotion as if they were going to a priest's house to get a name of Jesus [a particular *breve*] for fever.'[31]

There was great pressure on ecclesiastics to heal, given their access to the tools of their trade, so to speak, which the faithful considered to be of special efficacy. Although the rituals could be utilised and imitated by the laity as well, they were most effective in the hands of ecclesiastics, whose

status defined them as certified mediators between the sacred and the profane. It must also be said that, like the other 'healers' in the sacred system, the priest was also an ambivalent being who could bring bad luck simply by passing by, an eventuality that was countered by conjurations.[32] For their part, people went to these 'clerical healers' with the same expectations as when they confronted the local *magara*, 'creating pressures that these men were often ill-equipped to resist', according to one scholar.[33] The response of such clerics often went beyond what the Church considered acceptable. For instance, after repeated requests the Capuchin Don Matteo of Francavilla agreed to have a cunning woman proceed with the treatment of a sick girl, even though she made use of salt, blessed incense and palm branches in the 'fumigation': a misuse of blessed articles.[34]

Not always victims, clerics occasionally took advantage of their role as mediators for the sacred. One woman of Francavilla told the court of a Dominican priest and confessor who lived nearby, whom she asked to come over to rid her of the possession causing her illness. Pretending to heal her, he proceeded to touch her face, breasts and hands, before admitting a fondness for her and asking her to sleep with him. She also complained that he tormented her in the confessional with magical solutions to her problems.[35] But abusing the trust placed in them does not necessarily imply disbelief in such remedies. Indeed as we shall see, ecclesiastics – to varying degrees – often shared the beliefs of their parishioners, accentuating their involvement in the treatment of disease, occasionally using methods which differed not a whit from those of the wise woman.

When the archpriest of Francavilla was asked about the condition of the faith in the town by Bishop Kalefati in 1783, he responded:

> In this town the foolish credulity in demoniacal effects and in the superstitions to undo these effects prevails quite strongly. That the ignorant people believe in them is not surprising, but that a few ecclesiastics, and especially monks, encourage these false beliefs and superstitions – whether out of ignorance or out of malice – is displeasing to all good people.[36]

One of those interrogated by the bishop was Don Pietro de Laurentiis, infamous for his heavy drinking and healing activities, which included the recitation of the *orazione di Sant'Onofrio* over children infected with worms 'and other similar things'. He was repentant, telling Bishop Kalefati that 'because my Superior solemnly prohibited me from saying them, I promise God and Your Most Illustrious and Reverend Lordship to say them no more, and to warn the other priests from whom I heard them

never to say them, leaving to the Church the power to pray according to the Ritual, and nothing more.'[37] His comments suggest a widespread demand for the clerical practice of such activities. Thirty years earlier, two *chierici* of the town had even been denounced by the archpriest to the episcopal court for the same offence. The archpriest – calling them 'loose youths' (*giovani rilasciati*) – noted that they had admitted to saying the *orazione* on many occasions and would do so 'whenever called'.[38]

A further example of an ecclesiastic making use of unorthodox remedies – worth citing because of its detail – is that of Don Giuseppe Memmo of the village of Guagnano (in the archdiocese of Brindisi). He was examined by Archbishop Bovio during his 1565 visitation, and was found to read poorly, know no Latin and be without ordination papers. He recited a *carme* before the bishop which, when accompanied by a mass and a Paternoster and Ave Maria, cured the blisters which formed on cows' tongues:

> Jesus al nome de la Vergine Maria
> et del figlio santissimo
> in mezzo mare stava,
> con lagrime piangeva,
> de la fagarina alla lingua havea,
> et santo Joanne ad esso queste parole dicea:
> Priego te, Dio padre, et lo figliolo
> co' la sua madre Vergine Maria,
> et io lo voglio pregare
> al nome de la gloriosa Vergine Maria,
> che a quello N. la fagarina sana sia,
> al nome della Vergine Maria.[39]

The bishop decided to remove him 'from the ministry of the altar, for which he is not suited, because of his use of incantations'. As we shall see, his ignorance was not atypical, but this alone does not account for clerical participation in popular healing rituals.

What were the particular conditions of ecclesiastics in early modern Terra d'Otranto that made them share the *mentalité* of their parishioners? In 1727, for instance, Don Antonio Muscoggiuri was convinced by three of his parishioners that a certain Francesco Morleo had bewitched his mother and made use of a 'superstitious bill, so that he [Morleo] would have luck and favour' (*grazia e benevolenza*). The three warned Muscoggiuri to be careful and not think that he was 'protected by his habit'. Out of fear, Muscoggiuri denounced Morleo, making no use of the ecclesiastical remedies at his disposal.[40] The irony here is that Morleo *was* in a sense protected by his habit. Had he been more in tune with the

Catholic orthodoxy of the day he might have shrugged off the suggestions of his three parishioners as 'superstitious', while perhaps taking the precaution of performing a blessing or reading a passage from the gospels over his ailing mother. Failing this, he could have called in an exorcist, who dealt in maleficial conditions. What made him act as he did?

THE LOCAL CLERGY

The key to understanding the world-view of the clergy lies in an exploration of its conditions, social and economic as well as religious, in the wake of the Council of Trent. The Tridentine reforms were especially slow to affect the Otrantine clergy, due to the collegiate structure of the clergy, the general absence of seminaries, isolation, poverty, occasional non-residence of the bishop, and poor relations with the religious orders and confraternities, as we observed in chapter 2. In analysing this structure, Gabriele De Rosa speaks of two levels of Church hierarchy: the 'magico-sensitive church' of the local clergy and the 'Tridentine church' of the upper levels of the hierarchy; one immersed in a realm of magico-religious syncretism, the other formed on the model of reforming bishops like Carlo Borromeo.[41] The clergy of the *chiesa ricettizia* – because of its close-knit structure and connection with the land on which it depended for survival (often worrying more about the outcome of the harvest than the care of souls), frequently dwelling in precarious conditions – belonged to the former group, differing little from the peasants farming the adjacent land. Indeed, they were so much a part of the sentiments and passions of their communities that it is not surprising to see them participating in Carnival masquerades, going hunting, playing cards and dancing (and so on) alongside laymen. This is certainly the impression one receives from reading the pastoral visitations, especially the earlier ones describing the problems for the first time, as well as the ecclesiastical criminal trials. Not only are offences like keeping concubines, carrying guns, card-playing and drinking and brawling in taverns quite common, but many clerics were also found guilty of rape and murder. Although such crimes as the latter were surely not typical, they do represent the possible extremes of clerical behaviour. Their sins and crimes did not differ much in quality and quantity from those of the laity they served, principally because their way of life was so little different.[42]

But the denunciation of clerical shortcomings portrayed in the visitations and criminal trials must be seen in a wider context, for it is tempting to dwell on the clergy's 'backwardness' at the price of attempting to understand them and the society of which they were a crucial part. Of

course there were differences in social origin and differing levels of educa-
tion, but it would be misleading to establish too rigid a dichotomy
between the 'magico-sensitive' nature of the collegiate clergy and the
orthodox religion of the Church hierarchy. It is an oversimplification to
conclude that 'shepherds, peasants, sailors, priests and monks, lay nuns
and "enlightened sisters", act in the dimensions of a reality that is com-
pletely outside the rational, totally immersed, we could say, in a magico-
sensitive world resistant to time.'[43] First of all, it has been my contention
all along that local belief *was* rational, in that it was pragmatic: people
chose from the myriad of remedies available the one (or ones) with the best
track record for their particular malady or misfortune. Secondly, it is
perhaps more helpful and revealing to see the priest as a mediator between
the two different but interconnected cultures of orality and literacy,
whatever his position on the spectrum, as well as between sacred and
profane. This involved him in the struggle between local culture, of which
he was a part, and an orthodox hegemonic culture to which he owed
allegiance.

 The parish priest in particular had the function of mediating between
the parish and the outside world. Because of his pivotal role in the
community – his literacy and ritual importance – he was a some-time
doctor, notary, healer and even protestor.[44] We occasionally see clerics
representing or leading the community in protests against tithes or taxes
(somewhat ironically, perhaps, given the clergy's many exemptions).[45] In
other ways, the local priest, whether belonging to a parish or a collegiate
chapter, even if not a practitioner of popular or lay healing techniques, had
to deal somehow with the wishes, expectations and practices of his flock.
His role in the community was complicated by the Church's emphasis on
the efficacy of ecclesiastical remedies, so that he was at one time – it would
not be too far-fetched to say – a minister of God and a sorcerer-healer. As
we have seen, the sick approached him for cures, turning his mission of
pastoral care into one of much greater complexity. This was particularly
difficult where the local clergy viewed reform of its variegated activity as
something imposed on it from above or outside. And so the Church
hierarchy satisfied itself with attempting to limit clerical vice (from
concubinage to card-playing) and modify the lifestyle and habits of priests
rather than eradicate doctrinal ignorance and confusion, practically the
norm. The result – but only several hundred years after Trent (and after
the period covered by this book) – was that the priest was turned into what
Luciano Allegra calls a 'religious functionary', possessed of a rudimentary
doctrinal knowlege and distanced somewhat from the socio-religious
order of his flock.[46]

From the evidence that has survived in the ecclesiastical trials it is difficult to surmise in what particular instances the patient would be taken to an ecclesiastic either instead of or in addition to a cunning woman. In many cases it was a question of the availability and proximity of the diverse healers. Where both wise woman and ecclesiastic were consulted, one notices a trend towards first consulting a priest or friar, who identify the maleficial source and then give appropriate ecclesiastical treatment. The wise woman, usually the caster of the spell in the first place, was then consulted if the patient's condition did not improve. The trial records only detail cases where the patient/victim's condition remained grave, otherwise there would have been no need to resort to a denunciation before the court. If nothing else, the Church's message warning that only ecclesiastics were equipped to identify *maleficium* seems to have become gradually accepted. Most people apparently preferred the security of a gospel reading or blessing to confronting the unreliable *magara*, who was increasingly associated with the evils of diabolical witchcraft and the snares of the devil, the subject of chapter 8. It is tempting to come to another conclusion: that those who sought the help of a priest might also make greater use of other ecclesiastical remedies – such as prayer and pilgrimage – than those who only (or also) went to a wise woman. Although several people did think it sinful to seek a wise woman's cure, it would seem that most would attempt whatever methods of treatment were at their disposal and had proved effective in the past, orthodox or unorthodox. What may have changed as a result of the increasing clerical intervention in and christianisation of healing was the order in which people chose from this pool of available remedies.

EXORCISM

One ecclesiastical remedy that has been mentioned, but not sufficiently explored, is the rather more specialised field of exorcism, potentially the most ominous of rituals. In the Terra d'Otranto we frequently encounter the exorcist in his role of healer rather than as a caster-out of demons. Here he was in direct competition not only with practitioners of popular healing rituals, but also with those who performed what we might call extra-canonical exorcisms. This latter group was composed of both ecclesiastics and laymen (and they seem to have always been men). Because the procedure – as outlined by the exorcist Girolamo Menghi, among others – was extremely vague, it was difficult to draw the line between official and unofficial exorcists, at least in terms of the ritual performed.[47]

One such exorcism to protect the crops, which could be adapted to suit the circumstances, was given by Menghi in one of his manuals. At the head of the procession, the exorcist would intone:

I exorcise you pestiferous worms, mice, birds, as well as locusts and other animals. Through God the omnipotent Father and Jesus Christ his son and the Holy Spirit from both proceeding, that you immediately depart from these fields, vineyards and waters, and no longer dwell in them, but pass into those regions where you can harm no one; and by reason of the omnipotent God and the entire heavenly host and holy church of God, damning you wherever your curses may be found, that you may be wanting from day to day and waste away, because it is thought worthy to prove that none of your remains are found opportunely, unless necessary to human health and use, whereby it is good fortune to judge the living and the dead and the times by fire.[48]

In an even more elaborate form of exorcism, invading locusts or rodents could be put on trial. Such was the case in Segovia, Spain, in 1650. At the city's Hieronymite monastery it was decided – after consultation with local saints, played by villagers, and various St Gregories, acting as the prosecution – that the locusts would automatically fall under excommunication if they did not leave the territory immediately.[49] Harvest failure meant famine for everyone, town and country-dweller alike, so such tragedies were recorded alongside the most important political and religious events. In his chronicle, Antonello Coniger noted for the year 1504: 'The death of Pope Alexander. The creation of Pope Julius. In this year caterpillars came to Terra d'Otranto.'[50]

Other disasters like hail and rain storms could be equally menacing, especially in late summer, so Menghi also provided a similar sort of exorcism against storms. Like popular *scongiuri* (conjurations), it attempted to influence the sacred (and allay the storm) by reference to and invocation of certain sacred symbols, concluding: 'I pledge that you, hail and wind, by the five wounds of Christ, by the three nails that pierced his hands and feet, fall dispersed into the water. In the name of the Father, the Son and the Holy Spirit. Amen.'[51] There were popular conjurations against storms too, such as the one which beseeched St John to wake up and take the storm to a dark cave where it could rage without causing harm to anyone.[52]

Menghi was the exorcist *par excellence* of the latter half of the sixteenth century, writing his manuals from the experience gained practising in Venice, Bologna and Lombardy. Such was his fame that by 1600 roughly nine out of ten monasteries and individual ecclesiastics possessing exorcist manuals had at least one of Menghi's books, according to a study of 768 libraries conducted by Giovanni Romeo.[53] Curiously, Menghi's books

were rarely found alongside inquisitorial witchcraft manuals. This suggests that his readers (or users) were probably more interested in the practical element of his works than the theoretical, which identified the exorcism as a means of countering the perceived spread of diabolical witchcraft. The manual most often cited in episcopal trials involving an exorcist in some way is apparently his *Flagellum daemonum* (1577), where it is often mentioned in order to support claims regarding an exorcist's orthodox practice of the art.

Owing to the demand for healing by exorcism (its 'low' form, for domestic consumption),[54] there was a great temptation for ordinary priests to practise exorcisms. Here the exorcism was often used in conjunction with other treatments. A Lecce decree of 1640 stated: 'No one, whatever his appointed status, even if he is a Regular priest, dare to exorcise those possessed by evil spirits, or those suffering from some disease, nor themselves administer remedies or other concoctions to them, under penalty to be decided by us.'[55] The decree refers to the practice of these priest-cum-healers to administer 'medicinal' treatments – made of herbs such as St John's wort (known as 'devil-chaser' or *caccia diavoli*), rue or hellebore – along with their exorcisms as part of a general *purgatio.* In 1614 Florian Canale denounced the risky abuse of some clerics who, 'undertaking the treatment of a possessed person, would purge him, without any advice from doctors, with highly potent medicaments which induce vomiting and do great violence to the stomach... I have seen some depart this life through the rashness of others'.[56]

Worried as the Church may have been about the physical danger to patients through such treatments, its primary concern was that too much reliance would be put on false medicines rather than on the canonical exorcism, giving Satan the upper hand. For this reason synodal decrees of the province frequently stressed that exorcisms had to be performed only according to the Roman Ritual by exorcists approved and licensed by the bishop. All archpriests had to possess a copy of Menghi's *Flagellum daemonum,* and make certain that any exorcism was well regulated. 'By no means are exorcisms to be performed in the houses of laymen, nor in a profane place', warned the Brindisi synod of 1623,'but in the Church in the presence of other respectable men, and not in the presence of a great crowd of people'.[57] Particularly in the case of a possessed woman, the exorcist was not to touch her 'or do anything dishonest'.[58]

The proliferation of extra-canonical exorcisms was of serious concern for the Church, since the effects of the devil were not to be taken lightly. The Church authorities had to be certain that the practising exorcist was expert and 'of good and healthy morals, so that under the pretext of

chasing demons from the body, they do not root themselves there even more'. In his 1749 apologia for his pastoral edicts, the bishop of Oria, explained that it was of the greatest importance 'to know which exorcisms are being used, since certain manuscript exorcisms, not approved by the Church, and outside of the Roman Ritual, are circulating, which are usually suspect and not as efficacious as those ordained by the authority and command of the Church'.[59] The bishop was referring to the many versions of Church ritual guides which continued to circulate even after the promulgation of the Roman Ritual. It is interesting that they are referred to as being in manuscript form, like the illicit works of learned magic we shall discuss in chapter 7.

The demand for exorcisms continued unabated, a demand which the local clergy was often unable or unwilling to resist. Because of Church control, the number of trained licensed exorcists was limited to the larger towns of the province, as the ecclesiastical trials make clear. As a result, ordinary clerics frequently succumbed to pressures to heal or actively took the situation into hand. Their reaction was to see the devil's work in every malady. Cesare Carena, consultor and fiscal of the Roman Inquisition, warned that there were even licensed exorcists 'who judge every infirmity to be *maleficium*, whether because of little experience or to make business from it; and sometimes if the patients are not bewitched they bewitch them, by feeding their melancholic humour and by other illicit means, and cause terrible displeasing effects and scandals'.[60] Almost one hundred years after Carena, Ludovico Antonio Muratori, convinced that spells were 'mere fables' or else 'natural effects', noted the same all-too-common problem.[61] Once the patient was convinced that the devil was behind the disease, only an exorcism could bring about a cure. Certain exorcists, like certain healers and certain saints, acquired reputations which spread through the region because of their ability to undo sorcery and heal disease.[62] Unfortunately, there is relatively little documentation on the activity of exorcists, extra-canonical and otherwise, in the Terra d'Otranto. The following trial before the episcopal court of Gallipoli is one of the few.

In 1620 the infant Vasco d'Acugna, son of Don Giuseppe and Donna Elisabetta d'Acugna (Italianised version of the Iberian surname de Acuña) of Gallipoli, died, apparently victim of a spell meant to kill him and his mother.[63] The source of the magic, a charm consisting of a wax figurine pierced with a wooden splinter, tied with a knotted silk ribbon and wrapped in paper, was found by two children under a door while they were playing. When one of them, nine-year-old Paduano Tundo, called his mother (a household servant) over to look at what he had found, she

screamed and began 'shaking all over because of her great fear', saying that it was 'a *magaria* and an evil thing'.[64] Donna Elisabetta, having guessed the source of the charm, soon got into quite a state and feared for her life. She had much to fear, for the supposed culprits, Oratio Millone of Gallipoli and a notary-friend of his from San Pietro in Galatina, had apparently caused much trouble with their sorcery, including the death of a young girl. Since he was a local potentate, d'Acugna sent some of his men to capture the two suspects, but they only succeeded in finding Millone's servant. When the latter admitted to a knowledge of the crime, he was brought back to d'Acugna, questioned, and then placed in the castle gaol, while the guards went to look for Millone.

Meanwhile, the ailing Donna Elisabetta was visited by the Franciscan and exorcist Fra Pacifico da Lecce, who had come from Nardò when sent for. Since he arrived late at night, he made her 'a *breve* out of blessed paper, blessed rue, blessed wax and exorcised salt' to protect her until morning. He told the court that he did this 'according to those words that are written in the *flagello*', referring to Menghi's *Flagellum daemonum*.[65] The next day he administered two exorcisms, one in the morning and one at night, causing her to shake all over. Then the following day he was shown the charm and performed an exorcism lasting a gruelling three hours, during which time Donna Elisabetta 'screamed and writhed all over, and threw herself from her chair, not being able to stand it'.[66] The following morning Fra Pacifico, identifying the spell as the cause of her illness (and her son's death), asked Bishop Vincenzo Capece for permission to burn it, according to the accepted procedure. Then, once he had received 'said permission by way of a decree, and in the presence of many men and women, I performed the exorcism over the *fattura*, blessed it briefly, and burnt it, as is shown in the *flagellum daemonorum* [sic] on folio 150'. The day after, Donna Elisabetta, feeling better, went to mass and confession, and Fra Pacifico blessed members of the household.[67]

The trial is notable in several respects. It reveals the episcopacy's interest in ensuring that exorcists practised only the accepted canonical ritual. We also feel something of Donna Elisabetta's desperate urgency to obtain treatment, treatment that no doctor could give. Because of her status in Gallipoli an exorcist was able to come almost immediately, guaranteeing an orthodox cure. But what of those less highly placed in society?

Another case – this one held before the Oria court some sixty years later – can help shed some light in this regard. Angelo Nardello, a fifty-five-year-old farm labourer from Latiano, told the court that his wife Lucretia had suffered severe head, ear and tooth aches for the preceding five months which had kept her bedridden.[68] A friend of his then told him that

Antonio Pulli ('who is known as a *magaro*') had diagnosed his wife, who was suffering from similar symptoms, as possessed by evil spirits. That June Nardello visited Pulli about it, and Pulli came over to the house to visit Lucretia. He lit two candles, over which he sprinkled some salt (the influence of the canonical exorcism is obvious). When Pulli put out the candles and threw salt into the garden Lucretia's pain let up briefly. He concluded that she was indeed possessed (*spiritata*) and asked for twenty days to cure her by preventing the evil spirits from tormenting her. Later, after Pulli had made the sign of the cross and whispered some words (but which?), he and Nardello proceeded to look for the charm, which the latter eventually found in a doorway (the standard location). When Pulli threw it into the fire Lucretia found temporary relief, but Pulli said he would need a few more days to 'reach an agreement with the devils' and cure her. In canonical exorcisms such bargaining was expressly forbidden because of the risk and danger.

When nothing happened Nardello and his wife attempted a pilgrimage (see below) in the hope of a cure, but Lucretia's great pain made a quick return necessary. Nardello then told Pulli that he was taking his wife to a Capuchin friar in Francavilla, Fra Domenico, for an exorcism. Pulli accompanied them, warning them that the devils would not obey the friar (they were, after all, in competition). According to Nardello's denunciation, Fra Domenico held a reliquary over Lucretia while he read the exorcism from a book, but did not recognise anything evil in her condition. Returning home to Latiano, Nardello beseeched Pulli to come over. This time Pulli arrived with a bag, out of which he took a card in the form of a spinning wheel with white and turquoise threads attached (borrowed from learned magic?). He placed it first over Lucretia's chest, then under the bed, but neither position gave her any relief.

So, on 11 July the couple again sought the help of Fra Domenico, not an easy journey given Lucretia's declining condition. They told him all that had happened and Fra Domenico concluded that Pulli was in fact responsible for putting a spell on Lucretia. But, performing another exorcism, he then told Nardello that 'the said wife wasn't so much possessed by demons as suffering from frenzy [*male arrabbiato*]'. At this point Nardello, in desperation, took the charm (but had it not been burned?) to his son, Don Niccolò, a member of the collegiate church of Francavilla, who in turn brought it to the bishop's attention. Concluding the denunciation, Nardello informed the court that he went monthly to confession and communion and was not charging Pulli out of ill will, but because he was a known *magaro* in Latiano. We can sense his helplessness. Despite the various cures attempted for his wife's supposedly maleficial ailment, in-

cluding going repeatedly to the man he now condemned, she was still unwell.

Similar to Pulli's situation may have been the career of the layman Giovan Giacomo Marsicano of Naples, who in 1574, after numerous attempts, successfully exorcised members of his family after several priests and monks had failed. He had picked up the techniques by observing the clerics and, encouraged by his success, decided to expand his activities. His fame soon spread beyond the city walls. Shortly afterwards he appeared before the city's archbishop, Mario Carafa, although whether voluntarily or following a denunciation it is impossible to say, though the latter seems more likely. He was instructed to leave exorcisms to licensed 'priests and monks', but continued performing them none the less, because of 'such pestering by the people who came to my house'.[69] Experience led him to attribute diabolical possession to going to church too often, and he suggested that reciting the rosary in front of an icon or recounting two or three sins to the confessor was enough.[70] It was this heresy against the sacramental powers of the Church that resulted in his downfall, and despite being defended as a pious member of the Rosary confraternity, he was found guilty. The sentence was limited to payment of bail and absolute prohibition against performing exorcisms. Yet, like licensed canonical exorcists, Marsicano was only responding to the need in society for sources of healing.

A CASE OF OBSESSION

Although there are several examples of exorcisms for possession in the Terra d'Otranto, there was nothing like the hysteria of early modern France, which culminated in a series of show trials of possessed women utilised in the propaganda war against the Protestants.[71] In the Terra d'Otranto diabolical incursions tended to take the form of obsession, the hostile action of devils or evil spirits from without. In modern social scientific parlance obsession has been described as a 'persistent or recurrent fantasy, thought or judgment' symptomatic of neuroses often resulting from 'a constant repression of feelings or activities that are considered unacceptable, harmful or morally wrong'.[72] The type of obsession was often related to the particular repressed emotion, frequently the sexual instinct or a need for self-assertion – or a combination of both – at an unconscious level. In 1938 Joseph de Tonquédec, exorcist for the diocese of Paris, asked why people of religious conviction, perhaps caught in sexual conflicts they regarded as sinful, felt themselves at the mercy of evil, even to the point of believing that they had given themselves up to the devil and

'called him up from the abyss'. His conclusion was that such promptings came from within.[73]

Such an explanation would seem to fit the experiences of Maria Salinaro, a lay Carmelite nun, in her early twenties at the time of her first appearance before the episcopal court of Oria in 1727. Having led a 'chaste and spiritual life' up until the feast of Corpus Domini, 1725, that morning she had felt a 'temptation of the flesh'. She talked about it to her superior, who counselled confession and communion. Following this, Salinaro attended the procession, when she was troubled by 'a great noise' in her ears that prevented her from hearing the sermon and 'a mist' in her eyes preventing her from seeing the Host. If there were any doubt as to the origin of these effects, she next heard a voice inside her which said, 'Worship me, and not God, for there will be no mercy for you' (no doubt an indication of her repressed guilt). Recognising the devil's voice, she beseeched God's help, but the noise and 'suggestion' continued through-out the day. And that night, while she was in bed, the devil appeared to her as a tall man dressed in black and forced a pact on her: like a witch, she was promised her every wish, in exchange for renouncing the faith, God and the Virgin. The pact was followed by intercourse with the devil, an occurrence that continued three nights a week for the next twenty months. Influenced by ideas of diabolical witchcraft, and the attention the court paid to women suspected of it, she claimed to have been taken by her devil to the witches' sabbath, although she did not participate. She was greatly troubled. Neighbouring women told her that only 'bad fortune would come of it', and her spiritual adviser gave her 'excellent guidance and warnings... None the less that evening when I went to bed I would allow myself to be overcome by temptation and return to the usual things with the devil'. Salinaro was conscious enough of what people thought of her during the period of her obsession to go to confession on the vigil of the Immaculate Conception so that her absence would 'not give cause for talk'. Her later attempts 'to return to God' were accompanied by constant threats from the devil, and he told her that if she went to the Holy Office about her problem he would destroy her father's house and injure her. This threat was repeated on the morning of her voluntary appearance before the court; but having finally overcome him – we are not told how – she replied, 'You don't scare me, ugly beast. God created me and I belong to God and God will save me and have pity on my soul'.[74]

As I.M. Lewis observed, it is 'through succumbing to these seemingly wanton visitations that people in lowly circumstances secure a measure of help and succour'.[75] We might add that this was also true of people like Salinaro, suffering from repression, temptation and guilt, all working off

one another. Complaints such as obsession, therefore, often tended to become habit-forming, and we know that Salinaro appeared before the court in 1738 (mentioning a non-extant 1733 appearance as well) and again in 1741, on both occasions of her own volition. Perhaps she was seeking some form of attention and guidance from society against the crises she repeatedly underwent. The emphasis in her 1738 confession was on sinful sexual relations, not only with the devil, but with two priests as well, one of whom even caused her to become pregnant (although the devil, she said, brought about an abortion).[76] In his book, Lewis also notes that in societies where evil spirits are not the major deity, and play a lesser and destructive role, they tend to seek out the desperate and downtrodden.[77] Sure enough, after being absolved by the court and resisting the devil for several years, Salinaro – already in a precarious state – was mistreated by her brother one day and 'I gave myself to despair' (as she later told the court), at which point she was visited by her devil.[78] She was convinced to resume relations with him and so began a career as a witch, at which point we take our leave of her (to meet her again when we discuss witchcraft).

Although Salinaro's confession did not involve exorcism, because in obsession the evil spirits acted from without, it is clear that she sought the only ecclesiastical remedy available to her when she called the attention of the episcopal court to her plight (an 'ecclesiastical medicine' not mentioned by Menghi!). Although we do not know whether she tried more personal remedies like prayer or pilgrimage, her recourse to the episcopal tribunal is interesting since the court was a male domain, like exorcism (in both its orthodox and extra-canonical forms). On the other hand, healing was part of the female sphere, since the relationship with the body – vis-à-vis disease and reproduction – formed part of what were considered feminine powers and responsibilities. The exorcist dealt with bodies which had been affected by disease at the behest of supernatural forces, that is to say, demons. The efficacy of his techniques depended primarily on their ritual content: the sacred doing battle against the sacred. On the other hand, those of the *magara* almost always combined a quasi-medicinal remedy given healing virtues by a set ritual. While retaining the masculine–feminine distinction, it is useful to keep in mind certain features they shared. Because exorcism was not a sacrament, its efficacity did depend to a certain degree on such things as the moral qualities of the individual exorcists to overcome demons. That is why some exorcists could establish reputations and followings. Likewise, some healers were believed to be more effective than others. Moreover, exorcism, as we have seen, was frequently used as another form of disease treatment rather than specifically to expel demons.

As we have previously had occasion to remark, there was a fine line between ecclesiastically acceptable and unacceptable expressions of and forms of recourse to the sacred. What some bishops sought to eradicate, others accepted or tolerated. The same is true with regard to possession by evil spirits. The missioners active in the Kingdom of Naples, like those of the Congregation of the Apostolic Missions, were wont to tabulate the number of exorcisms performed as an indication of their success. The Lazarists, on the other hand, tended to regard the phenomenon as a 'popular error', using a sort of placebo effect to catch those they referred to as *finti spiritati* (falsely possessed). The presumed victims of possession were led

> to a place apart and in the presence of several people standing, and a piece of coal in a little silk purse was applied to their forehead, as if it were a relic, and they were told to have faith in order to be liberated, and we had some relations of theirs give them slaps, until they stated that they were liberated. Then, leading them into the presence of the *galantuomnini*, they were shown the false relic, and they were very severely reproved for the sham, exaggerating the scandal. They were not absolved if they did not first publicly ask for forgiveness from the people.[79]

Other forms of ritualised petition to the sacred were procession and pilgrimage. Both forms of devotion have been saved for last because they involve a strange and often tense combination of lay and clerical participation, as we shall see, and a level of group or community involvement not shared by the other remedies discussed so far.

PROCESSIONS

Petitional and penitential processions, although involving both clergy and laity, were often undertaken at the behest of the latter group as a response to natural disasters like plague, drought, hailstorms, insects, rodents and so on. They entailed the carrying of miraculous images (and occasionally relics), while those processing performed various acts of penance: walking barefoot, scourging themselves with whips, carrying heavy crosses, wearing crowns of thorns. There was also the occasional celebratory procession. In the year 1656, a time of catastrophic plague and penitential processions in Naples, a cavalcade of noblemen processed through the city of Lecce, followed by high mass – with six choirs – in the cathedral, to celebrate the intercession of St Oronzo (Orontius), who had spared the province from the plague.[80] The threat of the plague devastating the rest of the Kingdom was a time of great anxiety and tension in the Terra d'Otranto, and

occasioned many visions, according to the city's chronicler, Giuseppe Cino.

> From the city of Ostuni and throughout the entire province our saint was being seen, as in fact many saw him, with his pontifical habits, blessing and chasing the contagion away. Moreover, something that I myself witnessed *de audito*: above the walls and in the air an angelic melody was heard every night, so that we all rushed out of our houses to hear the voices, but we saw nothing other than the bright and starry sky, so, on our knees, we all venerated and prayed the saint to defend and liberate us.[81]

Devotion to this martyred bishop and patron saint of Lecce was rekindled and spread throughout the province. Altars were dedicated to him, statues put up in his honour in Lecce and Ostuni and the Christian name Oronzio (the 'i' was dropped during the eighteenth century) was increasingly given to infants.[82]

Yet even a celebratory procession such as that of 1656 reflected man's precarious condition and general helplessness when confronted by the evil and destructive forces of nature. Processions petitioning the divine, rather than celebrating its timely intercession, were grim and sombre affairs (morbid by definition). Drought was a common threat and procession a common response. During the drought of 1714, the mayor of the village of Racale wrote to his bishop, Mons. Antonio Sanfelice of the diocese of Nardò, asking his permission to hold a public procession, 'in order to placate the wrath of God outraged against sinners...so that he make it rain, considering the great need of water the countryside has'.[83] Such a procession would normally follow a vow made to a particular saint, occasionally the town or village patron or titular patron of the parish church, but most often a saint with a proven track-record regarding the request. It would then wind its way to the saint's shrine, where a mass would be said.

The image of St Peter at the shrine of S. Pietro in Bevagna (diocese of Oria) was held to be especially effective in granting rain, among other favours. This virtue is explained by the legend that the apostle Peter, along with Mark, had landed there and baptised many people in the adjacent river, the waters of which became miraculous. During periods of drought the people of nearby towns and villages would declare a vow to St Peter and petition their mayor to communicate it to the abbot of the shrine. Usually the procession was organised from Casalnuovo (later called Manduria), and involved spending the night out in the open in the shrub around the shrine, known as *il deserto*. In this respect it formed part of pilgrimage, as we shall see. At dawn the next day, the crowd of people would organise into a procession, followed by members of the con-

fraternities, the abbot and the miraculous image of St Peter, borne by several strong young men. As it was a penitential procession – that is, an attempt to obtain rain through the forgiveness of sins – many would scourge themselves, wear crowns of thorns and perform other gestures of penance. The procession would take five or six hours to reach the gates of Casalnuovo.[84]

As part of the procession an exorcism could be performed against such pests, combining the force of two ecclesiastical remedies. Processions of this type were typified by the rogations, fixed rites of petition where the priest processed through the parish in the last week of April and first week of May to pray for and bless the fields. Not only did the procession coincide with a period of critical importance in the agricultural cycle, it was also an important symbol, representing as it did, in the words of John Bossy, 'the ordered and visible progress of a whole community, carrying its banners against the forces of darkness'.[85] It, too, had its popular interpretation: celebration as well as supplication, the festivities contained more than just a hint of the ancient fertility rite. That it contained elements of a sexual nature was certainly the conclusion of the apostolic visitor to the Lecce diocese in 1627, Mons. Andrea Perbenedetto. He noted that during the vigils of certain feast days, such as the octave of St James (beginning 1 May) and the Assumption (15 August), women would parade through the streets in the middle of the night, often with tambourines, dancing and stopping at various churches to ask for indulgences (*perdonanze*). One of the centres of such activity was the church of Madonna del Puzzillo, named after a nearby miraculous well (an obvious focus for the rogations). Perbenedetto concluded that the women went more for fun than for devotion, risking their souls and attracting the attention of 'idle and impious young men, naturally predisposed to cause harm' and threaten the 'decency of many women'. His solution was to order the church doors closed at the first sounding of the Ave Maria bells, and to prohibit women from conducting all-night vigils inside or even visiting under pain of excommunication.[86]

PILGRIMAGE

A related form of devotion was the pilgrimage. It was often the result of a special prayer or vow to a particular saint, and could also entail the placing of a votive offering at the shrine in thanksgiving or a fast. The sanctuary of S. Pietro in Bevagna, mentioned above, was covered in ex-votos testifying to the favours bestowed by the saint. The possessed woman, Lucretia Nardello, attempted to go with her husband to the feast of Sts Peter and

Paul held there, hoping for a cure. Alas, they were forced to return to Latiano that same night because of the pain she was in.[87] The overnight vigil normally spent at the shrine, *il deserto*, recalls the idea that the pilgrimage can be seen in terms of a rite of passage, complete with its three phases of separation (from the daily lived experience), limen or margin, and the return to the community.[88]

The initial stage of separation was accompanied by distinct forms of ritual behaviour. For instance, a special habit could be worn on the pilgrimage, such as the white habit worn by pilgrims to the church of San Paolo in Galatina (the shrine of the *tarantati*) and San Donato in Montesano (frequently visited by epileptics, as we shall see in the next chapter). The route to the sanctuary could be completed on foot, as a form of penance. On arrival there, and before crossing the threshold, the pilgrim would frequently circle it three times.[89] This done, many pilgrims would approach the altar on their knees, beating their breasts or licking the floor in supplication and self-abasement. This form of devotion, introduced by the Jesuit and Redemptorist missioners, was practised as late as the 1950s in the Salento, before being prohibited by local authorities.[90]

The sanctuary was a 'sacred space' defined by the presence of a miraculous image or saint's relics. The overnight vigil there was part of the second or liminal phase, the 'marginal' nature of which was accentuated by the (most often) rural location of the shrine: a cave, the bush or *macchia* common to the Mediterranean, or atop a mountain. This vigil, Greek in origin, was a form of the Roman *incubatio*, according to which sleeping on the ground at shrines dedicated to thaumaturgical forces gave the latter the opportunity to indicate to pilgrims, in the form of a dream, the proper therapy or remedy to follow. Although visions could occur during the Christian vigil, the Virgin or saint to whom the shrine was dedicated usually worked the miracle or grace independently.[91]

The beneficent effects of both pilgrimage and shrine were prolonged after return to the community by the acquisition of holy articles at the shrine: paper images, statuettes, blessed ribbon, water and oil, which people kept in their homes or gave to relatives and friends. These frequently found their way into healing rituals, as we have seen. Certain powders, such as the one scraped from the walls of the cave shrine of St Michael at Monte Sant'Angelo (on the Gargano peninsula), also possessed healing qualities when mixed in water or wine and drunk. Devotees of the Madonna della Libera, in the form of itinerant pedlar-musicians, sold stones taken from her shrine throughout the Terra d'Otranto, the powder of which was taken as a medicine for quartain fever and difficult labour.[92]

The ex-votos covering the walls of shrines were silent testimony to favours granted and pilgrimages undertaken. By definition, an ex-voto is a devotional object made of wax, wood or metal (representing the part of the anatomy healed), or a small painted tablet (depicting the intercessory event), offered to the Virgin or a saint in response to a particular favour or grace received. By way of example, the intercession of Santa Maria del Casale – a miraculous image in a church outside Brindisi – on behalf of sailors and 'innumerable sick people...can be seen in the many votive tablets which hang in great numbers from the walls of this temple as witness to the Virgin's power in the company of her son... And, in fact, there are so many that if the church were not so large and spacious they would not all fit, since the walls are completely covered.'[93]

The vow made to the saint took on the form of a bargain struck between patron and client, and the ex-voto assumed the dual role of compensatory offering and liberating *scongiuro* serving to exorcise the malady or misfortune which had prompted the vow.[94] When Vernandia Tomasi's middle finger was about to be amputated by a doctor because of a severe infection, her sister brought back some rosemary from the tomb of Bernardino Realino. She brushed her finger with it, and when the infection started to recede, Vernandia promised the saint-to-be that she would hang an ex-voto, in the form of a silver finger, at his tomb. Some time later her mistress asked her if she had fulfilled the vow, to which she 'replied that she had not fulfilled it and that she did not even remember making it; and immediately after she left the house the former disease returned to the same finger, and on this occasion she renewed her vow, and as soon as she had taken it [the ex-voto] to the saint the disease left her completely.'[95]

Other objects could also be left at the sanctuary, reflecting the nature of the favour: anything from crutches and canes to swords and guns. The image of Santa Maria della Croce, in the Franciscan monastery chapel outside Francavilla (diocese of Oria), was noted for having cured numerous invalids as well as people whose lives had been in danger. In addition to ex-votos, many muskets, swords, pistols and daggers hung on the chapel walls. One local devotee, Captain Alessandro Bevilacqua, hung up his half-destroyed musket there after having invoked the Virgin of the Cross, while defending Messina from the French attack of 1674 and being saved from a surely fatal musket shot. Although her protection was not automatic like that supposedly provided by the incantations of learned magic against attack, she could hardly refuse the veneration of a true devotee. Bevilacqua left the followed verses beneath his musket:

Mi torse globbo ostil lo schioppo in mano
Della Croce MARIA fe' il colpo vano:
Non può colpo nemico esser feroce
Ove scudo è MARIA, spada la Croce.[96]

Of course, a vow could be fulfilled by the devotee in many ways. In 1617 a French mercantile captain, Daniel Audibert, found himself in peril while sailing in the waters off Gallipoli due to a sudden storm. 'There was no way of him being saved through human aid, so he had recourse to the Madonna Santissima dello Cassobio of the said city', making a vow of thirty *tumoli* of salt to 'her church' and three to the chapel of St Catherine should she intercede and save him and his ship. No sooner had he finished making this vow than the storm ceased.[97] This sort of event was a common *topos* in miracle accounts. A fifth-century Syriac manuscript called the *Transitus Mariae* recounts that when a group of Roman Christians was about to be shipwrecked in a storm, they prayed to the Virgin and were delivered from harm.[98] The Virgin Mary became known as the *stella maris*, patroness of sailors and localised in numerous Marian shrines along sea-coasts, where ex-votos depicting scenes of imminent shipwreck were hung (like Santa Maria del Casale, mentioned above).

For those who went on pilgrimage it often represented the only type of journey possible, especially for women. The emphasis was on the visiting of local shrines, whose reputation for miracles was well known to area residents and which were within relatively easy access. The shrines of regional importance, especially when further away, were limited to those people of greater means, for it could be a lengthy journey. In 1768 two priests, as they were about to set off from Gallipoli for the shrine of Monte Sant'Angelo, were approached by two women, apparently part of a crowd seeing them off. One of the women, Vernanda de Santis, said to them enviously: 'how much I would like to be a man so that I too could have the pleasure of seeing the world like you priests'. The remark was not appreciated and one of the priests angrily replied that de Santis was an ugly gossip who had to know everything, and he threatened to beat her with his crop.[99]

For those living near a shrine, protection was often afforded by the thaumaturgical saint, especially – it seems – if the miraculous waters of a well were part of the shrine and the saint's legend.[100] Paradoxically, the reality of a therapeutic pilgrimage signifies that the local saint was not healing local people, who were forced to go elsewhere for a cure. None the less, given the evidence available regarding the Terra d'Otranto, it would be difficult to conclude that shrines were only responsible for favours

regarding particular externally-caused forms of malady and misfortune, while 'rituals of affliction' treated diseases caused by elements within society.[101] Certain shrines had certain specialities, like certain saints; but together they covered just about every form of disease imaginable. The healing powers and protection, to say nothing of the peace of mind, they offered were utilised along with the remedies of ecclesiastics and wise women by an anxious people desperate for sacred help, because the profane offered so little comfort.

This constant search for supernatural assistance meant that the initiative for pilgrimage often came from below, resulting in the ambivalence and even resistance of the Church hierarchy. Much of this has to do with the personal reasons for which people undertook pilgrimage and the traditions that grew up around the shrine, both tending to operate outside the orthodox liturgical and ritual system. Especially in the case of images miraculously returning to the original rural site where they were first discovered (a motif we will examine further in chapter 6) in apparent rejection of the parish church, shrine images may represent – in the words of one scholar – 'a metaphor for what was in some sense a liberation of devotion from parish control...the resistance of local religion to the growing claims of the Church'.[102] The fact that so many of the images depicted Mary, most often as *Theotokos* (Mother of God), underscores the feminine nature of the healing activities and protection from nature that they provided. In this respect, pilgrimages and processions, with her or some thaumaturgical saint as the focus, were in some sense part of the same sphere of activity as that occupied by the local *magara*.

In this chapter we have examined a whole gamut of *medicine ecclesiastiche*, remedies to malady and misfortune accepted and encouraged by the Catholic Church. They range from what might be described as personal remedies, such as prayer, the rosary, the sign of the cross and various holy articles, through to those administered by ecclesiastics, or their (lay) imitators, like blessings, gospel readings and exorcisms; and ending with remedies generally based on community or group participation, such as processions and pilgrimages. Although this categorisation is somewhat artificial – the rosary was frequently a group devotion and pilgrimages often the result of very private vows – it serves to emphasise the way the various devotions actually functioned within society in the Terra d'Otranto. It is important to stress, however, that given the close-knit structure of the society few appeals for sacred help and intercession were truly private: they usually entailed the involvement, not to say concern, of at least a restricted number of friends and family.

We must also bear in mind that these remedial rituals were not the only ones used in time of crisis. It is time now to turn to those lay remedies and conjurations whose existence has been hinted at so much during the course of this chapter.

NOTES

1 Tommaso Delbene, *De Officio Sanctae Inquisitionis circa Haeresim* (Lyons, 1666), 309; cit. in H.C. Lea, *Materials toward a History of Witchcraft* (Philadelphia, 1939), II, 1033.

2 Cf. Mary O'Neil, '*Sacerdote ovvero strione*: Ecclesiastical and superstitious remedies in 16th century Italy', in Steven Kaplan, ed. *Understanding Popular Culture* (Berlin, 1984), 54.

3 Girolamo Menghi, *Compendio dell'arte essorcistica et possibilità delle mirabili & stupende operationi delli Demoni & de' Malefici con li rimedij opportuni alle infermità maleficiali* (Bologna, 1576), 241.

4 Robert Scribner, 'Cosmic order in daily life: sacred and secular in pre-Industrial German society', in his *Popular Culture and Popular Movements in Reformation Germany* (London, 1987), 5.

5 Mario Righetti, *Manuale di storia liturgica* (Milan, 1959), IV, especially 523–45.

6 *Constitutiones synodales ecclesiae metropolitanae Brindisinae...auctore Joanne a S. Stephano et Falces* (Rome, 1623), 151.

7 'Dorotea Rossi denuncia diverse donne per pratiche magiche', 24 July 1742, Francavilla, A.D.O., *Magia e stregoneria*, II.

8 Deposition of Carmina de Tomaso, 'Contro Giustina Quaranta per magia', 5 July 1742, Oria, A.D.O., *Magia*, II.

9 Mario Rosa, 'Pietà mariana e devozione del Rosario nell'Italia del '500 e '600', *Religione e società nel Mezzogiorno tra Cinque e Seicento* (Bari, 1976), 222. Cf. Marina Warner, *Alone of All Her Sex: The Myth and Cult of the Virgin Mary* (London, 1985 edn.), 305–9.

10 Arcangelo Caraccia, *Il Rosario della B. Vergine con indulgenze e privileggi concessi alla Compagnia* (Rome, 1627), 43. Cit. in Rosa, 'Pietà mariana', 228–9.

11 Serafino Montorio, *Zodiaco di Maria, ovvero le dodici provincie del Regno di Napoli, Come tanti segni, illustrate da questo Sole per mezzo delle sue prodigiosissime Immagini, che in esse quasi tante Stelle risplendono* (Naples, 1715), 471–2.

12 'Dorotea Rossi denuncia diverse donne per pratiche magiche', 24 July 1742, Francavilla, A.D.O., *Magia*, II.

13 'Summario delle denuncie contro Cecilia Pulli, maga di Latiano, 1722', A.D.O., *Magia*, II.

14 Caraccia, *Rosario*, 130–4; cit. in Rosa, 'Pietà mariana', 231.

15 Francesco Capecelatro, *Diario...contenente la storia delle cose avvenute nel Reame di Napoli negli anni 1647–1650* (Naples, 1850), 104. Cit. in Rosa, 'Pietà mariana', 242.

16 Deposition of Rev. Paolo Torrisio, 'Processus remissorialis Lycien. Bernardini Realino', 1623–1624, A.S.V., no. 1514, fol. 126.

17 Cf. Rosa, 'Pietà mariana', 238.

18 Ibid., 226.

19 Deposition of Antonio Cocciolo, 'Contro Rvdo. Giuseppe Antonio Papa', 1800, Squinzano, A.C.A.L., *Giudicati criminali*, no. 797; and deposition of Antonio Rao, 'Contro Rev. Francesco Mazzeo e Rev. Donato Calogiuri', 1740, Lizzanello, A.C.A.L., *Giud. crim.*, no. 860.

20 Deposition of Rev. Giuseppe Antonio Bottaro, 'Contro Nicodemo Salinaro per sortilegi', 16 July 1678, Francavilla, A.D.O., *Magia*, III, fols. 25r–26r.

21 *Constitutiones synodales*, p.200.

22 Deposition of Carmina de Tomaso, 'Contro Giustina Quaranta per magia', 5 July 1742, Oria, A.D.O., *Magia*, II.

23 Declaration of promotor fiscal, June 1709, 'Contro Caterina Patrimia per stregoneria e patto col diavolo', 14 August 1704, Francavilla, A.D.O., *Magia*, I.

24 Cf. O'Neil, 'Ecclesiastical remedies', 60.

25 Ludovico Antonio Muratori, *Della regolata divozion de' cristiani* (Venice, 1761 edn.), 347.

26 'Synodus Dioecesana celebrata in Ecclesia Cathedrali Ugentina', 1645, Archivio Diocesano, Ugento, fol. 66v; and *Constitutiones Synodales Editae et Promulgatae a Reverendiss. DD. Josepho Felice Salzedo vicario capitulari uxentino* (Lecce, 1720), 33–4. Both cit. in Salvatore Palese, 'Per la storia religiosa della diocesi di Ugento agli inizi del Settecento', in M. Paone, ed. *Studi di storia pugliese in onore di Giuseppe Chiarelli* (Galatina, 1976), 308.

27 Deposition of Vittoria de Arrico, 'Contro Antonella Seppi pro sua mala vita, fama et conditione', 19 May 1723, Torre S. Susanna, A.D.O., *Magia*, II.

28 Deposition of Colonna Calò, ibid.

29 Depositions of Isabella di Nitto and Laura de Lorenzo, ibid.

30 Deposition of Anna Sanasi, ibid.

31 In Luisa Accati, 'Lo spirito della fornicazione: virtù dell'anima e virtù del corpo in Friuli, fra '600 e '700', *Quaderni storici*, XIV (1979), 648.

32 Cf. Annamaria Rivera, *Il mago, il santo, la morte, la festa* (Bari, 1988), 284.

33 O'Neil, 'Ecclesiastical remedies', 65.

34 'Denuncia di Anna Corvino contro D. Matteo di Francavilla, Capuccino', 14 February 1741, Francavilla, A.D.O., *Magia*, II.

35 'Teresia Biascho denuncia pratica di magia', 18 October 1740, Francavilla, A.D.O., *Magia*, II.

36 Declaration of Rev. Carlo Donatino, 'Visitatio Personalis', Francavilla, 1783–1784, Mons. Alessandro Kalefati, A.D.O., no foliation.

37 Interrogation of D. Pietro de Laurentiis, ibid. He was referring to the Roman Ritual of 1614 which set out the rites and ceremonies of the Catholic Church.

38 'Denuncia contro D. Pietro Tomaselli e D. Pasquale Gerace', 23 April 1753, Francavilla, A.D.O., *Magia*, IV.

39 Translation: 'Jesus, in the name of the Virgin Mary / and of the Son, most holy / stood in the middle of the sea, / and with tears he wept, / for he had blisters on his tongue, / and St John said these words to him: / I pray you, God the Father, and the Son, / with the Virgin Mary his mother / and I want to pray him / in the name of the glorious Virgin Mary / that his (Name) blisters will be cured / in the name of the Virgin Mary.' 'Acta Sanctae Visitationis, Habitae in Metropolitana Ecclesia Brindisina et Uritana Ab Archiepiscopo Jo. Carolo Bovio, 1565', A.C.A.B., fols. 270r–v.

40 'Denuncia di Francesco Morleo per fattura', 25 April 1727, Erchie, A.D.O., *Magia*, II.

41 Gabriele De Rosa, 'Problemi religiosi della società meridionale nel Settecento attraverso le visite pastorali di Angelo Anzani', in *Vescovi, popolo e magia nel Sud* (Naples, 1983), 11.

42 Luciano Allegra, 'Il parroco: un mediatore fra alta e bassa cultura', *Storia d'Italia. Annali IV: Intellettuali e potere* (Turin, 1984), 915.

43 Gabriele De Rosa, 'Il Cilento nel Seicento e Settecento secondo le relazioni dei vescovi caputaquensi', in *Vescovi*, 101.

44 Allegra, 'Il parroco', 919.

45 Cf. 'Contro Rvdo Pasquale Magi', Campi, 1742, A.C.A.L., *Giud. crim.*, no. 818.

46 Allegra, 914.

47 Cf. Peter Burke, 'Rituals of healing in early modern Italy', *The Historical Anthropology of Early Modern Italy. Essays on Perception and Communication* (Cambridge, 1987), 212.

48 Girolamo Menghi, *Eversio daemonum e corporibus oppressis* (Bologna, 1588), 9; cit. in Piero Camporesi, *Bread of Dreams: Food and Fantasy in Early Modern Europe*, trans. D. Gentilcore (Cambridge, 1988), 157.

49 William Christian, Jr. *Local Religion in Sixteenth–Century Spain* (Princeton, 1981), 30. Curiously, Leonardo Vairo described this as being a popular practice, which he defined as 'superstitious and impious'. Cf. *De fascino libri tres, auctore Leonardo Vairo Beneventano, Ordinis S. Benedicti Canonici Regularis, ac sacrae theologiae doctoris* (Venice, 1589), 159–60.

50 Antonello Coniger, 'Le Cronache', in *Roccolta di varie croniche, diarj, ed altri opuscoli appartenenti alla storia del regno di Napoli* (Naples, 1782), vol. V, 48; cit. in Aurelio Lepre, *Storia del Mezzogiorno d'Italia* (Naples, 1986), vol. II, 69.

51 Girolamo Menghi, *Flagellum daemonum, seu exorcismi terribiles, potentissimi & efficaces, remediaque probatissima in malignos spiritus expellendos facturasque & maleficia effuganda de obsessis corporibus cum suis benedictionibus, et omnibus requisitis as eorum expulsionem* (Bologna, 1577), p.281.

52 Gigli, *Superstizioni*, 35–6..

53 Giovanni Romeo, *Inquisitori, esorcisti e streghe nell'Italia della Controriforma* (Florence, 1990), 122–6.

54 The 'high' form was that of the public exorcisms, often staged before large crowds and used for propaganda purposes. Cf. ibid., 151, note 14.

55 'Prima Santa Visita di Mons. Luigi Pappacoda', S. Pietro in Lama, 1640, A.C.A.L., *Sante visite*, VIII, fol. 244v.

56 Florian Canale, *Del modo di conoscer et sanare i maleficiati, et dell'antichissimo et ottimo uso del Benedire* (Brescia, 1614), 9. Cit. in Piero Camporesi, *The Incorruptible Flesh: Bodily Mutation and Mortification in Religion and Folklore*, trans. T. Croft-Murray (Cambridge, 1988), 166.

57 *Constitutiones synodales*, 1623, 49. See note 51 for the the full title of Menghi's work.

58 'Synodus Diocesana Ecclesiae Oritanae ab Ill.mo, et R.mo D.no Fratre Raphaele De Palma...Habita Anno Domini 1664', A.D.O., *Sinodi*, fol. 163.

59 Mons. Castrese Scaja, 'Apologia pro Editto emanato', 1749, A.D.O., *Sante visite*.

60 Cesare Carena, *Tractatus de Officio Sanctissimae Inquisitionis et modo procedendi in Causis Fidei* (Lyons, 1669), 490; cit. in H.C. Lea, *Materials toward a History of Witchcraft* (Philadelphia, 1939), vol. II, 954.

61 Ludovico Antonio Muratori, *Della forza della fantasia umana* (Venice, 1753 edn.), 104–5. He also concluded that where no exorcists had been there were no possessed people either, the presence of an exorcist being the cause of many a possession amongst women of overactive imaginations (p. 111).

62 Cf. Giovanni Levi, *Inheriting Power: The Story of an Exorcist*, trans. L. Cochrane, (Chicago, 1988), chapter 1.

63 Deposition of Chiara de Cesarea, 'Processo di furto commesso nella casa di D. Giuseppe d'Acugna da Paduano Tundo', 1620; A.C.V.G., *Processi penali*, no. 413. The document bears this title, although the trial has nothing to do with theft.

64 Deposition of Paduano Tundo, ibid.

65 Deposition of Fra Pacifico da Lecce, ibid.

66 Second deposition of Chiara de Cesarea, ibid.

67 Deposition of Fra Pacifico da Lecce, ibid.

68 'Angelo Nardello denuncia Antonio Pulli', 24 July 1681, Latiano, A.D.O., *Magia*, III.

69 'Processo a Giovan Giacomo Marsicano detto Cirignola', 1580, Archivio Storico Diocesano, Naples, *Sant'Ufficio*, 123a, fol. 21v. Cit in Romeo, *Inquisitori*, 128. He reproduces an extract from the trial in an Appendix. Cf. Jean-Michel Sallmann, *Chercheurs de trésors et jeteuses de sorts* (Paris, 1986), 176–8.

70 Depostion of Domenico Cimino, ibid., fol. 61r.

71 William Monter, *Ritual, Myth and Magic in Early Modern Europe* (Brighton, 1983), 87–8; cf. D.P. Walker, *Unclean Spirits: Possession and Exorcism in France and England in the late Sixteenth and early Seventeenth Centuries* (Philadelphia, 1981).

72 C.W. Baars, 'Obsession', *New Catholic Encyclopedia* (New York, 1967), vol. X, 622.

73 Joseph de Tonquédec, *Les Maladies nerveuses ou mentales et les manifestations diaboliques* (1938); cit. in Martin Ebon, *Exorcism Past and Present* (London, 1974), 88.

74 'Contro Maria Salinaro', 11 February 1727, Francavilla, A.D.O., *Magia*, II.

75 I.M. Lewis, *Ecstatic Religion: An Anthropological Study of Spirit Possession and Shamanism* (Harmondsworth, 1971), 72.

76 'Suor Maria Catarina Salinaro confessa di aver fatto un patto col diavolo', 18 April 1738, Francavilla, A.D.O., *Magia*, II. Salinaro described the devil as a 'handsome young man' with whom she had often 'had sex for several hours, even through the posterior part'.

77 Lewis, *Ecstatic Religion*, 72. This motif is also common to cases of witchcraft.

78 'Maria Caterina Salinaro confessa', 18 February 1741, Francavilla, A.D.O., *Magia*, II. The chronology of her account is somewhat muddled.

79 'Registro delle missioni e esercizi al popolo', Archivio della Casa della Missione ai Vergini, Naples, I, part II, fol. 31; cit. in Maria Gabriella Rienzo, 'Il processo di cristianizzazione e le missioni popolari nel Mezzogiorno: Aspetti istituzionali e socio-religiosi', in G. Galasso and C. Russo, eds. *Per la storia sociale e religiosa del Mezzogiorno d'Italia* (Naples, 1982), I, 479.

80 Giovanni Camillo Palma, *Semplice e diligente Relazione della rinnovata Divozione verso il glorioso martire di Christo, Patrizio, e primo vescovo di Lecce, S. Oronzo, di Gio. Camillo Palma Dottor Teologo, e Arcidiacono di Lecce,* in Appendix to Antonello Coniger, *Le Cronache* (Brindisi, 1700), 11 ff.

81 Giuseppe Cino, 'Memorie ossia notiziario di molte cose accadute in Lecce dall'anno 1656 all'anno 1719', reprinted in Appendix to *Rivista storica salentina*, 1905–6, 62.

82 Cino remarks with amazement that such was the name's popularity that in 1719 all the members of Lecce's city council bore the name Oronzio. Ibid., 123.

83 'Lettere di varie persone del 1714', Archivio della Curia Vescovile, Nardò, *Fondo bollari*, A a/3/48, fol. 27. Cit. in A. Carrino, 'La diocesi di Nardò tra la fine del '600 e gli inizi del '700', unpublished *tesi di laurea*, Università di Lecce, 1967–68, 78.

84 Giuseppe Gigli, *Superstizioni, pregiudizi e tradizioni in Terra d'Otranto* (Florence, 1893), 97–101.

85 John Bossy, *Christianity in the West, 1400–1700* (Oxford, 1985), 73.

86 Mons. Andrea Perbenedetto, 'Decreta Visitationes Apostolicae', 1627, A.C.A.L., *Sante visite*, VI bis, fols. 35v–36v.

87 'Angelo Nardello denuncia Antonio Pulli', 24 July 1681, Latiano, A.D.O., *Magia*, III.

88 Cf. Victor and Edith Turner, *Image and Pilgrimage in Christian Culture. Anthropological Perspectives* (Oxford, 1978), 2.

89 This widespread ritual was also important in other circumstances. At the shrine of Santa Maria del Ponte in Brindisi, where both men and animals could be cured, the circling was a crucial part of the invocation ritual. According to Serafino Montorio, 'Whenever an ox, cow, sheep or goat or other animal is taken ill by some malady, as soon as the owner has a mass celebrated before the prodigious image, then has the

infirm beasts blessed by a priest, circling around the church, they remain liberated of any infirmity'. *Zodiaco*, p. 466.

90 Annabella Rossi, *Le feste dei poveri* (Palermo, 1986, 2nd edn.), 75–6.

91 Rossi, *Feste*, 80.

92 Deposition of Beatrice Contistabile, 'Contro Beatrice Contistabile per aver fatto bere al figlio di Angela Coco acqua con polvere contro la quartana', 31 August 1697, Francavilla, A.D.O., *Magia*, I.

93 Montorio, *Zodiaco*, 463–4.

94 Cf. G.B. Bronzini, '"Ex voto" e cultura religiosa popolare', *Rivista di storia e letteratura religiosa*, XV (1979), 16 and 25.

95 Deposition of Rosata Tomasi, 'Processus remissorialis Lycien. Bernardini Realino', 1623–24, A.S.V., no. 1514, fols. 1681–2.

96 Translation: 'A hostile globe twisted the shotgun in my hand / MARY of the Cross made the shot harmless: / An enemy shot could not be violent / Where the shield is MARY, sword the Cross.' Montorio, *Zodiaco*, p.525. For the protection offered by learned magic against gunshot see chapter 7.

97 'Il capitano marittimo Daniele Audibert francese, salvato dal naufragio per intercessione della Ma. di Cassobio, 1617', A.C.V.G., *Confraternita S. Francesco di Paola*.

98 Cit. in Turner, *Image and Pilgrimage*, 161.

99 'Contro Sac. Lazaro Bruno per parole ingiuriose pronunziate contro Veneranda De Santis e Antonia Merico', 1768, A.C.V.G., *Proc. pen.*, no. 2263.

100 In this way, St Paul protected the people of Galatina from the bite of the tarantula spider.

101 Cf. Turner, *Image and Pilgrimage*, 12.

102 Christian, *Local Religion*, 91.

The magara:
popular healing rituals and the sacred

In July 1678 Donna Laura de Adamo appeared before the episcopal court in Oria stating that several years earlier her son had been ill for a period of ten months, the various medicines prescribed to him by a doctor having been of no use. Before her son's death the doctor informed her that it was probably not a natural illness and the family should therefore take the boy to a 'respectable ecclesiastic', so that by means of 'holy things, and with spiritual remedies' his condition might improve, adding that he knew of 'a good clergyman' in Lecce. Donna De Adamo testified that just before she was due to leave for Lecce, she was approached by a woman of the town who warned her: 'your son is bewitched, and it's necessary to help him with other means', and that she had better hurry since her son would be dead by that coming Sunday. The woman, Gratia Gallero, a local inn-keeper and weaver, then volunteered her services along with those of Cinzia Maietta, a potter. The two women instructed de Adamo to take some oil to the parish church, and light seven different lamps on seven different altars. They returned later with herbs to prepare a 'syrup', which they claimed to have used successfully to break other spells (de Adamo was able to recognise rue among the ingredients). But, de Adamo went on, her son did not want to take the potion before asking his confessor about it, even though the women told him that it was a 'syrup from the apoth-ecary's'. His confessor was hurriedly fetched, but the boy refused the potion even after it had been pronounced acceptable (that is, not magical). Perhaps in an attempt to strengthen their position, the two women insisted on examining the boy's trousers in an adjacent room. They returned proclaiming the discovery of several hairs, which they told de Adamo were part of the maleficent charm causing her son's illness. Never-theless, the boy died on the pre-announced day, leading de Adamo to suspect the women of being 'wise women and sorceresses' (*magare e fattucchiare*).[1]

Donna de Adamo's detailed and revealing deposition is a useful point of departure in an examination of popular healing rituals and the sacred because it suggests some of the possible healing techniques available to

patients in early modern Terra d'Otranto. Her title indicates that she was one of the few able to afford the services of a physician, who was none the less aware of the limitations of his profession. Her planned recourse to ecclesiastical remedies is rather more typical of the treatments within the reach of everyone. However, this meant a trip to Lecce, while the local cunning women were right at hand in her native town of Francavilla, and it was from them that she sought assistance, in a desperate attempt to save her son's life.

This chapter will explore those forms of ritualised response to malady and misfortune which functioned largely outside both the Church's liturgical framework and the realms of learned medicine. These included formulaic invocations and conjurations for the treatment of human and animal illnesses of all kinds. Some cures were immediately accessible, being the common lore of all members of society; others were restricted to community wise women (referred to in the Otrantine trial records as *magare*)[2] and midwives. As we shall see, they belong to the system of the sacred because they attempted to establish relations with the sacred and influence it, although they did so outside ecclesiastical structures. The healing rituals provided access to sacred power and assistance, in order to counter the threats and difficulties of everyday life and maintain a personal equilibrium and order.[3] In many ways they are analogous to the 'ecclesiastical remedies' or sacramentals discussed in the previous chapter, of which they were in part lay versions, interpretations and applications. The invocations also made use of the names and power of saints, often the patrons of specific ailments, and for this reason they overlap with the Church-approved, and often Church-sponsored, devotions to holy men and women and their relics to be discussed in the final chapter of Part II. Together, they formed a sort of pool of remedies which patients could dip into in times of physical psychological need, pragmatically going from one form to another – beginning with the one reputed most efficacious for the particular disease – until a cure was found.

MEDICAL PLURALISM

The most obvious characteristic of medicine in this period was its pluralism. As there was a saint connected with almost every malady, so too there was a variety of specialists dealing in specific complaints, like the unofficial or semi-official tooth-drawers (*cavadenti*), bone-setters (*concia ossi*), and surgeons or barbers.[4] The latter were found somewhere between the apothecary (*speziale*) and the more popular practitioners like folk healers. For women in labour there was the midwife, whilst those bitten by snakes

and other animals could have recourse to the itinerant *sanpaolari* who sold remedies at local fairs in the Terra d'Otranto.[5] Quack treatments such as these, however, were frequently condemned by official healers, whether physicians or Church exorcists, who regarded them as rivals. The Church went on to condemn all cunning folk, whose efficacity they considered – at least in theory – to be of diabolical origin: the result of a pact with the devil, either expressed or tacit.

Even within the realm of folk medicine there was what modern medicine might consider a surprising amount of variety. As elsewhere in Europe, techniques and rituals varied widely, from traditional folk remedies, predominantly herbal, to prayers and invocations accompanying the medicine, or even forming the sole means of treatment. The specialisation of such healers is apparent in Archbishop Giovanni Bovio's visitation of the Brindisi archdiocese in 1565, in the wake of the Council of Trent. In his visitation of the town of Guagnano, Bovio asked the local archpriest, Don Antonio Civino, if there were any *incantatores,* and he replied with the following list:

> Andrea Cappuccella; Antonio Agliano, alias Pipici, enchants [*incantat*] the pains of animals; Clementia Memma enchants the bewitched; Don Giuseppe Memmo enchants the diseases of animals; Pompilio Candido enchants the chill fevers of men; Sister Avenia enchants the pains of joints; Sister Rosata enchants headaches; the above are from Guagnano; Don Gabriele Passante enchants chill fevers.[6]

The use of the word 'enchant' instead of 'treat' or 'heal' demonstrates the view held by the upper clergy that the prayers and invocations recited by healers were spells, and their use of the sign of the cross and the wafer in healing, blasphemy. What they practised was perceived as *magarìa* or *fattucchiarìa* (*maleficium* or maleficent magic), a form of heresy. The Church's primary concern centred on the misuse of sacraments and sacramentals in attempting to contact the supernatural by channels other than those accepted by the Church. The first decree of the 1749 visitation of the Oria diocese listed all the activities which could result in excommunication for the guilty party, beginning with:

> 1. All those who misuse the Blessed Sacrament of the Eucharist, the holy oils, or any other article consecrated or blessed by the Holy Church, for magic, charms, spells and any other purpose, except that for which they have been instituted, consecrated or blessed by the Church.[7]

And the first synod of the Gallipoli diocese, held in 1661, prohibited the use and abuse of *brevi* ('or sheets of paper, to which are added words, signs, characters and unknown figures, as well as prayers') and blessed articles

like candles, palms, incense and holy water, which were taken from church 'under the pretext of piety and devotion'.[8]

POPULAR HEALING AND THE SACRED

Healing rituals which made use of such articles have traditionally been considered magical rather than religious by those describing and interpreting them. In the past, scholars have attempted to differentiate between the magical and the religious, identifying as magical those rites which possess an inherent or mechanical efficacy, and as religious those which seek or depend on the intervention of some higher power. However, this distinction is somewhat schematic and artificial, since 'magical' healing rites often made use of sacrificial ceremonies, as well as sacred vows, prayers, invocations and hymns; while certain religious rites, on the other hand, were claimed to exert their force *qua* rites.[9] The fact of the transubstantiation of the host *ex opere operato* could even be termed 'magico-liturgical', what Piero Camporesi describes as the 'dramatic apex of divine participations and supernatural presences, [which] could be the theatre of "mutationes, apparitiones, miracula"'.[10] The only way out of this quagmire is to view popular medical practices as part of a 'cultural dynamic'[11] in communication with official Catholicism – and, indeed, official medicine.

The cures themselves were quite varied, while tending to follow similar patterns. In 1600 the episcopal court of Gallipoli asked Antonia di Supersano, believed to be a *magara*, if she knew any prayers (*orazioni*) particularly effective in obtaining divine favours, besides the Paternoster and Ave Maria. She responded that she knew one called the prayer of St Anne:

> O' Cristo che allo voscho desti manna,
> facisti notti, e giorni e chiara dia,
> facisti l'oratione de Sant'Anna,
> le lagrime di Gioppo, et di Tobia.
> O' Cristo che pigliasti carne umana
> vala ventre de la Vergine Maria
> così mi fa contenti stà semana
> di quella che desidera l'anima mia.[12]

In order to be effective, according to di Supersano, it had to be accompanied by nine Paternosters and Ave Marias, as well as one mass and responsorial prayers.

Ecclesiastics, as we have seen, were considered particularly potent healers. In the 1565 visitation by the archbishop of Brindisi, cited above, the archpriest of Francavilla listed seven lay sorcerers, as well as two ecclesias-

tics whom he described as 'sorcerers enchanting pains of the joints',[13] apparently a common complaint. One of them, a Franciscan friar, Fra Nardo Gasparro, admitted to reciting the following *cantilena* in order to cure *tostulis,* a form of skin infection:

> La Vergine Maria alla seggia sedìa,
> lo suo figlio nanti apparìa.
> Chi vol laudar il nome dela Vergine Maria
> sano et salvo sia
> come fù Lazaro dela lepra c'havìa.
> Io ti dò la dieta
> come Jhesu Christo fù propheta:
> Non mangiar carne di scrofa, né carne di scrofa, né carne voglina, né carne di cervo, né caso cavallo, né finocchi, né cauli et lenticchia.[14]

Although one is for general needs and the other for a specific malady (even to the point of including the prescription), they both follow a similar format, that of the healing invocation, or *scongiuro curativo.* These conjurations worked by exorcising or conjuring the malady out of the body, making use of the verse form, easy to remember and recite. They consisted of a narrative nucleus, the *historiola* or *exemplum*, which told of a brief episode in the life of Jesus, the Virgin or the saints, and were most often disease-specific, operating on the principle of analogy. Thus the curing of Lazarus in Fra Nardo's *cantilena* gave the prescription that followed its special meaning and force, much in the way that the trials and tribulations of Christ were often referred to in invocations for ailments involving the blood, such as haemorrhages.[15] In fact, illnesses were often designated with the names of saints, who were in turn invoked by the people as thaumaturgical healers.

These invocations do not seem to have been common property. Although Jean-Michel Sallmann may be correct in asserting that all women knew the little prayers and invocations to the saints or the Virgin which were believed to cure disease and ward off the evil eye,[16] it is more likely that, given the prominence of cunning men and women, the verses, formulae and *scongiuri* tended to be the property of these 'select people, who keep the secret of the formulae and the ways in which they must be used'.[17] Indeed when they were communicated to others, in order to pass on the tradition, it had to be during particularly solemn feasts, so that they would not lose their curative powers.[18] In 1742 a *magara* living in Francavilla, Brigida di Taranto, was accused of saying 'certain orations of St Anthony and others, which had to be learned on Christmas night'.[19]

The brief magical formula that followed the *historiola* was usually

pronounced *sotto voce*, its very secrecy giving it limitless power. By their nature, such words had to escape the comprehension of the uninitiated in order to be effective. Giuseppe Cocchiara identifies this part of the invocation as a surviving pre-Christian magical formula on to which has been tacked the Christian *historiola*.[20] Yet often the magical formula itself, which depended on the exorcising power of words, took on a Christian form, as in the case of a cure for headaches practised by Camilla Nanni of Gallipoli.

In her first appearance before the episcopal court there Nanni denied any knowledge of how to make charms, admitting only to a knowledge of how to cure the 'malicello alli figlioli'.[21] Yet after several other women had testified against her, she gave a second deposition, in which she revealed that for headaches she made the sign of the cross three times on the patient's forehead, while saying three Paternosters and three Ave Marias 'in praise of the Trinity'. She recited the following formula between each prayer: 'every malady away, because Christ wants it so' ('ogni male fore, che Cristo così vole'). She was later released by the court and given a penance of fasting and praying to perform for two years, with a warning not to say the Paternoster, Ave Maria, Credo, Salve Regina or other prayers in ways not approved by the Church.

As suggested in the above cure, prayers were often recited in the treatment of disease, accompanied by the sign of the cross. In such cures there is often no necessary correspondence between disease and remedy, so that one ritual formula may not be used for just one disease, and one disease may not be treated by just one formula. Quartain fever, for example, was treated by several rituals, one of which was that employed in 1697 by Beatrice Contistabile to cure a young boy.[22] She gave the boy some water laced with a certain powder, which was to be accompanied by prayers (three Salve Reginas, Ave Marias, Paternosters and Glorias). When asked by the episcopal court, she admitted to buying a stone (shavings of which were used) in August for three palms' length of patent leather from four or five musician-pedlars who passed through town, bearing an image of the Madonna della Libera. She finished by saying that it was guaranteed not only to cure fevers, but to help pregnant women during cases of difficult labour.

From this and the other popular healing rituals described above, the Christian element and influence is clearly apparent. Indeed the pious sentiments expressed in such invocations, the appeal to the saints, and the use of masses, the lighting of candles or lamps and the orthodox prayers which accompany such rituals indicate that these remedies developed in a large part as extensions of ecclesiastical ritual remedies, and not simply

from some pre-Christian source.[23]

Nevertheless, to view these 'exorcising techniques' simply as lay versions or applications of ecclesiastical rituals would be to rob them of their richness and miss their other sources of inspiration. The folklorist and historian is not entirely to blame, since the invocations and prayers were often revealed by the healer without indicating the accompanying prescription or magico-medical practices. This is usually the choice of the informant (or, in the case of the episcopal and inquisitorial trials, the accused), for whom the secret of the prescription is greater than that of the invocation; and as the folklorist (or judge) is certainly not among the initiated, the secret cannot be revealed to him without both the ritual and the healer losing their efficacy.[24] Because of the importance of secrecy witnesses could not often be sure what the healer said or did.

In other cures the sacred seems to be entirely absent, at least as reported to the episcopal court in Oria. Witnesses in a 1678 trial were first asked the routine inquisitorial question of whether they knew of any 'magare et fattucchiare'. One of them, a forty-three-year-old lawyer named Giovanni Antonio Mela, deposed that nine years earlier his sister Maddalena had been bedridden with pains that forced her head into a queer position, 'which led to the suspicion that she had been bewitched'.[25] Their mother summoned Cinzia Maietta to break the spell, and Mela found her before his sister, holding a jar of what seemed like oil with rue in it. Maietta, whom we have already encountered, proceeded to anoint Maddalena's ear with the oil, in what could have been a straightforward imitation of an apothecary's ointment (like the one she tried to convince Donna de Adamo's son to accept). But Mela would have none of it, and asked Maietta what the remedy was supposed to do, before getting angry and sending her away (we do not know what Mela's sister or mother thought of his actions!). Mela concluded his testimony by adding that Maddalena got better without any medicine.

Yet even here the sacred makes an appearance, for rue was considered among the most 'virtuous' of the herbs gathered on St John's Eve. Other medicinal herbs so gathered included mint, thyme, St John's wort, camomille and garlic. The herbs were regarded as baptised by the dew of that night, and would be hung up in the house to provice protection for the following year. In the wake of Trent such practices were frequently condemned, as was the lighting of purification bonfires and the taking of ritual baths in the sea or rolling one's body in the dew-covered grass.[26]

Some cures were influenced by both official medicine and orthodox religion. On 30 June 1697, Donato de Quarto of Torre Santa Susanna was charged with using magic to cure Nicola Gargaro of the *mal francese* or

syphilis. De Quarto stated that he used to be a farm labourer but because of his asthma and old age (he was sixty-three) he was reduced to begging. While in Taranto at the feast of S. Cataldo, he met Gargaro and asked him to put him up for one night in his cooper's shop in nearby Francavilla, where Gargaro lived. Gargaro gave him charity for one month, during which de Quarto warned him not to go with women so much because of the risk, adding that Gargaro should let him know if he ever got ill, and he would pray for him to the Holy Spirit, Christ and St Francis of Paola in order to cure him.

De Quarto then returned to Torre, but was soon visited by Gargaro's father with news that his son had been taken ill, and beseeching him to come and help. In fact, Gargaro had been ill for ten days with syphilis, and despite the attention of various physicians his condition remained serious. On the way to Francavilla de Quarto stopped at the monastery of San Francesco di Paola to have two masses said for Gargaro and to get some ribbon blessed in the saint's name. When he arrived, he placed this on Gargaro, telling him he need no longer fear the disease. He then took some sour grapes and squeezed them over Gargaro's kidneys and genitals. It was this ritual which led Gargaro to suspect de Quarto of trying to bewitch him, since, as he told the court, he realised that his 'temporal and spiritual well-being' came only from Jesus, his mother and the saints. But de Quarto defended himself by saying that he had learned of the practice of spreading sour grapes over the body of a patient suffering from fever while he had been in hospital in Lecce the previous year. The court was satisfied that de Quarto knew the rudiments of the faith and his use of prayers was orthodox.[27]

Amulets, charms and other objects were also frequently employed to ward off and cure disease. We have already encountered the prohibition against the abuse of *brevi*, originally in the form of short prayers written on small pieces of paper and worn about the neck or sewn into the clothes as talismans (they often resembled pouches, containing assorted ritual objects). Ritual words and formulae had great magical properties. One woman of Francavilla claimed to know a prayer which would cause a soul to leave Purgatory or Paradise; if a mistake were made while reciting it, then a soul was added to Hell.[28] The abuse which so preoccupied the Gallipoli synod of 1661 centred on the strange cabalistic characters which were often written on such *brevi*, in particular when written on what elite magic called *carta vergine*. One witness described 'carta verginea' as a part of the caul, or 'a skin that appeared over the face of an infant when it is born, and that infant will then be happy at having his skin used to such effect.'[29] On the other hand, Martin del Río, the Jesuit theologian and

demonologist, defined such paper as being made from the skin of infants who died before baptism, although this practice takes us partly into the realm of fancy and diabolical witchcraft, to be discussed in chapter 8.[30]

Another object that exercised the function of a charm was mentioned by Camilla Nanni of Gallipoli in her cure for cachexia. As we have seen, the court warned her against the misuse of prayers, but this cure does not make use of any. According to Nanni the remedy consisted of rue oil, bay leaves and crushed garlic, up to this point quite a conventional herbal remedy; but this was administered while the patient wore 'a ring containing the great beast's nail'.[31] This was shavings of elk's horn, regarded as a panacea for all ills, and because of its shape was endowed with magical powers and phallic connotations. However, for the patient – and perhaps for the healer as well – most medical prescriptions were in some sense 'magical', since they worked by hidden and inexplicable means.[32]

One cure that worked on a symbolism of balances was described by the Bishop of Oria, Alessandro Kalefati, in his visitation of the church of S. Donato, outside the town of Latiano, in 1785.

> In front of the aforementioned main altar there hangs a rope for attaching a scale, on which infants are weighed, or people suffering from epilepsy, by the labouring people of San Donato who, with an equal weight of bread or grain, seek to obtain the favour of health.... I completely removed the said rope from the church, and recovered such free and spontaneous offerings of the faithful, howsoever they were offered.[33]

St Donatus is here invoked as patron of the 'male di San Donato', which included epilepsy and various other nervous disorders. Similarly to St Paul's relationship with tarantism (see below), St Donatus both 'sent' and 'cured' the malady, though not definitively, requiring annual visits to the chapel.[34] Epilepsy was usually assigned supernatural origins, and the *morbus sacer* was christianised during the Middle Ages into the 'mal de St Jean', 'St Valentins-Sucht' or the 'male di San Donato' according to prevailing cults.[35] In southern Italy the para-liturgical rite of weighing the patient and making an offering of the same weight in grain was a not untypical form of devotion, exemplifying the contractual relationship between saint–patron and devotee (see chapter 6) and symbolising, in this case, the power of the saint to restore equilibrium. Though prohibited by Bishop Kalefati in his diocese, devotion to St Donatus for the cure of epilepsy continued unmolested elsewhere in the Terra d'Otranto. It was still practised in the 1960s – minus the scales – at a chapel in Montesano (diocese of Ugento), with the grudging participation and supervision of the ecclesiastical authorities.[36] It has been suggested that rather than

epilepsy, the malady in question is a form of convulsive hysteria: a ritual malaise like that of tarantism, with the socially accepted treatment of a pilgrimage to the chapel, accompanied by convulsions and screams, where the saint's intercession is implored.[37]

DISEASE CAUSATION

In order to understand popular medicine in the Terra d'Otranto more fully we must attempt to discover what kinds of illnesses were recognised and what criteria underlay diagnosis. These are really one question. As the anthropologist Leonard Glick has remarked, 'the most important fact about an illness in most medical systems is not the underlying pathological process but the underlying cause', so that 'most diagnoses prove to be statements about causation, and most treatments, responses directed against particular causal agents'.[38] Causation can still fit into the three categories outlined by Rivers in 1915: human agency, non-human or supernatural agency, and natural causes.[39] The only difficulty we encounter regards the word 'agent'. For example, the *magara* may be regarded as the agent of the disease, but the source of power is ultimately supernatural, in which case it might be more accurate to refer to human 'actors'.

Diseases caused by human action are the ones which make up almost the entire total of cases brought before the episcopal and inquisitorial courts, since it was necessary to identify the perpetrator in order for the cure to be effective, leading to an increase of social tensions.[40] Although the cunning person's readiness to diagnose a human or supernatural cause for the patient's malady has been noted, in most cases their diagnoses of such causes were much more selective. Frequently the diagnosis of a spell was established only when other possible causes for the affliction had been dealt with and discarded, and other therapies had been tried. Although incurable by empirical means (when such means were within the economic reach of patients), not all incurable ailments were put down to spells, as our look at the recourse to saints will show, and as we shall see in our analysis of tarantism in the Terra d'Otranto. In fact, it was considered sorcery only when the disease appeared strange, and when patients felt themselves to have been the victims of aggression (which must, none the less, have been quite often). Sudden ailments and unfortunate accidents were not usually ascribed to sorcery or the evil eye; such an explanation was applied to illnesses that were slow to develop and difficult to explain. According to Adalberto Pazzini,'it is usually the [cases of] slow wasting away...the stubborn headaches, heaviness of the eyes, general malaise, the halting of development, which give rise to this suspicion, whereby in these

cases one prevails upon the judgement of the particularly expert person who is able to give a verdict.'[41]

The Church affirmed that only its exorcists and capable clergy could ascertain whether an ailment was caused by sorcery, and if diagnosis was positive, then only ecclesiastical remedies could be applied. Many lay people seem to have respected this. In many cases, however, diagnosis and treatment of ailments caused by *maleficia* fell first to relatives or lay 'specialists', or else their services were used alongside those of ecclesiastical remedies in a true expression of popular pragmatism. Indeed, in a 1703 case against Francesca Aromato of Oria, the accused attempted a myriad of cures for her infant son. After she had tried various remedies, such as having a mass said for him, having several priests chant the gospels over him, and bathing him in holy water from the church of Sant'Antonio (for which she was scolded by the priest), and 'suspecting superstitious things and magic' because the boy ate and drank but was never sated, she went to a woman familiar 'with such things'. This woman identified a cunning man who could help. After the cunning man had attempted to heal the infant by touching its head, he declared himself powerless over the spell which was 'ensnaring' the boy, 'since the ensnaring party is a woman with whom your husband Santo is involved and has relations'. At this point, suggesting the evil eye, Aromato remembered seeing a 'tall, tall woman' suspiciously walking outside her house as she was giving birth. She ended her deposition by stating that the boy got better, but we are not told how.[42]

In another case Vittoria de Arrico stated that after giving birth with the accused woman Antonella Seppi as midwife, she was soon unable to nurse her newborn son. So three days later she and her husband took the infant to the town's archpriest, who, after chanting the gospels over him, came to the conclusion that the child's mouth was bewitched ('tiene la ligatura alli musi'), as were the mother and father. At this point, de Arrico's relatives convinced her to take the child to Seppi in order to have the spell lifted. Seppi then spread some kind of ointment on the mother's breasts and the child's mouth, and de Arrico was able to nurse him.[43] As we shall have occasion to discuss, it was common for the suspected sorceress herself to be called to undo the spell, once sorcery was diagnosed. Patients were well aware that a healer could easily become a sorceress if crossed.

CHURCH CONDEMNATION

The recourse to cunning folk for healing purposes was widespread and not limited to one particular class or social group. The Church hierarchy of the Brindisi archdiocese were only too well aware of this, and in the synod

of 1663 they were quick to point out the influence of the devil:

> And because the fragility and slightness of mortals is such that with ease it gives
> way in everyone, so that in order to treat whatever infirmity, superstitious
> inventions, chimeras and medicaments are found and proposed, even though
> they are made available by foolish men and women [*huomicciuoli e donni-*
> *ciuole*] of low and evil condition; herein lies the serpentine astuteness of the
> enemy, who obscures ties of perdition and spiritual death in words and signs
> with the appearance of piety, which in truth are words and things of an express
> or tacit pact, which they superstitiously have with the devil...

The synod's prohibition against 'every sort of healing with words, signs,
notes or any other kind of such vain observance' was directed against

> any person of whatever status, quality or condition who applies, accepts,
> counsels, looks for or commands such vain healing, or to put it better,
> abhorrant magic, whether in men, women, or animals, trees or other living
> vegetation; since we know from experience that this diabolic superstition
> extends to all these types.[44]

This type of decree was fairly typical of the Counter-Reformation
Church, bent as it was on eliminating magical remedies in heretical
competition with its own ecclesiastical remedies in the form of
sacramentals. Throughout Italy the regional offices and representatives of
the Roman Inquisition stepped up the prosecution of 'superstitious of-
fences' after the 1570s. The absence of Protestant heretics in the Kingdom
of Naples meant that such offences came to constitute the prime focus of
late sixteenth- and early seventeenth-century inquisitorial activity. Episco-
pal courts usually dealt with what were called superstitious offences them-
selves, as was the case in the Terra d'Otranto, as part of their jurisdiction
over criminal matters (unless the case was particularly serious or complex).
Sometimes a representative of the Holy Office would handle cases for the
bishop or his vicar. Despite the demonological theory, the practice of these
representatives was to downplay an explicit diabolical pact, identifying
magical practices with ignorance and the misuse of rituals properly re-
served to the Church (as in the warning given to Camilla Nanni for her
unorthodox use of prayers). For this reason, the Roman Inquisition's
manner of operation differed 'markedly from related campaigns elsewhere
in Europe which placed greater strength on the diabolical nature of
popular magic'.[45]

As described in the Brindisi synod cited above, many of these healing
rituals were used in good faith by those practising and those receiving
them. There is no mistaking the piety of someone like Donato de Quarto
or Beatrice Contistabile, and it was precisely this that made their cures all

the more pernicious as far as the Church was concerned. Much of the campaign against popular healing thus consisted in instructing the faithful what was orthodox Church teaching on matters like intercession, sorcery, possession and so on. For this approach to be effective, the parish clergy and friars, as the 'local representatives of orthodoxy',[46] had to be reliable and well-trained. Preachers constantly reminded people to reveal any sorcery or witchcraft to the bishop or the Holy Office, and the absolution of sins in the confessional was routinely withheld pending the denuncia-tion of one's own or a neighbour's offences. Clearly this was at least partially effective: many plaintiffs appeared before the court 'spontane-ously' (voluntarily) because of a 'scruple of conscience'. Francesca Macarello, in an accusation cited above, made it as a confession to save her soul, 'having heard that when superstitious things are involved, one must denounce them right away to Vostro Signore Illustrissimo [the bishop]'.[47]

The drawback, of course, was that much depended on the orthodoxy of the local clergy, since it was up to them in the first instance to determine what was a superstitious invocation and what an acceptable and legitimate prayer, and to advocate only ecclesiastical remedies. In the 1741 Oria case cited above, Don Matteo, a Capuchin, recognised the misuse of sanctified articles by the *magara*, but in the end acquiesced and agreed to their use.[48] Ecclesiastics, because of their special links with the divine and their role and involvement in the local community, were often pressured into performing or accepting popular rituals. Indeed, as we have seen, some were full-fledged healers themselves.

Moreover, it was frequently difficult for the bishop on visitation to learn much from the clergy about magical practices in his diocese. When interrogated by the bishop, the clergy did not always reply willingly, often dodging the question or replying with half-truths, and hiding the facts or withholding names when possible.[49] In his visitation of Oria (then part of the Brindisi archdiocese), Archbishop Bovio asked the archdeacon, Pietro Corrado, about *sortilegi* (sorcerers). He replied 'that there are many, whose names he does not know'.[50] In Bishop Antonio Pignatelli's (later Pope Innocent XII) 1676 visitation of the Lecce diocese, all but one of the local archpriests said that there were no 'sorcerers, blasphemers, men keeping concubines or public sinners'. Only the archpriest of Squinzano, Donato Manca, furnished any names, responding that 'some news has reached him that Pascha Civina performs some superstitious acts, as was referred to him by Giustitia Ferrara and Theodora Persana'.[51] Many bishops failed to interrogate the clergy on such matters as part of their visitations, but the 1784 visitation by the bishop of Oria, Alessandro Kalefati, fits the Tridentine model. He diligently asked the archpriests if they knew of any

sorcery ('sortilegia, et sectatores inanis artis magiae') among the faithful. Some priests referred to lists of names handed to the Bishop during the course of the visitation, but Don Antonio Preti, archpriest of Avetrana, was clearly among the most perfunctory.

> There is indeed a little coarse and foolish superstition among the ignorant *minuto Popolo*, and I, who have always believed and believe it to be utter foolishness, do not fail to insinuate, preach, catechise and do all that I can to eliminate such foolishness and trifles from their souls.[52]

THE TRIAL RECORDS: POPULAR HEALING AND SOCIAL RELATIONS

So the historian's main source of information must be the episcopal and inquisitorial trials, but even these should be used with caution. It is important to keep in mind, for instance, that there was a large gap between the inquisitor preoccupied with the defence of religious orthodoxy and those who appeared before the court, whether as plaintiffs, defendants or witnesses, bent on preserving their honour, harming their enemies and mobilising relatives, friends and clients on their behalf.[53] Social factors frequently lay behind a denunciation for magical practices: it was a relatively safe and easy means of revenge for the victim of magic, given the plaintiff's position of strength in such trials. Although the paintiff had to make a signed denunciation, giving details about himself or herself if the accusation was in written form, it was up to the accused to prove his or her innocence. Appearing before the court, where Latin was used, at a time when most people spoke only their local dialect, must have been a nerve-wracking and frightening experience for the accused, whether innocent or guilty. No doubt the defendant felt more comfortable when giving testimony in the sole presence of the bishop, as in the trial against Camilla Nanni. When she was asked in the course of her second deposition why she had failed to be more forthcoming the first time around, she replied that if just the bishop had been present during her first deposition she would have spoken, 'but since the Vicar judge and Master of Acts were there I was afraid to testify'.[54]

Revenge was not the only motive in bringing an accusation before the court. We have already encountered plaintiffs troubled by their con-science, or their desire for salvation, or sure in the conviction that magic was evil and had to be condemned. Often there was a combination of feelings, as in the case of Francesca Macarello who made the denunciation to save her soul, having no doubt as to what was orthodox behaviour. She reported asking the accused, who had had recourse to two healers, the

following question:

> What do you mean? You know those people who make use of such magical things, who deserve to be burnt and punished by the law, and yet you hide them and don't publicise their names so that they can be punished like they deserve?[55]

According to Macarello the accused replied that she could never make public the names of those who had healed her son, resulting in their being punished for it. Macarello tried in vain to make her reveal the names.

Social relations were also crucial in the actual course of disease and diagnosis. When things broke down here, as they frequently did, they often led to the denunciations and trials which are our main source of information. In other words, if we regard the diagnosis of disease as a statement about malevolent sources of power, then it is logical that available treatments would be diagnosed to attempt a restoration in the 'balance of power' between antagonist (the healer-sorcerer) and victim (the patient).[56] If the malady had been caused by a human actor, and had to be exorcised or conjured out, then the most efficacious cure often depended on contacting and placating that same actor, whatever the Church had to say about it. Where illness was perceived to be caused by divine forces, such as a particular saint's anger, the only cure was his intercession and forgiveness, as we shall see in chapter 6.

In 1742 Carmina de Tomaso denounced Giustina Quaranta before the episcopal court in Oria.[57] In her deposition de Tomaso stated that a year before, 'during the fig and pear season', she had been offered a pear by the accused in return for some favour (we are not told what), but she declined. Shortly afterwards, de Tomaso's father Pascale became ill, and despite all the food he ate, he was soon reduced to skin and bones. De Tomaso went to the chapel of the Madonna del Soccorso where she lit a lamp for her father. She also prayed fervently to the Virgin for several nights, asking for his health to be restored, 'or else to discover what it was' causing the malady. The latter part of her prayer was answered when a woman (no identity given) appeared to her in a dream saying, 'Go find Giustina Quaranta and offer her something, and if you make her your godmother, your father will get better'. After Quaranta had agreed to be her godmother, de Tomaso asked her subtly: '*Commare*, don't you see that if you have some Saint you could pray to for my father's health I'll offer you something?' Quaranta was anxious to know what was on offer, and when de Tomaso suggested one *carlino*, she replied that it was not enough. They finally agreed on two *carlini* and a grain wick, Quaranta warning de Tomaso not to trick her.

According to de Tomaso's denunciation Quaranta then went to exam-

ine Pascale, saying that the illness was nothing, and that he could take out his hoe and go to work the next day, which he did, to everyone's amazement. However, things had not yet reached an end, as Pascale became ill again several days later. When de Tomaso went to see Quaranta about it, the latter agreed to heal him, while complaining that de Tomaso never greeted her when she saw her. After an improvement in Pascale's condition, the situation was once again knocked out of balance when Quaranta approached de Tomaso bearing a 'message of matrimony' from a man to which de Tomaso reacted very severely. Once again Pascale sickened, forcing de Tomaso to seek a rapprochement with Quaranta, who again restored his health.

By this time Pascale was understandably fed up with being the barometer of someone else's friendship, and he went to see the bishop. Perhaps Pascale failed to receive immediate satisfaction from him, as he returned home threatening Quaranta that if she made him ill again he would kill her. Of course, this had the effect of enraging Quaranta further, and immediately after she left, Pascale 'said he felt something like a ball in his chest, which seemed to be forcing out his spirit'. Pascale's wife went at once to beg Quaranta to come back and heal her husband. She was reticent at first, refusing to look at him, but then with a clap of her hands his ailment passed. At this point the accused and the plaintiff became closer friends (close enough for Quaranta eventually to take her along to the witches' sabbath, but that story will be told in chapter 8).

It was commonly held that those who were capable of healing could also harm, inducing the very symptoms they later offered to cure, in the way of 'qui scit sanare, scit damnare' (who knows how to heal, knows how to destroy). Indeed, as Carlo Ginzburg suggests, this phrase may be of popular origin.[58] Clearly, healer-sorcerers were in a position to gain standing within the community by so doing, which was no doubt desirable, given that they were often aged and unmarried (or widowed), with a meagre or irregular source of income. The cause was not always financial. In 1704 a forty-five-year-old widow of Francavilla, after being accused of sorcery by another witch, admitted to making a charm against a certain Andrea Greco for the purposes of revenge (he had stolen a cat for which she had been blamed). Greco unknowingly sat on the charm, consisting of three grains of 'enchanted salt', which caused him 'to blunder about and go mad [*far spropositi et impazire*]'. Greco's brother went to Donatino and begged her to cure ('sanare' is the word used) his brother. He was cured (that is, the spell was lifted) following her instructions. To thank her and make her peace with her, the boy's father gave her a new pair of shoes and some copper, adding that she could have anything else she wanted. But

Donatino, her position and honour restored, gave it all back, saying that nothing was due her. The balance had been restored.[59]

Healers could get quite testy if not shown the necessary gratitude. For instance, Lucrezia Epifane testified in 1704 that when her husband's two horses fell to the ground as if dead two years earlier, her neighbours suspected a spell (*fascino*), which she called Caterina Patrimia over to cure. Patrimia did so, Epifane recounted, by touching the horses' heads, making the sign of the cross and murmuring something which Epifane could not make out. Epifane was not making the denunciation for religious reasons, for she was of the opinion that Patrimia 'didn't make or use anything superstitious or against the Christian religion'. She also denied accusing her out of emnity. None the less, she noted that later she lent Patrimia one *tarì*, which she was slow to repay, insisting that Epifane and her husband were not grateful for her services. When Epifane's husband got ill shortly thereafter they immediately suspected Patrimia of being a witch and so came before the court (a full two months after Patrimia had first been accused).[60]

Of course, victims of sorcery could attempt to redress the balance by employing ecclesiastical remedies. On a wintry day in 1723 Antonella Seppi went to the house of Isabella di Nitto asking her for oil, but the latter had none to give, and not wanting to offend her and because it was quite cold she gave her some wood. However, Seppi did not send anyone to collect the wood, and the very next night di Nitto got a severe headache and was unable to eat. Di Nitto's husband went to ask Seppi what the illness was, and she replied that his wife was pregnant. Since di Nitto doubted this possibility, the couple called in Fra Gregorio Lupo, who concluded that it was a spell, and for 'many days tended me and gave me blessings, holy immersions [*bagni*] and read over me'. This, combined with the intercession of the Madonna di Galasso, soon cured her.[61] Di Nitto's accusation may have served both instrumental (that is, goal-directed) and symbolic functions. The specific goal was to see the wise woman punished for her misdeeds. The symbolic function concerns the transfer of guilt from the victim, who denied hospitality or kindness, to the accused, singled out as morally culpable.

MIDWIVES AND THE EVIL EYE

Because pregnant women were especially vulnerable to sorcery and the evil eye, midwives were often regarded with a certain degree of suspicion. An innocent practitioner might be accused of sorcery if a delivery had an unhappy outcome, or if there were difficulties in nursing the infant. The

occupation of midwife and the accompanying lore was often passed from mother to daughter. It was a tiresome job that won a grudging respect for the practitioner – which could easily turn to hatred if she was suspected of evil-doing – and payment in kind (foodstuffs or oil).[62] The newborn infant was particularly vulnerable to the dangers posed by envy and the evil eye, which caused it to cry, vomit, turn pale, sicken and even die. Given that as many as one-fifth of infants died at birth or during the first few months of life, the assumption that a midwife had killed by using sorcery was both convenient and plausible and presented the parents with a means of retribution.[63] Antonella Seppi, the midwife for Vittoria de Arrico mentioned above, was accused by Maria Monte of having caused her infant's death after she had refused to come to Torre Santa Susanna to help with the birth. Seppi said she had nothing to do with the infant's inability to nurse and its vomiting, suggesting 'it could be that since you live at the *masseria* the shadow of a fig tree harmed him'. Monte had enough faith in Seppi's powers to have her prepare a *breve* for the child to wear.[64]

Another midwife and general healer, Camilla Rubino of Latiano, was denounced by several women together in 1722. One of the women, Cecilia d'Adorante, deposed that after giving birth she went to Rubino asking for some of her 'childbirth potion' (*beveraggio del parto*), which the latter refused to give (we are not told why). D'Adorante left, expressing her displeasure, only to find on her return home that she was unable to nurse her infant daughter. She went back to Rubino, asking that she 'give back her milk', and although Rubino was reluctant at first – 'saying she wasn't Sts Cosmas and Damian' – she finally gave in and placed d'Adorante's nipple in her infant's mouth, and after a bit of blood the milk began to flow.[65]

The midwife's role was a pivotal one, since supernatural diseases threatened the unborn infant, the 'unchurched' mother and the unbaptised baby.[66] She not only assisted at births, but treated the diseases of infants and women – her activities overlapping with those of the wise woman in this regard – as well as sexual problems (another area fraught with malign influences). The invocation of the Virgin and the use of sanctified objects such as like saints' relics during difficult stages of labour was encouraged by the Church, and to this the midwife added her own prayers, invocations and charms. It was also up to the midwife to make sure that the infant was properly baptised, doing this herself if the infant was close to death. For this reason it was imperative that she should know and use the Church's baptismal ritual correctly, which the clergy was charged with teaching. The Brindisi synod of 1663 warned that midwives must only baptise infants in cases of emergency if they had been properly in-

structed.[67] And because of this power of baptism in the case of necessity, the Church was concerned that the midwife should not engage in 'superstitious' methods or sorcery. Many Church synods and decrees forbade such practices, suggesting that midwives continually fell under suspicion. The 1679 diocesan synod of Otranto stated:

> We warn midwives, and command them under pain of excommunication, that whilst bringing infants to baptism or carrying them back home from baptism they abstain from all superstitious observances, nor place anything above [the infants] while they are being baptised, which could be used afterwards in sorcery, or (as they say) for remedies.[68]

The bishop had authority over the licensing of midwives and, through parish priests, was able to keep an eye on their activities, ensuring that they were devout and of good habits. Obviously the parish priest's opinion in this regard depended on information gathered from his parishioners. It is difficult to know just what information, if any, priests communicated to their bishops, given the weakness in the parish structure discussed in chapter 2. However, it would seem that this rudimentary form of control over the midwives', activities, combined with their legal duties of examining women in cases of suspected rape and infanticide, as well as their generally respected position in Otrantine commmunities, protected them from accusations of diabolical witchcraft.[69]

Midwives, however, were sometimes accused of being the cause of nursing difficulties, such as galactophoritis. Because the woman's breasts were regarded as a source of life for the infant, they were under constant threat of drying up, the milk 'stolen' by envious women.[70] In Friuli, where the female body was often used in *preenti* (spells), the cure for galactophoritis is the only known occasion when the male organs demonstrated their lost magical powers: a comb (a few women actually mention the use of a man's penis for this purpose) was used to trace the sign of the cross on each breast.[71] In the ritual quoted by the ethnologist Ernesto de Martino, the comb had been replaced by a dirty cloth, with which one sign of the cross was made on each breast (alternatively, three signs of the cross were made with a finger), accompanied by prayers.[72] The intercession of St Agatha – a martyr whose breasts were cut off as part of her torture – was also sought, and her image could also be applied to the breasts.

Feelings of envy were often believed responsible for ailments affecting the mother and child following birth. In 1722 Anna Maria Palazzo stated before the episcopal court of Oria that Camilla Rubino had come to see her after she had given birth, complimenting her on her appearance,

saying that she did not even look as though she had given birth. As if to veil this open threat, Rubino gave Palazzo three kisses to protect her from aggression ('so as not to be bewitched'). Palazzo recounted that she had immediately felt a stabbing pain like three nails piercing her heart, and from this time on could only manage to swallow a bit of water. After twelve days of this, during which time Palazzo's mother said many prayers for her with no improvement, she had Rubino come over. Rubino kissed her three times (note the symmetry), after which Palazzo vomited, causing the pain to pass and her appetite to return.[73]

Such were the risks of the evil eye for the all but defenceless mother. But *malocchio* was by no means restricted to mothers and babes-in-arms. Since the evil eye was a form of spell (voluntary or involuntary) motivated by feelings of envy, anyone was a potential victim, particularly those of exceptional beauty or good fortune. Such was the relation between the evil eye and envy that the force was often known by the latter word (*invidia*). Envy may have been a frequent reaction, given that in a society of limited goods, when one gains another loses (or, at least, such would have been the perception). In 1704 Caterina Patrimia told the episcopal court of Oria that when one of her daughters had been ill fifteen years before, she had taken her to Antonia Donatino to have the spell lifted.[74] Patrimia had told Donatino that her daughter was 'bewitched, especially in the eyes and codola', and at times could barely see or stand up due to the pain in her kidneys. Donatino concluded that the pains which Patrimia's daughter suffered were caused by 'the eyes of those in love with her', because of her prettiness. Never is *malocchio* mentioned by name, perhaps because it is not as socially regulated and organised as sorcery, but the concept is clearly present.

Although in his discussion of the evil eye Helmut Schoeck concludes that there is no physical link between the aggressor and the victim,[75] it is in fact the malevolent eye contact that is all-important. Schoeck is correct in noting that the entire process takes place within the victim – who ascribes the eye of envy to an aggressor – especially when the evil eye is involuntary, often accompanied by feelings of futility and melancholy. It could cause anything from headaches to madness and was difficult to diagnose, the most widespread technique involving dropping three drops of olive oil into a bowl of water (the oil would separate or expand if there was *malocchio*; if not, the illness had another cause). Nicodemo Salinaro of Francavilla attempted a similar divining technique in 1678, employing a pitcher of water into which he dropped virgin wax, which was supposed to take the form of an angel when effecting the cure.[76]

Because of its unpredictability and hidden manner of operation the evil

eye was difficult to cure, the best medicine being preventative. Aside from not doing anything that would occasion envy (a potentially impossible task), there were *scongiuri* against the evil eye's manifestations. But the most effective protection came in the form of amulets and *phalli*, which were worn about the person, while children were given *brevi* to wear, or iron (in the form of a nail) was placed in or over the cot.[77] If the evil eye can be regarded as one of the particular manifestations of the negative which dot existence on an imaginary or perceived level (that is, the feeling of being dominated by dark forces), then such amulets and other types of 'low ceremonial magic' protected the individual on a psychological level from the risk of being unable to carry on when confronted by such forces. These techniques gave the individual the tools necessary to cope with the perils of life, by providing a protected realm of existence.[78] This protected realm of existence was expanded to the entire house and household when protective symbols were painted on stone roofs, as in the region of the *trulli* (bee-hive shaped houses) between Brindisi and Bari.[79]

ABORTIONS AND *RUFFIANE*

Despite the threats posed by the evil eye and more ritualised magic to mother and child, there were still a large number of undesired pregnancies. This is an aspect of popular medicine which is rarely discussed, either in the historical records or in the works of modern historians, although 'the numerous potions and medicines to procure abortion' are occasionally referred to.[80] Yet such techniques were not uncommon, and were the realm of midwives, though procuresses also seem to have possessed certain techniques, and apothecaries were sometimes accused of selling abortifacients.

Such medicine frequently had important social implications, and the relevant trials often reveal as much about amorous relationships in a closed and closely regulated society as they do about the lack of safe and reliable contraception and abortion techniques. Despite the opposition of churchmen, such techniques formed an important part of demographic strategies.[81] In 1702 for example rape charges were brought against Rev. Isidoro Dolce of Gallipoli by Giulietta Allegretti; but the case was not nearly so cut-and-dried as might appear.[82] Twenty-two-year-old Allegretti was pregnant owing to rape and *subsequent* sexual relations with the accused priest. The encounters were arranged by Rosa Melgiovanni, a *ruffiana* or procuress, described by one woman as running 'a bordello in her house, having always seen scandalous young people there'.[83] She does not seem to have been well regarded by the community, for another deponent stated

that she and her neighbours, 'in fact all of us in the area, thought the said Giulietta had been seduced by the said Rosa by means of spells.'[84] Allegretti recounts that Rev. Dolce told her not to worry about the relations, since he has had them with many women without any problems. But when she did get pregnant, Melgiovanni gave her herbs to drink and an ointment to rub on her belly that she said would cause an abortion. When this failed to work, Dolce brought a plaster which she was to keep on her belly for twenty-four hours, and told her that he was going to fetch a woman from Soleto who would perform the abortion. When Dolce failed to return (nor was he present to defend himself in court), Allegretti's aunt talked to a priest, who informed the city's governor, thus instigating the proceedings.

One wonders how frequently *ruffiane,* and cunning folk in general, had recourse to such abortion techniques. In 1745 the Sicilian canon G.E. Cangiamila noted that any priest will find in his parish

> those who *ex professo* perform the office of selling for charity medicaments to cause abortions both to inanimate foetuses and animate ones. This wickedness is often found among the women of the *malavita,* and not rarely the superstitious, who are also procuresses, and amongst midwives as well, also known as *mammane,* to whom the girls go with their mothers or neighbours for help.[85]

Domestic methods of inducing abortion consisted of bloodletting, as well as vigorous massages and blows to the womb, often endangering the mother's life as well. There were also various medicinal preparations, like the *venena abortionis,* the use and sale of which was forbidden by both secular and ecclesiastical authorities. In a 1674 case against a priest (and such cases naturally fell within the episcopal court's jurisdiction), an apothecary was suspected of providing – though not administering – an abortifacient, composed of ground herbs and roots, together with parsley juice.[86] Pills and syrups for this purpose, containing rhubarb and vetch, were sometimes illicitly supplied by apothecaries.[87]

TARANTISM

One illness that neither the *magara* nor the apothecary could cure was that reputed to be caused by the bite of the tarantula spider, a culturally-bound disorder known as tarantism. The official pharmacopoeia, not to be beaten, suggested the following *aqua vitale*:

> ℞ A good quantity of orange flowers, tender oak leaves, thistle, field scabious, sow-thistle, sage, marjoram, lavender flowers, wormwood, Coltsfoot, Viper's Grass, anise, borage, strawberry-tree leaves, lentils, rue, sedge, angelica root,

bay leaf, juniper, orange-tree bark, tormentil, one ounce zedoary, one ounce cinnamon. Everything is distilled in a bain-marie and served in water.[88]

Part of the ailment's problem lay in diagnosis. The symptoms of malaise, weakness and deep melancholy which plagued the *tarantato* (the victim of tarantism) were often thought to pertain to other illnesses, which resulted in recourse to a series of healers.

> Not always, nor everywhere, nor by everyone is the patient perceived to be a *tarantato*; sometimes they call the *musicanti* (musicians) only after they have had him examined by *messèri* (doctors), *masciari* (charmers), and *padri* (priests). Despairing, that is, of being able to recognise the nature of the malady in normal ways (for them), they believe that it must be caused by the poison of the *phalangio* spider, and must attempt the test of whether the patient can dance.[89]

The melancholy was such that one *tarantata* realised she had been 'bitten' because 'from that day on I hardly closed my eyes to sleep at all. A constant pain kept my whole person in discomfort. That however was nothing; the principal malady was a profound melancholy which assailed my spirit. Everything seemed so very dark to me; the people clothed completely in black, the houses painted black. The thought of death pierced my soul'.[90] Conjurations could be attempted, of the same sort as those used against the bites of vipers and rabid dogs, but they would have little effect against tarantism. Canonical exorcism, efficacious in many other instances, was useless against tarantism. This left only the ritualised dancing as a possible cure. In a case from the mid eighteenth century reported by Nicola Caputo, a fifteen-year-old girl from Lecce, Francesca Lupo, was affected by the usual symptoms of fever, anxiety and emaciation. Medicine was useless and her relatives thought her possessed, and for several years they tried canonical exorcisms, all in vain. It was only when she heard the music that they realised she was a *tarantata*, and the appropriate ritual remedy could be applied.[91]

In the early seventeenth century, Girolamo Marciano wrote in his manuscript that while walking through the 'torrid lands' of the Terra d'Otranto he heard wandering musicians playing pipes and drums, which, they told him, were to cure those bitten by the tarantula. Being curious, he followed them to a *masseria*, where a young man was dancing furiously but in ordered fashion to the rhythm of a drum.

> Likewise, one often sees a few men and women, old and decrepit, who have no strength at all, nor natural colour, stung by the tarantulas, who, as soon as they hear the music, and especially the sound most pleasing to them, rise up to dance and jump as if they were powerful youths for the space of three or four

hours at a time without ever tiring; and, once the music has stopped, become languid, very cold and frigid, as if dead. But once the music is begun again, their natural colour and vital spirits are excited, the languishing person is reinvigorated, and dances faster than before; and so continuing, while, with the sweat worked up by dancing, the poison is totally extracted and consumed...[92]

Yet the *tarantato* performed a ritual of which the dancing and music was only a small, if vital, part. In 1717 a British philosopher travelling in Apulia observed, for instance, that the days of dancing were not limited to three, different instruments were used for different patients, a mirror in which they saw the tarantula was used to direct their motions, often accompnied by the brandishing of a sword.[93] Coloured ribbons were placed before the *tarantato*, so he or she could pick the one relating to his tarantula and begin the dance, and a sort of ritual swing hanging from a tree was used, perhaps to simulate the movement of the spider along its web.[94]

As the town of San Foca, near Lecce, was protected from insect and snake bites by the Byzantine saint of the same name, so the town and surrounding countryside of San Pietro in Galatina was immune from tarantula bites, due to the local protection of St Paul. St Paul was regarded as the protector and patron of *tarantati* because of the episode at Malta described in Acts (28:3–5), where he harmlessly shook a viper off his hand. As part of the christianisation of tarantism it had come to be believed that when St Paul was travelling near Malta he landed at Galatina to stay at the house of a local Christian. To thank the man for his hospitality, St Paul gave him the power to heal the bites of poisonous animals, by making the sign of the cross on the wound and giving the patient some water to drink from his well. After his family line was extinct people continued to come to the 'house of St Paul' for the miraculous water, reputed to heal patients immediately.[95] Furthermore, cures for tarantula bites such as 'Maltese earth' were sold throughout the Terra d'Otranto by 'foolish women and market pedlars, who lie, saying they are of the house of St Paul'.[96] These *sanpaolari* showed signs similar to snakes under their tongues and knees or on their arms and legs in order to sell their cures, incurring the wrath of both the Church and the medical profession.

In 1752 the house and well at S. Pietro in Galatina were purchased by a wealthy local landowner, Nicola Vignola, for the sum of seven hundred ducats. Because of disputes between his family and the church chapter over the right to say masses (and the earnings they generated), a chapel was only built and consecrated in 1793. No doubt the church authorities hoped that the chapel would weaken the activities and influence of the *sanpaolari*

and put those poisoned by the 'animals of St Paul', notably the *tarantati*, under some sort of clerical control. In the 1837 visitation of the chapel, the archbishop of Otranto, Vincenzo Grande, wrote the following description of what we might call the institutionalised part of the ritual:

> It has an altar, where there is an image of St Paul painted on canvas, embellished with propriety. In the sacristy there is a well, and by drinking its water those who are affected by the poison of vipers or other animals most frequently regain their health, immediately from God, through the merit of the Blessed Apostle; whence it is believed such is the virtue of this water to be imparted in healing disease. Hence it is that the faithful come here from even distant places, and many make offerings which provide for necessities both in this chapel and in the sacristy of the mother church.[97]

Meanwhile, the *tarantati* continued to dance as part of the cure, while making a vow to St Paul, carried out by a visit to the chapel upon being successfully cured.[98] Such vows would have been accompanied by the following invocation:

> E Santu Paulu miu de le tarante
> famme la razia a mie e poi a tutte quante.
> E Santu Paulu miu de Galatina
> famme la razia a mie la prima prima
> a 'du la pezzecàu ci sia 'ccisa
> a sutta la putìa de lu fustiano.[99]

And musicians continued to wander the Salentine peninsula playing for the *tarantati*, though increasingly indoors because of religious pressure. Indeed it was the musician who took over the intermediary role played by the wise woman or priest in other forms of ritual healing. He was regarded as that extraordinary and powerful person able to 'hear' and interpret the hidden voice of the tarantula, and re-establish the relationship with the patient through the choice of the correct musical motif.[100]

In 1723 Francesco Malagnano, an eighteen-year-old field worker from Casalnuovo, confessed to the episcopal court of Oria that he had had a charm made for him to attract a certain girl named Apollonia. He was unable to carry out the spell because in the meantime he had been bitten by a tarantula, 'and having done several dances to get better, I was ill for more than a month', during which time she got married. But the story does not end here. He began working at a *masseria*, and while out in the fields one day he was approached by a woman he had never seen before, who asked him if he was married and if he knew about sex ('and many other dirty things'). She appeared a second time to tempt him; the third time was at night, while he was asleep, when she began to 'play around

with her hands', and he touched her, leading to his committing 'a sin of pollution'. The fourth time, he went on to tell the court, she told him she could arrange for sexual relations if he made a pact with the devil, to which he agreed. Later, when he was on an errand, a woman approached him asking if he wanted 'to know her carnally', but he took fright, shouting 'Madonna del Carmine, help me!', and then heard a voice which said, 'Stop it, he's just a poor boy'.[101]

In many ways Malagnano's case is typical. For many victims, tarantism was clearly a way of reacting to social pressures and restrictions, primarily regarding *eros*, which was barred by familial rank, custom and the trials of love.[102] For this reason, the phenomenon was predominant among women, including those from the upper classes. Of the eleven cases of tarantism described by Caputo for Campi (diocese of Lecce), seven involved women; the majority took place within a remarkably short span of time, during July of 1728 and 1729.[103] Although the frequency of so-called bites paralleled the increased possibility of being bitten during the summer months, it is more likely symbolic of the increased tension during this period of intensive labour, so crucial to the harvest's outcome, which resulted in a heightening of personal crises.[104] In this respect, tarantism could be seen as a ritualised response to profound psychological malaise, which could only be expressed in terms accepted by society, through the ritualised evocation and discharge of the crisis by music and dance. Or, as Claude Lévi-Strauss would have it, a 'language' which allows the patient to express otherwise unexpressed and inexpressable psychic states through the efficacy of its symbols.[105]

As early as 1621 the victims of tarantism had been observed by one author (a Dominican) not to be the victims of real tarantula bites. But he put their ritualised response down to fakery and charlatanism:

> These people pretend that they have been bitten by some animals that spring from the territory of Taranto (after which they are named) and have fallen into that infirmity, which makes them like madmen. They quiver and hurl their heads, shake their knees, often they sing and dance to the sound, move their lips, grind their teeth and make the actions of madmen. They ask for nothing, but their companion-leader says for all that he is an *attarantato*, and asks for and collects alms on their behalf.[106]

In the ritual a head *tarantato* did often guide the other assembled victims through it, in a form of choreatic dancing not unlike the St Vitus' dance, though this century has been witness primarily to deculturated, single 'performances'. Early condemnations of fakery exemplify the problems of the modern scholar when faced with illnesses which do not fit our medical

concepts. Such is the case with other culturally-bound maladies found throughout the world. A recent study of *susto* (literally, 'fright') in Spanish America concluded that 'whereas the villagers "knew" susto to be a sickness, we [the authors] were obliged to consider the possibility that it was, instead, a stylized pattern of behavior by which individuals attempted to correct troublesome social relations or to call attention to their social or emotional needs.'[107] *Susto* would appear to share much with tarantism. It is said to begin with a particularly startling or frightening experience, leading to a loss of vital substance or force. The onset of symptoms – physical and moral exhaustion with grievous deterioration of health and even death – could then be triggered by especially trying times for the individual, a period of great stress regarding the evaluations of the person's community role and performance.[108]

In 1621 a physician from Mesagne (archdiocese of Brindisi), Epifanio Ferdinando, wrote that he knew of many ecclesiastics who, because of their honesty and reserve, had not wanted to assent to the musical exorcism, and so had been pierced by 'terrible sorrows' (*malignas aegritudines*).[109] In 1705, Nicola Perrone, a priest in Campi, was afflicted with the malady.[110] The simple cleric was then thirty years old, having been ordained into the priesthood at the age of twenty-three, and lived at home with his mother and sisters.[111] While at home suffering the deep melancholy and physical weakness characteristic of *tarantati*, he heard music from the street accompanying a procession of the Blessed Sacrament. As he went to the door and caught sight of it, and hearing the music, his face became pale and he started trembling. Perrone called over the musicians and had them play various melodies until they hit upon the right one (matching the temperament of the tarantula that bit him), at which point he began to dance, finding relief and eventually a cure.

Perrone's case was outlined in Caputo's 1741 work on tarantism, *De Tarantolae anatome,* which presents numerous case studies of *tarantati* drawn from throughout Otrantine society. Indeed Caputo, a physician practising in Lecce, included his own wife among the cases. Yet increasingly, Enlightenment thinkers were beginning to regard tarantism as a useless and ineffective relic, in contrast to earlier writers who had discussed the phenomenon seriously in musico-medical terms. Towards the end of the 1700s Neapolitan intellectuals effectively severed any link between popular tarantism and the highest levels of cultural life. In his travels from Naples to Lecce undertaken in 1818, Giuseppe Ceva Grimaldi noted that the ritual dance was especially practised by the 'volgo'. He concluded, somewhat romantically, that even if it were an illusion, 'why deny happiness to this unhappy class, condemned to toil and poverty? Happy is the

prejudice that spreads a balm over the evils of life.'[112]

At the same time the Church had been doing its best to rid tarantism of those elements perceived to be non-Christian, if it could not eradicate the ritual altogether. One of the earliest works on tarantism, by the Jesuit Atanasius Kircher (1654), was based on information collected by two Otrantine Jesuits, Paolo Nicolello and Giovan Battista Galliberto, of the Lecce and Taranto colleges, respectively, who had talked with physicians and *tarantati* on Kircher's behalf.[113] This information no doubt contributed to the decree of the 1687 Lecce synod, celebrated by Bishop Michele Pignatelli, which threatened a year's imprisonment for ecclesiastics 'if [they] dance, lead the dances or play music on feast days or else are seized by the *morbo tarantae...*'.[114]

The Jesuit missioners from the Lecce college were also involved in this campaign. Whilst on a mission to the town of Caprarica (archdiocese of Otranto) in 1741, they reported widespread choreatic dancing inlvolving all classes of townspeople, noting in particular their state of undress. Typical of the mission accounts, this one concludes that the townspeople soon saw the error of their ways and sought forgiveness during the course of the mission.[115]

The Church's attempts to christianise the ritual had the effect of driving it underground, initiating the long process of cultural disintegration, where the various ritual elements slowly lost their meaning and effectiveness. When Richard Keppel Craven travelled through the province in 1820 he was told that in Brindisi, close to the historic 'centre' of tarantism, 'persons of rank and education superior to that of the middling classes had been attacked by the malady' and obliged to undertake the ritual dance. In Taranto, however, cultural disintegration had already set in, for he was told 'that the lowest and most ignorant among the labouring peasantry, and these only females, had ever shown symptoms of it during the last years'.[116]

Despite the 'deculturation' of tarantism underway towards the end of our period, there is no noticeable shift in wider beliefs regarding healers and their rituals. As always, popular medicine continued to be a predominantly female field, in part because poor, elderly women were frequently driven to the margins of society and so depended on such services for their livelihood, their activities often taking on an aspect of disguised begging. Yet healing and health were also a natural part of the female domain in southern Italian society: part of the woman's concern for the family's survival and well-being. Wise women – like those saints who caused and then cured diseases – continued to fulfil an ambivalent but necessary role

in society. A precise causal agent (as far as the patient-victim was concerned) also meant the imminent potentiality of cure. In the way that the magical representation of illness was mixed with the feeling of being dominated by dark forces, so the magical representation of the cure was mixed with the feeling of being cured.[117] We should not underestimate the importance of the healing rituals in 'the acting out of sickness, and the symbolic treatment of disease in its social context', which must have so appealed to the mind and imagination of the client.[118]

In wider terms, popular healing rituals were certainly no less effective than the other options from which people could also choose, which included the remedies of professional physicians and apothecaries, semi-professional barbers and surgeons, itinerant charlatans and pedlars, and the wide range of ecclesiastical remedies, from simple blessings to more complicated exorcisms. This pluralism was paralleled by the possible causes of disease, natural, supernatural and human. The persistence of lay healing rituals was in keeping with the continuity in the Church-sponsored forms of healing and protection during the early modern period. While the ecclesiastical authorities attempted to eliminate the extra-liturgical forms which it regarded as working through diabolical forces, the Catholic faithful were somewhat 'unfaithful' in their pragmatic adoption of whatever remedies proved efficacious. In the course of this and the preceding chapter we have had the occasion to observe the way the broad spectrum of ecclesiastical remedies and popular healing rituals overlapped, both in the way they were approached and in the techniques applied. Those struck by malady and misfortune, and those hoping (against all hope) to be spared it, had yet one more source of assurance: the Virgin and saints. These members of the Christian pantheon, and local attitudes towards them, are the subject of the next chapter.

NOTES

1 Deposition of Donna Laura de Adamo, 'Contro Nicodemo Salinaro per sortilegi', 16 July 1678, Francavilla, A.D.O., *Magia e stregoneria*, III, fols. 12r–14r.
2 The word *magara* is the italianised version of the dialect term *masciara* (and variants), said to derive ultimately from the Latin *magus* (although in medieval Latin the verb *magarizare* meant 'to apostasise to Islam'). Like the English 'wise woman', it takes in activities as both healer and sorceress. Related to *magara* is the word for a spell or charm, *magaria*.
3 Cf. Robert Scribner, 'Cosmic order and daily life: sacred and secular in pre-Industrial German society', in his *Popular Culture and Popular Movements in Reformation Germany* (London, 1987), 7–8.
4 Peter Burke, 'Rituals of healing in early modern Italy', *The Historical Anthropology of Early Modern Italy* (Cambridge, 1987), 208.

5 Girolamo Marciano da Leverano, *Descrizione, origini e successi della Provincia d'Otranto* (Naples, 1855), 182.

6 'Acta Sanctae Visitationis, Habita in Metropolitana Ecclesia Bridisina et Uritana ab Archiepiscopo Jo. Carolo Bovio', 1565, A.C.A.B., *Sante visite,* fol. 227r.

7 Mons. Castrese-Scaja, 'Editti per casi riservati e per i Sacramenti della penitenza e della Eucarestia', 1749, A.D.O., no foliation.

8 *Constitutiones Synodales Editae in Prima Diocoesana Synodo Gallipolitana...Ab Illustriss. ac Reverendiss. Domino D. Ioanne Montoya de Cardona, Episcopo Gallipolitano,* 1661, 41.

9 Cf. Jean Delumeau, *Catholicism between Luther and Voltaire,* trans. J. Moiser (London, 1977), 172.

10 Piero Camporesi, *La casa dell'eternità* (Milan, 1987), 207.

11 The expression is Ernesto de Martino's, *Sud e magia* (Milan, 1966 edn.), 87.

12 Translation: 'Oh Christ, who sent manna in the forest / made night, day and the light / you made the prayer of St Anne / the tears of Job and Tobias./ Oh Christ, who took human flesh / in the Virgin Mary's womb / so make me happy this week / with what my heart desires.' Deposition of Antonia di Supersano, 'Contro Agata dello Scalfore, Camilla Nanni e Atonia di Supersano per sortilegio', 1600; A.C.V.G., *Proc. pen.,* no. 1393.

13 'Acta Sanctae Visitationis... Ecclesia Brindisina', fol. 528r.

14 'The Virgin Mary was sitting on a chair, / her son appeared before her. / Whoever chooses to praise the Virgin Mary's name / shall be made whole and well / as was Lazarus of the leprosy he had./ I give you the diet/ as Jesus was a prophet: / Do not eat pork, fowl, deer, hard cheese, fennel, cauliflower or lentils.' In ibid., fol. 617v.

15 Dino De' Antoni, 'Processi per magia e stregoneria a Chioggia nel XVI secolo', *Ricerche di storia sociale e religiosa,* II, 4 (1973), 194.

16 Jean-Michel Sallmann, *Chercheurs de trésors et jeteuses de sorts* (Paris, 1986), 172.

17 I.M. Malecore, 'Letteratura e tradizioni religiose popolari nel Salento', *Lares,* XL, 2–4 (1974), 191.

18 Giuseppe Bronzini, *Lineamenti di storia e analisi della cultura tradizionale* (Rome, 1979), 12.

19 'Dorotea Rossi denuncia diverse donne per pratiche magiche', 24 July 1742, Francavilla, A.D.O., *Magia,* II.

20 Giuseppe Cocchiara, *Il linguaggio della poesia popolare* (Palermo, 1951), 123–6.

21 This refers to cachexia, a condition of weakness and wasting away, especially in children; from her first deposition, 'Contro Agata dello Scalfore, Camilla Nanni e Antonia di Supersano', 1600, A.C.V.G., *Proc. pen.,* no. 1393.

22 'Contro Beatrice Contistabile per aver fatto bere al figlio di Angela Coco acqua con polvere contro la quartana', 31 August 1697, Francavilla, A.D.O., *Magia,* I.

23 Cf. Mary O'Neil, 'Magical healing, love magic and the Inquisition in late sixteenth-century Modena', in S. Haliczer, ed. *Inquisition and Society in Early Modern Europe* (London, 1987), 91.

24 Cf. Giuseppe Bonomo, *Scongiuri del popolo siciliano* (Palermo, 1953), 9.

25 Deposition of Giovanni Antonio Mela, 'Contro Nicodemo Salinaro per sortilegi', 16 July 1678, Francavilla, A.D.O., *Magia,* III.

26 Cf. Vittorio Lanternari, 'La politica culturale della Chiesa nelle campagne: la festa di S. Giovanni', *Società,* XI (1955), 64–95.

27 'Nicola Gargaro denuncia Donato de Quarto della Torre S. Susanna per avergli promesso la guarigione da una malattia per mezzo di strofinamento con erbe', 30 June 1697, Francavilla, A.D.O., *Magia,* I.

28 'Dorotea Rossi denuncia diverse donne per pratiche magiche', 24 July 1742, Francavilla, A.D.O., *Magia,* II.

29 'Denuncia di Lucrezia Maria Aliffa', 5 April 1702, Francavilla, A.D.O., *Magia*, II.
30 Del Río, *Disquisitionem magicarum* (Magonza, 1600), cit. in Adalberto Pazzini, *La medicina popolare in Italia* (Trieste, 1948), 148.
31 Deposition of Camilla Nanni, 'Contro Agata dello Scalfore, Camilla Nanni e Antonia di Supersano per sortilegi', 1600, A.C.V.G., *Proc. pen.*, no. 1393.
32 Keith Thomas, *Religion and the Decline of Magic* (Harmondsworth, 1973 edn.) 225–6.
33 Mons. Alessandro Kalefati, 'Visitatio Personalis', Latiano 1785, A.D.O., fol. 18r.
34 We find the scale used in Friuli as well, to cure bewitched children. According to one witness the child was weighed on three successive Thursdays: 'when the child gains in weight...the witch withers and dies, and if the child withers, it is the witch that lives'. From the 1574 trial of Paolo Gasparutto, Archivio della Curia Arcivescovile, Udine. Cit. in Carlo Ginzburg, *The Night Battles*, trans. J. and A. Tedeschi (London, 1983), 27.
35 Guglielmo Lützenkirchen, 'Il "male di San Donato"', in Lützenkirchen, et al. *Mal di Luna* (Rome, 1981), 30.
36 Cf. Annabella Rossi, *Le feste dei poveri* (Palermo, 1986 edn.), 30–4.
37 Adriano Puce, 'Contributo psicologico-sociale allo studio del Male di S. Donato nel Salento', *Studi e materiali di storia delle religioni*, IX (1985), 261–97.
38 Leonard Glick, 'Medicine as an ethnographic category: The Gimi of the New Guinea Highlands' in D. Landy, ed. *Culture, Disease and Healing* (New York, 1977), 61.
39 W.H.R. Rivers, *Medicine, Magic and Religion* (London, 1927), 7.
40 Cf. Mary O'Neil, '*Sacerdote ovvero strione*. Ecclesiastical and superstitious remedies in 16th century Italy', in S. Kaplan, ed. *Understanding Popular Culture* (Berlin, 1984), 63.
41 Pazzini, *Medicina*, 103.
42 'Francesca Placida Macarello denuncia un atto di magia', 7 January 1703, Oria, A.D.O., *Magia*, I.
43 Deposition of Vittoria de Arrico, 'Contra Antonella Seppi pro sua mala vita, fama et conditione', 19 May 1723, Torre S. Susanna, A.D.O., *Magia*, II.
44 *Sancta Tridentina Synodus ad Praxim, seu Decreta et Constitutiones Sanctae Ecclesiae Metropolitanae Brindisinae, ad Illustrissimo et Reverendissimo Domino D. Francisco De Estrada* (Venice, 1663), 20.
45 O'Neil, 'Magical Healing', 94.
46 O'Neil, 'Ecclesiastical remedies', 55.
47 'Francesca Placida Macarello denuncia un atto di magia', 7 January 1703, Oria, A.D.O., *Magia*, I.
48 'Contro D. Matteo di Francavilla, Capuccino', 14 February 1741, Francavilla, A.D.O., *Magia*, III.
49 Gabriele De Rosa, *Vescovi, popolo e magia nel Sud* (Naples, 1983), 57.
50 'Acta Sanctae Visitationes... Ecclesia Brindisina', fol. 671r.
51 'Santa Visita Personale, fatta da Mons. Antonio Pignatelli, 1676', A.C.A.L., *Sante Visite*, no. 31, fol. 48v.
52 Mons. Alessandro Kalefati, 'Visitatio Personalis', Avetrana, 1784, A.D.O., no foliation. Note ignorance as the explanation for recourse to superstitious techniques. The devil is all but absent.
53 Sallmann, *Chercheurs*, 139.
54 'Contro Agata dello Scalfore, Camilla Nanni e Antonia di Supersano per sortilegio', 1600, A.C.V.G., *Proc.pen.*, no. 1393.
55 'Francesca Placida Macarello denuncia un atto di magia', 7 January 1703, Oria, A.D.O., *Magia*, I.
56 Cf. Glick, 'Medicine as ethnographic category', 62.
57 Deposition of Carmina de Tomaso, 'Contro Giustina Quaranta per magia', 5 July 1742, Oria, A.D.O., *Magia*, II.

58 Ginzburg, *The Night Battles*, 78.

59 Deposition of Antonia Donatino, 'Contro Caterina Patrimia per stregoneria e patto col diavolo', 14 August 1704, Francavilla, A.D.O., *Magia*, I.

60 Deposition of Lucrezia Epifane, ibid.

61 Deposition of Isabella di Nitto, 'Contra Antonella Seppi pro sua mala vita, fama et conditione', 19 May 1723, Torre S. Susanna; A.D.O., *Magia*, II.

62 Claudia Pancino, *Il bambino e l'acqua sporca: Storia dell'assistenza al parto dalle mammane alle ostetriche (secoli XVI–XIX)* (Milan, 1984), 38.

63 Cf. Brian Levack, *The Witch-Hunt in Early Modern Europe* (London, 1987), 127.

64 Deposition of Maria Monte, 'Contro Antonella Seppi pro sua mala vita, fama et conditione', 19 May 1723, Torre S. Susanna, A.D.O., *Magia*, II.

65 'Summario delle denuncie contro Camilla Rubino, maga di Latiano', 1722, Latiano, A.D.O., *Magia*, II. Cosmas and Damian, the saintly physicians, were believed to be capable of intercessing to cure any malady.

66 Thomas Forbes, *The Midwife and the Witch* (New Haven, 1966), 129.

67 *Sancta Tridentina Synodus*, 44.

68 Mons. Ambrogio Maria Piccolomini, *Synodum Diocesanum* (Venice, 1679), 23.

69 Cf. David Harley, 'Historians as demonologists: the myth of the midwife-witch', *Social History of Medicine,* III (1990), 11–12.

70 de Martino, *Sud e magia*, 44.

71 Luisa Accati, 'Lo spirito della fornicazione: virtù dell'anima e virtù del corpo in Friuli, fra '600 e '700', *Quaderni storici*, XIV (1979), 653.

72 de Martino, *Sud e magia*, 44.

73 Deposition of Anna Maria Palazzo, 'Summario delle denuncie contro Camilla Rubino, maga di Latiano', 1722, Latiano, A.D.O., *Magia*, II.

74 Deposition of Caterina Patrimia, 'Contro Caterina Patrimia per stregoneria e patto col diavolo', 14 August 1704, Francavilla, A.D.O., *Magia*, I.

75 Helmut Schoeck, 'The evil eye: forms and dynamics of a universal superstition', in A. Dundes, ed. *The Evil Eye: A Folklore Casebook* (New York, 1981), 198.

76 Deposition of Donna Antonia Quaranta, 'Contro Nicodemo Salinaro per sortilegi', 16 July 1678, Francavilla, A.D.O., *Magia*, III. The technique may have been influenced by learned magic, in which Salinaro did more than dabble, as we shall see in the penultimate chapter. A learned form of the evil eye, known as *jettatura*, also existed, a product of eighteenth-century Naples. Cf. Giuseppe Galasso, 'Dalla "fattura" alla "iettatura": una svolta nella "religione superstiziosa" del Sud', in his *L'altra Europa: Per un'antropologia storica del Mezzogiorno d'Italia* (Milan, 1982), 253–83.

77 One of the 'superstitions' forbidden by the Gallipoli synod of 1661. *Constitutiones Synodales*, 41.

78 de Martino, *Sud e magia*, 21 and 71–2.

79 Willa Appel, 'The myth of the *jettatura*', in C. Maloney, ed. *The Evil Eye* (New York, 1976), 16–27.

80 Keith Thomas (*Religion*, 223) mentions it after noting the rarity of charms to prevent conception in England, given the practice of both coitus interruptus and abortion.

81 Cf. Angus McLaren, *A History of Contraception from Antiquity to the Present Day* (Oxford, 1990), chapters four and five.

82 'Contro Rev. Isidoro Dolce per stupro commesso a Giulietta Allegretti', 1702, A.C.V.G., *Proc. pen.*, no. 2832.

83 Deposition of Agata Castro, ibid.

84 Deposition of Elisabetta Scozzana, ibid. Though scorned here, procuresses were also relied upon in the community. Besides setting up relationships and assisting poor

women in supplementing their meagre incomes – generally with 'gifts' rather than outright monetary payment, as we saw in chapter 2 – she could also serve as a scapegoat if things went wrong. Cf. Elizabeth and Thomas Cohen, 'Camilla the go-between: the politics of gender in a Roman household (1559)', *Continuity and Change*, IV (1989), especially 65–8.

85 G.E. Cangiamila, *Embriologia sacra ovvero dell'uffizio de' sacerdoti, medici e superiori circa l'eterna salute dei bambini racchiusi nell'utero* (Palermo, 1745), 11. Cit. in Pietro Stella and Giovanna Da Molin, 'Offensiva rigoristica e comportamento demografico in Italia (1600–1860): natalità e mortalità infantile', *Salesianum*, XL (1978), 17.

86 'Contro il Rev. Andrea Cortese per tentativo di aborto in persona di Petronilla Munda', 1674, A.C.V.G., *Proc. pen.*, no. 2003.

87 'Contra Chierico Giuseppe Lupoli, per immoralità', March 1768, A.C.V.G., *Proc. pen.*, no. 1726.

88 Nicola Caputo, *De Tarantolae Anatome et Morsu: Opusculum Historico-Mechanicum inquo nonnullae demonstrantur Insecti particulae ab aliis non ad huc inventae* (Lecce, 1741), 218.

89 L.G. De Simone, 'La vita della Terra d'Otranto', *La Rivista Europea*, VII, 3 (1876), 346.

90 Giuseppe Gigli, *Superstizioni, pregiudizi e tradizioni in Terra d'Otranto* (Florence, 1893; reprinted Bologna, 1986), 70.

91 Caputo, *De Tarantolae*, 133.

92 Girolamo Marciano da Leverano, *Descrizione,* 177–8. Marciano concludes his description by saying that the dancing continued in this manner for days at a time.

93 Ms. journal of George Berkeley, British Library, Add. ms. 39,308, fols. 51–5; cit. in Burke, 'Rituals of healing', 215.

94 Described by Ernesto de Martino in terms of its classical Greek origins as a form of ritual catharsis, stemming from the orgiastic cults and mystery religions of Magna Graecia, in his definitive work, *Terra del rimorso: Contributo a una storia religiosa del Sud* (Milan, 1968), 229.

95 Caputo, *De Tarantolae*, 229–30.

96 Marciano, *Descrizione*, 182.

97 'Santa Visita di Mons. Vincenzo Andrea Grande', II, 1837, Archivio Diocesano, Otranto. Cit. in *Terra del rimorso*, 109. The first mention of the chapel is in Grande's 1834 visitation, which is less detailed, although it does mention the vows made by patients to St Paul ('Santa Visita...', I, 1834, A.D.Otr.).

98 The *tarantato* experienced the same symptoms year after year on the 'anniversary' of the bite (hence *rimorso*, or remorse, both in its literal sense of 'biting again' and its figurative sense). This often meant repeated visits to the chapel to fulfil the vow, once this became an established part of the ritual. The *rimorso* is mentioned by Marciano (*Descrizione*, 178), who says it often continued for ten or twenty years, the *tarantati* dancing for up to ten days at the same time in which they were originally attacked.

99 Translation: 'Oh my St Paul of the tarantulas / grant this grace to me and then to everyone. / Oh my St Paul of Galatina / grant me this grace the very first / so that the stinger will be killed / from under the flounce of my dress.' In Malecore, 'Letteratura e tradizioni', 193.

100 Angelo Turchini, *Morso, morbo, morte: La tarantola fra cultura medica e terapia popolare* (Milan, 1987), 178. In Romania secret brotherhoods of trance dancers specialised in curing people who had been 'hit' or possessed by the fairies (known as *iele*). Analogous to the tarantism ritual, different melodies were used to diagnose the kind of possession, the victim being cured during the dancing ritual. Cf. Gail Kligman, *Calus: Symbolic Transformation in Romanian Ritual* (Chicago, 1981).

101 'Contro Francesco Antonio Malagnano', 16 March 1723, Oria; A.D.O., *Magia*, II.
102 Cf. de Martino, *Terra del rimorso*, 169.
103 Caputo, *De Tarantolae*, 111–41.
104 de Martino, *Terra del rimorso*, 158. Clara Gallini, however, examining a related phenomenon in Sardinia known as *argia*, has concluded that there the bite was real and not symbolic. Cf. Gallini, *La ballerina variopinta: Una festa di guarigione in Sardegna* (Naples, 1988).
105 Claude Lévi-Strauss, 'The effectiveness of symbols', in his *Structural Anthropology*, trans. C. Jacobson and B. Grundfest Schoepf (London, 1968), 167–85.
106 Rafaele Frianoro, *Il vagabondo, ovvero sferza de bianti e vagabondi*, reprinted in Piero Camporesi, ed. *Il libro dei vagabondi* (Turin, 1973), 133.
107 Arthur Rubel, et al., *Susto: a Folk Illness* (Berkeley, 1984), 113.
108 Ibid., 48.
109 Epifanio Ferdinando, *Centum historiae seu observationes* (Venice, 1621), 261; cit. in de Martino, *Terra del rimorso*, 171.
110 He is case XI in Caputo, *De Tarantolae*, 125.
111 'Santa Visita Personale', 1719, Mons. Fabrizio Pignatelli, A.C.A.L., fol. 110v.
112 Published in Naples, 1821. Reprinted as *Itinerario da Napoli a Lecce*, E. Panareo, ed. (Cavallino, 1981), 119–20.
113 Atanasius Kircher, *Magnes sive de arte magnetica libri tres* (Rome, 1654). The author was teacher of mathematics and Hebrew at the Collegio Romano, amongst other things. Cf. Turchini, *Morso*, 49.
114 'Prima Dioecesana Synodus', 1687, A.C.A.L., fol. 59; cit. in Marcello Semeraro, *Le Apostoliche Missioni* (Rome, 1980), 16. There is no record that Rev. Nicola Perrone of Campi was so punished.
115 'Literae annuae Neapolitanae Provinciae ab anno 1740 usque ad annum 1743', A.R.S.I., *Provincia Neapolitana*, 76 II, fol. 611.
116 Richard Keppel Craven, *A Tour Through the Southern Provinces of the Kingdom of Naples* (London, 1821), 186. Nevertheless, the dance was still performed around Taranto as late as the 1930s, complete with all the ritual paraphernalia (ribbons, mirrors, kerchiefs, as well as pots of basil and rue branches, were used in the dance). Anna Caggiano, 'La danza dei tarantolati nei dintorni di Taranto', *Il Folklore Italiano*, IX (1931), 72–5. At the time of writing, the most recent account of the phenomenon is in Domenico Antonino Conci, 'Il "rimorso" perduto: Storie e note di un viaggio incompiuto nel Salento', *Religioni e società*, 9 (1990), 37–48
117 de Martino, *Sud e magia*, 21.
118 Thomas, *Religion*, 245.

The saint:
image, presence, sacrality

Reaction to malady and misfortune often entailed some form of recourse to the saints, as we have had a chance to note in the preceding two chapters. The wise woman frequently accompanied her cures with invocations (*orazioni*) to a particular saint, related to the ailment by an event or charateristic narrated in the *historiola*. Society could also invoke the power of the sacred through the saints of the Catholic Church by means as diverse as prayer, pilgrimage and relic. The demands of this Christian society for the access to sacred power over natural misfortunes and calamities which the saints provided was unceasing. This fact often led local populations into conflict with the ecclesiastical authorities, as they continually proposed new holy people and miraculous events to meet the demand. Some of which the Church accepted as genuine, others it rejected as false, sometimes even seeing the hand of Satan in them. Yet all these manifestations in some way expressed the meaning and role of sanctity in early modern society, the subject of this chapter. We shall be discussing how saints were 'made', examining the process of negotiation which brought them from periphery to centre and back again; the models of sanctity in the Terra d'Otranto, focusing on local saints; saints and disease; holy men and women rejected by the Church; community patron saints; saints and the personalisations of the sacred; and relics. Finally, we shall explore the greatest of saints, the Virgin Mary, and devotion to her, primarily through an analysis of Marian images and shrines in the province.

THE CANONISATION PROCESS

If we are to discuss and explore what a saint was for the community we should first ask what a saint was for the Church, for the two concepts are closely interrelated. In Catholic terms, a saint can be readily defined as a person whose cult has been officially sanctioned by the Church.[1] By the late Middle Ages the process of canonisation had evolved from the spontaneous veneration of particular Christians as saints by the local community

to the official recognition by the local bishop and his synod.[2] In the eleventh century the term *canonizare* was used to define the procedure whereby a person was enrolled in the calendar of the local church, sanctioning his or her commemoration.[3] It soon became customary to ask for papal approval of the saint, so as to increase his or her dignity and authority, and ensure wide recognition through the calendar of the universal Church, a procedure which had become the rule by 1200. Finally, the trial format for the examination of prospective saints was instituted by Pope Gregory IX, consisting of judges, witnesses and the so-called devil's advocate.

The Protestant Reformation brought a 'crisis of canonisations' in its wake, as no further saints were proclaimed after 1523 for a period of sixty-five years.[4] With renewed confidence following the Council of Trent, the Congregation of Sacred Rites and Ceremonies was established in 1588. Amongst other things, it was to be the forum for the reformed and standardised canonisation procedure. The papacy further increased its right to define the sacred, through the control of saint-making, under Urban VIII, who instituted formal beatification of the 'servant of God' as a mandatory first stage in canonisation and limited cases till a minimum of fifty years had passed after the candidate's death (although introductory hearings could be conducted immediately following the holy person's death).[5]

While the making of a saint was officially controlled from Rome, the initial impetus – the development of a following around a particular individual reputed to be saintly – usually came from the local level. The process has been aptly described as 'the outcome of some sort of interaction between clergy and laity, centre and periphery, learned culture and popular culture'.[6] Of the local cults which proliferated, some would later be recognised by the papacy, others would be neither accepted or rejected, awaiting future developments, while still others would not be considered viable and would be quickly suppressed. As an example of this process, thirteen holy men and women who lived in the Kingdom of Naples between 1550 and the end of the nineteenth century have been canonised; another twelve have reached the stage of beatification, while the causes of approximately one hundred 'venerables' – the first stage of recognition – have been initiated and testimony recorded, but for one reason or another have proceeded no further.[7] This last group might be classified as the 'saints-in-waiting', for in reality they exist in a kind of limbo. Local cults in their name, persisting on the fringe of legality, may one day justify the reopening of their causes. One final group that will also be explored in the course of this chapter are those holy people who were examined by the

Church courts, but whose 'holiness' was deemed to be spurious or derived from diabolical sources, and who were frequently imprisoned by the Holy Office before their 'contamination' could spread to innocent Christians. It is often these latter cases which are of the most interest to historians of perception, for their exceptional nature means that they tend not to respect the rules followed by the mass of canonisation processes.

This polyvalent situation could exist – despite the dissemination of a model of cultural reference by the Church, which also served to restrict the sphere of canonisations – because most of the laity, and many clerics too, did not distinguish between venerable, blessed and saint. Furthermore, the new doctrine also presented inherent contradictions. On the one hand, in order to be a candidate for canonisation the holy person had to have a reputation (*fama*) of saintliness, which could only be manifest through group veneration. On the other hand, however, a public cult could not be authorised until after the holy person had been at least beatified, prohibiting organised forms of devotion.[8]

The advantage of the various records which document the saint-making process is that, through the testimony of witnesses, they allow us to explore sanctity as a value: that is, situated in collective representations and expressed through associated systems of behaviour within a given network of social relations. We shall be able to explore differentiations in this 'value' among the different levels of society which were involved in this procedure: the two different yet overlapping and mutually-conditioning viewpoints of the high clergy – the cause's promotor, members of the Congregation of Rites, interrogators – and of the deposing witnesses, educated and uneducated, clerical and lay.

As is often the case with the documents which historians must utilise and interpret in order to obtain their data, there are limitations to the canonisation processes. The first and most obvious lies inherently in the structure of the records themselves, for the process consisted of a position taken by the candidate's promotor, according to which witnesses were questioned. Besides supplying personal information of a civil and religious nature, the deponents responded to set questions or statements about the candidate's holiness, Christian virtues, miracles, prophecy, quality of his or her death and related events, as well as any miracles which had taken place after his or her death. The pre-established and somewhat formulaic nature of most of the questions often curtails the spontaneity of the responses, but not to the point where we are unable to probe perceptions, even at the level of the individual. Secondly, the canonisation records are not representative samples of the community, since only privileged witnesses – those known to have something to contribute – were examined.

The sample of witnesses can vary a great deal, depending on the candidate's own circle, as we shall see, but in all cases it is evident how the definition of sanctity is dependent on other people, for one is primarily a saint in the eyes of others.[9] Finally, the records are affected by the fact that the descriptions of sanctity are 'a community's recollections of a dead person's past existence', since such examinations could only be undertaken after a candidate's death.[10] And the fact that these values were constructed by the group and remodelled according to the collective representation of the particular servant of God becomes increasingly crucial after fifty years have elapsed and the beatification stage of the process can begin.

MODELS OF SANCTITY

In the two-stage process of canonisation, from origin in the periphery to official recognition by central authority, various models and concepts of sanctity could come into play. At the local level, people's ideas regarding the qualities and behaviour a prospective saint should exhibit derived from the medieval hagiographical models they had inherited as well as their own needs as a community. Conversely, the holy man or woman conformed to what the community expected of them, in part because they were nurtured on the same models and perceptions.[11] The holy person, representing the humanisation of the sacred, was freer to go beyond these established patterns of holiness only once he or she had gained acceptance and stature, while from the centre, the Church regulated this *fabrique des saints*[12] and proposed the cults devoted to them as models for the faithful, a challenge taken up by many local holy people. Such models, or 'routes to holiness', do not account for all canonisations but they do suggest the tendency of imputed saintliness to fit into established categories or stereotypes in something of a self-confirming process.[13]

According to these categories of officially recognised sanctity, statistically speaking, men had better chances of being canonised than women, particularly if they were Italian noblemen and members of a Religious Order, preferably of the Franciscan family.[14] The importance of models can also be observed qualitatively. St Giuseppe da Copertino (1603–63), in the diocese of Nardò, followed in the model of St Francis (who was in turn the *alter Christus*). Not only was he born in a stable, but he had a close affinity with birds and animals. Sacred models could also be 'contagious', in the sense that the imputation of sanctity might be derived from the holy person's proximity to other people later recognised as saints.[15] St Bernardino Realino (1530–1616), founder of the Jesuit College in Lecce and known as the 'father of the city', has been described as belonging to

the second generation of Jesuits, those following immdiately after the death of the founder.[16] We might expand this category to include the spatial contiguity of the sacred as a factor in the imputation of sanctity, as in the case of the above-mentioned Giuseppe da Copertino who lived a good part of his life at the tiny Conventual monastery near Copertino, home of the miraculous image of Our Lady of the Grottella ('little cave'), to whom he attributed his many miracles.[17] One resident of Salice was advised to go to the Grotella monastery for the benefit of his ailing daughter, 'because there is a very miraculous Madonna there called "of the Grottella", and a certain Fra Giuseppe, whom God pleases to perform miracles'.[18] The role of this image and others throughout the Terra d'Otranto in the personalisation of the sacred will be explored below.

In his study of post-Tridentine canonisation processes, focusing on representations of sanctity, Jean-Michel Sallmann has postulated the following model of a typical Counter-Reformation saint:

> Born of Catholic parents, the future saint has the vocation from the tenderest infancy. Once entered into a monastery, he shows himself to be respectful towards the precepts of the Church and the monastic vows and dedicates himself to the saving of souls, practising to a heroic degree the three theological virtues and the four cardinal virtues. God rewards him with the supernatural gifts of prophecy, the ability to see into souls and the possibility to perform miracles during his lifetime. Surrounded by the reputation of sanctity, he dies an edifying death which multiplies the miracles and prodigies and further increases his notoriety.[19]

One saintly person of early modern Terra d'Otranto who fits this model is Sister Rosa Maria Serio. Born in Ostuni in 1674, she entered the Carmelite convent of Fasano at the age of sixteen, where she became renowned for her charismatic gifts and strict penance, becoming its prioress before dying in 1726 after seven years of physical torment and mystical suffering.[20] In the introductory inquiry held three years after her death, Serio's father suggested to the examiners that signs of his daughter's holiness had begun even before her birth. He recounted that when his wife was pregnant with Rosa Maria, and she sat down in church instead of kneeling, the baby would kick in her womb until she knelt down. In the cot, she once tore at her swaddling clothes and gazed heavenward when two women were discussing Christ's passion nearby. And once, when she was four years old, her mother left her to go out and she began crying. When her mother returned she found her tranquil and still, holding an image of St Anthony of Padua, and the child said to her: 'This man told me to stay calm because your mother is coming home soon, and tell her that you'll become a nun.' Even as a child Rosa Maria had worn a black

habit and refused all ornamentation.[21]

And yet despite this – despite her very devout parents and family (at least one sister with her in the convent and a brother who was a Cathedral canon in Ostuni), her heroic virtues, her many miracles, both while alive and after her death, and her reputation of sanctity – she was never even beatified and remains but 'venerable'. This leads us to the important wider question of why some servants of God were canonised and others not. In suggesting hypotheses we must keep in mind papal interest in the making of saints and the types of saints favoured at any given time. Variation from accepted models by local holy people could even mean trouble from the Inquisition, as we shall see with Giuseppe da Copertino, who none the less was eventually canonised. Furthermore, to be officially recognised a servant of God often required the influence of various pressure groups like the Religious Orders, powerful families or strong rulers to keep his or her cause alive.

Yet in the end it all came down to central power and control, in what might be considered a form of labelling, like the accusations and trials for witchcraft to be discussed in chapter 8. Indeed the line separating sanctity and diabolism could be a very fine one and some unwary holy people were accused of crossing it by the Inquisition. The different definitions and concepts of saintliness held by the centre and periphery could result in the cults sometimes being rejected. This form of negotiation had the effect of encouraging official models of sanctity, and was part of the same process which encouraged the devotion to saints in areas other than where the cults first sprang up. Perhaps this interaction is best exemplified by the devotion to Mary spread by the Jesuits and other Orders and Congregations, which was complemented by the spontaneous development of shrines at the local level in response to very local needs and conditions, as we shall see. But before discussing the shrine legends, and before we look at the category of failed saints, let us first turn to some successful saints of early modern Terra d'Otranto to examine their roles in society and how they were perceived, both while alive and after death.

ROLES AND PERCEPTIONS

First and foremost, saints constituted the sacred in an accessible form, independent of any clerical intervention. To benefit from their virtue all one had to do was visit them while they were alive, or go to their tomb or invoke their name, swearing a vow, when dead. The saint was an embodiment of the sacred, where the sacred meant power over the natural order of things, without limitations or restrictions. According to Piero Camporesi,

he was a magician-cum-prophet who had mastered the occult world and lived in a privileged relationship with the sacred, able to overthrow the established order. He is the one 'who overturns physical laws, who reveals the unexpected, who prophesies a change of state, who inhabits another dimension full of remarkable, unheard-of and spectacular phenomena'.[22] The ability of the saint to dominate the elements – causing rain, raising the dead, escaping the laws of gravity – was perhaps the development, or even the consequence, of his superhuman strength in overcoming his own human nature, by depriving himself of meat, milk, clothing, shelter, conversation, sex, and so on.[23] Thus the levitations of the poor, rustic Giuseppe da Copertino were accompanied by severe mortification, fasting and acts of penance. As the 'flying saint' he achieved great renown throughout the region. One of his most fascinating experiences of flight at the Grottella monastery shares motifs with the Christmas story. Giovanni Caputo, a sixty-seven-year-old farm hand, told the inquiry that one Christmas Eve he and several shepherds were out watching over the sheep near the monastery, when Fra Giuseppe approached and asked them to come to the church and add a touch of festivity to the simple service by playing their bagpipes and whistles. As they played Fra Giuseppe began to dance and, letting out a shout, was lifted up into the air, 'and he flew like an angel in the air through the middle of the church.'[24]

Miracles were crucial to the identification of sanctity. They represented, according to Benedicta Ward, 'the ordinary life of heaven made manifest in earthly affairs, chinks in the barriers between heaven and earth, a situation in which not to have miracles was a cause of surprise, terror and dismay.'[25] Indeed miracles have similar roles to the popular healing rituals examined earlier in their ability to protect against the existential crises which continually threatened the otherwise defenceless individual and community. The miracle narratives themselves, which form the body of the canonisation processes and make up the saints' legends, reflect the social character of the event. In fact, a miracle can only exist if someone else regards it as such, and the more public it is the better (that is, the more convincing, reassuring). In another way, the miracle narratives justified and exemplified the saint's role *as* a saint: they asserted his or her special place as intercessor in the relations between man and the sacred.[26] In one account, the confraternity of Copertino (we are not told its dedication) processed to the monastery church of the Grottella asking for rain. Fra Giuseppe entered and knelt in front of the church's image of the Virgin, and before long he was lifted up in levitation above the altar, upon which, according to one witness, 'all of us, seeing this thing, began to weep and all of us screamed, seeking mercy from the most holy Virgin.'

After the mass they went outside and rejoiced to find it raining.[27]

The miracles were so crucial to defining the saint's influence with the sacred that the theological definition of their origin was often reversed. On the one hand, the Church taught that the ability to perform miracles was an outcome of the saint's supernatural gifts granted by God because of the saint's heroic exercise of Christian virtues. Yet, on the other hand, many people, clerical and lay alike, saw the saint's miraculous abilities as an example of his supernatural powers of which the heroic virtues were simply another manifestation. The chief function of the saint was to heal and perform miracles. In 1689 Brigitta Preite summed up the relationship by asserting: 'I always knew Fra Giuseppe of the monastery of the Grottella to be a holy monk, who performed miracles, healed the sick and liberated spirits'.[28] And the definition of a miracle was a wide one. At the investigation into the saintliness of Fra Giuseppe, witnesses were asked to distinguish between a favour or grace (*gratia*) and a miracle; but for most witnesses all extraordinary events were miracles. Vittoria Rozza, a tertiary nun of Copertino, admitted to not knowing the difference 'because I am a woman and I do not know these things'.[29] Indeed many ecclesiastics were also unable to distinguish, though all were anxious to vouch for the holy man's undoubted sanctity.

Saints were also defined by their function in the maintenance of the moral order through their gifts of clairvoyance and prophecy. Because of his ability to prophesy, Fra Giuseppe achieved 'a continuous penetration into the most hidden secrets of other people and, simply by their odour, [made] discoveries from far away of enchantments and spells'.[30] Holy men were frequently sought out as confessors, for – seeing all of the devotee's sins – they were able to bring about a reassuring and consoling total 'mental purification'.[31] As with Fra Giuseppe, once again, this ability, along with the ambivalence and strangeness inherent in being perceived as a saint, could engender fear as well as admiration or respect. A tertiary nun of Nardò, barely supporting herself by 'domestic work' (*esercitij femminili*), spoke to the simple friar on many occasions, but never with an easy mind: 'When I was going to see Fra Giuseppe, that evening I would think about what I was going to say, and when I went I feared his presence, and he would say that I shouldn't be afraid and should speak freely. And he would tell me everything that I had thought of saying to him.'[32]

The servant of God Sister Rosa Maria Serio combined her gift of prophecy with that of healing. According to the surgeon of the enclosed Carmelite convent where she was prioress, the sick would go to the convent and recommend themselves to her prayers once their doctors had given up all hope. Then, in a kind of spiritual lottery, 'if she sent them a

crucifix, they were already done for and there was no more hope for them; but if she sent other devotions, the sick person could rest assured that he would get better'.[33] Yet such a reputation for prophecy could occasionally result in scepticism amongst people of the area, for the holy person – especially in the case of an enclosed nun – inhabited a world of her own, far removed from the daily life of lay men and women. When the parish priest of Putignano was seriously ill with a catarrhal inflammation, his brother, a physician, was called. Being in Fasano at the time, the physician went to ask Sr Serio about the priest's chances. She sent him a chit bearing the following words: 'The infirmity of your brother is fatal, and only God can [help him].' However, when the doctor arrived in Putignano, he found his brother up and about, much to his great surprise and relief. He showed the chit to all those gathered, 'and they all made fun of the prophecy made to them...and they all discussed at length that it was the Servant of God's vanity, and they laughed and derided her'. Within three days the priest was dead, his illness having taken a sudden and unexpected turn for the worse, and 'they were all confused, and confessed that the said Sister Rosa Maria was truly a Servant of God.'[34]

SAINTS AND HEALING

It is surprising that moribund patients were content with her dire predictions, for Serio, like other holy people, was also an accomplished healer. In this regard, the saint complemented the other forms of healing, or reactions to malady and misfortune, discussed in the previous two chapters: the wise woman (*magara*) and the priest (representing the various ecclesiastical remedies which the Church put at the disposal of the faithful). Rather than regard the saint as being in a position of competition with these other therapeutical forms, it is perhaps more useful to examine how he or she fits into the behavioural system of early modern Terra d'Otranto.

Many saints had acquired their own therapeutic specialisations over the centuries, a process seemingly consolidated during the later Middle Ages. Most of these saints began as generic healers, like the living holy men and women to be discussed shortly. Of dead saints, only the Virgin and Sts Cosmas and Damian officially retain this position. Saints acquired their patronage of certain maladies in relation to their form of martyrdom, a disease suffered, a miracle performed, or simply in relation to the sound of their name.[35] It could also be determined by some fortuitous or miraculous event after the saint's death, linking him or her to a particular ailment.[36]

As suggested in the previous chapters, the remedial forms exemplified by the saint were all part of the same pool of beliefs, with the patient –

along with family and friends – pragmatically employing one or another, or all in succession, according to the circumstances and according to which were believed to prove efficacious. For instance, Vita Maria Vitale had taken her daughter, crippled by a 'nerve contraction', first to doctors, who had been unable to do anything for her, and then 'to many churches, and [she had] performed many devotions', without success. When a neighbour who had been cured of a maimed foot told her about Sr Rosa Maria, Vitale took her daughter to the convent to be cured.[37]

An example of a healer par excellence was Fra Giuseppe da Copertino. He would touch people with the sign of the cross, anointing them with oil from the lamp of St Francis while pronouncing the saint's blessing. Although simple in faith, his healing powers were so prolific, according to his hagiographer, 'that he was sought out by everyone, and even people from faraway towns came to see him, and requested graces and miracles, which he dispensed with ease, as doctors [dispense] their prescriptions for healing the sick'.[38] Witnesses to Fra Giuseppe's holiness were drawn from all classes, but the presence of the lower echelons of society is especially noteworthy, for they were not often called upon to testify at canonisation processes. One such witness, Caterina Imberi, a poor widow of Copertino, recounted that she often went to the church at the Grottella monastery, but when Fra Giuseppe was there, 'you couldn't get inside the church, it was so full of people from Lecce, Nardò, Lequile and other places. And lords and ladies came in carriages to şee Fra Giuseppe, and he had this fame among all classes of people, men as well as women.'[39] Fortunately he also visited the sick at their homes, like a doctor on house-calls, which was how Lucrezia Bove was cured of a severe fever.[40]

More than any other servant of God, Giuseppe serves as an example of the local therapeutic saint as 'Christian shaman', in his role, while alive and active, of healer within the community setting.[41] Like the shaman, the saint goes through something of a training period before reaching his 'specific states', where he performs acts (like levitation) and exists in a particular state of being (poverty and penance) which set him apart from the group, rendering him both extraordinary and marginal, admired and feared. But instead of abreacting on the part of the patient as the shaman would do, by reliving the disease-causing events 'in all their vividness, originality and violence',[42] the saint brings about a cure through intercession with and utilisation of divine power. While the shaman is a mediator between man and the supernatural, the saint is actually a part of the sacred, closely connected to it, whereby he can serve as intercessor and advocate on the part of the patient/client. Most importantly, the saint continues to provide access to the sacred long after his death – time does not diminish

his powers – through his relics, as we shall see below. Through legends and miracle accounts (the *historiolae*), the saint continues to figure in the petitional prayers of the faithful and in the invocations and *orazioni* of healers and wise women. This form of identification with particular saints during moments of crisis such as difficult childbirth or otherwise incurable diseases links myth and action, the ritual 'communicating' with the patient through what Lévi-Strauss has termed the 'effectiveness of symbols'.[43]

The miracle cure is made up of three moments: the patient's request, the intervention by the saint (alive or dead) and the healing of the patient.[44] We have already observed that the request is often made as a last resort, after other forms of treatment have been attempted. Given the rapid course of disease, exacerbated by general weakness and malnutrition, the patient was frequently offered to the saint on his deathbed. On many occasions the patient only found out about the saint's reputation during this time of existential crisis. Angela Nicolizza of Otranto, suffering from incurable tumours in her legs and feet, was told about Bernardino Realino by her husband's cousin, a priest, who informed her of his reputation of sanctity and a recent miracle which had occurred in the vicinity.[45] The spread of the holy person's fame could also depend on the nature of their piety and spiritual gifts as well as their own lifestyle and contacts. Giuseppe da Copertino was widely known because of his wondrous feats and general accessibility, while Rosa Maria Serio's fame was more restricted, in part because she was an enclosed nun, and in part because of the less 'sensational' forms of devotion. She was known primarily through personal contacts with the convent: witnesses in the 1729 process were drawn not from the general population, but from people who either knew her directly or who knew her through family or friends.

The most orthodox holy man in early modern Terra d'Otranto – we might even say the most 'Tridentine' – was perhaps Bernardino Realino. Many of those who knew him, like the wife of Ottavio Rosato, an illiterate ex-shoemaker, even recognised that his healing abilities came from his being a 'saintly man' (and not vice versa, as was more common in canonisation processes).[46] Rosato's recollections of the saint reflect Bernardino's own nature. He often sat with Bernardino in his room, where they prayed together, Bernardino showing great compassion and encouraging him that the prayers of the poor found favour with God.[47] It is no wonder his holy reputation spread throughout the city of Lecce. One resident declared:

> He was so dedicated to helping his neighbour, and he took care of us with such care and diligence that he seemed created by God to help others. He listened to all those who went to him to tell him of their tribulations and afflictions

with great charity and readiness; he consoled the afflicted and gave good counsel to those who needed it. And I went many times to tell him of a few tribulations and troubles of mine, and he listened to them with such compassion that he showed he would have willingly borne all of them himself if he had been able... Whoever sought him ought to have him pray God for their maladies and tribulations, he would offer with all readiness to pray to God for them.[48]

What we have here is the pastoral use of sanctity, where the holy person – in contrast to the shaman – is able to provide salvation and a moral example. In this, there was a potential source of tension between the devotee, seeking a cure, and the saint. 'In the eyes of the applicant', according to Vauchez, 'the function of the saint was to heal, not to convert. But for his interlocutor, the thaumaturgical power of which he was a repository was a gift from God, not a personal privilege.'[49] Bernardino did not go so far as to demand a change in the beliefs of his devotees, though he did seek to stress his 'edifying' side over his 'wonder-working' side, not always successfully. When Giuseppe Pupina, a tailor in the city, went to confess himself to Bernardino, hoping that he would cure his impotence (which he believed was caused by a ligature), the servant of God 'made the sign of the cross on my forehead, telling me that the spell could be real, but that he did not believe it, and added: "Go, my son, for tonight you will be consoled"'. His wife's pregnancy shortly thereafter served to confirm Pupina's belief in Bernardino's powers of healing and prophecy, rather than destroy his belief in the power of sorcery.[50]

The second stage of the saint's miraculous cure is that of intervention, which, as we have seen, can take different forms. While alive, the holy person performs most cures by personal contact, either by placing his hands over, or making the sign of the cross on, the diseased organ. It is this personal contact, this physical presence of the sacred, which also gives the saint's relics their efficacy. Another category of healing, more sacramental, involves the holy person's use of prayer and the administering of communion and confession. This form, adopted by Rosa Maria Serio and Bernardino Realino, was by no means exclusive and could be used alongside personal contact. Its use was due in part to the influence of Tridentine teaching and the Church's increased stress on the sacraments.

But the first category seems to be the one preferred by the saints themselves. It is certainly the one that most impressed (and reassured?) the witnesses testifying at the canonisation processes, and has much in common with the rituals of healing performed by the wise women. The sign of the cross, anointing oils and the recitation of prayers were used by both. Whereas the *magare* had their invocations to lend sacred power to their

cures, holy people often used the relics of other saints who had gone before them. Of course, anyone could own and use relics in this way, if they were fortunate enough to be able to acquire them; but when utilised by the saint they seemed to provide a 'sure-fire, double-barrelled' cure which none could duplicate.

Another holy man from the Terra d'Otranto, the Jesuit Francesco de Geronimo of Grottaglie (1642–1716), carried a relic of St Cirus (physician and martyr) while preaching and on missions. In Taranto he was appealed to by a local priest to cure the crippling pains in his side. Francesco went to him and, 'having made the sign of the cross on his side with the relics of St Cirus, he commanded him to go celebrate [the mass] without any fear at all; adding that never more would he be afflicted with similar pain.'[51] Francesco was also an accomplished exorcist, employing the relics of St Cirus to cure, in the words of Camporesi, 'the convulsions, swoonings, hysterical passions, ambiguous pathological states, frequent in convents'.[52]

For his part, Giuseppe da Copertino not only followed the saintly model of St Francis of Assisi, but used the saint's blessing and oil from his lamp in performing cures. According to a lay brother of the Conventual Franciscans,

> many people with diverse ills came to be touched by him, and he sent them to anoint themselves with oil from the lamp of St Francis so that they would receive a favour, and some were healed. Many people from different places looked for something of Fra Giuseppe's, and he would give them the blessing of St Francis written with his own hands [that is, Giuseppe's], and they took them with much devotion, and then said that many sick people had been healed with the blessing.[53]

Rosa Maria Serio made occasional use of the manna of St Nicholas in her cures. This myrrh or oil flowed from the tomb of St Nicholas in Bari, and was held to be most effective in curing pains in the joints and the loss of speech, sight or hearing.[54] On 6 December, the feast of the saint, Serio would anoint her fellow nuns with the manna. One year a nun, suffering from an incurable infection which had spread from her finger to her entire arm and threatened to take her life, beseeched Serio to anoint her arm with it. According to the convent's surgeon, Serio made the sign of the cross on the nun's arm and forehead with the oil, and said to the nun: 'Rest assured, because the saint will grant you the favour; but remember to perform some special devotion each year and once a month, when you are able.'[55]

The final stage of the miraculous cure is the actual healing of the patient. Of course, this stage is implicit in the miracle – a necessary element of it – which the saint never denies, unless for some failing on the part of the patient. In the case of a living saint the cure usually took place

immediately. If it was at the hands of a dead saint, the cure often took place following a vision where the saint appeared, or following a request for his intercession or the application of one of his relics. The stereotypical miracle cure was the immediate one, but there is no reason why the cure could not take considerably longer without losing its miracle classification. This was especially true in the case of a living saint who was present to encourage and reassure the desperate patient. The tertiary nun Virgilia Antoglietta was only cured by Bernardino Realino after one year, during which time she frequently went to him and asked him to pray for her, which he promised to do, blessing her and 'clearly saying to me that I would be cured of that ailment'.[56] But patience, like faith, could waver, especially where a dead saint was asked to intercede before God on behalf of the patient/devotee. If the saint seemed to be failing the devotee, it might be because he or she needed some encouragement, resulting in a kind of bargaining with the sacred. If the saint failed to supply the requested cure he or she might be discarded, as we shall see.

Although one could assemble a list of the types of maladies healed by the saints, both living and dead, in comparison with those treated by other forms of ritual healing, it is important to bear in mind that, like other non-scientific cures, the saint treated the malady's supernatural origin or cause, rather than what we would identify as its organic or natural cause. We saw in chapter 5 that for both the patient (or victim) and the healer diagnosis meant ascertaining the malady's *causation*, the symptoms themselves as-suming but a secondary importance. Analogously, it is frequently difficult, if not impossible, to be sure of the specific nature of the disease cured by the saint's intercession. We are usually given but the vaguest of symptoms, from which it is difficult to diagnose the exact ailment (what to make of the all-too-common fevers and tumours?). For living saints patterns in healing are less noticeable because, in theory at least, the saint's thaumaturgical powers were effective in countering any malady which put the patient's life in danger or profoundly troubled his or her daily life.[57] After the saint's death, however, his or her relics quickly seem to acquire definite specialities (reminiscent of specialities within the Catholic pan-theon), which sometimes owe their origin to events in the saint's own life, but more often seem to acquire a life and traditions of their own.

Given some of the similarities in function between saint and cunning woman, it is interesting to see how the saint employs healing gifts in complete opposition to the *magara*. Like the Church with its set of ecclesiastical remedies, the saint saw him or herself as a competitor for the hearts and minds of the faithful. We have already seen how Bernardino Realino declined to believe in the magical origin of a man's impotence.

Giuseppe da Copertino was much more forthright in his approach. One witness noted that Fra Giuseppe was especially opposed to *maleficium*, and recounted that when Giuseppe found out about a woman who had made a charm against her husband (because she was involved with another man), he convinced the woman to hand the charm over to him. Of course, this did not entail denying the charm's power, which was what made sorcery a thing to be hated and feared. When the witness and Fra Giuseppe were walking back to the monastery with the charm in order to burn it, it began to thunder and flash lightning though the sky was clear, and they grabbed on to one another out of fear.[58]

Fra Giuseppe was able to detect the presence of sorcery in both its practitioners and victims, according to witnesses. Giuseppe Turi, a sculptor from Copertino, was warned by Fra Giuseppe 'not to have himself touched by a Woman' in an attempt to treat his worsening eyesight. Yet despite this combination prophecy-warning, Turi was convinced by his mother that a wise woman could cure him, only to have her touch cause him to lose his sight all but completely. He went to Giuseppe asking forgiveness, and the latter cured his eyesight with his saint's touch. What was perceived as right competing against wrong by the saint, was simply a matter of choice and efficacity as far as this patient was concerned.

Turi was a confident devotee of the servant of God, telling the Congregation of Rites that 'I bear so much affection for Fra Giuseppe that I would go to gaol for his canonisation if God wills it'.[59] He must have had in mind the controversy Fra Giuseppe's activities had caused the ecclesiastical authorities. In 1638, eight years after experiencing his first 'flight', he was summoned to Naples to be examined by the Holy Office, suspicious that witchcraft might be behind his ecstasies and levitations. After he was examined, even experiencing a flight in the monastery of San Gregorio Armeno, in full view of the judges, the trial records were sent to the Roman Congregation of the Holy Office. Here, in February 1639, in the presence of Pope Urban VIII, he was absolved of the charges of simulated sanctity and the abuse of popular credulity. But this was not the end of the story. Although his Christian virtues were fully recognised, he was forbidden from returning to Copertino, and was sent to Assisi. After his flights began to recur and he developed a vast following, he was transferred by the Holy Office to the isolated Capuchin monastery of San Lazzaro in Pietrarossa (near Macerata), where he was held a virtual prisoner. Later that same year (1653), he was transferred to an even more forbidding hermitage at Fossombrone. In 1656 he was pardoned by Pope Alexander VII and sent to the monastery of San Francesco at Osimo (near Ancona), where he died five years later.

Given the fine line separating orthodoxy and heresy (of the diabolical variety), distinguishing true saintliness from 'simulated' sanctity was no easy matter for the Church. The example of the eventually canonised Giuseppe da Copertino (in 1767) would seem to demonstrate that any distinction between magic and religion is an artificial one, having little basis in popular belief and practice, reflecting instead decisions taken by the ecclesiastical authorities. It is interesting that shortly before Fra Giuseppe was canonised Ludovico Antonio Muratori was able to dismiss categorically the reality of witches' flights to the sabbath, (because the devil was no longer believed to have such powers), while admitting to being impressed by Giuseppe's 'flights'.[60] Placing both magic and religion within the larger context of ritual systems and ideological representations as we have done in the preceding chapters allows us to determine the various levels of power of which they are an expression. A brief examination of the category of failed saints – proposed as holy by the periphery but rejected by the Church authorities – will serve to highlight just such ambiguity of the sacred and the forces of control which attempted to define it.

SAINTS-IN-WAITING AND FAILED SAINTS

Sanctity was defined by two Church tribunals, the Congregation of Rites and the Holy Office. The former was concerned with deceased servants of God, the latter examined people suspected of 'simulated' or questionable sanctity while they were still alive. As far as the Holy Office was concerned the anomalous religious experiences it investigated were occasioned by the opposing categories of true saintliness and diabolical seduction, or the possibility of the suspect having feigned everything (which could likewise have been inspired by the devil).[61] Amateur and professional religious women, including tertiary and enclosed nuns, were often consulted by people – frequently women, but occasionally by religious and secular officials – regarding their state of grace, the destination of particular souls after death, whether they would have children, and so on. This activity was another manifestation of that unceasing demand for access to sacred power which led people to 'fake' miracles, both by purposely staging them or, more likely, by declaring occurrences miraculous which, upon examination by the bishop, failed to meet Church criteria. It was the same in the Terra d'Otranto. The Gallipoli synod of 1661 proposed punishing those who faked or spread word of false miracles, decreeing that nothing should be declared miraculous without having first been examined and approved by the Church.[62]

The investigation of such visionaries – some well known and influential, others of more localised fame – by the Inquisition, suspicious of the devil and fraud, was another expression of Church desire to define and regulate the sacred. But as William Christian notes, the cultural type survived throughout the early modern period, despite repression and control.[63] One example of the type has already been discussed in another context: Sr Rosa Maria Serio, a mystic who received the crown of thorns and the stigmata. The restricted and more or less orthodox nature of her following and the fact that she was an enclosed Carmelite nun, where her mystical experiences could be regulated if need be, spared her from the risk of having to appear before the Inquisition. But being an enclosed nun was not always enough. In a well documented case examined by Judith Brown, the Theatine nun Benedetta Carlini was investigated for her visions, stigmata, mystical marriage with Christ (complete with wedding band) and an exchange of heart between her and Christ. Accused of 'demonic illusions', Carlini spent most of the rest of her life in a convent prison where she died in 1661. Yet even after all her years in prison, crowds of people flocked to the convent gates when she died, seeking to touch her body and leave with a relic or two. One nun wrote in her diary: 'As she was always popular among the laity, when they heard of her death they created much agitation while the body was still unburied and it was necessary to bar the doors of the church to avoid any uproar and tumult until the burial.'[64]

In such cases of presumed sanctity there was always a tension, an ambivalence, which often makes it difficult for the modern historian to isolate the particular reasons why the Inquisition decided in favour or against the suspect. On the one hand, for example, we have the case of the Neapolitan nun Orsola Benincasa (1547–1618), famous throughout the city for her visions and ecstasies, accompanied by pronounced prophetic and messianic tendencies.[65] Imprisoned by the Holy Office, she was examined, exorcised and depilated, but no sign of the Devil was found, and she was released, her orthodoxy recognised. Watched over by a representative of the Holy Office and obliged to reform the congregation she had founded into a female branch of the Theatines, she nevertheless became an adviser to Neapolitan high society, though her prophesying was now restricted to the private domain. Her process began shortly after her death and she was pronounced venerable in 1793.

On the other hand, we have someone like her fellow Neapolitan Alfonsina Rispola, a poor tertiary nun living at home with her aunt. Rispola was first brought before the episcopal tribunal of the Holy Office in 1581 and again in 1592, when she was forced to remain in a convent and

abstain from any activity 'ad suspectam sanctitatem'.[66] Besides receiving the crown of thorns and the stigmata, she was also a visionary. On one occasion St Anne appeared to her while she was in bed at night, telling her not to fear the plague then threatening the city for it would not come to Naples (Rispola was able to comfort a worried neighbour with the message).[67] Another of her mystical experiences concerned a spiritual voyage to Hell, Purgatory and Heaven following an accident: it was perhaps this incident which justified her ability to discourse with the saints and the deceased, being able to tell the other nuns in the convent whether a departed relative or friend was in Heaven or Hell.[68] Word had got about of her close contacts with the sacred and she was asked by one man to pray for his sick daughter. According to Suor Virginia, Rispola often prayed for the illnesses of other people, assuming them herself as a result.[69] First accused (falsely, it would seem) of boasting of her visions and holiness, she was kept in prison despite the intervention of the Holy Office in Rome, which was convinced that her experiences were 'good rather than bad things', and suggested that she be released to house arrest and allowed to receive the sacraments while a proper trial was conducted.[70] Nevertheless the representatives of the Holy Office in Naples remained unconvinced of the orthodoxy of her account, and, after twelve years of prison and questioning, Rispola finally switched over to their view of her experiences as diabolical temptations. She was condemned to life imprisonment in the convent of Santa Maria della Consolazione in Naples.

In both cases we have the beginnings of local sanctity. However, while Benincasa was accepted by the Church authorities, Rispola's case for sanctity was rejected as 'simulated'. Both were proposed as holy by the periphery, but only one was accepted. What might account for Rispola's rejection and condemnation? One possible explanation is Rispola's marginal position as a tertiary nun. It was difficult enough for a regular enclosed nun to pass the test, but a woman living in the public space, professing healing and visionary powers, was a possible source of scandal for the Church. Rispola, like the tertiary nun of Bologna examined by Luisa Ciammitti, may have aimed too high, towards saintliness, claims which the Church regarded as subversive. Both were poor, lone women, lacking institutional protection, in a society where the institutional role represented a form of self-defence and a reassurance for others.[71] The position of tertiary or lay nun, the only religious one open to poor women, meant taking a vow of chastity but living at home. And although it provided the woman with more of a position than she would normally have had it was still not the relative security of a convent, where the nun was subject to religious discipline and supervision. The poor lay woman

with a gift of visions and miracle-working powers could easily be confused with the wise woman, who after all fulfilled a similar role in society. The position of tertiary nun provided scant protection from the increasing desire of the Counter-Reformation ecclesiastical hierarchy to regulate forms of access to and expressions of the sacred. None the less extraliturgical cults continued to spring up about such holy people who appeared to have been 'chosen' by God, many continuing to flourish even after the holy person's death and condemnation by the Church, fruit of a spontaneous and endless local desire for manifestations of the sacred.[72]

PATRON SAINTS

This need for a local sacred presence, especially in the form of mediators and protectors, is also reflected in the proliferation of patron saints. Already important in the early Church as friends and patrons, deriving in part from the ancient legal concept of a reciprocal pact between a strong patron and a weak client,[73] prior to the foundation of the Congregation of Rites the choice of a patron saint had been up to the community and its bishop. As with Church control of the saint-making process, the election of community patrons was also increasingly regulated. A 1630 decree issued by the Congregation of Rites stipulated that patrons had to be recognised saints and that the election had to be unanimously supported by community representatives (notables, clergy and bishop). The proposal was then to be examined by the Congregation in Rome to see that it met these stipulations before it was officially approved.

The purpose of the patron saints was to intercede on behalf of their clients – in this case, the community – to protect them from natural disasters, epidemics and any other form of calamity which might threaten them. Martyrdom for the community was a natural criterion which marked the saint as chosen by God and a fitting representative for the community. Not only was martydom sufficient to ensure sainthood, but when it occurred to a native son or daughter, who would naturally seek to support his or her community's interest before God, it made that martyr the most obvious choice as patron. And the more martyrs the better. The eight hundred citizens of Otranto who refused to renounce Christianity after surrendering their city to the Ottoman Turks in 1480, and were subsequently executed on a hill near the city, became immediate objects of veneration after Otranto was retaken a year later.[74] Alfonso of Aragon had the remains of 240 martyrs brought to Naples, while other relics made their way to Lecce, Tivoli, Venice and even Spain (the rest were deposited in a cathedral chapel constructed for the purpose). In 1539 the *sindaco* of

Otranto, following campaigning by citizens of the town, declared the martyrs principal patrons of the city. In that same year the first hearings were held for their beatification. Their cause was resumed twice, in 1660 by Bishop Adarzo and again in 1677 by Bishop Piccolomini, before being more definitively set up almost eighty years later under Bishop Caracciolo (1755). The acts of the *processo ordinario* were then sent to the Congregation of Rites and the martyrs of Otranto were finally beatified in 1771, their feast to be celebrated on 14 August.

Community support of its patron was celebrated on the saint's feast day, when a special office was recited and his or her legend was read out. Especially on such occasions, but throughout the year as well, the patron saint's statue represented the object of community devotion and a celebration of the saint's presence in its midst. For the town of Trepuzzi in the diocese of Lecce their patron, St Oronzo, warranted two feasts, the first of which was celebrated on the Sunday following 26 August:

> Following the second vespers the statue of the said saint is carried with sacred pomp through the whole town. Likewise the same feast is celebrated on 20 February with equal solemnity, a procession and with exposition every evening for eleven days, in memory of this town having been liberated from the earthquake by the saint's intercession.[75]

Oronzo (Orontius) is the Otrantine saint par excellence, believed to have single-handedly spared the region from the disastrous plague of 1656, reviving a cult that was in fact far older. Apparently proclaimed bishop of Lecce by St Paul himself, Oronzo was martyred during the persecutions of Nero. In the eleventh and twelfth centuries cults devoted to him are mentioned in such palces as Taranto and Monte Sant'Angelo, and an 1181 document mentions what is probably a rural church dedicated to him, which by 1407 was also the site of a fair celebrated there on the last Sunday of August.[76] He was patron of Ostuni from at least the mid-1500s, where a cave in which he is supposed to have lived for a time is venerated. His patronage of Lecce was suppressed in 1640, only to be recognised again by the Congregation of Rites in 1658 after a proposal made by Bishop Pappacoda in gratitude to the saint for having spared the city from the plague.

As with all other forms of access to sacred power, the demand for intercession was high. It was the same city of Lecce which in 1616 asked the dying Bernardino Realino to act as the city's protector, which he accepted.[77] And it was Lecce which in 1688 sought to elect thirteen new patrons at one time. Its total of eighteen elections in the period 1630–99 was second only to the capital of the Kingdom, Naples, which elected

twenty-one new patrons during the same period. In fact, twenty-six communities in the province of Terra d'Otranto elected new patrons in the years 1630–99, a higher number than any of the Kingdom's eleven other provinces.[78] What can be deduced from this and what do the elections of patron saints reveal about religiosity during this period?

First of all, both the number of elections and the number of new patron saints is highest during the last decade of the period (1690–9). According to Sallmann, this would seem to suggest a gap between the culmination of institutional Catholic reform in the years between 1625 and 1650, and the reform of cultural and devotional behaviour. Prior to 1690 the election of new patrons responded to entirely local considerations and was not linked to wider developments. Thus the 1605 election of St Thomas Aquinas as the city of Naples's eighth patron was promoted by the nobles of the *Seggio* on the basis of his origin in the vicinity and his relation to the city's nobility, as well as his learning and holiness.[79] Second, and perhaps more surprisingly, increases in the numbers of new patrons chosen did not generally correspond to the incidence of natural disaster like plague or earthquake. Rather, they seem to be related to the influence of new models of devotion and the economic strength of certain regions. According to Sallmann, the relative prosperity and openness to the outside world of the Terra d'Otranto led to an increased communal vitality and sensibility to new devotional models, as also exemplified by the widespread success of baroque architecture in the province.[80]

Finally, owing to what Sallmann calls the atemporal quality of sanctity, the elections are almost equally divided among the four categories of saints of the early church (bishops like Oronzo and thaumaturgical saints like Cosmas and Damian), medieval saints (primarily members of the mendicant order, such as the exceedingly popular St Anthony of Padua), Counter-Reformation saints (who are just beginning to be recognised in this period, like St Filippo Neri), and members of the Holy Family (primarily the Virgin Mary, in her various manifestations).[81] Lecce's patronal elections got the balance just about right: six ancient saints, six medieval saints, four Counter-Reformation saints and two members of the Holy Family (St Anne and St Joseph). Once a new saint was recognised as patron he or she possessed the same efficacy of the most obscure martyr of the early church, while the ancient saints themselves remained ever current, though particular saints could periodically fall out of favour.

Each time the community added a new patron saint it weakened the power of the one(s) previously chosen by breaking down the exclusive nature of the patron–client relationship. None the less, the seventeenth century was characterised by what has been called a 'patronage hunt'.[82] In

part this was due to the efforts of the Religious Orders in support of their own saints, and to important cities like Naples and Lecce attempting to preserve their dominance over symbolic access to the sacred. But, as Sallmann concludes, it also 'reflects a period of anguish, a convulsive search for supernatural protection, favoured and negotiated by the Catholic Church.'[83] It affected all levels of society: from the ruling classes who elected the patrons to the poorer classes, who had to be content with supporting and 'consuming' this expression of the sacred. Competing factions within the aristocracy and the clergy could make use of these devotions for their own prestige. A good example is the controversy in Lecce over the relics of St Irene – the city's principal patron before the election of Oronzo – whose body the Theatines claimed to possess. Beginning in 1603 the Jesuits asserted that it was really the body of the minor saint Ireniana. The Theatines reacted by staging demonstrations against the Jesuits, complete with a chant that went:

> Viva, viva li Teatini
> c'hanno vinto alli Gesuini
> lo corpo di S. Irene
> crepa, crepa alli Gesuini![84]

Occasionally the poor could make their own voice heard, but only in terms acceptable to the élites. In 1764 the Sardinian ambassador to Naples wrote of the famine then ravaging the entire Kingdom:

> The famine is appalling, accompanied by riots and pillage. One man tears the bread from another's mouth, and there is killing and wounding whenever bread is distributed... Between eight and ten thousand women have gone to ask the Archbishop to expose San Gennaro's relics, and public penances are all confused with Carnival. Many have perished in the provinces... The processions of women with crowns of thorns and crosses on their backs are pitiful and gruesome. The famine is thought to be a chastisement from God. Images work miracles in abundance, except that of multiplying bread. A crucifix which opened and shut its eyes has been cut to pieces, because everybody wants a relic.[85]

PERSONALISATION OF THE SACRED

This constant quest for sacred power could be revealed just as easily by the rejection of patrons as by their election, a fact which demonstrates one aspect of the relationship to patron saints – and saints in general – which numbers fail to reveal: the intense personalisation of the sacred in the figure of the saint. To remain with the principal patron in the sacred hierarchy of

Naples, St Gennaro. We know about the miraculous liquefaction of his blood from the accounts of many eighteenth-century travellers in Italy. Because a failure in the miracle augured badly for the city, the assembled crowd, and especially the self-styled 'relatives' of the saint, would be 'filled with rage and indignation at the saint's obstinacy if there were a delay in the miracle', and would threateningly yell: 'Yellow-face – what are you waiting for?!'[86] The saint was so tied to the city's identity through his role as protector that his figure was used by the court to legitimise its authority, as in the foundation of the Knightly Order of St Januarius in 1738. When he failed to protect the city from the Republican advance in 1799, St Gennaro was identified as a traitor and subjected to much abuse by the populace: 'Go, get out of here, St Gennaro you pig, even you're a Jacobin, phooey!'[87] He was soon replaced as principal patron by St Anthony of Padua – ratified by the Congregation of Rites in 1800 – and his statue was thrown into the bay. His patronage was restored on Bourbon re-entry into the city.

Such treatment of saints, including insults and threats, could also take place between the single devotee and the saint he or she invoked, the scene shifting from the civic to the domestic environment. Uncooperative statues and images could be shoved into the cupboard as punishment, or outside, in the household well. If the saints reneged on their duties they had to be taught a lesson and were 'punished'. Moreover, if a long time passed without granting any of the favours sought by devotees, the saint could be easily forgotten. Two proverbs gathered in 1774 by the Gallipolitan cleric Carlo Occhilupo reflect this fact: 'You don't say Paternosters to a saint who won't grant favours' ('A santo che non fa grazzie non dire paternostri') and 'You don't light a candle for a forgotten saint' ('A santo dimenticato non se duma lampa').[88] There was always another miracle-working saint to take their place.

Saints – like cunning folk – were believed to be proud and unpredictable, and were generally regarded as ambivalent beings.[89] The saints could take vengeance on those who offended them, especially if they were regarded as thaumaturgical saints. Saints attributed with the power over certain diseases had the power to provoke them in whoever ridiculed their power, made fun of them or otherwise insulted them by neglecting to fulfil a vow or make an offering. In the previous chapter we saw the ambivalent relationships of St Paul to tarantism, St Donatus to certain nervous disorders (like epilepsy), and St Anthony to erysipelas (St Anthony's fire). The patient was only cured when the saint's wrath was placated, through prayer and pilgrimage.

The saint, an embodiment of the sacred in his power to mediate between the human and divine, was thus personalised and domesticated.

This was expressed in the close and familiar contact between the devotee and the saint, which generally operated outside of formal ecclesiastical structures, responding to individual and group needs and anxieties. Although contact with the saint and the favours expected of him has often between described as magical and formulaic, the relationship is perhaps better described as contractual, like that between patron and client, as suggested above. The devotee knew that the saint's capabilities were vitually unlimited, that what was miraculous for the ordinary Christian was in fact within the normal realm of possibilities for the saint.[90] If the saint refused to perform he or she might need a bit of coaxing from the devotee. In 1735 an image of Giuseppe da Copertino was brought to a nun at the Carmelite convent in Lecce, on her deathbed after years of the most excruciating physical torments. Hoping for a miracle, the priest at her bedside took the image into his hands 'and addressing his words to the venerable servant of God, said this: "Now it's time, if you yearn to be beatified soon", and fervently recommending the same dying woman to his intercession, he prayed to him that if he should wish to console her, he give a sign of it that same night.'[91] He then placed the image on the nun. The bargaining worked, for she was soon completely healed, (although despite the miracle Fra Giuseppe was not beatified for another eighteen years!).

Another example, which also focuses on an image, concerns a priest of Grottaglie who was suffering from severe stomach spasms aggravated by colic, which prevented him from even lying in bed, so great was the pain. He turned to the invocation of several saints (whom he did not name in his testimony), but there was no response. Then he remembered Francesco de Geronimo, a native son, and he exclaimed:

> Come on now, you who are a fellow countryman. Come on, either make it so that this pain goes away altogether or is at least transferred to another part of my body. And if my health should return I'll have your image painted on canvas, as an indication of your charity towards me.

The saint cured him, but made certain that the devotee fulfilled his side of the bargain. Finally able to fall asleep, Francesco appeared to the priest and said: 'You have already obtained what you desired. Now keep your word, and continue as you are doing.' The latter request referred to the priest's habit of saying prayers of thanks every day.[92]

The saint is identified with his or her image, a materialisation of the sacred which is analogous to its personalisation in the form of the saint. The image, like the relics we shall be disussing shortly, guaranteed the reality of sacred power, demonstrating 'a need for concreteness, for imme-

diacy, more than for physicality pure and simple'.[93] The figure or likeness of the saint was crucial, hence the expression 'vado al santo' (I'm going to the saint) for going to church. According to Richard Trexler the cult of Corpus Christi encouraged this reverential attitude towards the material representation of saints by 'validating one of the strongest religous tendencies: to give form to power on the principle that power was imputable in objects.'[94] So if the Host was the image of God, how much more plausible a painting of the Virgin or a saint must have been. The physical reality of the image was stressed by its decoration, usually on the saint's feast. So widespread was this custom that it sometimes led to abuses, and the second synod of Oria forbade the practice of 'certain women' of adorning images with 'vain ornaments and hairpieces'.[95]

As we saw in chapter 4 in the context of forms of prayer, the image could respond physically to a request made of it – in one case, by knocking against the wall. The image could also occasion visions of the saint, in which case it aided in identifying the saint in the vision. A gravely ill woman of Ostuni recommended herself to Sr Rosa Maria Serio (shortly after the venerable's death), whose image was hanging in view above her bed. Several nights later, lying awake, Serio appeared to her, 'whom I immediately recognised as Sister Rosa Maria because I had her portrait in sight'.[96] The most obvious sign of the image's role in materialising the saint and affirming the presence of the sacred was in its anthropomorphic qualities. Rev. Francesco Sordini, a Cathedral canon in Lecce, was a devotee of Giuseppe da Copertino and had fixed an image of the servant of God on the headboard of his bed. When summer came the bed-curtains were removed and with them the image of Giuseppe. Unawares, Sordini went to bed and that night was taken ill with fever, and turning to the image for succour, he found it gone. After shouting at the servants, he went to fetch it himself, where he found it still attached to the headboard. He said: 'Oh, Fra Giuseppe, tonight my servants allowed you to catch cold outside my room, and for this reason I felt the heat of fever'. After hanging up the image he slept peacefully, his health restored.[97]

As suggested in the above example, the image was often used to heal disease, frequently by application to the affected part of the body. Rev. Sordini gave an image of Fra Giuseppe to his daughters (he had been married, and 'widowed, before joining the priesthood) who used it to alleviate severe labour pains.[98] In the same fashion the image could 'bodily' take on the disease as some saints were known to do. Thus a fisherman from Taranto, on his deathbed with fever, placed an image of Francesco de Geronimo on his burning forehead and prayed for the saint's intercession. When the image fell accidentally to the ground, the person picking it up

noticed that it had turned dark red and seemed to burn.[99]

The image is able to heal not because it is a mere representation of the saint, but because by bearing the saint's likeness it actually *is* the saint, and takes on all the sacred powers associated with the saint and his body. In this sense the image is more than a portrait: it is a relic.

RELICS

The widespread popularity of relics as embodiments of the sacred and as sources of devotion is yet another expression of attitudes towards the sacred that calls into question the official–popular distinction so often made when discussing such beliefs and practices. The functions of relics are several, from the commemorative and meditative, the devotional and liturgical, to the representative and personifying. But if the canonisation processes are anything to go by, it was their therapeutic or thaumaturgical functions which were considered the most vital. Before we examine the role and significance or relics in early modern Terra d'Otranto, let us distinguish between the various types, of which there are five. First of all, corporeal relics are the saint's bodily remains, ranging from the entire corpse to the most minute fragments thereof. Asscociative relics are objects habitually used by or connected with the holy person, such as articles of clothing or personal devotional items. Related to these are topographic relics, places associated with the saint, whether natural or man-made (like a building or cave where he or she resided). Next, we have substitute or secondary relics, referring to items which have come into contact with a corporeal, associative or topographic relic, and so becoming relics in their own right (such as a rosary applied to a saint's remains). Finally, there are the symbolic relics, which we have just discussed: those items – like images and icons – which are identified with the holy person and so treated as a part or extension of (as well as a representation of) that person's body.[100]

Let us begin with the bodily remains of a holy person, for the entire community would unite around the protection he or she offered as a native or adopted citizen. We saw in chapter 4 how crowds of people in Lecce flocked to see the body of Bernardino Realino after his death, attempting to secure personal relics of their own. As such a potent symbol and source of power precautions had to be frequently taken with a saint's corpse, as in 1741 when the body of Rosa Maria Serio had to be moved 'from the said common burial, because it suffered from damp and was in danger of being stolen.'[101] In this ceaseless quest for saints and relics to protect the community, according to Aron Gurevich, believers would not even stop at killing the holy man himself in order to possess the line to

sacred power his body offered. In his *Life of St Romuald* Peter Damian told how the mountain-dwellers of Umbria threatened to kill their holy man when he told them he was leaving, so that they would have at least his lifeless body as patron of their land.[102] Perhaps a bit extreme, but it serves to demonstrate the importance of a saint's remains at the community level as a source of community protection and pride.

Lesser relics gave access to the sacred for smaller groups of people, even individuals – for those fortunate enought to own them. The competition for them and their use and the sense of possession they engendered in their owners could be just as intense as that over the saintly corpse. The Gallipoli synod of 1661 decreed that saints' relics must not be taken out of the churches, nor circulated about and kept in private homes, since their suitable place was in a church (no doubt relics thus circulated occasionally failed to find their way back).[103] Acknowledging the continual demand for relics, the synod went on to forbid anyone from proposing or circulating new or previously unknown relics to the faithful, a further example of ecclesiastical attempts to regulate the consumption of the sacred.

This cannot have been an easy phenomenon to control, given the potentially unlimited supply of relics (they could be cut up and divided into the smallest pieces without losing their efficacy). People went to the holy person's tomb or sought out their relics (including images) of their own accord, without feeling the need for clerical mediation. Thus Bernardino Realino's relics were treasured even while he was still alive and his tomb became something of a shrine immediately after his death.

> It is very true [commented one lay witness] that Father Bernardino was held by everyone to be a saintly, indeed most saintly man, and whilst alive they sought him out and held his relics in reverence, as I did, and they had portraits made, which they kept among the other images of saints... And it is also very true that the said reputation of sanctity of Father Bernardino after his death has never been wanting, but has grown every day, and because of this, everyone has recourse to his tomb for their needs, which is all full of different ex-votos, candles, oil lamps and similar things, which are usually seen in the churches and tombs of canonised saints.[104]

Because the supply of relics never met the apparently insatiable demand for them, relics were often circulated about to those in need by their kind owners. A former tinseller, Giuseppe Ottivio, described how he knew of Bernardino's sanctity through a cane of his which Ottivio venerated as miraculous and which circulated among women in labour, easing the pains of childbirth by its touch. After mentioning two recent cases, Ottivio concluded that 'besides [this] I don't know anything else in

particular about the said cane, because I don't remember, although many other times and continually I have lent it to women in labour in similar situations'.[105] Of course the proven efficacy of a certain relic could also have the opposite effect of making its owner over-protective and unwilling to lend it out. After testifying at length about Bernardino's complete unselfishness and his readiness to help anyone in need, Francesco Verdesca, a nobleman of Lecce (worth 12,000 ducats), mentions the relics he possesses:

> I have a biretta and some manuscripts of the said Father Bernardino, and I keep them with much veneration, and I wouldn't give them up for any large treasure; and although many sick people have come to ask me to lend them the biretta for their devotion with the hope that they would be granted health through it, I do not willingly lend it because of the fear that it would not be returned.[106]

Even physicians, recognising the limits of their profession, participated in the widespread hunt for relics. A doctor of Fasano, Bartolomeo Carelli, after paying a visit to Sr Serio, spotted some clothes soaked with blood, which a nun told him were from the 'Servant of God's rib wound' (remembering that she had the crown of thorns and the stigmata). He asked Serio's sister, a nun at the same convent, if she would give him one, and she went with great secrecy to fetch it and Carelli took it home wrapped up in some paper.[107]

Like the relics of Francesco de Geronimo's blood, considered the most wonder-working and so the most sought after, those of Rosa Maria Serio were also in great demand, no doubt a reflection on her constant acts of bodily mortification while alive (her primary devotion was the Passion of Christ). As Piero Camporesi has lucidly observed, 'this was the very blood, the very symbol of physical vitality which, with grim fury and maniacal intent, [the saints] forced out of their living bodies, in their headlong frenzy to destroy that filthy and impure vessel of vice'.[108] So powerful was the attraction of blood that the body of the venerable Sr Chiara d'Amato went unburied for two days after her death in 1694, while a barber was called in to bleed her arm, 'and a copious quantity of blood flowed from the vein, collected by the various religious women and devotees present'.[109] A further prominent example of the blood relic is the typology involving the blood clot, contained in an ampoule, which miraculously liquefies from time to time, examples of which are found primarily, but not uniquely, in the Naples region.[110] In 1623 a Lecce physician, Giuseppe Cosmà, praised a certain Lucretia Petrarola who had the foresight to collect some of Bernardino's blood while he was still alive, taking advan-

tage of a fall of his. She sealed it in an ampoule where it maintained the consistency of fresh blood, even bubbling occasionally. Cosmà compared this to the miracle of St Gennaro in Naples.[111]

Another popular category of relic consisted of the saint's own correspondence and papers, in fact, anything written by the saint (an example of the associative relic). The popularity of letters as relics presents problems for the historian wishing to study the saint's correspondence. In the case of Bernardino Realino, a prolific letter-writer, it has been suggested that his output reached a peak during the years 1600–12, a time of relative health and activity for the saint. But this hypothesis may be conditioned by the survival rate of his letters: as time went on they were increasingly kept by the recipients as objects of veneration and miraculous cures, so that they never reached the Congregation of Rites.[112] Because the canonisation hearings stressed the miraculous as a test of sanctity, particularly miracles taking place after the holy person's death (as proof that he or she was interceding on behalf of devotees), one receives the exaggerated impression that the saint's writings were *applied* rather than read. Thus when a doctor of Roffano (in the diocese of Ugento), Giuseppe Grasso, was taken ill with a life-threatening intestinal obstruction, his son, a Jesuit priest, brought him several sheets of paper bearing Bernardino's handwriting, which were applied to his body, curing him.[113]

Such was the case for a saint known primarily for his spirituality and learning! In the case of Giuseppe da Copertino, sought out for his thaumaturgic and apotropaic gifts, the use of his letters as relics is much more in keeping with his healing activities while alive. Thus his letters were used in everything from difficult pregnancies – where the doctors had given up – to curing fevers and headaches caused by *maleficium*, which priests had been unable to counter with ecclesiastical remedies.[114]

For those testifying at the canonisation processes sanctity was proved and expressed by the holy person's ability to heal, regardless of his or her other gifts. Frequently, miracles after the saint's death follow the typology of those which they performed while alive, as in the case of Giuseppe da Copertino. So too with Francesco de Geronimo, who was an accomplished exorcist, as we have seen. De Geronimo's activity continued after his death, through his relics. In 1718 Lionard' Antonia Spagnuolo of Grottaglie became possessed and, 'impelled time and again by her fits, she would burst out in the screams of a lamenting woman, beat her head on the ground, tear out her hair, bite her arm with rage and give way to other similar frenzied behaviour, frightening and grievous not only for the servants, but for the neighbourhood too'. She tried pious devotions and exorcisms but nothing would liberate her, so she went to the archpriest of

Grottaglie, who also happened to be de Geronimo's brother. He touched her head with a reliquary containing pieces of clothing which had belonged to the saint, causing her to fall to the ground, screaming wildly. At this point, he applied the relics again, and she regained her senses and kissed the reliquary, cured of her malady.[115]

As any saint was a potential exorcist, so were any relics potential instruments in the exorcism rite. In a case, involving a relic of Rosa Maria Serio's, a physician lent a relic (a piece of cloth) to a priest suggesting he should use it in exorcising a woman whom the priest had been unable to treat with success (meaning that her ailment must have been of supernatural origin). Performing the rite, the priest took the relic, 'which he held over the said woman, and she began to shout and scream, saying, "Take it away, take it away; it's fire, it's fire!"', after which she immediately calmed down.[116]

Yet the relics could also take on a life and significance of their own, independent of and unrelated to the holy person's activities and gifts while alive. The same relic just mentioned was used by the doctor when the woman – no longer possessed – was pregnant but because of her weakened condition would be unable to give birth 'without some supernatural help', according to the doctor. As an act of charity he went to fetch the relic, and placing it on her, said to her: 'have living faith in this, because I have placed it on you'. Then, 'as soon as she had touched it and kissed it, in my presence she immediately and happily gave birth to a living baby girl, without any harm to the mother and to much wonder and amazement'.[117]

In fact it is regarding difficult deliveries that individual relics frequently acquired their own healing traditions or therapeutic pedigree – for example, the cane (with possible phallic connotations) which had belonged to Bernardino Realino and which eased labour pains when touched to the womb; or the chair of the same saint which acquired another life as a miraculous birthing stool. Its history, like those of many other relics, began in a somewhat accidental fashion. (In general, the afflicted were ready to try any means available to alleviate their suffering; and with success, the relic's reputation quickly spread, reinforced by subsequent miracles.) In this case, Dorotea Viva of Lecce obviously knew of the existence of the chair which Bernardino used to sit on. In great pain and apparently unable to give birth, she sent someone to ask Rev. Paolo Torrisio if she could borrow the chair. When the chair was returned to the Jesuit College, Torrisio was told that

as soon as the said Signora Dorotea sat down on the said chair, all her

difficulties ceased and she gave birth successfully... And for this reason [Torrisio concludes] all the women in labour of this city, when they feel difficulties in giving birth, send for the said chair to be brought, and seated on it they give birth successfully.[118]

One form of relic not discussed much so far is the secondary or substitute relic: that item which becomes a relic in its own right through contact with a primary relic, whether corporeal, associative or topographic. It is in the use of this type of relic that we can observe the closest resemblance with the healing rituals employed by the wise woman, for it often lacks clerical mediation. Oil was frequently employed as a secondary relic, similar to its use in popular healing. Such was the case when a woman took some oil from the lamp burning at Bernardino Realino's tomb with some wadding and anointed the afflicted bodily parts of her ailing nephew with it. After this she rested, and the cure was revealed to her in a vision, confirming its miraculous provenance. The doctor who had earlier given up hope for the patient pronounced him miraculously cured and said he could go back to work without fear.[119]

Another striking case points to the parallels between invocation of the saint and the *orazioni* used by wise women in addressing the supernatural. Laura Leganza recounted that on one occasion the two horses her family owned seemed about to die from dehydration, according to a helpless stable hand. So she went to the church of the Gesù (in Lecce) to go to confession and hear mass, before going to Bernardino's tomb and praying him to intercede and heal the horses.

> Because on that day there were several fronds, as of roses, above the said tomb, I took an end and returned home. In the presence of my sister Isabella Leganza I began to touch the horses with these fronds, saying over and over: 'Oh, Father Bernardino, heal them.' And immediately, much to me and my sister's amazement they started to eat, and all their malady ceased, and they haven't had anything more.[120]

As hinted throughout this chapter, physicians too believed in the powers of relics over ailments which they were helpless to cure. Rather than regard them as a form of competition, physicians realised that relics – and the activities of living.holy people – could complement the capabilities of their own profession.

Moreover, miraculous cures could often be lent validity by a physician's judgement, particularly when the doctor himself was the patient. Ladislao Miglietta was healed of a headache and fever by a cushion which had belonged to Bernardino Realino. He placed the cushion on his head 'and immediately his headache ceased, and the apprehension, and little by little

the fever left him, and the said Ladislao, who was a doctor, and knew the nature of his malady, then said publicly that he had been healed by a miracle of Father Bernardino'.[121] But in an age when most could not afford the services of a doctor – and, given their 'medicaments', it was probably just as well – the doctors could also recognise the uses of other remedial forms (what we might today call alternative medicine), without condemning them as quackery, since they involved orthodox religious beliefs. In one case a doctor began treating a woman who was swollen from the waist down and unable to move about, but was doubtful whether she would get better, because her husband, a tanner, 'is poor and cannot afford the costs required for the treament of this ailment. Certainly [the doctor went on], it was not something to be cured in a few days, nor in this winter season.' During a particularly painful night for his wife, the poor tanner invoked Bernardino's intercession, and by the morning her swelling had all but disappeared. For the doctor it was a miracle not only because it happened during March – 'before summer came, although it would have been a miracle even in summertime' – but because it was instantaneous, whereas 'by natural means those thick and abundant humours which she had in her body would have to dry very slowly, nor could they drain themselves all at once'.[122]

Common to all the expressions and roles of sanctity we have discussed was the unceasing quest for sacred sources of power, often spontaneous and localised in nature. Even the saints recognised as suitable for veneration throughout the universal Church began as locally sought-after holy people: Barnardino in Lecce and Giuseppe in Copertino. Others travelled widely, but always retained a devoted following in their place of origin: Lorenzo in Brindisi and Francesco in Grottaglie. Periphery and centre met in their canonisation. This process of negotiation is nowhere more evident than in the growth of Marian shrines during our period, throughout Catholic Europe in general, and the Terra d'Otranto in particular. Devotion to the Virgin Mary will be the subject of the next section.

MARIAN DEVOTION

We have not focused on the Virgin up to now, the most important of saints, because in many ways she is unique. As Queen of Heaven and *Theotokos* she was the paragon of sacred power combined with accessibility, and her ability to intercede related to every human need. In this sense – like no other saint – she was universal, as manifested through her feasts (Annunciation, Purification, Nativity, Assumption, Conception), the mass and the Office of the Virgin. Yet, at the same time, she was

continually being 'localised', each apparition and image having its own origin and assuming its own reality. A further key to Marian popularity and predominance in the south of Italy – and once again we are speaking of a devotion diffused amongst all levels of society – lies not in such things as pre-Christian survivals of devotion to some kind of earth goddess (although these may have a minor role of continuity, as will be suggested in our look at Marian images), but in the activity of the Counter-Reformation Church in encouraging the cult of Our Lady.[123] The phenomenon is thus primarily a historical one. It involves, for instance, Orders like the Jesuits which spread Marian devotion as part of their missions. It was the Jesuit Wilhelm Gumppenberg who compiled the *Atlas Marianus* in 1672, and it was the Jesuit missioners active in the Kingdom of Naples who instructed reapers to dedicate sheaves of wheat to the Virgin rather than to their lady loves, employing the successful technique of adapting forms of popular culture to the content of Tridentine ecclesiastical culture.[124]

The encouragement of the cult of Mary seemed to respond to a need for a further personalisation and incarnation of the divine. As was the case with other images, there was a practical identity between the Virgin and her image in the devotee's mind. Thus the image was not referred to as 'the image of the Virgin', but simply as 'the Virgin'. For example, an image of Our Lady of the Immaculate Conception was personalised as 'La Concetta' when it was reported missing from an unused chapel in Gallipoli.[125] Moreover the image possessed real sensory attributes. On the one hand, an image could be threatened with water in order to coax it to intercede, as was done in the case of drought. But it could also react in anger if physically mistreated. A man who had lost a large quantity of money playing *bocce* threw one of the wooden balls at the nearby image of Our Lady of the Olives (just outside the town of Mesagne, in the diocese of Brindisi), leaving a dark red mark. Not only was the man's arm rendered immediately useless, but he was arrested by the authorities and condemned to the gallows.[126] To mark the occurrence and as a reminder to other 'profaners' its dedication was changed to Our Lady of Justice, and in 1579 to Our Lady of Mercy, thought more in keeping with the Virgin's forgiving nature.[127] By throwing his ball at the image the man may have been showing anger at the Virgin's failure to bring him victory. The response to failure was not usually the conclusion that the saint-image lacked power, but that it had been unwilling to help. Such perceived malevolence on the image's part could easily lead to 'instructive vengeance' on the part of the devotee, who had in many cases invested much in the image, emotionally – in the form of trust or prayers – and perhaps

financially. This profanation of an image, its defilement, can even be considered a sacred act, since it too 'envinces the power of the image'.[128] But if the profanation is unjustified the image will seek retribution, as we have seen. In fact, the *topos* of the irate player is a common one, lying at the origin of Naples's most famous and popular shrine, the Madonna dell'Arco. According to the legend, the thrower of the ball was, after a summary trial, hanged from a tree which dried up on contact with the profaner.[129]

Devotion to the Virgin helped to fill the void created by the Church's increasing control of the saint-making process and the punishment it meted out to 'false' saints. Her well-rooted position in the Christian religious universe made her acceptable locally as protrectress and provider of miracles; while at the centre, she provided the Church with orthodox doctrinal models.[130] The various Otrantine Marian images which performed miracles and became shrines owed their origin to local, primarily lay, discovery, as recounted in the images' *inventio* narratives. The whole process suggests a need for the sacred presence not satisfied by the institutional Church, especially in the countryside, and a laity which 'is able to bestow upon itself, prior to ecclesiastical discipline, the sacral object which it needs'.[131] At the same time, quick acceptance and approval by the Church authorities was due to the fact that the event itself was a verifiable *fait accompli* due to the presence of the sacred image, already a worthy object of veneration in itself.

This is not to say that there was no ecclesiastical control. Far from it. As with other focal points of devotion, the Church attempted to keep a close watch over activities associated with the image and its shrine, especially once its healing powers were widely known, to make sure they remained within the bounds of orthodoxy. One example will suffice. At the cave church of Our Lady of Calimanna, outside the town of Supersano (diocese of Ugento), pilgrims came seeking liberation from evil spirits, for which the image had gained a reputation. In this regard, apparently 'scandalous' rites had developed at the shrine which brought together 'evil men and women and ignorant priests', prompting the vicar of the diocese, on visitation, to prohibit strictly 'such corruptions'. (Alas, he was no more specific than this, but we can imagine the screaming, writhing *spiritati*, surrounded by anxious relatives and onlookers, as cures were sought and vows fulfilled.) As a result, the tiny church declined as a centre of pilgrimage, leaving only the immediate townspeople, who were permitted to continue their devotion of the image.[132] However, such events as this were not incorporated into the image narratives, which sought to glorify and account for the presence of the sacred.

IMAGE NARRATIVES

Let us begin our analysis of the image legends of the Terra d'Otranto by
relating a typical narrative: that referring to the image of Our Lady of the
Grottella. We have already encountered this image in connection with
Giuseppe da Copertino. According to the account given to Serafino
Montorio, included in his *Zodiaco di Maria* of 1715, the image was painted
in 57 AD by order of St Peter and venerated in a local cave. The cave was
closed during the persecutions of Diocletian and remained undiscovered
until 1543, when a young cowherd came across it while pursuing a stray
calf. The calf was found kneeling in adoration before the image, which was
lit by two candles. News of the miraculous event spread quickly, and the
clergy and people went there in holy procession. The cave was then turned
into a chapel and it became the site of a Franciscan monastery.[133]

As with the above image, most miracle-working images acquired oral
traditions which explained why they were powerful and effective. Many
healing shrines in the Terra d'Otranto, as elsewhere, probably began as
simple votive churches or images in churches and wayside altars, which
then acquired legends to explain and justify the care shown by the Virgin
to a particular community. For this reason the image narratives enable the
ethno-historian to explore the significance and role of these miraculous
images and the shrines which grew up around them. In chapter 4 we
explored these shrines and pilgrimages to them as sources of ecclesiastical
healing, spiritual and physical. Now it is time to see what light the
narratives can shed on processes like the materialisation and localisation of
the sacred.

The image narratives themselves could be broken down into real – that
is, real to those present at the time – and legendary, stories for which there
was no contemporary report and which were used to lend importance to
an already existing image. But since the people involved as discoverers and
devotees rarely made this real–legendary distinction, we must consider
both as integral and important parts of the cultural system.[134] Indeed
Montorio himself, whose compilation forms the basis for this analysis,
makes no comments on the narratives, and gives equal treatment to recent
events and those placed in the remote past.

Of the thirty-seven Marian images described by Montorio for the Terra
d'Otranto (others are mentioned without descriptions), thirteen have
discovery narratives which although they vary in content share similar
topoi. Typically, the image was discovered by a lay man or woman, usually
following some kind of extraordinary event, like a vision, or by following a
stray animal to a previously unknown cave. The event would then be

substantiated by some kind of prodigious occurrence, like a miraculous cure, or series of them, and a chapel would be built on the site by clergy and people, all in historical time (eight of the narratives related by Montorio include precise dates, five of which are post-1520).

Perhaps the most striking feature of these images is their rural (that is, extra-urban) origin, thereby competing with other sacred mediators like saints' relics, which were kept protected in cathedrals, parish churches and monasteries. The process involved the re-establishment of a sacred land-scape over cathedral- and town-centred religion, to serve as an appropriate intermediary between the local society and the forces of nature with regard to the crucial issues of weather and disease, birth and death.[135] This is especially apparent when the urban world – represented by the bishop – attempted to appropriate the image, by building a chapel for it in town. In such cases the image often forced a return to its rural location or became too heavy to move, indicating its desire to be venerated on the spot, close to the natural world.[136]

This connection was manifested in the exact point of discovery, whether in a cave, the bush (*macchia*), a spring, a wood, or in semi-natural sites like wells or ruined chapels. In addition, caves, springs and wells are obvious links to the underworld, suggesting a plausible link bewteen Mary and the earth, successor to the mother goddesses reponsible for fertility. Indeed a strange narrative contained in a witchcraft accusation from the diocese of Oria located two Marian images in an underground cave into which the accused was led – as into the underworld – by the devil, where she found herself surrounded by treasure. The images spoke to her, regarding her possibilities of escape.[137]

However, we must also bear in mind that in the Terra d'Otranto the presence and rediscovery of images in caves may simply be a result of such sites left vacant by hermits and monks of the Byzantine tradition (in the same way as many of the 'Madonne nere', or Black Madonnas, may have eastern origins). Several narratives assert this real possibility, such as the three images said to have been painted in caves by St Peter and his disciples, which may be a legendary elaboration of the presence of Byzantine monks in the area.[138] One of the images, Our Lady of Casole, was apparently 'rediscovered' in 1040, when it became part of a Basilian monastery, which later passed to the Franciscans.

The rural element is also present in the discoverers of the images who were often herdsmen, woodsmen, and hunters. Like the bulls or cows which participate in the finding of the images – half wild and half domestic – they are appropriate mediators between society and nature, between the uncultivated, wild locations where the images were found and

the local society which venerated them.

A variation on this theme of the auto-production and consumption of images for a local geography of the sacred, is the images which relate to the sea and sailors, so important to the economy and collective psyche of a peninsula like the Terra d'Otranto. Three of the images described by Montorio were known as special protectors of mariners. In one narrative, a sailor was navigating in the Gulf of Taranto when a storm came up, threatening him and his cargo. Like the Frenchman Daniel Audibert mentioned in chapter 4, the sailor made a vow to the Virgin, in this case promising to build a church in her honour if she interceded on his behalf. A light appeared, to which he directed his boat and he was able to beach it safely. Looking for a suitable site for the promised chapel, he came across a small cave and on one of its walls was painted an image of Mary. He decided to turn the cave into a church, built in the shape of a ship.[139]

Related to the protectors of sailors are those images whose narratives dealt with the greatest threat by sea, that of Turkish attack. This was a constant menace for the province, and much of the Kingdom as well. One image, Our Lady of Otranto, the only one in the form of a statue, was taken by a Turkish soldier as booty during the invasion of the city in 1480. On arriving home, the soldier carelessly tossed it under his bed. It was retrieved by his Christian slave (also captured at Otranto) when the soldier's pregnant wife was on the verge of death because of her labour pains. The slave made the man swear that if his wife was healed through the statue he would take it back to its rightful place. His wife delivered safely but, remaining unconverted, the soldier kept his side of the bargain by setting the slave and statue adrift in a small boat without oars or sails. The craft and its cargo managed to reach the port of Otranto unharmed, and amidst much celebration the statue was placed on the main altar of the cathedral.[140] Despite the legendary quality of the narrative, it clearly related to the particular needs of the people of Otranto, whose consciousness was dominated by this invasion and the eight hundred citizens martyred by the Turks. The reality of the narrative is therefore not at issue. Its importance lies in the role it played as a form of sacred defence against a beleaguered city. In a similar vein, the shrine of Our Lady of Leuca (also known as 'Finibus Terrae' because its was at the peninsula's tip) provided a rallying point against the Turks, because of its many miracles and the devotion to it. A long series of Turkish attacks along the coast – the shrine was sacked repeatedly between 874 and 1689[141] – did not prevent people from settling under its protection. In fact, the presence of the shrine despite such adversity was the only reason for the settlement, a very

concrete example of the province's sacred geography.

Like the saints and their relics discussed above, the Marian images of the Terra d'Otranto often developed their own specialisations or reputations, which complemented rather than contradicted Mary's position as general intercessor and patroness. The importance of some images as weather regulators confirms their role in responding to agricultural needs, as do those reputed to heal animal diseases. The need for sacred control over the natural course of events frequently found its way into the image narratives, so pressing and constant was it. Thus our Lady of Leuca was said to have appeared to a terribly ill woman of Alessano in 1670, telling her to go to a cave near Salignano and rescue an image hidden in a cave. Because she was so ill, the woman sent her son and nephew. They found the image and told the people of the town, who remained incredulous. However, one of the townspeople said that if the story was true then the area would receive much-needed rain, and immediately the sky began to cloud over and before long it was raining. Convinced of the image's existence, the townspeople then hurried to the cave. The small supply of food was miraculously sufficient to feed the assembled multitude, with much left over.[142]

This narrative also serves as an example of the variegated origins of the image legends. Accounts of the *inventio* of saints' bodies, legends of other Marian shrines, near and far, *exempla* of miracle visions, apocryphal lives of Mary and the Bible itself all found their way into these narratives. The Religious Orders, especially Dominicans and Carmelites, enriched the legends still further.[143] Such information was spread by preachers, hermits, pilgrims, itinerant pedlars and, later on, by a flood of devout pamphlets, consisting of prayers, miracle narrations and litanies focusing mainly on Mary and the Infant Jesus. Motifs derived from these sources were combined with real or perceived events and miracles to form the image narrative, which investigation and re-statement then simplified, removing any contradictions.

One typical motif is the vision which guided the chosen individual – frequently a woman – to the image, a crucial part of five Otrantine narratives. As William Christian remarks, 'these visions are high drama, sacred plays in which everyday persons are suddenly elevated out of the normal round and granted ambassadorships to heaven, a foretaste of eternity'.[144] At the same time, they are also 'social visions', for although they may initially involve only one or two people directly, they eventually involve the entire community, as the vision and image are recognised and a chapel built, which then becomes the focus of pilgrimage. According to the image narrative of Our Lady of Cotrino (outside Latiano in the diocese

of Oria), for instance, the Virgin appeared in a dream before a young peasant woman named Lucia who was blind, deaf and dumb, telling her about an image hidden in the bush outside the town of Latiano. She wanted the image recovered and a church built on the site. That morning when she awoke, Lucia, who had earlier vowed herself to St Lucy without success, found herself cured of her infirmities. She and her husband then went to Latiano, where they found the image as foretold, and lived nearby while a chapel was constructed. The shrine, mentioned in Archbishop Bovio's visitation of the Brindisi archdiocese in 1565 (which then included what became the Oria diocese), was put under the control of the Latiano church chapter in 1607 by Bishop Fornari, to keep track of the rising number of donations, and under the supervision of an oblate from 1652.[145]

Visions like this, though rarely of national import, were outside of the ordinary realm of events and occasioned a whole range of emotions, from joy to awe and even terror.[146] There was also pride when the communities realised they had been singled out in this way, similar to the pride felt by people of the towns and cities over their saints and relics. This meant that old, neglected images were often re-activated not only as a form of local competition but to revive a lost sacred presence. This could occur naturally or by counterfeit means, since 'miraculous' events could be staged or strange occurrences exaggerated for the glory of the Virgin. The Oria synod of 1664 warned parish priests to be on their guard against new miracles proclaimed by the populace and spread by 'rumour and gatherings of people'.[147]

When the visions of lay seers were corroborated by the wondrous discovery of new images and ensuing miracles and portents they were relatively difficult to doubt, however. At the same time, the image narratives, by their very nature, do not concern themselves with such minor trifles as episcopal approval: it is all taken for granted. In the legends, bishops and the clergy in general react to an already existing situation, a *fait accompli*. The authorities recognised that such images were worthy of veneration (*hyperdulia* in the case of the Virgin), whatever miracles were said to have occurred.

Visions on their own were another matter altogether, and were examined very carefully. As with the visions and ecstasies of failed saints, their nature could be diabolical, their origin a Satanic temptation. The Church was of course concerned with making and imposing this distinction. But as we shall see in our discussion of witchcraft narratives, in the popular mind there were no such ready distinctions. In this conception of the sacred, devil or Virgin could come to the aid of the beleaguered individual by appearing in visions offering succour. Divine and diabolical manifesta-

tions of the sacred formed part of the same pool of beliefs. Saints, too, could bring about as well as cure disease: an expression of *their* inherent ambivalence.

In this section of the book I have sought to outline the various levels of belief and practice with regard to the sacred, in particular the attitudes manifested in reaction to malady and misfortune. The ritual system formed a pool, from which the afflicted – and that meant everyone, at one time or another – could draw. This included recourse to a variety of 'healers', represented by the figures of priest, wise woman and saint. Together, they provided forms of sacred protection against the hazards and afflictions of daily life, and provided a way of ordering the cosmos. They allowed people to deal with and overcome the crises of existence through a whole series of ritual possibilities and responses.

Following the Council of Trent, the Catholic Church attempted to limit the use of popular healing rituals which it regarded as 'superstitious': that is, those achieving their effects by illicit (diabolical) means. Only later was their efficacy called into question by the authorities, at which time they ceased to be a threat as far as the Church was concerned. But in the meantime, the Church encouraged the use of its own 'ecclesiastical remedies' and stressed the sinfulness of popular magic through preaching and confession, often making absolution dependent on the denunciation of a known practitioner to the episcopal court. In the same way, it sought to regulate other forms of recourse to the sacred, as we have seen in this chapter with regard to the veneration of saints.

Yet despite this control by the ecclesiastical authorities, the behavioural system showed a surprising resilience, due to its ability to adapt and co-exist throughout all levels of society in different forms and to different degrees. Where the local clergy actively participated in traditional practices and shared traditional beliefs, as sometimes with popular forms of healing, the reforms ushered in by the Council of Trent were slow to penetrate, a situation exacerbated by the independence of the clergy and its poor state of doctrinal preparation. In those areas where ecclesiastical control was more successful, as with models of saintliness, local communities sought the access to the sacred they provided through negotiation with the centre. Devotions in harmony with the traditional belief system, and in some ways influenced by it, like the recitation of the rosary, the veneration of relics, blessings and exorcisms and other Church 'remedies', found ready acceptance, and soon formed part of the pool, sometimes altered or 'interpreted' to fit local needs. In this sense we are not dealing with an entirely closed system of belief; nor can it be called passive.

Although we may speak of cultural disintegration with regard to tarantism (and even this took many hundreds of years), most of the phenomena are characterised by a process of negotiation and interaction among the various levels of society, whether clerical and lay, educated and uneducated, centre and periphery. The popular classes were thus not an isolated group in early modern Terra d'Otranto: all classes participated in and belonged to this system, sharing in these attitudes towards the sacred and the techniques used to tap the powers of the sacred.

This is not to say that all levels of society participated in all its aspects to the same degree. The response to malady of a peasant living in a small village, with a barely literate and poorly trained priest, would have differed from that of an educated nobleman or *civile* living in the city of Lecce. But it was a difference of degree or emphasis in selecting from the various overlapping responses provided by the sacred system. Both 'patients' would have venerated the saints, perhaps personally devoted to a few in particular, and – depending also on the particular malady – would have invoked their help. The peasant might have done so through one of the many conjurations and *orazioni* at his disposal, which the nobleman would most likely have disdained, the Church having convinced him or her of the error of such 'superstitions'. The peasant had no reason to give them up: the Church sacramentals, because they worked in similar ways, were simply absorbed into his or her mentality. The peasant's religious beliefs were pragmatic rather than doctrinal, emphasising what was seen effectively to tap sacred power, and without a complete change in mentality it was difficult to convince him or her that this way was wrong.

Seen as a whole, then, the system of overlapping 'signs' remained in place and continued to function in much the same way throughout the early modern period. There were, of course, the processes of reform (clerics involved in lay healing rituals, for example), christianisation (tarantism) and negotiation (Marian devotion), but these were slow, manifesting themselves over the *longue durée*, varying from place to place and among different levels of society. In Part III we shall leave the realm of what is usually classed as 'popular religion', as we examine the pace of Church reform – and local responses to it – with regard to those ritual attempts to influence the sacred and give order to everyday life through recourse primarily to spirits, demons and the devil, as much a part of the system of the sacred as the pantheon of saints.

NOTES

1 Pierre Delooz, 'Towards a sociological study of canonised sainthood in the Catholic

Church', in S. Wilson, ed. *Saints and their Cults* (Cambridge, 1983), 189.

2 Peter Brown, *The Cult of Saints* (Chicago, 1981), 8–9 and 31–3.

3 Benedicta Ward, *Miracles and the Medieval Mind* (London, 1982), 184–5.

4 Peter Burke, 'How to be a Counter-Reformation saint', in *The Historical Anthropology of Early Modern Italy* (Cambridge, 1987), 49.

5 The three stages of sainthood consisted of venerable (a holy person due veneration as an example of holiness but no formal cult permitted), blessed (cult permitted within specific areas, such as within Religious Orders) and saint (veneration due by the universal Church).

6 Burke, 'Saint', 48.

7 Jean-Michel Sallmann, 'Il santo e le rappresentazioni della santità. Problemi di metodo', *Quaderni storici*, XIV (1979), 585.

8 Ibid., 587.

9 Cf. Delooz, 'Sociological study', 198.

10 Ibid., 194. Examinations by the Holy Office for cases of 'simulated sanctity' provide the exception to this rule, for the suspect was generally alive and active.

11 Jean-Michel Sallmann, 'Image et fonction du saint dans la région de Naples à la fin du XVIIe et au début du XVIIIe siècle', *Mélanges de l'Ecole Française de Rome*, 91.2 (1979), 858.

12 The expression is André Vauchez's. Cf. *La Sainteté en Occident au derniers siècles du moyen age d'après les procès de canonisation et les documents hagiographiques* (Rome, 1981).

13 Burke, 'Saint', 56.

14 For a more extensive analysis, cf. ibid., 54–5.

15 For example, several furure saints – Neri, Xavier, Canisius and Borgia – were closely associated with Ignatius Loyola. Cf. Romeo De Maio, 'L'ideale eroico nei processi di canonizzazione della Controriforma' in his *Riforma e miti nella Chiesa del Cinquecento* (Naples, 1973), 262 and Burke, 'Saint' 57.

16 Mario Gioia, S.J., 'Per una biografia di san Bernardino Realino, S.J. (1530–1616): Analisi delle fonti e cronologia critica', *Archivum Historicum Societatis Jesu*, XXXIX (1970), 3.

17 This motif is repeated in the more recent example of the Capuchin Padre Pio, whose monastery of San Giovanni Rotondo has its own miraculous image of the Madonna. Cf. Christopher McKevitt, 'San Giovanni Rotondo and the shrine of Padre Pio', in J. Eade and M. J. Sallnow, eds. *Contesting the Sacred* (London, 1991).

18 Deposition of Giuseppe Gravili, 'Process apostolicus Neritonen… Iosephi a Copertino', 1664, A.S.V., *Congregazione dei Riti*, no. 2045, fol. 211v.

19 Sallmann, 'Il santo', 588.

20 Cf. Giuseppe Gentili, *Vita della Venerabile Madre Rosa Maria Serio di S. Antonio, Carmelitana* (Venice, 1741).

21 Deposition of Antonio Serio, 'Processus informativus…Rosae Mariae Serio', 1729, A.S.V., *Con. Riti*, no. 704, fol. 242v.

22 Piero Camporesi, *The Incorruptible Flesh*, trans. T. Croft-Murray (Cambridge, 1988), 37.

23 André Vauchez, 'Santità', *Enciclopedia Einaudi* (Turin, 1984), XII, 444.

24 Deposition of Giovanni Caputo, 'Proc. ap. Nerit.', 1689, A.S.V., *Con. Riti*, no. 2045, fol. 129r. In Potenza there was a belief that the monks had a magical formula allowing them to go up and down in the air, gradually gaining hight, so they could fly among the clouds and position the rain and hail over the peasants' fields in order to destroy their crops. Apparently it was meant to force reluctant peasants into paying the tithes owed the monasteries. Ernesto de Martino, *Sud e magia* (Milan, 1966 edn.), 49.

25 Ward, *Miracles*, 216.

26 Sallmann, 'Image et fonction', 845.

27 Deposition of Benedetto Vetrano, 'Proc. ap. Nerit.', 1689, A.S.V., *Con. Riti*, no. 2045, fol. 74v.

28 Deposition of Brigitta Preite, ibid., fol. 116v.

29 Deposition of Vittoria Rozza, ibid., fol. 124v.

30 Domenico Bernino, *Vita del Bea. Padre Fr. Giuseppe da Copertino De' Minori Conventuali* (Rome, 1722), 55.

31 Sallmann, 'Image et fonction', 850.

32 Deposition of Teresa Fatalò, 'Proc. ap. Nerit.', 1664, A.S.V., *Con. Riti*, no. 2045, fol. 212v.

33 Deposition of Giuseppe de Luca, 'Proc. inf.', 1729, A.S.V., *Con. Riti*, no. 705, fol. 1033v.

34 Deposition of D. Giovanni Romanazzo, ibid., no. 703, fol. 671.

35 Annamaria Rivera, *Il mago, il santo, la morte, la festa* (Bari, 1988), 286–7. For the latter, she gives the example of St Aurelian, protector of ear diseases because of the resemblance of his name to *aures* (ears). Cf. François Lebrun, *Se soigner autrefois: Médecins, saints et sorciers aux 17e et 18e siècles* (Paris, 1983), 113–14.

36 Adalberto Pazzini, *La medicina popolare in Italia: Storia, tradizioni, leggende* (Trieste, 1948), 230.

37 Deposition of Vita Maria Vitale, 'Proc. inf.', 1729, A.S.V., *Con. Riti*, no. 704, fols. 589v.–590v.

38 Bernino, *Vita*, 56.

39 Deposition of Caterina Imberi, 'Proc. ap. Nerit.', 1689, A.S.V., *Con. Riti*, no. 2045, fol. 122r.

40 Deposition of Lucrezia Bove, ibid., fol. 133r.

41 Sallmann, 'Image et fonction', 864.

42 Claude Lévi-Strauss, 'The sorcerer and his magic', in his *Structural Anthropology*, trans. C. Jacobson and B. Grundfest Schoepf (London, 1968), 181.

43 Lévi-Strauss, 'The effectiveness of symbols', in *Structural Anthropology*, 201. Cf. Peter Burke, 'Rituals of healing in early modern Italy', in *Historical Anthropology*, 211.

44 Sallmann, 'Image et fonction', 865–70.

45 Deposition of Angelà Nicolizza, 'Processus remissorialis Lycien...Bernardini Realino', 1713, A.S.V., *Con. Riti*, no. 1515, fol. 421v.

46 Deposition of Ottavio Rosato, 'Proc. rem. Lyc.', 1623, A.S.V., *Con. Riti*, no. 1514, fol. 917.

47 Ibid., fol. 914.

48 Deposition of Francesco Verdesco, ibid., fol. 334.

49 Vauchez, 'Il santo', in J. Le Goff, ed. *L'uomo medievale* (Rome-Bari, 1987), 380.

50 Deposition of Giuseppe Pupina, 'Proc. rem. Lyc.', 1623, A.S.V., *Con. Riti*, no. 1514, fols. 1818–19.

51 Carlo de Bonis, S.J., *Vita del Venerabile Padre Francesco di Geronimo della Compagnia di Gesù* (Naples, 1747), 128.

52 Camporesi, *Incorruptible Flesh*, 59.

53 Deposition of Ludovico de Dragoni, 'Proc. ap. Nerit.', 1664, A.S.V., *Con. Riti*, no. 2045, fol. 264r.

54 Charles W. Jones, *Saint Nicholas of Myra, Bari and Manhattan* (Chicago, 1978), 271.

55 Deposition of Giuseppe de Luca, 'Proc. inf.', 1729, A.S.V., *Con. Riti*, no. 704, fol. 1035v.

56 Deposition of Virgilia Antoglietta, 'Proc. rem. Lyc.', 1623, A.S.V., *Con. Riti*, no. 1514, fol. 1399.

57 Cf. Sallmann, 'Image et fonction', 854.

58 Deposition of Ludovico de Dragoni, 'Proc. ap. Nerit.', 1664, A.S.V., *Con. Riti*, no.

2045, fol. 265v.

59 Deposition of Giuseppe Turi, ibid., fol. 228r.

60 Ludovico Antonio Muratori, *Della forza della fantasia umana* (Venice, 1753 edn.), 92–4.

61 Giovanni Romeo, 'Una "simulatrice di santità" a Napoli nel '500: Alfonsina Rispola', *Campania sacra*, VIII–IX (1977–8), 161.

62 *Constitutiones Synodales editae in prima Diocoesana Synodo Gallipolitana...ab Illustris. ac Reverendis. Domino D. Ioanne Montoya da Cardona Episcopo Gallipolitano* (Naples, 1661), 42.

63 William Christian, *Apparitions in Late Medieval and Renaissance Spain* (Princeton, 1981), 185.

64 Anonymous diary, Archivio di Stato, Pisa, *Corporazioni Religiose*, 924, ins. 1; cit. in Judith Brown, *Immodest Acts: The Life of a Lesbian Nun in Renaissance Italy* (Oxford, 1986), 137.

65 Cf. Jean-Michel Sallmann, 'La sainteté mystique féminine à Naples au tournant des 16e et 17e siècles', in S. Boesch Gajano and L. Sebastiani, eds. *Culto dei santi, istituzioni e classi sociali in età preindustriale* (Rome–Aquila, 1984), especially 684–7.

66 Romeo, 'Simulatrice di santità', 160. The article consists mainly of a transcription of the trial against her: 'Pro Rev. D. Prom. fisc. Curiae Archiepisopalis Neapolitanae contra Alfonsinam Rispolam de Neapoli...', Archivio Storico Diocesano, Naples, *Processi di Sant'Ufficio*, no. 133c. The case is also discussed by Sallamnn, 'Sainteté mystique', 693–7.

67 'Contra Alfonsinam Rispolam', fol. 7v.

68 Ibid., fols. 28r and 43r.

69 Ibid., fols. 25v-27v. The orthodox version of this was the 'corona' which lay women could purchase. It consisted of one of the nuns reciting the rosary, while wearing an iron girdle, holding out her arms in the position of the cross, and could be accompanied by various abstentions and mortifications. The devotion often served to supplement the income of poor convents. Cf. Kathryn Norberg, 'The Counter-Reformation and women: religious and lay', in J. O'Malley, ed. *Catholicism in Early Modern History* (St Louis, 1988), 138.

70 Letter from Cardinal Santa Severina, 20 April 1590, ibid., fol. 21r.

71 Luisa Ciammitti, 'Una santa di meno: storia di Angela Mellini, cucitrice bolognese (1667–17 –)', *Quaderni storici*, XIV (1979), 628.

72 For a discussion of extra-liturgical cults in southern Italy during the 1960s, see Annabella Rossi, *Le feste dei poveri* (Palermo, 1986 edn.), 46–66.

73 Brown, *Cult of Saints*, 60–4.

74 For a 1537 account, cf. Giovanni Michele Laggetto, *Historia della guerra di Otranto del 1480* (Maglie, 1924). The entry by Niccolò Del Re in the *Bibliotheca Sanctorum* on the martyrs is quite thorough; vol. IX (Rome, 1967), columns 1303–6.

75 'Visita pastorale di Mons. Salvatore Spinelli', Trepuzzi, 1792, A.C.A.L., *Sante visite*, no. 195, fol. 13v.

76 Cf. Raffaele De Simone, *S. Oronzo nelle fonti letterarie sino alla metà del Seicento* (Lecce, 1964), and the same author's entry on the saint in the *Bibliotheca Sanctorum*, VIII, columns 51–3.

77 'Proc. rem. Lyc.', 1623, A.S.V., *Con. Riti*, no. 1514, fols. 9r–17r.

78 Jean-Michel Sallmann, 'Il santo patrono cittadino nel '600 nel Regno di Napoli e in Sicilia', in G. Galasso and C. Russo, eds. *Per la storia sociale e religiosa del Mezzogiorno d'Italia* (Naples, 1982), 193–4.

79 Giuseppe Galasso, 'Ideologia e sociologia del patronato di san Tommaso d'Aquino su Napoli', in *Per la storia sociale*, II, 219.

80 Sallmann, 'Santo patrono', 193–4. This 'prosperity' and 'openness' is perhaps over-stated, given the long period of decline discussed in chapter 1. Yet the importance of Lecce as a religious centre no doubt helped spread the new religious devotions, as it helped spread its version of baroque architecture. Cf. Michele Paone, 'Per la storia del barocco leccese', *Archivio storico pugliese*, XXXV (1982), 89–138.

81 Ibid., 195–8.

82 Galasso, 'Ideologia', 213.

83 Sallmann, 'Santo patrono', 208.

84 Translation: 'Long live the Theatines / who have won the body / of St Irene over the Jesuits / down with the Jesuits!' Maria Antonietta Visceglia, *Territorio, feudo e potere locale* (Naples, 1988), 288–90.

85 Cit. in Harold Acton, *The Bourbons of Naples: 1734–1825* (London, 1956), 111 (no reference given). St Gennaro (Januarius) was the principal patron of the city.

86 John Moore, *A View of Society and Manners in Italy* (London, 1790), 402.

87 Benedetto Croce, 'I lazzari negli avvenimenti del 1799', in *Varietà di storia letteraria e civile* (Bari, 1935), I, 198.

88 'Veri motti, buoni consigli, e giusti avvertimenti...', D. Carlo Occhilupo, Biblioteca Provinciale, Lecce, ms. 76, fols. 1–9. Occhilupo (1702–75) was a cathedral canon in Gallipoli and rector of the Confraternity of the Crucifix. Cf. Luisa Lazaro Congedo, 'Una raccolta settecentesca di proverbi salentini', in M. Paone, ed. *Studi di storia pugliese in onore di Giuseppe Chiarelli*, V (Galatina, 1980), 7.

89 Cf. Judith Devlin, *The Superstitious Mind: French Peasants and the Supernatural in the Nineteenth Century* (New Haven, 1987), 17.

90 Giuseppe Galasso, 'Santi e santità', in *L'altra Europa: Per un'antropologia storica del Mezzogiorno d'Italia* (Milan, 1982), 72.

91 'Proc. ap. Lyc.', 1737, A.S.V., *Con. Riti*, no. 2042, fol. 22r.

92 De Bonis, *Vita...Francesco di Geronimo*, 452.

93 Galasso, 'Santi', 69–70.

94 Richard Trexler, 'Florentine religious experience: the sacred image', *Studies in the Renaissance*, XIX (1972), 10.

95 'Synodus Diocesanae Ecclesiae Oritanae ab. Ill.mo et R.mo Fratre Raphaele De Palma...E.po Oritano et Regio Consiliario', 1664, A.D.O., *Sinodi*, fol. 189.

96 Deposition of Laura Protontino, 'Proc. inf.', 1729, A.S.V., *Con. Riti*, no. 703, fol. 220l.

97 Deposition of Rev. Francesco Sordini, 'Proc. ap. Nerit.', 1689, A.S.V., *Con. Riti*, no. 2049, fol. 165v.

98 Ibid., fol. 166r.

99 At which point the man's fever began to subside. De Bonis, *Vita...Francesco di Geronimo*, 409.

100 Peter Moore, 'On the significance of relics in religion, with special reference to Christianity and Buddhism', paper presented at the Interdisciplinary Conference on Pilgrimage, Roehampton Institute, London, 1988, 3–5.

101 Deposition of Rev. Vespasiano Vitagliani, 'Proc. super non cultu', 1741, A.S.V., *Con. Riti*, no. 701, fol. 25r.

102 Aron Gurevich, *Medieval Popular Culture: Problems of Belief and Perception* (Cambridge, 1988), 41.

103 *Constitutiones Synodales*, 15. Henceforth priests had to receive special permission for the use of relics in devotions in people's homes.

104 Deposition of Ursula Fornaro, 'Proc. rem. Lyc.', 1623, A.S.V., *Con. Riti*, no. 1514, fols. 1415–16.

105 Deposition of Giuseppe Ottivio, ibid., 1713, A.S.V., no. 1515, fols. 189r. and 192r.

106 Deposition of Francesco Antonio Verdesca, ibid., 1623, no. 1514, fol. 343.

107 Deposition of Bartolomeo Carelli, 1729, 'Proc. inf.', A.S.V., *Con. Riti*, no. 705, fol. 1048v.

108 Camporesi, *Incorruptible Flesh*, 60.

109 'Proc. beat. Chiara d'Amato', 1700, A.C.V.N., H/1, introductory statement, no pagination.

110 Cf. Delooz, 'Sociological study', 210.

111 Deposition of Giuseppe Cosmà, 'Proc. rem. Lyc.', 1623, A.S.V., *Con. Riti*, no. 1514, fols. 2350–2.

112 Gioia, 'Biografia', 7.

113 Deposition of Giuseppe Grasso, 'Proc. rem. Lyc.', 1713, A.S.V., *Con. Riti*, no. 1515, fol. 159r.

114 Cf. Deposition of Laura Falconiero, 'Proc. ap. Nerit.', 1664, A.S.V., *Con. Riti*, no. 2045, fol. 280v.

115 De Bonis, *Vita...Francesco di Geronimo*, 432.

116 Deposition of Bartolomeo Carelli, 'Proc. inf.', 1729, A.S.V., *Con. Riti*, no. 705, fol. 1049r.

117 Ibid.

118 Deposition of Rev. Paolo Torrisio, ibid., fol.169.

119 Deposition of Giuseppe Velano, ibid., fols. 896–7.

120 Deposition of Laura Leganza, ibid., fols. 1663–4.

121 Deposition of Francesco Antonio Verdesca, ibid., fol. 345.

122 Deposition of Giuseppe Cosmà, ibid., fol. 2353.

123 Cf. Galasso, 'Santi', 75.

124 Adriano Prosperi, '"Otras Indias": missionari della Controriforma tra contadini e selvaggi', in *Scienze, credenze occulte, livelli di cultura: Convegno internazionale di studi* (Florence, 1982), 229.

125 Excommunication edicts of 1725 (no. 54) and 1728 (unnumbered), A.C.V.G., *Scomuniche*.

126 He got off lightly. In 1700 Oronzio Colonna of Lecce was hanged for a similar offence and his arm cut off and hung from the S. Giusto gate. Giuseppe Cino, 'Memorie ossia notiziario di molte cose accadute in Lecce dall'anno 1656 all'anno 1719', reprinted in Appendix to *Rivista storica salentina*, 1905–6, 89.

127 Serafino Montorio, *Zodiaco di Maria, ovvero le dodici provincie del Regno di Napoli, come tanti Segni, illustrate da questo Sole per mezzo delle sue prodigiosissime Immagini, che in esse quasi tante Stelle risplendono* (Naples, 1715), 480–1. Montorio was a Dominican of the monastery of S. Maria della Sanità in Naples. His collection is more complete for the Terra d'Otranto than the much more ambitious collection compiled by Wilhelm Gumppenberg (I used the Verona edition of the *Atlante Mariano*, published in 1839–47).

128 Trexler, 'Sacred image', 25–6.

129 Cf. Rivera, *Il mago*, 341.

130 Adriano Prosperi, 'Madonne di città e Madonne di campagna: Per un'inchiesta sulle dinamiche del sacro nell'Italia post-Tridentina', in Boesch Gajano and Sebastiani, eds. *Culto dei santi*, 621–2.

131 Alphonse Dupront, 'Religion and religious anthropology', trans. M. Thom, in J. Le Goff and P. Nora, eds. *Constructing the Past: Essays in Historical Methodology* (Cambridge, 1985), 130.

132 'Visitatio pastoralis habita pro universa dioecesi Uxentina a R.mo D.no D. Thoma de Rossi...vicario generali', Archivio Diocesano, Ugento, *Visite e Sinodi*, fols. 74rv. Cit.

in Salvatore Palese, 'Per la storia religiosa della diocesi di Ugento agli inizi del Settecento', in M. Paone, ed. *Studi di storia pugliese in onore di Giuseppe Chiarelli*, IV (Galatina, 1976), 306.

133 Montorio, *Zodiaco*, 514–15.

134 Christian, *Apparitions*, 7–8.

135 Cf. Christian on Spanish image legends, ibid., 18–20.

136 The parish priest of Guagnano (diocese of Brindisi) wanted the image of Our Lady of the Rosary moved into the parish church, but when he and his flock arrived in procession to cart it off, it became too heavy to move and a chapel had to be built on the site. Its popularity eventually led to the area's urbanisation, as people settled around it, till it became part of Guagnano proper. Montorio, *Zodiaco*, 472.

137 'Denuncia contro Antonia Macarella per aver avuto rapporti col diavolo', 29 December 1745, Erchie, A.D.O., *Magia*, II. The case will be the subject of further discussion in terms of its folklore motifs in chapter 8.

138 Santa Maria delle Rasce (near Leuca), S.M. della Grottelle (near Copertino) and S.M. di Casole (near Alezio); Montorio, *Zodiaco*, 498, 514 and 516. Such Byzantine 'crypts' originated anywhere between the tenth and fifteenth centuries. Cf. Enrica Follieri, 'Il culto dei santi nell'Italia greca', in *La Chiesa greca in Italia dall'VIII secolo al XV secolo*, II, *Italia sacra*, no. 21 (Padua, 1972), 555.

139 S. Maria del Pesco (also, della Luce), near Castellaneta; Montorio, *Zodiaco*, 503.

140 Ibid., 460.

141 Tasselli, 'Croniche del Santurario di S.M. di Leuca', cit. in Giuseppe Ceva Grimaldi, *Itinerario da Napoli a Lecce e nella provincia di Terra d'Otranto nell'Anno 1818* (Naples, 1821; republished, Cavallino di Lecce, 1981), 80–4.

142 An obvious re-echoing of the New Testament motif. The image is S. Maria delle Rasce; Montorio, *Zodiaco*, 498–9.

143 Giulio Sodano, 'Miracoli e Ordini religiosi nel Mezzogiorno d'Italia (XVI–XVIII secolo)', *Archivio storico per le province napoletane*, CV (1987), 303.

144 Christian, *Apparitions*, 4.

145 Montorio, *Zodiaco*, 529–31; cf. Damiano Leucci, *S. Maria di Cotrino, Latiano (1607–1922)* (Galatina, 1987), 78.

146 Christian, *Apparitions*, 26.

147 'Synodus Diocesanae', A.D.O., fol. 191.

PART III *Demonic presences and the sacred system*

7 The sorceress and the necromancer:
popular and learned magic

In practice the Church tended to lump all 'superstitious magic' together, believing that whatever the purpose the means were more or less the same. Rituals as diverse as healing, divination, love magic, maleficent spells and treasure hunting (a branch of learned or élite magic) tended to be condemned together, because of the belief that they all acquired their power through the devil. Such was the case in the 1749 excommunication edicts of the Oria diocese:

> II. All those who perform magic, enchanting, sorcery, evil spells and every other superstition, in which the devil co-operates through invocation, that is, done by an expressed pact, or by themselves or others before them, whether to find treasures, locate lost articles, discover hidden or future things, obstruct couples in the legitimate practice of matrimony, advise action, harm human beings or animals, heal them from worms, pains or other infirmities, or for any other unjust end; and all those who knowingly look for or co-operate in these things.[1]

Yet each type was used under widely differing circumstances and frequently performed by separate practitioners. Healing rituals, as we have had occasion to observe, served a purpose which is at first glance quite distinct from that of divination or love magic, to say nothing of the separate realm of learned magic. Despite differences in intent, all these forms – even the most maleficent – sought to bring some kind of order to the profane world by tapping the sacred, so it is no accident that they should overlap with one another. This part of the book will attempt to explore the relationships amongst the various types of maleficent magic, whether they were believed to derive their power from God and the saints – that is, the divine – or from demons, spirits and Satan himself – the diabolical face of the sacred – in an unceasing attempt to control daily events. We shall also explore the ways in which these 'signs' fit other described in Part II.

Malefice – sorcery or *maleficium* – was generally characterised by three features. First, it was an extraordinary act, relating to extraordinary circumstances, substances or individuals. Second, it was not subject to

experimental observation or explanation. Third, it had harmful intent.[2] Accusations and trials for the casting of spells seeking to cause bodily harm, death (to people as well as animals) or some other tribulation were certainly the most common. Techniques included image or homeopathic magic, the placing of magical substances close to the intended victim and the recitation of incantations, usually in conjunction with the first two methods. Because the sorcery employed to cause bodily harm was in some sense the reverse side of popular healing, previously discussed, by way of example I shall discuss the ligature, and the lengths people of early modern Terra d'Otranto were forced to go in order to escape it, particularly when they were due to be wed. Indeed an undercurrent of lust, love and marriage runs through this chapter. Divinatory magic was also important. Its relationship to forms of sorcery was often complementary, given that knowledge of a particular situation might lead to the desire to take some form of magical action. In this way it provided the weak and powerless with a means of maintaining relative stability in their lives, at least psychologically. For this reason poor women often made use of beneficent and maleficent magic, as we shall see. Finally, turning to an essentially male preserve, this chapter will explore the role of learned magic at the town and village level in the Terra d'Otranto, where its uses – treasure hunting aside – often came to resemble those of the less articulate popular magic. Its activities were embodied in the figure of the necromancer, a term which since the late Middle Ages had ceased to refer specifically to those who used corpses in their activities, and was now applied to conjurers of demons in general.

LOVE MAGIC

One of the most common forms of magic denounced before the episcopal court of Oria was that which went under the rubric of *incanti ad amorem* or love magic. The Church regarded the aim of such charms to be the coercion to sin through the subversion of free will, although most of the denunciations before the ecclesiastical tribunals were in fact made by the disappointed users of such charms. In such a situation the plaintiff had to denounce himself along with the accused practitioner. In 1723 Francesco Quaranta, steward of an estate belonging to the Celestine order, found himself in love with a young woman who was already engaged, according to his confession before the episcopal court of Oria. While he was telling his friends about his feelings, one of them, known as Zuzumbrillo, said he could help and agreed to tell Quaranta a 'secret' in exchange for five *carlini*. During Carnival he gave Quaranta two small red candles which he

was to light in front of the girl's house, and a whitish powder to sprinkle over her. Then he took Quaranta to the church of the Celestines in Oria, where Zuzumbrillo gathered some wax from the altar and instructed Quaranta to put it under the doorway of her house. Lastly, in a phallic ritual appropriate to love magic, he had Quaranta pierce the side of a vase with a kind of stiletto. Quaranta admitted that he did everything as instructed, although he never had the occasion to sprinkle the powder secretly over the object of his affections. When he revealed everything to his confessor that Easter he was told that his sins could only be absolved by the bishop; he told the court (in October!) that he had meant to approach the bishop many times, 'but the devil overcame me and restrained me'.[3]

A very common element in the love philtres was the powder meant to be sprinkled on the desired person or mixed in that person's food, a kind of magical aphrodisiac. Renata Rozza, an unmarried woman of Francavilla, confessed to sending a pot of beans – in which she had mixed such a powder – to Fra Angelo di San Giovanni d'Iddio in order to gain his attentions. When it failed, Rozza came to the conclusion that 'the said powder was a joke'. The powder in question, according to Rozza's friend Maria di Luca, had been obtained from a wandering pilgrim, 'old, with a long beard and ragged clothes' who had stayed in Francavilla for a few days.[4] A similar powder was offered by a street beggar, carrying a small painted image of St Anthony, to Pietro Vitugno. When the beggar asked if he was single (*vacantio* as opposed to *accasato*) and if he wanted to buy some special powder, Vitugno jokingly replied yes, but he did not know how to shoot a gun. When the beggar told him the powder's true use Vitugno responded that he was really married with two children and had no use of it. But before taking his leave he gave the beggar some alms, being a devotee of St Anthony. Cataldo Balsamo's reaction to the beggar's powder was rather different: 'When I heard these words [about the powder]', he testified, 'I sent him to the devil and left. But now that so many misfortunes have happened in Ceglie, I thought that this damned man must have sold it to more than one person in this town.'[5] His obvious fear is an indication of the powder's supposed efficacy and the success of the Church in inculcating fear of such 'superstitions'.

Despite the fact that the accusations were frequently made by those for whom there had been no result, the belief in such powders or the hope placed in them did not fade. Like learned magic with its endless complexities and variations (see below), failure could be blamed on a mis-performance of the ritual. Makers of the charms and philtres could be more sceptical than the users, perhaps owing to having seen numerous failures and realising at the same time the need to defend themselves. Caterina

Verardi of Oria gave Leonardo de Milato a pouch during Carnival (a common time for making advances, given the relaxation of social rules) which contained a powder to be sprinkled on the girl as she walked by. At the same time he was to say the words 'May discord be with N.N. and may concord be with me'. When this failed to achieve the desired result he went to Verardi for another charm, which she made with a candle while muttering words to the devil, according to de Milato. When this, too, failed to work, Verardi sagely advised him that he must also 'explain himself to the girl' – that is, reveal his intentions. Despite this realistic and sensible advice de Milato must have regretted his use of magic for he accused Verardi of causing him to lose his soul.[6]

One scholar has suggested that the makers of such charms (in Modena) were usually lower-class urban women who made up a social group distinct from village healers.[7] In the Oria diocese as well those charged with making love charms were not usually charged with other 'superstitious' offences, like healing, sorcery or divination. Thus it may have been a rather specialised practice, although it would be unwise to make too much of such a distinction, especially at the village level. More important for the historian is to discover who had recourse to such techniques, and under what circumstances, whether in the do-it-yourself form or through a recognised *magara*. The denunciations themselves point to men as the most common users of love magic, often when their intentions could not be expressed more openly and directly (in the case of a married man, for instance). However, the ethnologist Ernesto de Martino suggested that such magic was in fact employed and practised more often by women, for 'due to her condition as the traditionally passive element in the events of love and the strength of custom which prevents her from taking realistic intiatives in this domain, the woman more easily trusts in the little world of magical conspiracies, love philtres, soothsaying and divinatory practices, and in any case she remains tied to this world longer and more tenaciously than man'.[8] The discrepancy may be due to the limitations of ecclesiastical court records as a source. Women could not publicly denounce the failure of a love philtre without seriously damaging their reputation and honour, while men could perhaps get away with it. When Teresia Biascho was visited at home by Fra Lorenzo Calò on the bishop's behalf in order to make a denunciation, she stated that 'I cannot go myself in person [to the court] so as not to give my relatives cause for suspicion (and for other things) who could cause me harm because of it.'[9]

There was however one occasion when the acknowledgement of love magic by a woman was perfectly acceptable, but even here only as the object or victim: in the explanation or justification of socially inappropri-

ate affairs. Here it served as a means of saving face and protecting one's reputation. In chapter 5 we encountered the case of Giulietta Allegretti, who was raped by Rev. Isidoro Dolce followed by repeated sexual relations, all arranged by the procuress Rosa Melgiovanni. According to one witness Melgiovanni must have been a sorceress, since only through magic could she have led an honourable girl like Allegretti into committing such actions.[10]

In 1714 Cataldo Gioia of Ceglie denounced Giuseppe Nigro for having deflowered his daughter Domenica, followed – once again – by subsequent sexual relations. According to the plaintiff the crime was all the more serious because it was accomplished by 'superstitious and diabolical things, that is, some powders and herbs; these devilish things were enough to cause the aforementioned Domenica to fall, and were so powerful and strong that she felt no shame in offending her honesty.'[11] In this case, not only the girl's honour, but that of the entire household was in question, because Nigro had entered and led Domenica away without anyone noticing, and he was also charged with enchanting the rest of the family so that he could have his way with her.[12]

As we have seen, many of the love charms gained their supposed efficacy through contact with the supernatural, in both its divine and diabolical forms. The *orazione* of St Anthony could be recited, along with one Paternoster and Ave Maria and three Glorias to cause 'pain and torment to the heart and mind of the person one desired'.[13] Quite widespread was the knotting technique, or ligature, which derived its power by being performed in church as the priest uttered the words 'Dominus vobiscum' during the Mass, or by a direct invocation of the sacred. According to Nicolò Farina's instructions to the lovesick Giuseppe Greco, the latter had to take one of his shoelaces along with one belonging to the girl and tie them together with three knots. Before tying the first knot he was to say 'Sicut Christus fuit in columna legatus'; then, before the second knot, the words 'sive Diabolus tu allega in amore con', followed by the girl's name and the third knot.[14] Twelve years later, unsure whether he had told Bishop Labanchi everything, the accused admitted to learning the technique from a Carmelite friar, who allegedly knew other spells for opening locked doors and winning at cards.[15] Such spells were usually performed during the mass, and could begin with an invocation of the devil, thus combining very diverse forms of sacred power. Ambiguity towards the sacred was an important element of popular belief, as we shall see in our discussion of diabolical witchcraft.

LIGATURES, MARRIAGE AND PROTECTIVE MAGIC

The ligature was also frequently used to cause impotence in men, the symbolism of the knot being readily apparent. In fact, this was the traditional explanation for male impotence, particularly in the first years of marriage when fertility was all-important and the potential cause of much envy. The importance attached to producing offspring meant that a lack of obvious fertility was seen as something of a scandal and a source of despair, not only for the newly-married couple but for the two families as well. Numerous Church synods condemned those who impeded the consummation of marriage. The Oria synod of 1641 stated: 'We wish that witches and sorceresses shall incur the penalty of excommunication for rendering newlyweds unable to couple, leading them into a fury or to detesting one another.'[16]

In 1723 Anna Sanasi accused Antonella Seppi of causing her newlywed son's impotence through magic.[17] Like the spells discussed in chapter 5 (where we first encountered Seppi), Sanasi's best possibility for a cure was with the *magara* herself. When approached, Seppi asked for fifteen *carlini*, which Sanasi did not have and so was forced to give her a gold ring as a pledge, an indication of her desperation. Sanasi told the court that in order to undo the spell Seppi gave her 'an *agnus dei*, which she said was a decoction, inside a black-coloured pouch', to be hung above her son's bed. Here the *agnus dei*, an ecclesiastical remedy (consisting of a wax medallion made from paschal candles), is used in a decidedly popular context. The couple must certainly have been desperate by this point, for Laura de Lorenzo, the bride's mother, deposed that they first went to Fra Gregorio Lupo, a Capuchin friar, who recognised the spell and read the gospels over the afflicted couple. This was repeated several times without success, at which point they went to a cunning man in the nearby town of Erchie, who gave the husband and wife each a pouch to wear. Finally, the couple agreed to go to see Seppi, but declined to follow her advice, considering it sinful.[18] This *iter* is a typical feature of the sacred system, characterised as it is by the pragmatic search for protection. It is also interesting that the couple considered the *magara*'s treatment sinful. Obviously Tridentine reforms were having some effect.

Given the risky nature of the wedding from a magical point of view, it was vital to chose the right partner and marry on an auspicious day. According to the Lecce synod of 1663 there were traditional practices for the selection of a husband which the Church viewed as sinful and attempted to eliminate. On the vigil and feast of St John the Baptist the unmarried women of the diocese would display vases of flowers and other

decorated articles outside their houses. Male passers-by would leave an offering as a sign of their intentions, and the women would then dance with the donors, often leading to courtship and marriage.[19] This custom was part of an exchange of bouquets culminating in a declaration of *comparatico* between a man and woman (the so-called 'godparents of St John'), as a prelude to nuptial rites.[20] The Gallipoli synod of 1663, while condemning magic aimed at causing impotence and marital strife, also forbade the use of potions, charms, ligatures, incantations and other magic performed either to set up weddings or impede them.[21]

Such a major step as marriage was circumscribed by 'fate' and undertaken with many precautions since so many things could go wrong in a couple's life. In the words of one scholar, 'because so much of life was brutal, because peasants lived in world of "total scarcity", because the mythical past offered an alluring respite from the unknown future, rural culture viewed fate with awe and fear'.[22] The same was true for urban culture as well, which exhibited the same face-to-face community style of life as its rural counterpart during the early modern period, as discussed in chapter 1. In any case, one method of 'testing the waters' was divination, another was a kind of preventative magic used to ward off spells in church during the wedding ceremony. In Gallipoli it took the form of having the bride leave the church by a different door from the one through which she entered.[23] Nevertheless the threat of sorcery by envious or enraged neighbours was always present and the public ceremony exposed the couple to expressions of ill-will. The problem might have been avoided as in Languedoc where, according to a local doctor, not ten marriages in a hundred were celebrated publicly in church for fear of the *aiguillette*. The couples would go in secret to a neighbouring village to receive the clerical benediction.[24]

The most popular solution, however, brought popular practice into conflict with Counter-Reformation attempts at transforming 'marriage from a social process which the Church guaranteed to an ecclesiastical process which it administered'.[25] Before the Council of Trent – and for a long time after it – marriage in much of Italy consisted of a contractual agreement between the two families (the *sponsali* or spousals), followed by a ceremony conducted or witnessed by a notary (less often a priest) at which the ring was placed on the bride's finger. This could then be followed by a nuptial mass or other public ceremony, depending on local custom.[26] For the lower echelons of society the priest's role could be greater – where the giving of the nuptial ring occurred more often in church or before a priest or monks serving as witnesses[27] – but nowhere was it obligatory, since mutual consent of the (physically mature) spouses

was considered sufficient by canon law. After Trent the Church required that the 'ring ceremony' should take place at the church door (and in front of the altar according to the Roman Ritual of 1614), before a parish priest and witnesses. The couple was encouraged to avoid conjugal relations until the blessing of the marriage at a nuptial mass.

Yet as St Bernardino had noted, couples were 'encouraged by senseless relatives' to rush 'into the union of the flesh' immediately following (or even before) the private spousals, due to 'the fear of spells and enchantments' which threatened the couple with impotence.[28] This tendency was apparently not altered by the increased role of the Counter-Reformation Church in marriage. The apostolic visitor to the Lecce diocese in 1627, Monsignor Andrea Perbenedetto, bishop of Venosa, condemned the custom which resulted in many couples not having their relationship sanctified until after a period of several years, some even dying in sin because of it. 'And then,' concluded Perbenedetto, 'the barbarous thing: thinking that by doing evil good results, and offending God and their souls by consummating the marriage before it is contracted and before the clerical benediction, so that the devil does not bother them.'[29] The situation was further complicated in the diocese of Lecce by the Interdict of 1711–19, during which time couples frequently married at home, owing to the absence of episcopal regulation. Some priests continued to celebrate domestic nuptial ceremonies for over a decade following the revocation of the Interdict.[30] This led to confusion among the laity as to correct practice, as the marriage trials demonstrate.[31] The slow pace at which matrimonial customs were reformed throughout the peninsula is another example of the need to extend study of the Counter-Reformation to include the eighteenth century.[32]

DIVINATION

Of course the vicissitudes of love and marriage did not stop even after children had been born, and threats to the relationship were all about. This insecurity was particularly felt by the wife who frequently remained at home while the husband plied his trade or sought work as a farm-labourer, often far away. When twenty-five-year-old Sebastiano Barca left his twenty-one-year-old wife Geromina to go on business to Naples during Carnival, Geronima became worried after not receiving any news and 'she wept all day long'.[33] A friend took her to Camilla Nanni to find out whether Sebastiano was dead or alive. Nanni recited some prayers and tossed some broad beans to the ground, divining that he was still alive. Yet Geronima's concern for her husband was mixed with suspicion. In a

somewhat garbled declaration made later, she mentioned bringing a pair of Sebastiano's trousers to Nanni to ascertain whether he was gallivanting around with the women of Naples.

Although not religious activities in an orthodox sense, the ritual techniques employed in various forms of divination and the locating of lost or stolen objects depended on forms of intercession, especially appeals to the saints, in ways not approved by the Church. One example is the scissors-and-sieve technique used (with variations) throughout Europe to identify thieves and for general divinatory purposes, in which function cunning folk had very little competition. In 1730 Nicolò Farina told a fellow resident of Francavilla that to discover what a certain person is doing (or has done), whether good or bad, all one had to do was utter a few words.[34] Elaborating, Farina said his technique consisted of taking a bean-pot (known as a *favvaro*), into which he put five crosses made of splints and a pair of scissors. He then raised it with his hands and, according to the witness, intoned: 'Through the intercession of Sts Peter and Paul and St Anthony Abbot, I pray you to tell me the truth, in respect I tie you as St John bound the Lamb.' Finally, he tied the scissors with a strip of black ribbon, and their movement inside the pot would indicate an affirmative answer. According to other testimony, in cases involving lost articles, the pot was expected to rotate at the mention of the thief's name.[35]

The 1661 synod of the Gallipoli diocese condemned all methods of divination, from the interpretation of sounds made by animals and birds, and dreams (especially those occurring at dawn), to the numbers of table-guests and the patterns made by the spreading of oil, wine and salt. And it added that such rituals were routinely performed before undertaking a transaction, setting out on a journey, contracting marriage (see above), gathering herbs, shaving beards and concerning death and other events, good and bad.[36] Yet in practice, as we shall see in the following chapter, the ecclesiastical authorities – and the episcopal tribunals in particular – tended to regard such activities as stemming from ignorance rather than wilful apostasy.

Even the prediction of lottery numbers was anathema. Given the popularity of lotteries, techniques to divine winning numbers were exceedingly widespread and common.[37] Dreams were variously interpreted and different subjects and occurrences were thought to correspond to different numbers. But there were other techniques as well. Vito Cavallo confessed to the episcopal court in Oria that he had been approached by the apothecary of Erchie who wanted to know 'some secret for treasure or lottery numbers'. After being promised remuneration, Cavallo instructed the apothecary to say a 'novena of the Immaculate Conception', go to

confession and wear two lists of lottery numbers inside his shoes; after nine days he would get a trembling in his arm, at which time 'the numbers he wrote down would be the winning ones'. Later, he told the apothecary – rather more conventionally – that if he dreamt of a ringing bell on the night of the novena then the number of rings would correspond to 'the number he had to play'.[38]

Potentially the most dangerous of divination techniques from the Church's point of view was the consultation of those possessed by spirits. In an attempt to find treasure – on which, more below – Nicodemo Salinaro sought the advice of a possessed woman.[39] This was perfectly logical given the demoniac's perceived position as a liminal being with direct connection to the supernatural. However, only official exorcists were permitted to interrogate the possessed, and then only under licence from the bishop. The 1661 Gallipoli synod vehemently declared: 'No one shall, under any pretext, presume to interrogate *energumenos* and those possessed by spirits who offer some strange oracle either about the future or occult things.'[40]

It is one thing to describe the various practices regarding divination and fortune-telling, quite another to ascertain when particular individuals would have recourse to them and what kind of relationship the practitioners had with their clients. Fortune-telling was a serious matter, for the consultations were often connected with sorcery or the casting of spells. For instance, if Geronima Ortive, in the accusation examined above, had been told her husband Sebastiano was having an affair, she might have decided to have some magic done against him to make sure it did not continue. For this reason it may be unwise to draw too sharp a distinction between divination and love magic, the latter also being a natural outcome of a divinatory consultation.

Fortune-telling techniques like the ones we have examined were very common in the Terra d'Otranto, owing in part to the presence and influence of wandering bands of gypsies. One writer noted in the mid eighteenth century that gypsies 'have brought to Italy the method of smoothly extorting money, even from the poor peasants, actually robbing them under the specious pretext of revealing future events to them.'[41] The repertoire of gypsy women supposedly included 'philtres and mysterious remedies' designed to locate stolen goods, find treasure, ward off the evil eye and excite the passions of lovers. The Otranto synod of 1679 warned the faithful to beware of gypsies, 'who easily deceive the simple and careless by means of their illusions and divinations'.[42] Yet it is difficult to go beyond the repeated stereotype, and ascertain just what influence the gypsies had on indigenous techniques of divination, love charms and so

on. They have left few traces in the diocesan archives, aside from the occasional reference to their presence (and their menace). Bishop Pappacoda of Lecce, for instance, while on a visitation outside the village of Monteroni in 1642, noted that the chapel of S. Giovanni Battista was occupied by a small group of gypsies whose fires had darkened the ceiling. In the chapel he found 'various musical instruments, in particular a tambourine and, as it is called in the vernacular, a guitar, on top of the wooden altar, above which were even hanging some of the offenders' clothes…and there was also a bed, to the great disgrace of this same church, so that it resembled a tavern rather than a temple of God.'[43] The ecclesiastical courts do not seem to have shown any interest in them, but this is in keeping with their attitude towards other marginalised members of society, like beggars. Likewise in Spain, where the gypsies were suspected of blasphemy, irreligion and superstition, they were rarely tried by the Inquisition, owing to their impenetrable language, culture and mobility.[44]

The first years of the eighteenth century none the less mark the end of government edicts against the gypsies and the silence of ecclesiastical sources for more than a century. Settling outside towns in the Terra d'Otranto, the gypsies performed their customary trades of blacksmith and horsetrader, becoming an established feature of village life. This more sedentary way of life in comparison with their habits in other regions of Europe eventually brought them into close contact with the people and dominant culture, resulting in their gradual religious acculturation.[45]

In fact, there was an ethnic diversity throughout the Kingdom of Naples which to a limited extent had the effect of bringing different popular traditions together. In northern Apulia there were the Waldensian communities of Provençal origin, while Albanian settlements were scattered throughout southern Italy, chiefly in Apulia, Calabria, Basilicata and Sicily. The Albanians had come during the fifteenth century to escape the Turkish invasion, forming their own settlements where language, culture and religion were kept largely intact. In practice, however, the Church came to regard them as Latin-rite Christians under the control of the Catholic episcopacy. Once again, it is impossible to discover their precise impact on native culture. Antonia Donatino of Francavilla confessed to making maleficent charms in an attempt to cause the death of Nicola Corvino; when these failed, she went to an Albanian woman who, for the cost of seven *carlini*, prepared some powder to put in the man's fireplace.[46] In this case, the stranger's magic was simply presented as another alternative among the many techniques available.

MALEFICIUM AND SOCIAL RELATIONS

Malefice, like the impotence-causing ligature, was frequently the reverse side of popular healing, in as much as it was often the supposed source of ailments which required a ritual cure. In 1609 Rosa Goffrida, while trying to convince her husband to come back to her, was interrupted by his employer, Rev. Carlo de Donato, who shouted from a window that he would never come back home since Rosa was a 'gypsy sorceress' who wanted to poison him.[47] She retorted that he had no right to interfere in the affairs of husband and wife, and that she would complain to the bishop about having been abandoned. De Donato replied, according to Rosa: 'Gypsy sorceress! Husband poisoner!... If you tell the bishop about it you can stick your nose up my arse!' The woman's husband, Bernardino Schivano, carter and ploughman for de Donato, seemed to agree with his employer, and with good cause. He described Rosa as a 'haughty woman of very bad habits', who not only had tried to poison him on many occasions but had placed a charm in his jacket.[48] Recognising the charm's hair and ribbon as his wife's, he became very frightened and immediately left the land he had been ploughing. When asked by the ecclesiastical court of Gallipoli if 'because of the said things that he wore, as he said above, did he feel any harm to his person and limbs, and what effect did they have?', Schivano replied that he had serious pains in his head for four days, neither ate nor drank and was unable to stand up. However, 'as soon as he became aware of the said charmed articles and got rid of them, the pains went away and he got better'.

The use of magic – and the resulting accusation – is thus an element in the expression of social tensions. When twenty-year-old Oronzio de Quarto decided to break off relations with Maria Mosella, the girl's widowed mother – perhaps considering him a good 'catch' for her daughter (we note that he was educated) – threatened him, saying: 'If you don't come to my house any more, I'll make you come by wicked means [*con li tristi*]', and that 'by means of this cross of Christ, if I do like so, you won't live two hours'.[49] After forcing him to give her ten *carlini*, she told him not to fear her threats or be angry, having said those words 'more to bring me discomfort than to cause me harm'. Here magic was an obvious bargaining tool in social relations. Alas, it backfired and the woman was denounced before the ecclesiastical court.

Aside from a means of explaining and regulating awkward or inappropriate relationships, sorcery – or rather, the accusation of its use – could be employed to incriminate people. As the victim could use the spell as a means of face-saving among his or her neighbours, so, conversely, it was a

means of causing the 'loss of face' in others accused of employing it. Frequently those accused of other crimes were also identified as *fattucchiari* to present them in a worse light before the ecclesiastical judges, for it had the effect of increasing the bad reputation (*mala fama*) of the accused. In one well known case in Martina Franca magic was employed both to explain an unacceptable social rapport and to justify a hasty trial, incriminating an apparently innocent man. In 1704 the ninth Duke of Martina, Francesco Caracciolo, accused an illiterate tailor, Gaetano Faraone, of having used sorcery to ingratiate himself with the previous Duke (Caracciolo's father), to the point that Faraone was able to become the Duke's sole confidant and adviser. Yet it would appear, rather, that Faraone had become the late Duke's favourite 'because he was aware of his own cleverness, knew how to turn it to his own advantage and could trick at will'. Eventually, by various 'expedients and stratagems', Faraone's influence was such that 'all the favours and business of the government of Martina went through his hands'.[50] This rise to prominence – not unlike that of Giulio Cesare Croce's fictional peasant Bertoldo, whose rustic astuteness led to his becoming King Alboino's counsellor[51] – enraged those close to the Duke, and just two weeks after his death Faraone was charged by the local prosecutor. Deponents testified that 'Faraone was an ignorant man, whereby incapable of assuming predominance in the heart of Duke Pietraccone, which instead took place by means of magic spells; this judgement seems all the more well-founded since Faraone was intimate friends with Nardantonia Casparro, alias "la Pignatara" [potter], and Grazia di Mascio, these women being commonly held to be expert in charms and spells'.[52]

Casparro confessed to making two charms, along with di Mascio, for Faraone, both of which he tossed into his well as part of the ritual. Di Mascio confirmed Casparro's testimony before the governor's court on 24 January 1724, but when the governor sent two confessors to her two days later they claimed that she refused to confess her sins and died without any sign of penitence. Her sudden death is peculiar, given that she had been fine two days earlier. Adding to the suspicious character of the trial was the manner in which three friars, exorcising the well, drew up the two charms from the water, both of which were found to be in perfect condition. A month later Faraone deposed that he had been falsely accused in order to damn his good standing. At this time he was already ill, allegedly because he had repeatedly 'struck his chest with a stone, asking forgiveness from God for his sins'. Although doctors declared that the wounds had led to a severe fever, Faraone was led back to the Duke's prison, where he died just over two months later. He was denied a Church burial despite having received the last rites before his death.

While it is possible that Faraone had had recourse to *maleficium* to ensure his position with the succession of the new Duke, for Ascanio Centomani, writing thirty-five years later in a climate of reform against baronial abuses, it was a complete fabrication, with Duke Francesco being responsible for Faraone's death in prison. When the Duke was brought before the Reale Sacro Consiglio of Naples to face various charges in 1741, he stated in his defence that the trial against Faraone had been instigated by the curia of Taranto and the Holy Office. They had allegedly undertaken a lengthy investigation of the affair before instructing the Duke to imprison Faraone. Although Duke Francesco could give only indirect evidence of this – in fact, the trial had been directed by the governor, an appointee of the Duke – he was absolved, though not with a *formula piena*, and his jurisdictional powers were curtailed.

In the ducal trial of Faraone the two women Casparro and di Mascio were used as pawns to incriminate the accused. Yet given their influence in society, there is little doubt that both the sorcery and the *magara* were feared. When nine-year-old Paduano Tundo showed his mother a strange object he had found underneath the door, she screamed and started 'shaking all over for the great fear', saying 'that it was a spell and an evil thing'.[53] Threats to make someone 'melt little by little like a candle' – a very common form of image magic – were taken very seriously;[54] and in one case the victim of a spell began to waste away, 'melting like wax in the fire' as threatened, dying two months later in hospital.[55] Indeed Don Giuseppe Bottaro, treasurer and 'third dignitary' of the collegiate church of Francavilla – who, as an ecclesiastic, had direct access to Church remedies – was quite afraid of two local *magare*. They must have been quite a sight, for he stated: 'Not only have I felt horror at seeing them, but I have also fled from them, making the sign of the cross over my heart because of the fear that their glance alone instilled in me.'[56]

However, as suggested in chapter 5, *magare* were a necessary evil because of the vital services they provided. They helped alleviate – if only slightly – the feeling of helplessness all men and women felt when confronted by the often hostile powers of the world. One had to accept the good with the threat of the bad, for they were reputed to be able to heal as well as harm. Their knowledge and use of divinatory and amatory magic served to help maintain a peasant concept of order and balance, as did their ability to cure disease. This ambivalent function is typical of the representative figures of the sacred system discussed in Part II. The priest – believed to bring bad luck in addition to his sacramental powers – and the saint – who could provoke as well as heal the disease of which he was patron – both had their negative sides.

THE *MAGARA* AS SORCERESS

But who were these wise women, these *magare*? First of all, they *were* primarily women, who, given their customary roles of cook, healer and midwife, were believed to have a direct connection with the practice of *maleficium*. Moreover, despite the informal power relationships so crucial to village and town life, women found it more difficult to defend themselves and their interests, and so more frequently turned to sorcery as a means of doing so – or were naturally suspected of employing it for this purpose.[57] The gender bias present in accusations of sorcery (and witchcraft, as we shall see in the next chapter) might also reflect a struggle among women for control of the feminine space, possibly intensified by the number of unmarried women, lacking familial support.[58] The fact that many women suspected of sorcery were widows may be explained by the fact that such women lacked the protection of a husband, who could exert influence in containing rumour. But perhaps more importantly, in a patriarchal society women who were subject to the control of neither father nor husband were a source of suspicion and even fear. It may also be true that there was a tendency to suspect healers and cunning women of sorcery as old age brought on increasingly eccentric or anti-social behaviour, making neighbours uncomfortable. At the same time, their old age increased their chances of having been widowed.

Another characteristic often shared by accused *magare* was poverty. Although not usually the poorest members of society – the itinerant poor, for instance, do not figure very highly in the trials – they frequently lived on a subsistence level, many having to beg in order to survive. As such, they were weak and vulnerable, and often depended on both beneficent and maleficent magic to sustain their precarious status, socially as well as financially. As we shall see in the next chapter, they were often the ones suspected of having invoked or made a pact with the Devil – being considered the most likely to resort to such a step. And because such women were dependent on their local community, whether rural or urban, they could easily arouse resentment and even guilt amongst their neighbours. Thus the resulting accusation could be either an attempt at legitimate retaliation or a projection of the guilt felt by the accusers on to the accused. In this regard it has been suggested that a general decline in the standard of living, beginning in the fifteenth century and continuing into the eighteenth, may have made neighbours less tolerant in dealing with the poor and more prepared to rely on accusations of sorcery to maintain their position in society.[59] However, this must be regarded in connection with the increased vigilance on the part of the ecclesiastical

courts and the influence of preachers and confessors in convincing people of the evils of *maleficium,* typical of the two centuries following the Council of Trent.

The wise woman need not have been a poor widow in order to arouse suspicion and fear, as the following example from the Oria diocese makes clear. Francesco Greco testified in 1742 that while he was labouring on episcopal farmland the known *magara* Giustina Quaranta approached and began purposely to uproot the onions, damaging the adjacent flax in the process.[60] Greco's young brother-in-law unwisely began to shout at her: 'For the love of God, we've worked here and we still have to pay our master. I'm shouting more for the flax than for the onions, which will be crushed and damaged. At least if you want onions, tell us, and we'll get them for you without harming anything, because we know where to put our hands.' Quaranta replied angrily that she would make him pay for this outrage; and sure enough, Greco concluded, two months later his brother-in-law got severe pains and died that very night. Having heard of other *maleficia* of which Quaranta was suspected he connected the two events and decided to testify against her.

Even though Greco and his brother-in-law were in the right they felt guilty at having incurred the wrath of Quaranta, and projected it on to the accused, in accordance with the 'guilt-reversal' model mentioned above. Although a number of women in the Terra d'Otranto were accused of sorcery by dissatisfied and repented clients, many, like Quaranta, were regarded primarily as troublesome neighbours, the accusations being by no means restricted to those dependent on charity. In this case, as in most others, the accused was known to the victim and was believed to bear a grudge against the victim (and accuser) as a result of some face-to-face contact which soured relations. Quaranta, it seems, was especially apt at 'creating' such social situations – a kind of emotional blackmail – which resulted in a mixture of community animosity and feelings of guilt being directed against her.

LEARNED MAGIC

The practice of *maleficium* was of course denounced by both the ecclesiastical and lay courts, as well as the Holy Office, although the sorts of punishment meted out varied widely. The courts could be quite severe in cases where malefice – popular or learned – was clearly proved. The secular tribunal of Lecce punished practitioners in collective public ceremonies during Holy Week, building on the lugubrious lenten atmosphere. Such was the case in 1680, when 'four women, three young and one old, were

whipped through the entire city for sorcery.'⁶¹ The ecclesiastical courts made occasional use of torture but could also threaten relaxation to the secular arm. For instance, Cecilia Pulli of Latiano, variously charged with 'stealing' a mother's milk, performing impotence magic and giving someone a 'love powder' to use,⁶² stated several years later 'that she didn't do it, but since Dr Miccioli told her that if she admitted everything she would be freed by the bishop, otherwise she would be tormented by the executioner of Lecce, and so she said that she did it.'⁶³ But the main threat, at least for the ecclesiastical tribunals, was learned magic, in part because it purported to offer an alternative cosmology, whereas popular magic tended toward the particular and the defensive, without assuming an explicit doctrine. Of course, it possessed an *implicit* cosmology and sense of the sacred, transmitted rather than taught; but it was the sub-system of the necromancer, with its circulating, secret texts, which was of greater concern to the Church after Trent. That is to say, although popular magic sought recourse to the sacred in both divine and diabolical forms, it worked alongside Catholic rituals to procure protection and security during moments of crisis, not attempting an all-inclusive interpretation of reality. Even though popular and learned magic were denounced together by the Church, learned magic, as we shall see, was potentially a much more serious affair.

The relationship between popular and learned magic is a thorny question but holds much fascination because of the light it can shed on oral and élite interactions in early modern Terra d'Otranto. Cecilia Pulli, typical of the traditional village *magara*, was also accused of attempting to locate buried treasure – the most common use of learned magic – along with a priest and several other people, a mere six years after her previous trial.⁶⁴ In this respect, the illiterate and literate worlds had been much closer together during the late Middle Ages, when books like the *Sword of Moses*, written down around the tenth century, contained a series of prescriptions and formulae which used divine or angelic names to counteract all bodily ills.⁶⁵ The belief in spirits, present in daily life, formed the basis on which both learned and popular magic could develop, for it was possible to use their supernatural powers to protect oneself from aggression, predict the future and acquire wealth or love.⁶⁶ The belief in sympathetic magic, the occult virtues of precious stones, charms and incantations had their popular variations. So, if the *magara* had a powder to attract men, the *necromante* (necromancer) had a special ring which had power over women when touched. We have also seen the use of popular divination by a jealous spouse to ascertain her husband's activities; a man from Ceglie admitted to discovering that his wife was involved with three

different suitors by means of a demonic *libretto*, which also allowed him to keep abreast of developments.[67]

On the other hand, there is a noticeable difference in approach, for 'while the poor *fattucchiare* could only invoke the oral tradition and the transmission of a predominantly feminine culture, the intellectuals claimed a scientific method and employed all the resources of their knowledge in magic, alchemy and astrology in their experiments'.[68] Yet there was a constant interaction between oral/popular and learned/élite cultures, if indeed such clear distinctions can be applied to life at a local level in the Terra d'Otranto. In Part II we saw how popular medicine (in a way not unlike modern social historians) borrowed techniques and rituals from other 'fields', including ecclesiastical remedies and official medicine. Likewise, the local Church was influenced and conditioned by the demands and practices of the faithful. The clergy were potential mediators in this regard too. When interrogated in 1783 by Bishop Kalefati, Don Nicola Farina of Francavilla promised to mend his ways. 'I am aware,' he responded, 'of the accusations made against me both for the superstitious hunting of treasures and the superstitious healing of diseases, for which I have been previously warned by the Curia, and I promised not to give cause for talk in this regard, as I now promise again, since it is not in keeping with the duties of any Christian.'[69]

The Neoplatonic and philosophical speculation of the Renaissance reached a peak in the Kingdom of Naples at the end of the sixteenth century in the form of Giambattista Della Porta (from Naples), Giordano Bruno (Nola) and Tommaso Campanella (Calabria). They represented a vast cultural movement rooted in the professional classes and the mendicant monasteries of the Kingdom.[70] None the less, the 'necromanti' – as those practising explicitly demonic magic were generically called – tended to be more interested in practical applications like protective and amatory magic. In 1596 Giovanni Venneri told a neighbour, Virginia Rizza, of his power over women, showing her some sheets of paper covered in writing, and asserting 'I can make any woman I want come to my house because I have the book of necromancy.'[71] Venneri had often bragged of his protection from musket shot and knife jabs too, claiming 'I command the devils' and 'nothing at all can harm me' as long as he wore a certain ring.[72] In another case, Domenico Pinto told the episcopal court in Oria of a priest who visited him while he was in prison. This priest had revealed an incantation to him that protected against musket shot, consisting of the words 'Sole, Aspice Vim.'[73] Pinto asked him: 'How can that be? You're a priest and you say these words? And there isn't superstition in it?' But the cleric had no doubts: 'Every morning as I leave the house I say them, but

always under the pretext that if there were superstition, they wouldn't have their effect.'

Yet it was the recovery of buried treasure that most interested the lawyers, notaries, priests and friars who practised demonic magic. Local mythology frequently indicated ruined castles, monasteries and chapels as the sites of buried treasure.[74] Excess cash was often deposited underground for safekeeping and such hoards occasionally turned up accidentally. Many such sites were rumoured in the area of Francavilla. The secretary to Bishop Marco Parisi wrote in 1648:

> In these four places [Casivetere, Caselle, S. Giovanni and Casalino] tiles, vases and stones have been seen along with many bones of the dead, and there is the certain assertion of old people, friends of the truth, that in all the above villages the heavens – through the protection of the Madonna Santissima della Fontana – have conceded to various residents of Francavilla the provision and grace of treasures hidden and left in those places by the French nation when she was mistress and then driven out.[75]

The occasional discovery of buried treasure, like Don Pasquale Manca's lucky find in Ostuni in 1795, was enough to keep the rumours circulating.[76]

In one of the few Oria trials conducted with the participation of the Holy Office, Nicodemo Salinaro of Francavilla, a surveyor, was charged with *sortilegium* (a term that had ceased to be applied simply to soothsaying). While in prison Salinaro gave a message to the prison bursar, Domenico Argentina, directed to Don Francesco Fasiello and concerning Salinaro's temporary release from gaol. Argentina accompanied Salinaro to his home, where Salinaro removed a book from beneath several dishes – quarto size, bound in parchment and written in Hebrew and Latin – and took it back with him to his cell. He then extracted some loose sheets from the book and told Argentina to give them to Fasiello. When Argentina commented on their 'demonic character', Salinaro told him that they were used to find treasure, make a man invisible and to help 'obtain grace'.[77] Salinaro confessed to Fasiello that he had gone treasure-hunting with several other men, 'driven by the need and poverty he had', and gave up the book to his confessor.[78]

Of course the possession of and trade in such books were prohibited by both Church and state throughout Italy. In a chapter entitled 'De libris prohibitis' the second Oria synod explicitly condemned 'books of geomancy, hydromancy, aeromancy, pyromancy, onomancy, necromancy, the magic arts, sorcery, prophecy, divination, auguries, related incantations'. It went on to forbid booksellers from dealing in books or printed matter containing 'orations, incantations, stories [*fabulas*], predic-

tions for the year – commonly lunar – or so-called prognostications.'[79] Cornelius Agrippa's *De occulta philosophia*, the most popular book of magic in the Kingdom of Naples, was banned by the ecclesiastical authorities, who kept a vigilant eye on the activities of booksellers, often resorting to subterfuge to catch unwise merchants in the act.[80]

Yet there was a large clientèle for occult titles, and such works frequently surfaced in trials, whether for magical or other crimes.[81] Nicodemo Salinaro, before being charged a second time in 1689, asked the illiterate Tomaso di Milato to keep several books and *carte* for him, warning him not to tell anyone about them. Perhaps remembering Salinaro's previous incarceration, di Milato grew suspicious and asked Don Geronimo Pastorelli over to have a look at the material.[82] Recognising some of the pages as occult in nature, Pastorelli and another priest, Don Donato Casalino, delegate of the episcopal court, arranged to catch Salinaro with the books on his person, since he had made an appointment to collect them from di Milato, believing himself to be in the clear. Thus it was that Salinaro was searched as he returned from di Milato's and a copy of the *Clavicola di Salomone* ('Key of Solomon') was found tucked under his coat along with two other handwritten books. When they searched his house they found, hidden amongst books on arithmetics, a manuscript version of the *Gabala Regnum* (*sic*).[83]

Although at least one of the books owned by Salinaro was printed, most were in manuscript form. Works like the *Key of Solomon* often circulated clandestinely in jealously-guarded handwritten versions, not primarily because of the difficulty of obtaining printed copies or the fear of prosecution, but because printed texts were considered useless. The book had to be copied out by the magician himself, using a consecrated pen and paper, preferably from a well-known magcian's copy.[84] Such texts and loose sheets were usually hidden by the magician among other sheets and papers to avoid discovery. Don Andrea Ciriaco, while going through his cousin's papers (also a priest) with Don Sinferiano Carozzo, discovered various suspicious writings 'containing, in our estimation, diabolical things, in particular a small treatise on magic and various other sheets of papers with diverse characters and secrets, all evil and contrary to the Catholic religion'.[85] They told the court that they did not confiscate the papers immediately because they feared the owner would get angry 'and into such a frenzy that he would shoot a musket at one of them'.[86] As a complete guide to magic, as well as the art of medicine, the *Key of Solomon* was considered worth the great effort and expense required to track down and obtain a copy, one priest saying that 'he held his copy dear, as if it were worth a thousand *scudi*'.[87]

Owning and safeguarding the right book, however, was only the beginning. The magician had then to locate the potential site of treasure. According to one witness this could only be done by having a 'dove plucked alive by an unmarried girl': the dove was placed in a circle etched on the ground, and where it stopped flapping about there would be treasure.[88] Or, one might be as fortunate as Luca Capobianco who was shown the position of a cairn of gold and silver by St Joseph in a dream.[89] It also helped if the magician in charge of the ceremony was an ecclesiastic, given the latter's recognised proximity to the supernatural (this same concept helps explain their involvement in popular healing discussed in chapter 4). They were no doubt also called upon to officiate at magical rites because of their expertise in the ritual use of holy oil, water and candles.[90]

In 1702 Don Nicolò Marciano of Otranto appeared of his own will before the episcopal court of Oria to confess his 'misdeeds, sins and wickedness committed against the Great Divine Bounty'.[91] He admitted to having gone treasure hunting around Latiano in the company of Abbot Giuseppe Argentina of Francavilla, Fra Barsonofrio, a lay brother of the monastery of San Francesco di Paola, and the notaries Domenico Pinto of Oria and Francesco Cariolo (or Carignulo) of Carovigno. According to Marciano it was the two notaries who made most of the preparations and instructed him on the procedure to be followed, although no doubt Marciano also wanted to minimise his own role in the affair, and in the first attempt to retrieve the treasure he was told to stand back because he had not fasted and was not purified.[92] Two nights later, having fasted, he was instructed to make a 'circle with virgin chalk, sprinkled with kid's blood'. The kid had been slaughtered earlier by the two notaries, who chose it from a flock belonging to Dr Francesco dell'Aglio, curiously nicknamed 'il medico pagano'.[93] According to Marciano's confession, at midnight he washed his hands and feet, put on a white stole and, barefoot, entered the circle from the west. Once inside, he lit the candles of consecrated wax, one of which sat on a table containing the kid parchments, a wand, aspergillum and holy water and incense. To placate the demons guarding the treasure he left the circle with one of the parchments in hand which bore the words written in blood 'on the invocation of the Demons', listing them as 'Tan, Varax, Panteon, Bartonisa, Servigeat, Agla, On, Tetragramato'. Then Marciano knelt three times, re-entered the circle, lit the incense and uttered the conjuration, at which point 'one hoped to find treasure'. But despite performing everything 'according to what was written in Pinto's book' they had no luck.[94]

The complexity and elaborate nature of the ceremony is only hinted at in Marciano's summary description of the events. Because the 'darker powers' were believed to be the custodians of underground wealth, the rite had many stages, as the demons were in turn called and failed to appear, all the while increasing the ritual's drama and tension. The complicated ceremony meant that lack of success would not be blamed on the 'master' but on some deviation or failure in carrying out the often ambiguous instructions. In the case of the Marciano expedition it was decided that the wand had not been made at the correct time, and they awaited the next full moon. When they failed on two further occasions they apparently gave up and burnt everything, promising 'with firm mind never again to fall into such errors'.[95]

Giovanna Bax, whose house in the countryside outside Latiano apparently lay over the treasure, also confessed to the whole affair, saying 'My soul has been obstructed and oppressed by an infinity of faults, but by confiding in the piety of Jesus Christ crucified, I hope to obtain pardon for my many faults.'[96] One who was not repentent was the illiterate steward of Dr dell'Aglio's farm, Onofrio Guscio. Evidently he understood very little of what these representatives of learned culture were up to, for he suggested that the two notaries slaughtered the goat (leaving him to clean up) and then ate it during the last few days of Carnival. Guscio adds matter-of-factly and without explanation that on that same night Don Marciano 'tossed the blessed water, wore the stole and said words which couldn't be heard.'[97] There is no mention of treasure hunting. The cultural gap could not be wider.

The combination of gullibility and greed sometimes led people to foolish lengths, and it was not only the gypsies who used magical techniques to separate people from their money. According to a somewhat patronising prosecutor at the episcopal court in Oria two women had sought a treasure of which a mutual friend of theirs had dreamt by approaching Antonio 'il Raschiante' (the 'scraper' or 'cougher') of Francavilla. He charged them eleven *carlini* for his first consultation, and told them that he would make the treasure appear in his godmother's house, 'so the King's men don't find out'; they had to begin by having three Greek masses said in Lecce. He announced that his fee would be thirty *carlini* and fifteen *rotole* (approximately fifteen kilos) of foodstuffs which, according to the prosecutor, the 'incredulous women sent'. On Easter Sunday 1745 Raschiante performed the rite and 'pretended to transport the treasure', but told the women he would need two candles (costing twelve *carlini* each), plus an additional twelve ducats 'with which he had to buy gold so as to retrieve the treasure [from the devil], and the

said women believed everything and gave it to him'. After sending them some worthless trinkets, Raschiante said he was losing the struggle with the devil and immediately required another fifteen *carlini*. The women, by now suspicious, denounced Raschiante to the prosecutor, who sought to have him convicted along with his godmother, 'who I believe acted in concert with the same, to cheat poor, ignorant people out of a lot of money'.[98]

One wonders how much the prosecutor represented the Oria court's views regarding the threat of learned magic which only forty years earlier had still been rather severe. Indeed it was during the episcopacy of Bishop Labanchi (1720–46) that most of the accusations were made, a fact to which we shall return in the following chapter (as the same pattern exists for accusations of diabolical witchcraft).[99] In this case we have the added complication that Raschiante was accused of being a simple cheat rather than a bona fide magician. Despite the obvious belief of the two women in the efficacy of such techniques to find buried treasure, it is the penultimate denunciation made before the episcopal court for any form of treasure hunting (the last being two years later).

As we have had occasion to observe, learned demonic magic did influence popular magic to some extent at the town and village level in the Terra d'Otranto. Yet despite the Church's condemnation of them together they remained two distinct forms of magic. Popular magic – divination, fortune-telling, love philtres and so on – was a primarily female occupation, like the related and overlapping realm of popular healing already discussed. Furthermore, it offered men and women a ritual way of dealing with crisis situations which complemented, rather than competed against, the role of the Church in society, relying as it did on the sacred for its efficacy. Learned magic, on the other hand, was an entirely male phenomenon (clerical and lay), with women as passive observers, although it too made use of the sacred by frequently employing priests to conduct the intricate ceremonies. It was a well-articulated cosmology which competed against the monopoly of official religion. When applied at the local level it did not attempt to confront the existential crises with which popular magic frequently dealt. It concerned itself with the locating of buried wealth, protection from bullets and its own type of love charms, satisfying the needs of those who employed it.

Ironically, popular magic, with no texts and no comprehensive philosophical system, was long to outlive its learned counterpart, surviving into the present day. The relation of popular magic, especially sorcery, to diabolical witchcraft has proved equally unshakeable. It is to this relation-

ship, and an explanation of the accusations for witchcraft before the ecclesiastical courts in the Terra d'Otranto, that we now turn.

NOTES

1 Mons. Castrese-Scaja, 'Editti per casi riservati e per i Sacramenti della Penitenza e della Eucaristia', 1749, A.D.O., *Sante visite*, no foliation.

2 Richard Kieckhefer, *European Witch Trials: Their Foundations in Popular and Learned Culture, 1300–1500* (London, 1976), 5–6.

3 'Francesco Gregorio Quaranta denuncia Giovanni — alias Zuzumbrillo', 30 October 1723, Torre S. Susanna, A.D.O., *Magia e stregoneria*, II.

4 'Renata Rozza confessa di aver usata una certa polvere magica', 5 March 1729, Francavilla, A.D.O., *Magia*, I.

5 Depositions of Pietro Vitugno and Cataldo Balsamo, 'Domenica Maria Gioia contro Giuseppe Nigro per stupro, con atti magici e sortilegi', 16 January 1714, Ceglie, A.D.O., *Magia*, I.

6 'Leonardo de Milato confessa di aver consultato una strega', 28 March 1742, Oria, A.D.O., *Magia*, II.

7 Mary O'Neil, 'Magical healing, love magic and the Inquisition in late sixteenth-century Modena', in S. Haliczer, ed. *Inquisition and Society in Early Modern Europe* (London, 1987), 101.

8 Ernesto de Martino, *Sud e magia* (Milan, 1966 edn.), 17.

9 'Teresia Biascho denuncia pratica di magia', 18 October 1740, Francavilla, A.D.O., *Magia*, II.

10 Deposition of Elisabetta Scozzana, 'Contro Rvdo Isidoro Dolce per stupro commesso a Giulietta Allegretti', 1702, A.C.V.G., *Processi penali*, no. 2832.

11 Declaration of Cataldo Gioia, 'Domenica Maria Gioia contro Giuseppe Nigro per stupro, con atti magici e sortilegi', 16 January 1714, Ceglie, A.D.O., *Magia*, I.

12 Despite belief in the spell's effectiveness, the whole trial resembles something of a cover-up, perhaps for the break-up of a promised relationship with the offended party trying to save face.

13 Second deposition of Dorotea Rossi, 'Dorotea Rossi denuncia diverse donne per pratiche magiche', 24 July 1742, Francavilla, A.D.O., *Magia*, II.

14 'Giuseppe Greco denuncia Nicolò Farina per pratiche magiche', 24 March 1730, Francavilla, A.D.O., *Magia*, II.

15 'Nicola Farina denuncia Fra Oronzio di Francavilla per arti magiche', 12 May 1742, Francavilla, A.D.O., *Magia*, II.

16 *Synodus Dioecesana Ecclesiae Vritanae, a Reverendissimo Domino D. Marco Antonio Parisio* (Naples, 1646), 30.

17 Deposition of Anna Sanasi, 'Contra Antonella Seppi pro sua mala vita, fama et conditione', 19 May 1723, Torre S. Susanna, A.D.O., *Magia*, II.

18 Deposition of Laura de Lorenzo, ibid.

19 *Secunda Synodus Dioecesana ab Aloysio Pappacoda Episcopo Lyciensi* (Rome, 1669), 65. This practice existed elsewhere. According to the 1755 visitation of the bishop of Campagna and Satriano, south of Naples, the donation was called an 'Adone' (Adonis); cf. Gabriele De Rosa, *Vescovi popolo e magia nel Sud* (Naples, 1983), 65.

20 Annamaria Rivera, *Il mago, il santo, la morte, la festa* (Bari, 1988), 152–6. Rivera notes that in many southern Italian dialects the words *compare* and *commare* (godfather and godmother) are synonymous with 'lover'.

21 *Constitutiones Synodales Editae In Prima Dioecesana Synodo Gallipolitana...Ad Illustris. ac Reverendis. Domino D. Ioanne Montoya De Cardona Episcopo Gallipolitano* (Naples, 1661), 178.

22 Rudolph Bell, *Fate and Honor, Family and Village: Demographic and Cultural Change in Rural Italy since 1800* (Chicago, 1979), 51.

23 *Synodo Gallipolitana*, 40–1. Varieties of this practice are known throughout Italy. Cf. Cleto Corrain and Pierluigi Zampini, *Documenti etnografici e folkloristici nei Sinodi Diocesani italiani* (Bologna, 1970).

24 Félix Platter writing in 1595, cit. in Emmanuel Le Roy Ladurie, *The Peasants of Languedoc*, trans. J. Day (Urbana, 1974), 204–5.

25 John Bossy, *Christianity in the West, 1400–1700* (Oxford, 1986), 25.

26 Christiane Klapisch-Zuber, 'Zacharias, or the ousted father: nuptial rites in Tuscany between Giotto and the Council of Trent', in *Women, Family and Ritual in Renaissance Italy*, trans. L. Cochrane (Chicago, 1985), 184–6. For a Florentine example of the process, see Gene Brucker's detailed case study *Giovanni and Lusanna. Love and Marriage in Renaissance Florence* (Berkeley, 1986).

27 Klapisch-Zuber, 'Zacharias', 196. An ecclesiastic frequently played the role of mediator in setting up the partnership and privileged witness at the ceremony.

28 S. Bernardini, *Opera omnia* (Florence, 1950–78), IV, 469–70; cit. in Klapisch-Zuber, 'Zacharias', 19

29 Mons. Andrea Perbenedetto, 'Decreta Visitationis Apostolicae', 1627, A.C.A.L., *Sante visite*, VI bis, fols. 43r–v.

30 Mario Spedicato, 'Demografia, economia e società a Carmiano alla fine dell'antico regime', in Spedicato, ed. *Chiesa e società a Carmiano alla fine dell'antico regime* (Galatina, 1985), 79.

31 A 1746 trial stressing the proper performance of weddings involves a couple in a hurry, a deaf priest and irate parents: 'Informatio contra Josephum de Lorenzis et Romanam Castagna', 1746, A.C.A.L., *Giudicati matrimoniali*, no. 1148.

32 Cf. Angelo Torre, 'Il consumo di devozioni: rituali e potere nelle campagne piemontesi nella prima metà del Settecento', in *Quaderni storici*, XX (1985), 182–3.

33 Deposition of Geromina Ortive, 'Contro Agata dello Scalfore, Camilla Nanni e Antonia di Supersano', 1600, A.C.V.G., *Proc. pen.*, no. 1393.

34 'Giuseppe Greco denuncia Nicolò Farina per pratiche magiche', 24 March 1730, Francavilla, A.D.O., *Magia*, II.

35 O'Neil, 'Magical healing', 90.

36 *Synodo Gallipolitana*, 40.

37 The *lotto* was exported from Genoa and begun in Naples around 1680. From the eighteenth century a manual, *La smorfia del lotto*, has been continually republished (and revised) indicating what winning numbers correspond to what dreams.

38 'Vito Antonio Cavallo confessa di conoscere certe fatture', 5 July 1749, Erchie, A.D.O., *Magia*, II.

39 Deposition of Domenico Migliazzo, 'Contro Nicodemo Salinaro per sortilegi', 16 July 1678, Francavilla, A.D.O., *Magia*, III, fols. 8r.–11v.

40 *Synodo Gallipolitana*, 42.

41 Pietro Pompilio Rodotà, *De' giuochi d'industria, di sorte e misti* (Rome, 1769), 79. Cit. in Adriano Colucci, *Gli zingari: Storia di un popolo errante* (Turin, 1889), 208.

42 *Synodum Diocesanum*, Otranto, Mons. Ambrogio Piccolomini (Venice, 1679), 65.

43 Mons. Luigi Pappacoda, 'Visitatio Pastoralis', 1642–3, A.C.A.L., *Sante visite*, X, fol. 159r. My thanks to Don Carmine Maci for pointing this reference out to me.

44 Maria H. Sánchez Ortega, *La Inquisición y los gitanos* (Madrid, 1988), especially chapter

four on gypsy magic.

45 Little is known about this process, the result of which is that today their divinities are no longer distinguishable from the God, Devil, Virgin and saints of the Catholic Church. Cf. Massimo Olmi, *Italiani dimezzati: Le minoranze etnico-linguistiche non protette* (Naples, 1986), 136–7 and 156.

46 Deposition of Antonia Donatino, 'Conto Caterina Patrimia per stregoneria e patto col diavolo', 14 August 1704, Francavilla, A.D.O., *Magia*, I. The Albanian woman was probably a resident of the nearby village of San Marzano, predominantly Albanian even today.

47 Deposition of Rosa Goffrida, 'Contro il Rvdo D. Carlo de Donato per ingiurie', 1609, A.C.V.G., *Proc. pen.*, no. 1420.

48 Deposition of Bernardino Schivano, ibid. Popular magic was ever realistic and pragmatic: backed up in this case by attempted poisonings. The close association between poisoning (*veneficium*) and sorcery (*maleficium*) was held by the secular and ecclesiastical courts as well.

49 Deposition of Oronzio de Quarto, 'Denuntiatio in causa S. Officij contra Maria Mosella', 13 November 1681, Francavilla, A.D.O., *Magia*, III.

50 Isidoro Chirulli, *Istoria cronologica della Franca Martina cogli avvenimenti più notabili del Regno di Napoli*, II (Venice, 1752), 142. Cit. in Giuseppe Chiarelli, 'Abusi feudali e un processo per magia nella "Franca Martina" del secolo XVIII', in *Studi di storia pugliese in onore di Nicola Vacca* (Galatina, 1971), 27–8.

51 Giulio Cesare Croce, *Le sottilissime astuzie di Bertoldo* (Bologna, 1608). Cf. Piero Camporesi, *La maschera di Bertoldo: G.C. Croce e la letteratura carnevalesca* (Turin, 1976).

52 The depositions are contained in a summary of the case written by Ascanio Centomani, *Risposta de' querelanti all'istanza e scritture prodotte dall'Illustre Signor Duca di Martina* (Naples, 8 April 1741), no pagination. Cit. in Chiarelli, 'Abusi', 28.

53 Deposition of Paduano Tundo, 'Processo di furto commesso nella casa di D. Giuseppe d'Acugna da Paduano Tundo', 1620, A.C.V.G., *Proc. pen.*, no. 413.

54 Deposition of Polonia Pittara, 'Informazione de sortilegis contra Giovanni Girolamo Venneri', 1596, A.C.V.G., *Proc. pen.*, no. 16.

55 Deposition of Maria Ortive, 'Contro Agata dello Scalfore, Camilla Nanni e Antonia di Supersano per sortilegio', 1600, A.C.V.G., *Proc. pen.*, no. 1393.

56 Deposition of Rev. Giuseppe Antonio Bottaro, 'Contro Nicodemo Salinaro per sortilegi', 16 July 1678, Francavilla, A.D.O., *Magia*, III, fols. 25r–26r.

57 Cf. Brian Levack, *The Witch-Hunt in Early Modern Europe* (London, 1987), 126–7.

58 G. R. Quaife, *Godly Zeal and Furious Rage: The Witch in Early Modern Europe* (London, 1987), 108.

59 Levack proposes this hypothesis on the basis that more people were competing for limited resources, *Witch-hunt*, 129.

60 Deposition of Francesco Greco, 'Contro Giustina Quaranta per magia', 5 July 1742, Oria, A.D.O., *Magia*, II.

61 Giuseppe Cino, 'Memorie ossia notiziario di molte cose accadute in Lecce dall'anno 1656 all'anno 1719', reprinted in *Rivista storica salentina*, 1905–6, 74. Little is known about how the state courts of the Kingdom of Naples tried such offences, owing to the lack of surviving records.

62 Depositions of Nunzia Sperta, Elisabetta Trippa and Donata Rubino, respectively, 'Summario delle denuncie contro Cecilia Pulli, maga di Latiano', September, 1722, A.D.O., *Magia*, II.

63 Deposition of Cecilia Pulli, ibid., April 1726. According to the Oria synod of 1641 a

sorcerer was to be 'pardoned if the magic does not smack of obvious heresy, and under promise of withdrawing and retracting those same arts which were mentioned, as well as burning in front of him [the bishop] the books and other instruments that were used in performing the magic'. *Synodus Vritanae*, p.74.

64 In 'Summario delle denuncie contro Cecilia Pulli', 23 April 1732, A.D.O., *Magia*, II.

65 E. M. Butler, *Ritual Magic* (Cambridge, 1949), 32.

66 Jean-Michel Sallmann, *Chercheurs de trésors et jeteuses de sorts: La Quête du surnaturel à Naples au XIVe siècle* (Paris, 1986), 190.

67 Deposition of Cosimo di Leonardo Argentiero, 'Palma Maria Ligorio contro Cosimo di Leonardo Argentiero', no date, Ceglie, A.D.O., *Magia*, I.

68 Sallmann, *Chercheurs*, 186.

69 Mons. Alessandro Kalefati, 'Visitatio Personalis', Francavilla, 1783–84, A.D.O., *Sante visite*, no foliation.

70 Sallmann, *Chercheurs*, 156. For the philosophy surrounding natural magic see D. P. Walker, *Spiritual and Demonic Magic from Ficino to Campanella* (London, 1958).

71 Deposition of Virginia Rizza, 'Informazione de sortilegis contra Giovanni Girolamo Venneri', 1596, A.C.V.G., *Proc. pen.*, no. 16.

72 Deposition of Perna Alessandrella, ibid. While admitting to wearing a silver ring (but 'as a remedy for *la discezi*', that is, the convulsive disorder eclampsia), Venneri stated in his twenty-six-point defence that he could barely write and 'does not have enough ability or intelligence to be able to exercise the art of necromancy'. Item twenty of defence declaration, January 1601.

73 Literally, 'Sun, be in the aspect of the man'. Cf. 'Denuncia di Domenico Pinto', 18 March 1698, Oria, A.D.O., *Magia*, I.

74 The Oria synod of 1641 condemned those who looked for buried treasure in churches (*Synodus Vritanae*, 11), while the Brindisi synod of 1663 specifically forbade 'the frequenting of sacred places to draw out and dig for treasures...and this decree of ours is against any person who in any way counsels, commands, gives news of or participates in similar searching for treasures'. *Sancta Tridentina Synodus ad Praxim, seu Decreta et Constitutiones Sanctae Ecclesiae Metropolitanae Brindisinae, ab Illustrissimo et Reverendissimo Domino D. Francisco De Estrada* (Venice, 1663), 19.

75 Cit. in Gigli, *Superstizioni*, 61.

76 Manca found the treasure inside an all but uninhabited palace in the town. Needless to say, the palace's owner, Duke Lopez, was less than pleased, and Manca was forced to seek sanctuary in a church. 'Acta declarationis ecclesiasticae immunitatis favore Rev. Pasquale Manca', 1795, A.C.A.L., *Giud. crim.*, no. 759.

77 A strange statement indeed, further testimony to the ambivalence of the sacred. Deposition of Domenico Argentina, ibid., fols. 1r–3v.

78 Deposition of Rev. Francesco Maria Fasiello, ibid., fols. 5v–7v.

79 'Synodus Diocesana Ecclesiae Oritanae ab Ill.mo et R.mo D.mo Fratre Raphaele De Palma...Habita Anno Domini 1664', A.D.O., *Sinodi*, fols. 68–9.

80 Pasquale Lopez, *Inquisizione, stampa e censura nel Regno di Napoli tra '500 e '600* (Naples, 1974), 181.

81 Cf. Paul Grendler, *The Roman Inquisition and the Venetian Press, 1540–1605* (Princeton, 1977), 196.

82 Deposition of Tomaso di Milato, 'Contro Nicodemo Salinaro per sortilegi', fols. 166v–168v.

83 Deposition of Rev. Donato Antonio Casalino, ibid., fols. 158r–159v. The book was a version of the Kabbalah.

84 Butler, *Ritual Magic*, 48.

85 'Rev. Andrea Ciriaco confessa di aver trovato certe scritte magiche', 25 May 1735, Oria, A.D.O., *Magia*, I.

86 Deposition of Rev. Sinferiano Carozzo, ibid.

87 Archivio Storico Diocesano, Naples, *Sant'Ufficio: informazioni e denunce*, vol. 107, fols. 163–168. Cit. in Lopez, *Inquisizione*, 186.

88 'D. Felice Teofilato denuncia Francesco Sarlo', 30 July 1742, Francavilla, A.D.O., *Magia*, II.

89 'Luca Capobianco confessa di aver cercato un tesoro', 13 November 1735, Francavilla, A.D.O., *Magia*, II.

90 Cf. Lopez, *Inquisizione*, 188.

91 'Il Rev. Nicolò Marciano di Otranto si denuncia', 2 April 1702, Oria, A.D.O., *Magia*, I.

92 According to the Solomonic rite a period of purification – chastity and abstinence – had to precede the actual ceremony. Cf. Butler, *Ritual Magic*, 51.

93 'Denuncia di Onofrio Guscio', 22 April 1702, Francavilla, A.D.O., *Magia*, I.

94 According to the rituals described the book in question was most likely the *Key of Solomon*.

95 'Il Rev. Nicolò Marciano di Otranto si denuncia', 2 April 1702, Oria, A.D.O., *Magia*, I.

96 'Denuncia di Giovanna Bax', 8 April 1702, Francavilla, A.D.O., *Magia*, I.

97 'Denuncia di Onofrio Guscio', 22 April 1702, Francavilla, A.D.O., *Magia*, I.

98 Prosecutor's denunciation, 'Contro Lucrezia Giodici e Beatrice Bruno per aver cercato un tesoro', 12 August 1745, Oria, A.D.O., *Magia*, II.

99 This differs from the episcopal court of Gallipoli which, according to surviving trial records, showed little interest in magic – whether beneficent, maleficent or diabolical – after 1620.

8

The witch:
witchcraft narratives and folklore motifs

Of all the crimes judged by the ecclesiastical courts, the most curious and puzzling is perhaps that of witchcraft, complete with the traditional paraphernalia of Satanic pact, night flight and sabbath. Historians have devoted much effort to this subject, especially in the last decade, and though some very expert work has been done there still seems to be a great deal of confusion about just what is being discussed under the rubric 'witchcraft'. This chapter will set out to clear up some of this confusion, while exploring the phenomenon both in terms of its proper judicial context and in regard to its meaning and place in the belief system of early modern Terra d'Otranto.[1]

First of all, witchcraft is not synonymous with sorcery. That is to say, sorcery (*maleficium*) can – and did – exist without reference to the devil, even though as far as the Catholic Church was concerned all magic was in some way demonic. Thus accusations of sorcery, as discussed in the previous chapter, did not necessarily mean, or lead to, accusations of witchcraft. In fact, this occurred but rarely. On the other hand, accusations of witchcraft almost always involved the practice of *maleficium*, and witches were usually suspected of sorcery (their *raison d'être*, so to speak). Given the nature of the trials and accusations, which we shall turn to shortly, it would seem fitting to explore the phenomenon as an outgrowth of sorcery rather than as something existing independently.

Although most scholars agree on the use of the term 'witchcraft' to refer to the Satanic pact and actions stemming from it, we are still faced with the problem of separating demonological myth from actual practice. We must distinguish between the writings and treatises about the phenomenon penned by contemporaries (which, of course, have a history of their own), the story of the persecution of suspect witches throughout Europe (the witch-hunt), and the study of witchcraft as practised. As Ricardo García Cárcel has noted, this final connotation of the term could be further subdivided into what was real in witchcraft – such as the invocations, charms and possession – and what was imaginary, such as the night flight and sabbath orgy.[2] In attempting to account for the witchcraft

accusations and confessions it is important to keep these distinctions in mind.

DEMONOLOGISTS AND INQUISITORS

The course of witchcraft accusations and confessions in the Terra d'Otranto has much to do with the legal mechanisms which existed at the time. In a sense, they set the parameters for the phenomenon, as well as recording it for posterity. In so far as the activity of the ecclesiastical court was influenced by the works of the demonologists, many of whom wrote from their experiences as inquisitors, they too are relevant to the analysis.

Although Italian intellectuals and the Papacy had done much to formulate the standard view of witchcraft during the Middle Ages, they afterwards did relatively little to encourage its development. A survey of Italian and Spanish witchcraft literature suggests that a stereotypical view of the phenomenon was never widespread in the Mediterranean.[3] In Italy early work on the subject may be characterised by Gianfrancesco Pico della Mirandola's *Strix* (1523), which, instead of being voluminous and encyclopedic, was a lively and elegant dialogue.[4] The character of Dicaste, resembling a lay or ecclesiastical judge, regarded witches as heretics who went to 'synagogues' or 'sabbaths' (like the Jews, we could add), insulted the cross (like the Albigensians) and performed their own perverse rituals (literally so, as they were upside-down versions of Catholic rituals). Peter Burke has described this conceptualisation of alien beliefs as the exact opposite of one's own in terms of the intellectual principle of 'least effort', because it is far less demanding than entering into the structure of those beliefs.[5] This approach may be of especial use in helping us to decipher the writings of later demonologists, who were more severe and condemning towards the witches. These works and their authors were part of a world-view which expressed evil as an inversion of good: to maintain its intellectual coherence, demonisn was therefore linked with all privations of good.[6]

When much of the *Malleus maleficarum* was called into question in the works of Pietro Pamponazzi and Gian Francesco Ponzinibio, Paolo Grillando responded with a defence of the inquisitorial point of view.[7] His *Tractatus de hereticis et sortilegiis* (1527) was based primarily on cases he had adjudicated in Rome and Arezzo, and gave detailed accounts of the witches' covens, believed to have taken place under the famous walnut tree of Benevento. Later authors, like Francesco Maria Guazzo, made great use of Grillando's cases and opinions in their work.[8] The one-time inquisitor of Modena, Bartolomeo Spina, was also critical of the opinions of the *giureconsulto* Ponzinibio, as he was of the *Canon episcopi*.[9] He and Guazzo

represent the culmination of Italian demonology in terms of severity, but it is interesting to note that their examples come largely from northern Italy and northern Europe (France and Germany in the case of Guazzo). Despite the high numbers of accusations and trials for sorcery, the witch-hunt never held sway in the Kingdom of Naples.

In accounting for the rise in accusations against suspected witches in much of Europe during the late sixteenth and early seventeenth centuries the importance of the courts themselves should not be underestimated. Although the essentially functionalist theories are quite helpful in accounting for reactions from below, we must also note 'the extension of public judicial systems and a greater willingness to bring to court disputes where witchcraft was suspected'.[10] The activity of preachers and confessors was also crucial in convincing people that the proper means of reacting to supposed acts of sorcery and witchcraft was through the episcopal tribunals. Denunciations and confessions alike frequently began by citing the confessor's suggestion to bring the case to court; indeed absolution often depended on it. In explaining the character and content of the accusations and confessions we must account for these historical processes of mediation between the different cultural levels of the complex society that was early modern Europe.

It has been suggested that the change brought about by the 'judicial revolution' in England and elsewhere from restitutive to abstract justice allowed for the victimless crime of simply being a witch, a 'servant of Satan'.[11] This may help to explain the relative absence of witchcraft persecution in Mediterranean Europe. Here, traditional forms of justice held sway within the inquisitorial and episcopal courts, based on penance, and such concepts as the victimless crime and truth by self-accusation were foreign.[12] Although the Roman Inquisition was far more concerned with illicit magic – the crime which included witchcraft – than the Spanish, neither treated the matter with great severity. In the Otrantine diocese of Oria accusations of witchcraft numbered only eight, out of a total of forty-six for 'magic and superstition'; and of the eight, five did not reach a verdict (according to surviving records). Furthermore, most of the accusations were made during the episcopate of Bishop Labanchi (1720–46), in clear contrast with the neighbouring tribunal at Gallipoli, for which there are no surviving accusations of *maleficium* after 1620 (and none at all for diabolical witchcraft), and with the Inquisition at Naples, which was most active during the early decades of the seventeenth century.[13] This would seem to suggest an increased role of the bishop and his tribunal in the prosecution of *maleficium*, although his pastoral visitations give no indication of any extraordinary judicial zeal on his part. None the less the

activity of his court against crimes of magic (in élite and popular varieties) and sorcery did not lead to the prosecution of suspected witchcraft offenses, of which the court was somewhat dubious and treated with leniency.

This relative lack of severity was due in part to the emphasis that the Roman Inquisition placed on judicial propriety, especially where witchcraft accusations were concerned. The common view that witchcraft was more pagan superstition and ignorance than diabolical apostasy – a view having its roots in the ninth-century *Canon episcopi* – was coupled with the rare use of torture, central control and assigning little weight to the denunciations made by accused witches. The 'Instructio pro formandis processibus in causis strigum, sortilegiorum, at maleficiorum' has been called the 'fullest and most eloquent expression' of this responsible attitude.[14] It was circulated first in manuscript form among the provincial tribunals of the Inquisition (in Italy and abroad) before appearing in print, first in the second edition of Eliseo Masini's *Sacro Arsenale* (1625) and later in appendix to Cesare Carena's *Tractatus de Officio Sanctissimae Inquisitionis* (the Cremona edition of 1655). When it was finally published in Rome as a thin pamphlet in 1657, it was without the references to the illegal meddling of secular magistrates. As Tedeschi suggests, this may have been done in order to avoid compounding the conflict with the secular courts, which were at this time accusing the Holy Office of being lax in the prosecution of witchcraft, contesting its jurisdiction and augmenting the severity of their own procedures.[15]

Yet the 'Instructio' reflected longstanding inquisitorial practice, preceding its first citation in a 1624 letter written by Cardinal Giovanni Garcia Millini, a senior cardinal of the Holy Office, to the Bishop of Lodi in response to procedural questions. It seems to have been meant to check the severity and haste of the courts caused in part by the *Malleus maleficarum*, counselling care in gathering evidence, in particular before imprisoning, torturing or handing a suspect over to the Holy Office.[16] In 1626 the Cardinal wrote to the apostolic nuncio of Florence, advising him that matters of witchcraft were 'most fallacious and, as daily experience shows, much greater in men's apprehension than in the reality of occurrences – each disease, the cause of which is not immediately discovered or an efficacious remedy found, being much too facilely reduced to sorcery.'[17] The letter-writing activity of Cardinal Millini testifies to the centralising concern of the Holy Office in maintaining the judicial propriety of its provincial branches, especially where it operated through the episcopal courts, as in the Kingdom of Naples. For instance, in response to a query of 1620 regarding the difficult and inconclusive case of a man suspected of

causing several deaths by sorcery, the Cardinal – somewhat patronisingly – advised the Bishop of Gallipoli, Vincenzo Capece, that there was not enough evidence against him to interest the Holy Office, but that the bishop should none the less continue with the case.[18] The cardinal inquisitors never passed sentence on a case sent to them unless they were convinced that they possessed all the facts of the case, including any extenuating circumstances.[19] There are many letters like the above one, almost sarcastic in tone, in which they responded to endless queries on procedure or advice on sentencing by instructing local officials what was routine business and what was not. At the same time, this exchange is an indication of the centralising concern of the Roman Inquisition. This same concern is manifest in the many sentences sent to Rome by local inquisitions for confirmation or revision. For instance, in the two years 1580 and 1582, 225 sentences were sent, thirteen of them from dioceses in the Kingdom of Naples, including eight from the tiny Otrantine diocese of Castro, primarily regarding cases for *maleficium*.[20] This high proportion of sentences sent by the bishop of Castro may, in fact, reflect the presence of particularly difficult cases in the diocese for these two years, or the very cautious and painstaking procedure of the court, or the inability and unpreparedness of the local curia to try crimes of this sort and its insecurity in reaching a verdict.

The increasing activity of the ecclesiastical courts in the decades following the Council of Trent does not alone suffice to account for the number of accusations made before it. As we have had occasion to observe in previous chapters, most of the cases for 'magic and superstition' were initiated from below. What led neighbours to accuse a woman (usually) of sorcery, as opposed to merely accepting or tolerating her ambiguous role as village wise woman, realising that someone who could heal could also harm? It has been suggested that in taking the *magare* to court, the accusers may have been dealing with illicit magic in the way they thought would be most effective, especially as a last resort. But what about the accusation of 'witchcraft'? How does this more specific accusation fit into the general scenario, and how do accusations in the Terra d'Otranto compare with findings for other parts of Europe?

MALEFICIUM AND ACCUSATIONS OF DIABOLICAL WITCHCRAFT

Because the charge of diabolical witchcraft was based on a criminalisation of a set of magical activities, suspects were not selected at random, but generally had a prior reputation for *maleficium*, based on the recognition of a series of more or less public 'performances': blessings, incantations,

curses and manipulations. As a result, various levels of labelling were employed by neighbours which, depending on other factors, might or might not result in a formal accusation before the court.[21] This seems to have been true throughout Europe, independently of whether the accusations culminated in a large-scale witch-hunt. Because witchcraft was essentially an imagined crime, the initial stages of accusation and prosecution are thus the most important in attempting to determine the contributing factors, with the result that a qualitative study of the trial records is potentially more revealing than a quantitative one. Furthermore, the trial records do not always give us the information we need (such as age, marital status, occupation, dealings with neighbours), so that our interpretation of the social dynamics leading to accusations must be based on a relatively small sample.[22]

Richard Kieckhefer has suggested that there are four different classes of trial document which the historian of witchcraft must take into consideration.[23] They vary in their level of 'reliability' as a source for determining actual belief and practice according to their origin. Thus the most valuable are those trials which begin with the original 'spontaneous' depositions of witnesses or charges of defamation. These are followed by trials which although initiated by a judge or prosecutor, seem to be free of learned influence. Less reliable still are those trials which show signs of judicial coercion and may contain information deriving from representatives of the intellectual élites. Finally, those trials containing charges of diabolism are the least reliable, because of obvious meddling from above. One trial can, of course, belong to several types. Frequently the first part of a trial will belong to the first type, only to be transformed into the fourth type toward the end. In this instance, the two sections should be studied separately, paying due attention to the dynamics of the case.

Although Donna Laura de Adamo of Francavilla Fontana was persuaded to make her 1678 denunciation of two *magare* by her confessor, the depositions seem to be free of learned influnce.[24] The denunciation was used to introduce the subject of popular healing rituals. The witnesses in the case linked the practice of sorcery with other negative attributes like prostitution, singling out one of the women, Gratia Gallero, not only as a 'magara e fattucchiara', but a 'public prostitute and loose woman', the object of 'public talk and rumour [which] for many, many years has circulated and circulates among the people of this town'.[25] As far as the Church was concerned, the possession of a bad reputation or 'fame' – the *mala fama* of many Otrantine trial records – was a virtual crime in itself, so that it was almost always mentioned in conjunction with charges of illicit magic.[26] Common too were links with moral shortcomings like 'filthy

behaviour' or religious deviance, like blasphemy or absence from church. But in this trial both *magare* were careful to keep up appearances:

> Sometimes [Gallero testified] when I went to the Madonna di Finemundo I confessed myself and told the confessor that I had made and given salt, blood and enchanted herb; and at Easter I took communion, for fear of being excommunicated. Furthermore I heard mass almost every day, but when the high point of the mass was reached I didn't look at the Host or Chalice directly, but hid, turning my face the other way, because I knew that I was given to the devil and damned. When I recited the rosary sometimes, I found myself regretting it. I went accompanying the Viaticum and to sermons and other devotions to show that I was a Christian like any other.[27]

It is with the confessions of the two suspects that the trial takes a quantum leap. From the charges of *maleficium* (principally love philtres and ligatures) made by the deponents against the women, we pass suddenly and directly to the Satanic pact, night flight and the witches' sabbath. Their depositions both open with an expression of their desire to save their souls, confess all and be forgiven, after which they succinctly descibe the pact, only commenting on the spells of which they were accused when specifically asked to do so by the court. Clearly there has been some sort of judicial prompting, perhaps in the form of counsel to the defence, but without the supporting documentation we can do no more than hypothesise. Our trial record has now shifted to a 'fourth-class' document! None the less Gallero's account is not bereft of originality. After being taken to the sabbath by the other *magara*, Cinzia Maietta, Gallero saw 'an ugly form of man' seated 'as at court', surrounded by others, 'who resembled the figures of demons painted in the picture and church of St Anthony Abbot in this town'.[28] One wonders if this last parallel was hers. The place where the witches united was the walnut-tree of Sobrino (not the usual one at Benevento), and there she promised herself to the head devil. She was then presented to her personal devil, who went by the all-too-common name of Martiniello, a version of the name frequently applied to familiars in Italy and France.[29] This was followed by the usual dancing and songs blaspheming God and the heavenly host. Then came the feasting, each woman seated beside her own demon. They ate roast meat, without salt, and – according to the path of least resistance mentioned above – 'exactly as we Christians bless the table at the beginning and thank God at the end, so in reverse fashion [*alla roversa*] we cursed and blasphemed God, the Trinity, Father, Son and Holy Spirit, the Madonna and the Saints.'[30] Interestingly enough, the witches of Francavilla who attended 'li balli' were divided into various companies (*squadre*), of which Gallero said Nicodemo Salinaro – the learned magi-

cian whose case was investigated in the previous chapter – was the head. Certainly this was a curious mingling of different levels of society, learned magic and demonology with popular magic.

This connection is explained in part by the fact that Maietta's husband was a potter (she painting the vases he made), and Salinaro had asked him to make special 'magical' vases for his rituals.[31] Maietta's own account of the diabolical pact contains another *topos*, that of poverty. As the trial began she and her husband were living in a rented house, since the one they owned had been taken away from them because of debts. She recounts that several years before, while walking along the road bemoaning her own misery, she called out to the devil for help and he appeared to her in the form of a shepherd, promising riches – promises which were never fulfilled. Despite the importance of the devil in her confession, most of her spells have nothing to do with him, and the court seems primarily concerned with ascertaining if she knows any other *maleficos*. On one occasion, however, she was instructed by her demon to obey the wishes of Giovanni Guisa, who had Maietta, Gallero, Salinaro and a certain Caterina Ciminello assemble together at the Capuchin monastery one night. They were there to punish Fra Giovanni Battista, exorcist, who had allegedly been sent for (by the diocese?) because he was 'experienced in recognising those who have been bewitched', and who they were afraid was aware of Guisa's use of sorcery to cause a man's death. The beating they gave the friar was more on the conventional side, however:

> Together we tormented the said Fra Gio: Battista, who was here to exorcise the said D. Michelino; and we tormented him in this way, that is, the said Gio: Maria [Guisa] held the Capuchin father by his feet, upside down in the air, Nicodemo beat him from behind, la Tauricella [Gallero] pulled him by the sleeves, I by the ears, and the said Caterina beat him on the arms.[32]

Not exactly the stuff of which demonological treatises were made, and yet we must still account for the various witchcraft motifs. In the previous chapter the social tensions which resulted in the accusation and prosecution of suspected *magare* were discussed. The sorcery they were seen to perform was believed to bring about real results, whereas witchcraft existed totally in the mind. The role of the Church, as well as the 'monkish fantasies' of inquisitors and demonologists, is clear even in areas like the Terra d'Otranto where there were no witch-hunts. It was not for lack of effort. An ecclesiastic of Latiano unofficially examined several women who, he affirmed, had confessed to the Satanic pact and numerous acts of sorcery, resulting in deaths. Convinced of their guilt, he wrote to the bishop of Oria, asking him to conduct an investigation and 'make them

abjure publicly and express detestation of their errors'. The bishop should then decide whether to have a public confession and release them, or have the Holy Office pass them over to the secular arm which, he admits, might take a while because of the slow pace at which the Holy Office operates (suggesting that he thought it was overly careful in its procedures). Since the missive lacks both date and signatory, the Holy Office may have been right in regarding the activities of the local episcopal courts with some suspicion.[33] None the less, it reveals the hatred which at least some ecclesiastics bore towards suspected witches, and the possibility that the greater severity of the secular courts better reflected the more widespread hatred of witches.

Spared the religious uncertainties of the northern European confessional conflicts[34] and not as affected by the social and economic change which increased village tensions elsewhere[35], both of which have been identified as factors leading to the rise in witch trials, only three accusations in the diocese of Oria *began* with a charge of witchcraft. It is now a matter of accounting for these. What made the demonology of the judges acceptable both to those who made the accusations and those who 'spontaneously' confessed?

WITCHCRAFT AND POPULAR CULTURE

On the one hand, we should not ignore the possible contributions of traditional folk culture, elusive though it often is. Belief in night-flying witches existed in parts of Germany as far back as the eleventh century, and diabolical evidence emerges in trials before its codification by demonologists, theologians and lawyers.[36] In this regard, anthropologists have found two sorts or levels of belief: first, a widespread belief in malefice, and second, a belief in the night 'witch', who flies through the air and assembles for cannibalistic feasts. The former belief is concerned with and present in daily life, while the latter, less commonly found, represents communal fears and fantasies. Research in modern-day Greece – where the diabolising of traditional beliefs typical of western Christianity did not take place – has explored narratives which deal with a whole host of spirits, demons and fairies, like the *exotika* and the nereids. The latter, for example, are beautiful female spirits who tempt, trick and harm men, and form 'a dancing, naked, ecstatic community of the night, musical and wild'.[37] Similar beliefs existed both in Graeco-Roman antiquity and among the pre-Christian Germanic and Celtic peoples, surviving into the Middle Ages, before being interpreted by medieval inquisitors in terms of Satan-worship.[38]

The mythical dimension of the sabbath stereotype was such a success, as

Carlo Ginzburg has suggested, 'because it embodied in a perverted form the structure of an ancient myth, deeply rooted in the folklore of various parts of Europe'.[39] Beginning with fourteenth-century French trials against lepers and Jews, the Satanic attributes were then transferred to those myths regarding communication with the dead or battle against evil spirits to ensure the fertility of the crops.[40] The inquisitorial view could then be extended outside the original areas through the use of torture and other physical and psychological pressures, facilitated by periods of religious or socio-economic crisis.

In this respect, witchcraft accusations and confessions represent the interaction between the beliefs of judges and inquisitors on the one hand and popular beliefs in *maleficium* on the other, and their content may vary according to the integration of local belief systems – and their symbolic representations of the sacred – into the wider uniform system of the sabbath (and all its implications).[41] At the level of popular culture, people were concerned with the *effects* of a cunning woman's maleficent power – attempting to evade or neutralise it – rather than with its practical origins. But when accusing a suspect before the episcopal tribunal they came into contact with an institution which operated within a different framework. For this reason, the trials often consist of several different levels of discourse, as mentioned above. Of course, it is all but impossible to retrieve the local belief system in its pure state, but important elements can be recovered without the historian revealing too many of his own assumptions in the process.

In the footsteps of Ginzburg, Gustav Henningsen has explored the Sicilian fairy cult of the *donni di fuora* (literally, the 'women from outside', as in the Greek *exotika*) using a series of trial summaries sent between 1547 and 1701 by the Sicilian office of the Spanish Inquisition to the archives of *la Suprema* in Spain. Before being transformed into stereotypical witches by the inquisitors, the *donni* were believed to perform good deeds, healing people, assisting them in their spinning and other tasks and helping them find hidden treasure. Among those accused, Henningsen found no persons of wealth. Where financial status could be determined, they were poor women. This led him to describe the cult as a 'daydream religion that allowed poor people to experience in dreams and visions all the splendours denied them in real life'.[42] This suggestion is an important clue in understanding such beliefs, including the role of the pact with Satan in witchcraft accusations and confessions in the Terra d'Otranto and elsewhere, which we shall be discussing below.

THE DEVIL: TEMPTATIONS AND NARRATIVES

Of course, the standard explanation favoured by demonologists for women's attraction to the devil was their insatiable lust. In a case of demonic obsession discussed in chapter four, Maria Salinaro described the devil as a 'handsome young man' with whom she had often 'had sex for several hours, even through the posterior part'.[43] In another confession three years later she stated that she had made her original pact with the devil 'for the convenience of being able to give vent to my wild desires [*sfrenate voglie*] in the vice of dishonesty that had become my habit'.[44] And in 1704 a forty-five year-old widow, Antonia Donatino, confessed to making a pact with the devil, who visited her while she was in bed, making love to her for more than half an hour, and 'he left me so tired, and almost dead'.[45]

Why all this sex? G.R. Quaife has recently suggested that not only did such confessions reflect the misogynistic theories of demonologists, they also reflected the unsatisfied sexual needs of women. Noting that few male peasants seem to have engaged in fore- and after-play, Satan 'brought pleasure into the dull lives of disturbed, bored and frustrated women, even if only in the imagination'.[46] Such fantasies, he concludes, could result from an absence of sexual activity, severe depression (following a husband's death, for example) or advanced senility. Then again, it may also have been a case of the suspected women telling the inquisitors what they thought they wanted to hear, given their wish to escape punishment and given the lack of pleasure they seem to have derived from such relations. The rather uninhibited accounts of sexual relations may also reflect the strong physical component present in popular magic as well.[47] In any case it would be wrong to make too much of it. As Mircea Eliade has remarked, rural populations are only moderately interested in sex, and the witches sought other goals than the simple gratification of lust.[48]

Taken in context, it would seem that the sexual fantasies express a desire on the part of the women to transmute their own condition. Significantly, the devil offers all sorts of things, such as money and magical powders. The victims of these temptations were almost always poor, helpless women, and the devil's promises were closely related to their plight, giving us little reason to doubt the reality of such fantasies.[49] Antonia Donatino admitted to making her pact with the devil because of his promise to take care of a meddling ex-lover of hers.[50] More common was the hoped-for satisfaction of economic needs, not unusual considering that many accused witches were weak an helpless, with no other means of power or influence. Such was the case of the peasant Rosa Tardea who lamented 'that the more she toiled, the poorer she saw herself get'. She was one of

Maria Salinaro's 'disciples', an indication that Salinaro really believed her obsession and counselled the devil's help to others. Alternatively, she may have been so anxious to confess that she listed her 'disciples' to please the court. Another woman she claimed to have converted to the devil was Francesca Antonia di Toripietto, married to a poor peasant. As the devil had helped Salinaro, Salinaro advised di Toripietto that 'if she wanted to be well, and be supported and helped, it would be good to call the devil for help'.[51] She must have so advised the entire neighbourhood, for she listed twenty-one other 'disciples', none of whom were interrogated by the episcopal court. Perhaps her previous confessions had stretched the court's patience and credulity to the limit, for by 1741 the intellectual climate regarding witches was changing.

Temptations could also be induced by religious fear and despair, such as the lack of hope in salvation. It tells us something of the nature of religious instruction – and perhaps of the ability of oral culture to shift orthodox beliefs to suit its own psychological needs – that the devil frequently promised to pay women's debts and lead them into Heaven. Antonia Donatino confessed that the devil appeared to her and said, 'I am your Angel and I've come here to grant you Paradise'. He returned often with the same promise, and told her (and this is the strange part) that she must recite the rosary, give alms to the poor and fast on Saturdays![52] When Leonarda Mingolla was asked by a somewhat doubting court what prayers her devil had her recite, she replied: 'I worship you, oh lord and devil, attend to my soul'.[53] How can this confusion of divine and diabolical be explained?

In a 1519 case examined by Carlo Ginzburg, a suspected sorceress described two similar visions, one of the Virgin Mary and one of the devil, both of which were coming to her aid. For the inquisitor the vision of Mary must therefore have been a result of the devil's trickery, whereas for the suspect both were equally real. According to the popular conception of the sacred, both the devil and the saints of Heaven could give succour in time of need. In Ginzburg's words, 'divinity, as Chiara [the suspect] can understand and venerate it, is a divinity which intervenes to draw her from her misery, first casting a spell on her landlords who have put her out, then healing them so that she may return to her land: and it matters not whether a celestial or diabolical divinity is involved'.[54]

As we have had occasion to observe with regard to lay visions, the Church – as part of its attempt to define and control the sacred – sought to impose a distinction between divine and diabolical visions, thereby acknowledging the similarity of forms they could take. A woman of Vicenza was returning home one evening in 1560, giving vent to her anguish and

misery, and 'grieving over and lamenting with mournful voice the heavy burden of [her] children without any means of providing for their needs', when she heard a voice calling her. She turned about and 'saw a woman dressed in white like a nun's habit who tried to console her with comforting words, and she revealed herself to be the blessed Mary of God and Queen of Heaven the Virgin Mary'. Perhaps because of its resemblance to many a devilish temptation, the Inquisitor-General in Rome, Cardinal Michele Ghisleri, declared the vision a 'diabolical illusion'.[55]

Yet the whole historical period was fraught with ambiguity, for the years of diabolical temptation were also those of the great mystical ecstasies of the baroque saints. The language and experience of both was remarkably similar. According to Fulvio Salimbeni, 'if the witches lie prostrate and exhausted when the devil has visited with them, the female mystics confess to an ineffable sweetness and a state of complete languor when Jesus visits them'.[56] The seventeenth-century mystics sought *anéantissement* (loss of self) before God, as a prelude to spiritual union: a kind of 'life in death' which left them physically drained.[57] Compare this with Antonia Donatino's words describing her relations with the devil, cited at the beginning of this section. The ambiguity is similar to that which existed between the recognised visions of canonised saints (or those about to be), and the visions – considered diabolical and heretical – of those not accepted into sainthood. Operating more often on a basis of shame than of violence, the authorities were determined to control the autonomous figures of sorceress and 'priestess' (the pseudo-saints examined by the Church). As far as the Inquisition was concerned both they and the witches were misled by the devil, the 'Father of lies'.

This ambivalence may be explained by the fact that in popular culture the devil, rather than being the personification of evil, had more the semblance of a demon. And in the confessions he appears 'more as a legendary figure of folklore than as the master of a demonic cult'.[58] Otherwise powerless women could boast to their neighbours of relations with 'their' devil as a means of acquiring respect, as a forty-five-year-old *donna di fuora* who confessed 'that sometimes to please her listeners she had told them things that she had neither seen nor had any knowledge of'.[59]

Some of the narratives have a distinctly folktale-like quality. In 1745, on the advice of Abbot Filippo Coccioli, Giacomo Carrozzo denounced Antonia Macarella for relations with the devil, based on what she had revealed to him (Carrozzo) in a conversation.[60] Macarella told him that one day she was walking outside the town when someone called out to her. She immdiately thought it was Vito Braccio, with whom she had had an

affair, but who had since broken off relations, leaving her despondent. So she responded irately: 'what the devil do you want?' The voice asked in reply: 'Don't you recognise me, since I'm the devil, your friend?' After he had identified himself – appearing, as usual, in time of crisis – Macarella recounted that the devil bade her to follow him, leading her to a 'certain place, where he made the earth open up' and they went inside.

The devil (like some fairy-tale ogre) told her to wait there until he returned, adding that the treasure she saw about her was hers. Going deeper inside, Macarella found three mounds of gold and silver, and she put them in a sack, hoping to carry them off. But realising that she could not locate the way out of the cave, and looking about in dismay, she saw an image of the Virgin Mary, 'with such large eyes', and another one facing in, frightful in appearance, 'with such wretched hair, that is, dishevelled'. The latter image warned her that she would not be able to leave unless she took all of the treasure, a truly herculean task. At this point she grew afraid and, dropping the riches she was carrying, found the exit and quickly returned home and went to bed. That night the devil visited her, and she explained her plight, but fearing the reaction of her husband sleeping in bed beside her, told the devil to return another time.

Two features of this narrative are particularly striking. Firstly, the accuser's obvious belief in it, since it forms the principal evidence against Macarella – or at least the possibility that he thought the court might believe it. Secondly, its resemblance to a folktale is intriguing, right down to the motifs traceable in Aarne-Thompson's classification of types, with relevant Italian examples.[61] For example, the causing of the earth to open up is similar to type no. 676 ('Open Sesame'), while the time spent in the cave resembles type no. 313, in particular 313G ('flight from giant's cave'), and the motif G465 (where the hero is promised to the Ogre, led to his dwelling, assigned an impossible task – such as removing a mountain or mound in one night (H1101) – and is helped to escape by a magical object). The two images of the Virgin reflect type no. 706A ('Help of the Virgin's statue').[62] Although the absence of sufficient data makes it difficult to historicise the various elements of such tales, the devil is here portrayed more as a mischievous sprite – the *scazzamurello* – whom the hero always manages to outwit, than as the prince of darkness.[63] Tales of the duped devil were most likely derived from the folklore about stupid trolls and giants and, according to J.B. Russell, reflected the resentment that the humble felt for the powerful.[64]

Perhaps it is in the nature of the folktale to minimise the threat in order to entertain and strengthen the sense of community security by relieving tension and fear, for even the few Salentine tales about witches lack any

sense of urgency. Thus a tale entitled 'Zio Gilletto' (Uncle Gilletto), where the witches' sabbath becomes a *divertimento* in the Land of Cockaigne.[65] On the other hand, the urgency we do find in the actual witchcraft accusations and confessions seems to be buttressed by motifs shared with the folktale, though they both seem to draw from the same narrative pool. In 1742 Carmina de Tomaso told the court of Oria that she had been threatened by Giustina Quaranta, a known *magara* who was also alleged to bear the devil's mark. On one occasion Quaranta warned de Tomaso that if she did not treat her well she would make her appear ugly and deformed. To demonstrate that this was no empty threat she forced her to look in a mirror, and, to her horror, de Tomaso saw that she was ugly and deformed: 'that in fact it seemed as if I had changed', she told the court. Quaranta then said that if she was treated kindly de Tomaso would be beautiful, 'as in fact at the same time while looking at myself in the said mirror, I saw myself totally different from the way I had seen myself a short time before, and no longer deformed and ugly, but like I am naturally, and this act was repeated quite often.'[66]

Folktales conceptualised how the natural and supernatural were related by means of the narration of a diachronic sequence of concrete events. For this reason, according to Robert Rowland, the readily available folktales were utilised to translate the more abstract notions of the relation between natural and supernatural held by the inquisitors and preachers into a form which made sense at a popular level. Here, evil was represented by wrongdoing and misfortune, manifested in particular events, or a sequence of such events. It was a matter of explaining how the supernatural irrupted into everyday life. Folktale motifs, as an integral part of the belief system, were naturally adopted and utilised in this way in inter-personal contacts at the local level, finding their way from here into witchcraft accusations. Likewise, suspects not only told their judges the élite version, which was the most effective form of confession because it frequently led to acquittal or some light penance; they also 'drew on local folklore in an attempt to satisfy their questioners' demands for a complete account of the significance of their actions'.[67]

It is impossible to underestimate the power and importance of storytelling in traditional society. In this sense it is useful to regard narrative as a social transaction, in which both of the parties involved – narrator and audience – have some interest in participating. This model has the advantage of suggesting that each narrative is the result of a certain set of social conditions and cultural choices. Thus 'any narrator's behavior will be constrained in part by various assumptions he will have made concerning his present or presumed audience's motives for listening to him'.[68] These

dynamics were in play whenever a local *magara* boasted of her powers to her neighbours, or when the same woman – or her neighbours, as witnesses – was obliged to relate and re-articulate the event to men in legal authority.[69] This was a challenge similar to the one faced by the tellers of pardon tales (in the form of letters of remission to the king) in sixteenth-century France, as studied by Natalie Davis. From the telling of the pardon tale, to its transcription by the notary and its approval by the king and the court, there was an exchange and mediation of cultures. As Davis concludes, 'the stakes were different for supplicants, listeners and pardoners, but they were all implicated in a common discourse about violence and its pacification.'[70]

The above discussion of the folktale motifs present in the witchcraft narratives told to the episcopal court of Oria may seem a somewhat tenuous and problematic subject matter for the ethno-historian. Yet I believe they are useful in demonstrating the imposition of learned witchcraft beliefs on to those commonly held about sorcery, and the way in which the unlearned levels of society – given their oral traditions – came to terms with such ideas when confronted with moments of crisis. What is difficult to ascertain is just what practical consequences these motifs had for those relating them. Some folk beliefs were real and immediate, having relevance on to day-to-day affairs, while others were more remote, pertaining to different or undefined realms of time and space, and not directly relevant to daily life.[71] There seems little doubt that they believed what they were confessing. Throughout the trial records the scholar can usually manage to separate popular from learned belief, sorcery from witchcraft, or account for transformations in the latter when taken on by the former. In the same way, it would seem that the devil remained 'un-diabolised' in popular culture: a trickster capable of fulfilling fantasies and even bestowing Paradise to those who call upon him.

JUDICIAL REACTIONS

How did the courts react to this? The answer must be, with scepticism, although the accusations themselves were taken seriously enough. Sorcery, more than witchcraft, seems to have been their primary concern. In 1742 Bishop Labanchi of Oria, writing in support of the episcopal court's jurisdiction over the case against the suspected witch Giustina Quaranta (the secular court was claiming it as its own, witchcraft being a *delictum mixti fori*), made no mention of witchcraft. She was to be prosecuted 'for the many times she had blackmailed people, threatening them with evil if they did not give her the things and money she wanted from them, such

254 Demonic presences and the sacred system

that she had become infamous and kept people almost in dismay.'[72] And if the episcopal prosecutors were still credulous, the representatives of the Holy Office were not, making certain that judicial standards were maintained. In the case against Caterina Patrimia, the court was inclined to believe Patrimia's confession until an inquisitor pointed out that it was impossible to stipulate a pact of ten years' duration with the devil, as Patrimia claimed to have done, after which time she had withdrawn 'to look after the interests of her soul'. According to theologians, the inquisitor declared, the devil always exacted a promise not to return to the Catholic faith.[73] In the context of the inquisitorial 'Instructio' discussed above, the inquisitor's report charged that the trial records were full of legal invalidities: no formal charges had been laid, no statements had been taken other than those of the two suspects, which anyhow lacked their signatures or marks. Furthermore, Patrimia's sin could not have been apostasy since the formal pact with the devil had to be finalised by eleven rites, including the devil's baptism, of which there is no trace; and, he went on, no other documents supported Patrimia's confession that she was a witch. In fact, several priests had even testified as to her Christian behaviour. Because of these points, and the inadequate defence offered the two women by the promotor fiscal, they should be immediately liberated and absolved, the representative of the Holy Office concluded. At this point the trial came to an end.

The last surviving accusation of witchcraft laid before the episcopal court of Oria dates from three years later. As the court had made accusations of magic – beneficent and maleficent – and witchcraft possible, it now rendered them very unlikely. In part the attitudes of the educated levels of the clergy, which provided the judges and prosecutors, were slowly changing. Not that they now denied the possibility of witchcraft: it was more a case of the increasing impossibility of establishing certain proof in particular instances. At the popular level, belief in sorcery continued much as before. And if a belief in witches and the Satanic pact managed to filter down and affect notions of malefice, it had no means of expression, for the courts were increasingly reluctant to regard such accusations seriously.

It would seem that in the Terra d'Otranto witchcraft accusations do not provide the enigma that they do in other European regions. The close relationship of witchcraft to maleficium is clear, as is the role of demonologists and inquisitors in gradually diabolising aspects of popular belief, though without the impact made elsewhere. When the devil does make an appearance, it is not usually as the personification of evil, but as the trickster of folklore. Or he may appear in visions as the bestower of

favours, in which guise the ambivalence between divine and diabolical sources of power is readily apparent. This ambivalent sense of the sacred is consistent with that manifested in other areas of of the system, such as the pragmatic relationship between popular healing rituals and sacramental remedies. It was this ambiguity that the Church had sought to counter following the Council of Trent, as it attempted to define, regulate and reform access to and attitudes towards the sacred.

NOTES

1 I shall be focusing exclusively on the activities of the province's episcopal tribunals. The low survival rate of trial records from the secular courts of the Kingdom of Naples has meant that little work has been done on their activities with regard to witchcraft. An earlier version of this chapter was presented at the Italo-Canadian Conference on 'Norm, precept and social reality in the late Middle Ages' (Ottawa, 1990).

2 Ricardo García Cárcel, 'La stregoneria in Europa', in N. Tranfaglia and L. Firpo, eds. *La Storia: I grandi problemi dal Medioevo all'Età Contemporanea*, IV: *L'Età moderna (2): La vita religiosa e la cultura* (Turin, 1986), 443.

3 Brian Levack, *The Witch-Hunt in Early Modern Europe* (London, 1987), 202.

4 Cf. Peter Burke, 'Witchcraft and magic in Renaissance Italy: Gianfrancesco Pico and his *Strix*', in S. Anglo, ed. *The Damned Art: Essays in Literature and Witchcraft* (London, 1977), 32–52.

5 Ibid., 40.

6 Cf. Stuart Clark, 'Inversion, misrule and the meaning of witchcraft', *Past and Present*, 87 (May 1980), 98–127.

7 Julio Caro Baroja, *The World of the Witches*, trans. N. Glendinning (London, 1964), 104.

8 Guazzo's *Compendium maleficarum* was published in 1625. Cf. S. Abbiati, A. Agnoletto and M.R. Lazzati, eds. *La stregoneria: Diavoli, streghe, inquisitori dal Trecento al Settecento* (Milan, 1984), 276–7 and 279.

9 For his activity as an inquisitor, see M. Bertolotti, 'Le ossa e la pelle dei buoi: un mito popolare tra agiografia e stregoneria', *Quaderni storici*, XIV (1979), 470–99.

10 John Bossy, *Christianity in the West, 1400–1700* (Oxford, 1985), 78.

11 Christina Larner, 'Crimen exceptum? The crime of witchcraft in Europe', in V.A.C. Gatrell, et al. *Crime and the Law: The Social History of Crime in Western Europe since 1500* (London, 1980), 69.

12 Cf. Bossy, *Christianity*, 139.

13 William Monter and John Tedeschi, 'Toward a statistical profile of the Italian Inquisitions, sixteenth to eighteenth centuries', in G. Henningsen and J. Tedeschi, eds. *The Inquisition in Early Modern Europe: Studies on Sources and Methods* (Dekalb, 1986), 146.

14 John Tedeschi, 'The Roman Inquisition and witchcraft: an early seventeenth-century "Instruction" on correct trial procedure', *Revue de l'Histoire des Religions*, CC (1983), 188.

15 Ibid., p, 176.

16 Giuseppe Bonomo, *Caccia alle streghe: La credenza nelle streghe dal sec. XIII al XIX con particolare riferimento all'Italia* (Palermo, 1959), 295–7.

17 Millini's letter was accompanied by a copy of the 'Instructio'. Cf. M. Battistini, 'Una lettera del Cardinale Millini riguarda a un processo di stregoneria', *Rivista della storia della Chiesa in Italia*, X (1956), 269–70.

18 Letter from Cardinal Millini to Bishop Capece, no date, 'Processo di furto comesso nella casa di D. Giuseppe d'Acugna da Paduano Tundo', 1620, A.C.V.G., *Processi penali*, no. 413.

19 John Tedeschi, 'Inquisitorial law and the witch', in B. Ankarloo and G. Henningsen, eds. *Early Modern European Witchcraft: Centres and Peripheries* (Oxford, 1989), 114.

20 The sentences are part of the dispersed papers preserved at Trinity College, Dublin, Ms. 1225 and 1226; cit. in Monter and Tedeschi, 'Satistical profile', 139.

21 Larner, 'Crimen exceptum', 52.

22 Cf. Levack, *Witch-Hunt*, 117.

23 Richard Kieckhefer, *European Witch Trials: Their Foundations in Popular and Learned Culture, 1300–1500* (London, 1976), 45.

24 Contained in 'Contro Nicodemo Salinaro per sortilegi', 16 July 1678, Francavilla, A.D.O., *Magia e stregoneria*, III, fols. 12r–14r.

25 Deposition of Giovanna Mottisi, fol. 17v, and deposition of D. Giuseppe Carlo Meo, fol. 26v in ibid.

26 The phrase 'common whore and witch' was also used in the same way throughout England, according to Alan Macfarlane, *Witchcraft in Tudor and Stuart England: A regional and comparative study* (London, 1970), 277–9.

27 Deposition of Gratia Gallero, 'Contro Nicodemo Salinaro', fol. 35v. The 'Madonna di Finemundo' is a shrine located at Leuca, on the tip of the Salentine peninsula.

28 Ibid., fol. 29v.

29 According to Giuseppe Bonomo the name Martin was frequently applied to billy-goats (perhaps in reference to Martin of Tours, protector of cuckolds), which the devils closely resembled, according to demonological works. Bonomo, *Caccia*, 332 and 335–6.

30 Deposition of Gratia Gallero, 'Contro Nicodemo Salinaro', fol. 29v.

31 Deposition of Giovanni Leonardo Centonze, ibid., fol. 59r.

32 Second deposition of Cinzia Maietta, ibid., fol. 43v. The Capuchin friar and exorcist does not appear to be involved in the case agsint Gratia Gallero, Cinzia Maietta and Nicodemo Salinaro.

33 'Contro varie donne per magia e pratica col diavolo', no date, Latiano, A.D.O., *Magia*, I.

34 Jean Delumeau, *La Peur en Occident (XIVe – XVIIIe siècles): Une cité assiégée* (Paris, 1978), 375.

35 Keith Thomas, *Religion and the Decline of Magic* (Harmondsworth, 1973 edn.), 669–75. For a French example, see Robert Muchembled, 'The witches of the Cambrésis: the acculturation of the rural world in the sixteenth and seventeenth centuries', in J. Obelkevich, ed. *Religion and the People, 800–1700* (Chapel Hill, 1979), especially 259–63.

36 Larner, 'Crimen exceptum', 65.

37 Richard and Eva Blum, *The Dangerous Hour: The Lore of Crisis and Mystery in Rural Greece* (London, 1970), 218–19. The authors suggest that women narrate accounts of the nereids as a way of keeping men in line; it also offers a harmless means of expressing the dream-like 'antithesis of the marital state'.

38 Norman Cohn, 'The myth of Satan and his human servants', in M. Douglas, ed. *Witchcraft Confessions and Accusations* (London, 1970: A.S.A. Monograph 9), 11. Cf. by the same author, *Europe's Inner Demons* (London, 1975).

39 Carlo Ginzburg, 'The witches' sabbat: popular cult or inquisitorial stereotype?', in S. Kaplan, ed. *Understanding Popular Culture* (Berlin, 1984), 45–6.

40 Cf. Carlo Ginzburg, *I benandanti* (Turin, 1966); translated as *The Night Battles:*

Witchcraft and Agrarian Cults in the Sixteenth and Seventeenth Centuries, trans. John and Ann Tedeschi (London, 1983).

41 Cf. Robert Rowland, '"Fantasticall and devilishe persons": European witch-beliefs in comparative perspective', in Ankarloo and Henningsen, eds. *Early Modern European Witchcraft*, especially 178–89.

42 Gustav Henningsen, '"The Ladies from Outside": an archaic pattern of the witches' sabbath', in ibid., 200.

43 'Suor Maria Caterina Salinaro confessa di aver fatto un patto col diavolo', 18 April 1738, Francavilla, A.D.O., *Magia*, II.

44 'Maria Salinaro confessa di aver fatto un patto col diavolo', 18 February 1741, Francavilla, A.D.O., *Magia*, II.

45 Confession of Antonia Donatino, 'Contro Caterina Patrimia per stregoneria e patto col diavolo', 14 August 1704, Francavilla, A.D.O., *Magia*, I.

46 G.R. Quaife, *Godly Zeal and Furious Rage: The Witch in Early Modern Europe* (London, 1987), 99–102.

47 Cf. Luisa Accati, 'Lo spirito della fornicazione: virtù dell'anima e virtù del corpo in Friuli fra '600 e '700', *Quaderni storici*, XIV (1979), in particular 655–8.

48 Mircea Eliade, 'Some observations on European witchcraft', in his *Occultism, Witchcraft and Cultural Fashions* (Chicago, 1976), 91.

49 Thomas, *Religion*, 621–8.

50 Confession of Antonia Donatino, in 'Contro Caterina Patrimia per stregoneria e patto col diavolo', 14 August 1704, Francavilla, A.D.O., *Magia*, I.

51 'Maria Caterina Salinaro confessa', 18 February 1741, Francavilla, A.D.O., *Magia*, II.

52 Confession of Antonia Donatino, 'Contro Caterina Patrimia per stregoneria e patto col diavolo'.

53 'Contra Narda Mingolla (per magia)', 21 September 1722, Latiano, A.D.O., *Magia*, II.

54 Carlo Ginzburg, 'Stregoneria e pietà popolare: Note a proposito di un processo modenese del 1519', in *Miti, emblemi, spie: Morfologia e storia* (Turin, 1986), 17.

55 From the *Ragionamento del Rever. P.F. Pietro Martire Gattino di Vicenza dell'ordine di s. Domenico...nel caso della visione veduta fuor della porta di santo Lazzaro* (Bologna, 1561), fol. 5r; cit. in Adriano Prosperi, 'Madonne di città e madonne di campagna: Per un'inchiesta sulle dinamiche del sacro nell'Italia post-Tridentina', in S. Boesch Gajano and L. Sebastiani, eds. *Culto dei santi, istituzioni e classi sociali in età preindustriale* (Rome–Aquila, 1984), 624.

56 Fulvio Salimbeni, 'La stregoneria nel tardo Rinascimento', *Nuova rivista storica*, LX (1976), 321.

57 Mino Bergamo, 'La passione della perdita', in his *La scienza dei santi* (Florence, 1984), 11.

58 Kieckhefer, *Witch Trials*, 36. While in northern Europe this applies principally to the earlier trials, in the Terra d'Otranto – if the Oria records are anything to go by – the narratives were never completely diabolised.

59 Department of the Inquisition, Archivo Histórico Nacional, Madrid, Libro 900, fol. 522r; cit. in Henningsen, 'Ladies from Outside', 198.

60 Declaration of Giacomo di Cataldo Carrozzo, 'Denuncia contro Antonia Macarella per aver avuto rapporti col diavolo', 29 December 1745, Erchie, A.D.O., *Magia*, II.

61 Antti Aarne and Stith Thompson, *The Types of the Folktale: A Classification and Bibliography* (FF Communication 104, Helsinki, 1961, second edn.). For a further discussion of the type, see Vladimir Propp, *Morphology of the Folktale* (Austin, 1968), chapter three.

62 For the motif of the mounds of gold and silver which the hero is prevented from taking by Fortune, see the Salentine tale 'La vita non è sogno' (Life isn't a dream), in Giovanni

Battista Bronzini, ed. *Fiabe pugliesi* (Milan, 1983), 75–6.

63 Cf. in ibid. 'Il diavolo beffato' (The mocked devil), 162–3, and 'La Vergine strappa due anime al diavolo' (The Virgin snatches two souls from the devil), 167–8.

64 Jeffrey Burton Russell, *Lucifer: The Devil in the Middle Ages* (Ithaca, 1984), 76.

65 In a somewhat literary translation by Giuseppe Gigli, *Superstizioni, pregiudizi e tradizioni in Terra d'Otranto* (Florence, 1893), 247–59.

66 Deposition of Caterina de Tomaso, 'Contro Giustina Quaranta per magia', 5 July 1742, Oria, A.D.O., *Magia*, II. Her narrative is reminiscent of the Snow White tale type, particularly no. 709B, 'A magic mirror tells her stepmother that Snow White is more beautiful than she'.

67 Rowland, 'Fantasticall', 181.

68 Barbara Hernstein Smith, 'Narrative versions, narrative theories', *Critical Inquiry*, VII (1980), 234.

69 For narrative and the law, see Victor Turner, 'Social dramas and stories about them', in *Critical Inquiry*, VII (1980), especially 155–8.

70 Natalie Z. Davis, *Fiction in the Archives: Pardon Tales and their Tellers in Sixteenth-Century France* (Cambridge, 1987), 112.

71 Kieckhefer, *Witch Trials*, 40.

72 Note from Bishop Labanchi to V[ostro] S[ignor] Pacio, no date, 'Contro Giustina Quaranta per magia'.

73 'Notula pro Caterina Patrimia et Rosa Lombardi contra Pretensum per Rev. Fiscali Promotorem', in 'Contro Caterina Patrimia per stregoneria e patto col diavolo', 14 August 1704, Francavilla, A.D.O., *Magia*, I. In the popular conception, at least, a pact with the devil would seem to function in a way similar to the contractual relationship between saint and devotee as explored in chapter 6.

Concluding remarks

In the preceding chapters I have sought to reconstruct the sacred system of early modern Terra d'Otranto, which I hope will serve as a model for other areas on the 'periphery' of Catholic Europe. By way of conclusion I shall briefly summarise the constituent features of this model.

The sacred system served as a response to the existential needs of this essentially agricultural society, providing protection against the vagaries of the weather, the irruption of disease into everyday life and other misfortunes constantly threatening the order which man attempted to impose on the cosmos. For this reason, its most fundamental components were those rituals meant to respond to the 'extraordinary' by addressing the power of the supernatural. The sacraments of the Catholic Church were undoubtedly important, for they too made possible access to the sacred, especially those relating to the biological rites of passage. The rituals of baptism and extreme unction were accompanied by popular twists and interpretations. But the rituals that most fit the everyday needs of the faithful were of a more *ad hoc*, spontaneous kind, whether of ecclesiastical or folkloric origin. In this way, Church sacramentals and ecclesiastical 'medicines' – prayer, rosary, pilgrimage, procession, blessing, exorcism, and so on – mingled with popular conjurations, invocations and ritual cures.

They were more than parallel systems, for they interacted and borrowed from one another. It is, therefore, often difficult to clearly distinguish between what is of 'official' and what is of 'popular' origin. In terms of participation, everyone belonged to and utilised the orthodox religion of the Church, though not necessarily to the same degree. At the same time, many clerics made use of lay, popular rituals, generally condemned by the Church hierarchy as 'superstitions'. When someone was taken ill, the victim of a neighbour's sorcery (say), that patient could seek confirmation of the malady's origin and a cure through a pool of ritual remedies, some clerical and some lay, pragmatically trying one then another until a cure (or death) resulted. Often what determined the type of 'healer' consulted – wise woman, priest, exorcist, physician – was a question of availability, accessibility and reputation, despite the Church's attempts to convince the faithful that only it was equipped to deal with diseases of maleficial origin.

Clerical and lay spheres overlapped in more fundamental ways. Impor-
tant for both was the sense of touch, physical contact, which formed a
language of gesture.[1] Touching 'the saint' (that is, in the form of his or her
relics) or being touched by a holy man or woman was analogous to the
healing touch of the wise woman, for they provided a means of transmit-
ting sacred, otherworldly power to this world in time of need. Making the
sign of the cross, kissing a relic and genuflecting – to say nothing of the
many acts of penance and self-debasement (like the *strascino*, licking the
ground on approach to the altar of a shrine) – are examples of where
orthodox clerical culture and lay, popular culture meet with perfect ease
and harmony. But, as often happens, the former may move on, and ritual
actions which it once encouraged may later be proscribed. For example,
the macabre penitential processions, the *strascino* and the blessed *abitini di
Maria* (worn as protective amulets) were all fostered by missionary activ-
ity, found their way into local religiosity, only to be looked down upon by
learned circles, clerical and lay, beginning in the mid eighteenth century.
None the less they continued to form an important part of popular culture
into the second half of the present century. Likewise, the adjective so often
used by the authorities to describe and condemn unorthodox ritual activi-
ties – superstitious – undergoes a transformation during the early modern
period: from an activity believed to acquire its efficacy through the
intervention of diabolical forces, to one which is vain and irrational.

In other important ways local expressions and interpretations of the
sacred found their way up and were accepted by the Church. One such
possibility, though increasingly regulated by the Church after Trent, was
the veneration of a local holy man or woman, proposed to the ecclesiastical
authorities as saintly. Where the laity and some local clergy saw life-saving
miracles at the hands of such 'saints', the Church often saw the work of the
devil. The Church's reluctance to canonise such people, especially when
they failed to meet its own rigorous saint-making criteria, exemplifies the
often strained relationships between centre and periphery. Local religiosity
was more successful regarding the proposal of Marian shrines, based on
the discovery of miraculous images, told through the mythical and often
atemporal *inventio* narratives. They represent the need for a sacred pres-
ence not satisfied by organised ecclesial structures, particularly in the
countryside. While the Church did not feel bound to accept the miracles
and visions of presumed saints, it was apparently only too ready to accept
the *fait accompli* of a miraculous image, in part because any sacred
representation was already worthy of veneration of its own accord.

For the laity, and some clergy, the saint – like the wise woman – was an
ambivalent, unpredictable being, capable of healing as well as harming. If

the saint caused harm, for instance by sending the malady of which he or she was patron, it was not necessarily because the devotee had sinned. More probably it was because the saint had been offended in some way by something the devotee had done or failed to do.

As there was no notion of sin in the relationship between saint and devotee, since the saints were not considered confessors or judges, so the idea of a devil who was all-evil and the cause of sin in the world was slow to take root. Despite frequent preaching on the subject and the activities of the ecclesiastical courts, the devil continued to be seen as the trickster of folklore, though during our period it would seem that the view is more and more relegated to the lower echelons of society. The Church was thus at least partially successful in diabolising the notion of wrong behaviour, even if the demonic continued to be utilised as yet another channel to sacred power by both popular and learned forms of magic.

Both of these forms overlapped at the local level, for here learned magic was less interested in experimentation and philosophical speculation than in practical applications like protective and amatory magic, and, above all, treasure-hunting. *Necromanti* possessed written spells to 'obtain grace' and favours in the same way that witches were promised paradise and magical powers by their devils. In fact, the ambivalence of the demonic in our sacred system is most clearly expressed in the local versions of witchcraft and the Satanic pact, which were never completely diabolised and lack the evil, community-threatening element expressed for other areas of (especially northern) Europe.

Archival sources allow us to piece together the sacred system of a locality in its fundamental aspects, but they reveal less about the varying degrees of participation and focus among the different levels of society. However, certain tentative conclusions can be arrived at from our data. In the Terra d'Otranto lay, popular healing rituals belonged essentially to the female domain, in line with the woman's role in caring for the well-being of the household. The same seems to have been true of the related forms of *maleficium* and witchcraft. On the other hand, learned or élite magic was exclusively male, involving both laymen and ecclesiastics. As far as orthodox religion was concerned, if organised forms of devotion, like the confraternities, tended to privilege males with at least a trade or a parcel of land, other forms, like processions and the Forty-hours devotion, involved the entire community. This was supplemented by an ever-evolving pilgrimage network, consisting of a hierarchy of national, regional and local shrines.

The system as we have described it was more or less constant, but it was not immobile. New forms of devotion were periodically introduced,

gained favour and took their place alongside more traditional ritual forms. On the other hand, the Tridentine reforms of the Church aimed at eradicating or christianising what it defined as superstitious or unorthodox had the least impact on the mass of society. Because the basic structures, from agricultural techniques to standards of life, remained basically unchanged during the early modern period, there was no shift away from traditionally held notions of the supernatural. No other 'means of ordering the natural world' was discovered which could replace the need for sacred intervention.[2] Nor was there the radical shift in social attitudes, expectations and behaviour that charactersied the English village of Terling during roughly the same period.[3] Finally, there was little difference between town and country religiosity in the Terra d'Otranto, given the predominance of the peasant agglomerations known as agro-towns and the agricultural structures dominating even the cities.

The temporal story was slightly different – though the difference is one of degree only – for the local aristocracy and nascent bourgeoisie, who had closer links with literate, clerical culture. Learned culture tended to focus increasingly on symbols to interpret the power of the sacred, while the popular continued to stress gestures. Nevertheless, gestures remained important for all elements of society because of their immediate, repetitive, comforting solicitation of the sacred. Towards the end of the period (that is, the second half of the eighteenth century), the piety of the educated classes was becoming somewhat simpler, marked by a sharper distinction between the sacred and the secular and increasingly influenced by outside scientific and philosophical developments.[4] It would be overstating the case to speak of an important shift in mentality in the Terra d'Otranto, but the new rationalist outlook did mark a gradual change in attitudes towards 'superstition'. The word itself is now increasingly defined as the ignorant and ineffectual beliefs of the uneducated, rather than the menacingly diabolical beliefs of the sixteenth- and seventeenth-century demonologists and theologians. The result, however, was not the secularisation or dechristianisation which characterised some other European regions. Requests for masses contained in wills were directed more and more towards low rather than high masses during the eighteenth century, but they did not decline in importance or numbers.[5]

Even the revolution of 1799 and the French decade that followed several years later (1806–15) did not spell the end of Church power and influence. In fact, the Church came out of the experience shaken but intact: we could even say 'streamlined'. Reformed from outside – brutally in the case of the Religious Orders and confraternities, most of which were suppressed – the organisation of the Church was ultimately strengthened and its local,

parish role increased. By the time of the Restoration ecclesiastics were becoming religious functionaries, distinct from their flocks, in charge of the adminstration of the sacred. At the same time the Church was becoming more rural in orientation.

For the time being this suited the nature and needs of local society, but it would soon be part of the Church's strategy of contrasting a rising 'libertine', anti-clerical bourgeoisie with a simple, devout peasantry, content with its faith and traditions.[6] Although still somewhat in the future, a radical fragmentation of the sacred system, as perceived by society, into the opposing elements of religion/magic/science – recognisable as 'modern' – was already apparent. As far as the Terra d'Otranto is concerned, it is only towards the end of the early modern period that changes in the sacred system are noticeable. What characterises our model is continuity, for even well into the modern era most of the population continued to participate in the sacred system and believe in the powers of its various figures, from bishop to witch. The model serves as further testimony to the benefits to be derived from the *longue durée* approach when studying the history of religious developments and mentalities.

NOTES

1 What Alphonse Dupront has called the *gestuaire sacral*. Cf. 'De la "religion populaire"', in his *Du sacré : Croisades et pèlerinages. Images et langages* (Paris, 1987), 441.
2 Robert Scribner, 'Cosmic order and daily life: sacred and secular in pre-industrial German society', in his *Popular Culture and Popular Movements in Reformation Germany* (London, 1987), 15.
3 Keith Wrightson and David Levine, *Poverty and Piety in an English Village: Terling, 1525–1700* (New York, 1979), 144–62.
4 Peter Burke, 'Religion and secularisation', in Burke, ed. *The New Cambridge Modern History. XIII: Companion Volume* (Cambridge, 1979), 298. Keith Thomas, *Religion and the Decline of Magic* (Harmondsworth, 1973 edn.), 767–91 offers an account of the mental and technological changes in England which resulted in an increased faith in human intitative and ability.
5 Francesco Gaudioso, 'Testamento e devozione: Il caso di Lecce fra i secoli XVIII e XIX', in his *Testamento e devozione* (Galatina, 1986), 72–3. This contrasts with the situation in Provence studied by Michel Vovelle, *Piété baroque et déchristianisation en Provence au XVIIIe siècle* (Paris, 1973).
6 Carlo Ginzburg, 'Folklore, magia, religione', *Storia d'Italia. I: I caratteri originali* (Turin, 1972), 660.

$Bibliography$

MANUSCRIPT SOURCES

The following is a listing of the holdings or *fondi* consulted at the various archives. Full references are in the notes.

Archivio della Curia Arcivescovile, Brindisi (A.C.A.B.)
 Visite pastorali: 1565, 1654, 1716–25
 Sinodi: See under printed primary sources

Archivio della Curia Vescovile, Gallipoli (A.C.V.G.)
 Confraternite: Confraternita di Maria SS.ma del Cassopo e S. Francesco da Paola
 Processi penali: Forty-five *buste* (volumes/folders), XVIc to XVIIIc
 Scomuniche: Three *buste*, XVIIc to XIXc
 Visite pastorali e sinodi: visitations: 1655, 1660, 1675, 1714, 1735, 1764; synod: 1661

Archivio della Curia Arcivescovile, Lecce (A.C.A.L.)
 Giudicati civili, criminali, matrimoniali e di patronato: Forty-two *buste*, XVIIc to XIXc
 Sinodi: 1663, 1686
 Visite pastorali: 1627, 1640–41, 1642–3, 1719, 1753–4, 1792–5

Archivio Diocesano, Oria (A.D.O.)
 Magia e stregoneria: Four *buste*, XVIIc to XIXc
 Processi civili e criminali: XVIIc to XVIIIc
 Sante visite: 1749, 1783–4, 1800
 Sinodi: 1641, 1664

Archivio della Curia Vescovile, Nardò (A.C.V.N.)
 Processi di beatificazione: Chiara d'Amato (1700–24); Ludovico Maria Calco (1756)

Archivio Segreto Vaticano, Rome (A.S.V.)
 Processi di beatificazione (Congregation of Rites): Giuseppe da Copertino (1664–8, 1689, 1737–42): Bernardino Realino (1623, 1675, 1713); Lorenzo Russo [or, da Brindisi] (1628); Rosa Maria Serio (1729, 1741–2)

Archivium Romanum Societatis Iesum (A.R.S.I.):
 Provincia Neapolitana: Historia, vols. 72–6 II; Piae Sodalitates, vol. 177

PRINTED PRIMARY SOURCES

Bernino, D., *Vita del Bea. Padre Fr. Giuseppe da Copertino De' Minori Conventuali.* Rome, 1722.
Caputo, N., *De Tarantolae Anatome et Morsu: Opusculum Historico-Mechanicum inquo nonnullae demonstrantur Insecti particulae ab aliis non ad huc inventae.* Lecce, 1741.
Ceva Grimaldi, G., *Itinerario da Napoli a Lecce e nella provincia di Terra d'Otranto*

nell'Anno 1818. Naples, 1821; reprinted with an intrdocution by E. Panareo, Cavallino di Lecce, 1981.

Cino, G., 'Memorie, ossia notiziario di molte cose accadute in Lecce dall'anno 1656 all'anno 1719', reprinted in *Rivista storica salentina*, 1905–6, 62–130.

Coniger, A., *Le Cronache.* Brindisi, 1700. Also in A.A. Pelliccia (ed.) *Roccolta di varie croniche, diarj, ed altri opuscoli così italiani, come latini appartenenti alla storia del Regno di Napoli.* Naples, 1780–82, vol. IV, 1–54.

Constitutiones synodales ecclesiae metropolitanae Brindisinae...auctore Joanne a S. Stephano et Falces. Rome, 1623.

Constitutiones synbodales editae ab Horatio Fortunato, Episcopo Neritonen, in sua prima synodo, celebrata anno MDCLXXX die XI Iunij. Lecce, 1681.

Constitutiones Synodales Editae in Prima Diocoesana Synodo Gallipolitana...Ab Illustrss. ac Reverendiss. Domino D. Ioanne Montoya De Cardona Episcopo Gallipolitano. Naples, 1661.

de Bonis, C., *Vita del Venerabile Padre Francesco di Geronimo della Compagnia di Gesù.* Naples, 1747.

d'Engenio, C., *Descrittione del Regno di Napoli, diviso in dodeci provincie...* Naples, 1671.

Gentili, G., *Vita della Venerabile Madre Rosa Maria Serio di S. Antonio, Carmelitana.* Venice, 1741.

Giannone, P., *Istoria civile del Regno di Napoli.* Naples, 1723, trans. J. Ogilvie, *The Civil History of the Kingdom of Naples,* two vols. London, 1729.

Giustiniani, L., *Dizionario geografico ragionato del Regno di Napoli,* five vols. Naples, 1797–1816.

Nuova collezione delle Prammatiche del Regno di Napoli, fifteen vols. Naples, 1803–5.

Gumppenberg, W., *Atlante Mariano,* eight vols. Verona, 1839–47 edn..

Infantino, G.C., *Lecce sacra ... ove si tratta delle vere origini, e fondationi di tutte le chiese, monasterij, cappelle, spedali e altri luoghi sacri della città di Lecce.* Lecce, 1634.

Keppel Craven, R., *A Tour Through the Southern Provinces of the Kingdom of Naples.* London, 1821.

Kramer, H. (with J. Sprenger) *Malleus maleficarum* (c. 1486) trans. M. Summers, London, 1986 edn.

Mancarella, A., *Vita del B. Giuseppe da Cupertino, Sacerdote Min. Conv. di S. Francesco.* Lecce, 1754.

Marciano da Leverano, G., *Descrizione, origini e successi della Provincia d'Otranto.* Naples, 1855. According to the publishers, the manuscript was penned in the first half of the seventeenth century.

Menghi, G., *Compendio dell'arte essorcistica et possibilità delle mirabili & stupende operationi delli Demoni & de' Malefici .* Bologna, 1576.

Flagellum daemonum, seu exorcismi terribiles, potentissimi & efficaces. Bologna, 1577.

Montorio, S., *Zodiaco di Maria, ovvero le dodici provincie del Regno di Napoli, Come tanti segni, illustrate da questo Sole per mezzo delle sue prodigiosissime Immagini, che in esse quasi tante Stelle risplendono.* Naples, 1715.

Moore, J., *A View of Society and Manners in Italy .* London, 1790.

Muratori, L.A., *Della forza della fantasia umana.* Venice, 1753 edn.

Delle regolata divozion de' cristiani. Venice, 1761 edn.

Occhilupo, C., 'Veri motti, buoni consigli, e giusti avvertimenti lasciati da savi, letterati e plebei, e villani huomini antichi à posteri per loro regola, uso e governo...posti in registro in alfabeto da me don Carlo Occhilupo in questo libro nel 1774...', Biblioteca Provinciale, Lecce, ms. 76, fols. 1–9. Reprinted in L.L. Congedo, 'Una raccolta settecentesca di proverbi salentini', in M. Paone (ed.) *Studi di storia pugliese in onore di Giuseppe Chiarelli,* V (Galatina, 1980), 5–65.

Palma, G.C., *Semplice e diligente Relazione della rinnovata Divozione verso il glorioso*

martire di Christo, Patrizio, e primo vescovo di Lecce, S. Oronzo, di Gio. Camillo Palma Dottor Teologo, e Arcidiacono di Lecce , in Appendix to A. Coniger, *Le Cronache* . Brindisi, 1700.

Panettera, A., 'Notizie della città di Lecce, 1610–55', reprinted in *Rivista storica salentina,* 1904–5, 32–61.

Piperno, P., *Della Superstitiosa Noce di Benevento: Trattato Historico del Sign. Pietro Piperno Beneventano, Filosofo e Medico.* Naples, 1640; reprinted Sala Bolognese, 1984.

Prima Dioecesana Synodus S. Hydruntinae Ecclesiae, ab Illustriss. et Reverendiss. in Christo Patre, et Domino D. Michaele Orsi, Archiepiscopo Salentinorum Primate. Naples, 1733.

'Regole comuni della Congregatione della Santissima Annonciatione della Beatissima Vergine nel collegio della Compagnia di Giesù nella magnifica città di Lecce', 1582, reprinted in Appendix to Lopez, 'Confraternite laicali', 209–38.

'Regole per la congregazione eretta sotto il titolo di S. Anastasio sotto la protettione del SS. Crocefisso, e di S. Francesco Xaverio in Tuturano tempore missionis peractae per Reverendum Padrem Honofrium Paradjso Societatis Iesu in mense Ianuarij 1740', reprinted in Appendix to R. Jurlaro, 'Le confraternite della diocesi di Brindisi in età moderna: Prime indagini', in Bertoldi Lenoci, *Confraternite pugliesi* , 489–91.

Sacco, F., *Dizionario geografico-istorico-fisico del Regno di Napoli,* four vols. Naples, 1795.

Sancta Tridentina Synodus ad Praxim, seu Decreta et Constitutiones Synodales Sanctae Ecclesiae Metrpolitanae Brindisinae, ad Illustrissimo et Reverendissimo Domino D. Francisco De Estrada. Venice, 1663.

Schinosi, F., *Istoria della Compagnia di Giesù, appartenente al Regno di Napoli.* Naples, 1711.

Secunda Synodus Diocesano ab Aloysio Pappacoda, Episcopo Lyciensi. Rome, 1669.

Swinburne, H., *Travels in the Two Sicilies.* London, 1793.

Synodum Diocesanum, Otranto, Mons. Ambrogio Maria Piccolomini, Venice, 1679.

Synodus Dioecesana Ecclesiae Vritanae, a Reverendissimo Domino D. Marco Antonio Parisio. Naples, 1646.

Vairo, L., *De fascino libri tres.* Venice, 1589.

PRINTED SECONDARY WORKS

Aarne, A. (and S. Thompson), *The Types of the Folktale: A Classification and Bibliography* . FF Communication 104, Helsinki, 1961, second edn.

Abbiati, S. (with A. Agnoletto and M.R. Lazzati), *La stregoneria: Diavoli, streghe, inquisitori dal Trecento al Settecento.* Milan, 1984.

Accati, L., 'Lo spirito della fornicazione: virtù dell'anima e virtù del corpo in Friuli fra '600 e '700', *Quaderni storici,* XIV (1979), 644–72.

Acton, H., *The Bourbons of Naples: 1734–1825.* London, 1956.

Alessi, G., 'Il gioco degli scambi: seduzione e risarcimento nella casistica cattolica del XVI e XVII secolo', *Quaderni storici,* XXV (1990), 805–32.

Alexiou, M., *The Ritual Lament in Greek Tradition.* Cambridge, 1974.

Allegra, L., 'Il parroco: un mediatore fra alta e bassa cultura', *Storia d'Italia. Annali IV: Intellettuali e potere.* Turin, 1981, 895–947.

Amabile, L., *Il Santo Officio della Inquisizione in Napoli,* two vols. Città di Castello, 1892.

Anglo, S. (ed.), *The Damned Art: Essays in the Literature of Witchcraft.* London, 1977.

Antonacci, A., *I processi nella causa di beatificazione dei martiri di Otranto (1539–1771).* Galatina, 1960.

Appel, W., 'The myth of the *jettatura* ', in C. Maloney (ed.), *The Evil Eye.* New York, 1976, 16–27.

Baars, C.W., 'Obsession', *New Catholic Encyclopedia.* New York, 1967, vol. X, 622.

Barbagli, M., *Sotto lo stesso tetto: Mutamenti della famiglia in Italia dal XV secolo al XX secolo*. Bologna, 1984.

Baroja, J.C., *The World of the Witches*. trans. N. Glendenning. London, 1964.

Barrella, G., *La Compagnia di Gesù nelle Puglie*. Lecce, 1941.

Battistini, M., 'Una lettera del Cardinale Millini riguarda a un processo di stregoneria', *Rivista della storia della Chiesa in Italia*, X (1956), 269–70.

Bell, R., *Fate and Honor, Family and Village: Demographic and Cultural Change in Rural Italy since 1800*. Chicago, 1979.

(with D. Weinstein), *Saints and Society: The Worlds of Western Christendom. 1000–1700*. Chicago, 1982.

Bergamo, M. (ed.), *Jeanne des Anges: Autobiografia. Il punto di vista dell'indemoniata*. Venice, 1986.

La scienza dei santi: Studi sul misticismo del Seicento. Florence, 1984.

Bertoldi Lenoci, L. (ed.), *Le confraternite pugliesi in età moderna: Atti del seminario internazionale di studi*, Centro ricerche di storia religiosa in Puglia. Fasano, 1988.

Bertolotti, M., 'Le ossa e la pelle dei buoi: un mito popolare tra agiografia e stregoneria', *Quaderni storici*, XIV (1979), 470–99.

Black, C.F., *Italian Confraternities in the Sixteenth Century*. Cambridge, 1989.

Bloch, M., 'A contribution towards a comparative history of European societies', in *Land and Work in Medieval Europe*, trans. J.E. Anderson. London, 1967, 44–81.

Blok, A., 'South Italian agro-towns', *Comparative Studies in Society and History*, II (1969), 494–505.

Blum, R. and E., *The Dangerous Hour: The Lore of Crisis and Mystery in Rural Greece*. London, 1970.

Bonomo, G., *Caccia alle streghe: La credenza nelle streghe dal sec. XIII al XIX con particolare riferimento all'Italia*. Palermo, 1959.

Scongiuri del popolo siciliano. Palermo, 1953.

Borromeo, A., 'Contributo allo studio dell'Inquisizione e dei suoi rapporti con il potere episcopale nell'Italia spagnola del Cinquecento', *Annuario dell'Istituto storico italiano per l'età moderna e contemporanea*, XXIX–XXX (1977–8), 219–76.

Bossy, J., *Christianity in the West, 1400–1700*. Oxford, 1986.

'The Counter-Reformation and the people of Catholic Europe', *Past and Present*, 47 (1970), 51–70.

Braudel, F., 'L'Italia fuori d'Italia: Due secoli e tre Italie', *Storia d'Italia, II: Dalla caduta dell'Impero romano al secolo XVII*. Turin, 1974, 2092–248.

The Mediterranean and the Mediterranean World in the Age of Philip II, trans. S. Reynolds, two vols. London, 1975 edn.

Briggs, M.S., *In the Heel of Italy: A Study of an Unknown City*. London, 1910.

Bronzini, G.B., '"Ex voto" e cultura religiosa popolare', *Rivista di storia e letteratura religiosa*, XV (1979), 3–27.

(ed.) *Fiabe pugliesi*, trans. G. Cassieri. Milan, 1983.

Lineamenti di storia e analisi della cultura tradizionale. Rome, 1979.

Brown, J., *Immodest Acts: The Life of a Lesbian Nun in Renaissance Italy*. Oxford, 1986.

Brown, P., *The Cult of Saints: Its Rise and Function in Latin Christianity*. Chicago, 1981.

Brucker, G., *Giovanni and Lusanna: Love and Marriage in Renaissance Florence*. Berkeley, 1986.

Burke, P., *Popular Culture in Early Modern Europe*. London, 1978.

The Historical Anthropolgy of Early Modern Italy: Essays in Perception and Communication. Cambridge, 1987.

'A question of acculturation?', in *Scienze, credenze occulte, livelli di cultura: Convegno internazionale di Studi*. Florence, 1982, 197–204.

'Southern Italy in the 1590s: hard times or crisis?', in P. Clark (ed.), *The European Crisis of the 1590s.* London, 1985, 177–90.

'Witchcraft and magic in Renaissance Italy: Gianfrancesco Pico and his *Strix* ', in S. Anglo (ed.), *The Damned Art: Essays in Literature and Witchcraft.* London, 1977, 32–52.

Caggiano, A., 'La danza dei tarantolati nei dintorni di Taranto', *Il Folklore Italiano*, IX (1931), 72–5.

Calabria, A., *The Cost of Empire: The Finances of the Kingdom of Naples in the Time of Spanish Rule.* Cambridge, 1991.

Camporesi, P., *Bread of Dreams: Food and Fantasy in Early Modern Europe*, trans. D. Gentilcore. Cambridge, 1988.

La casa dell'eternità. Milan, 1987.

'Cultura popolare e cultura d'élite fra Medioevo ed età moderna', in *Storia d'Italia. Annali IV: Intellettuali e potere.* Turin, 1981, 79–157.

The Incorruptible Flesh. Bodily Mutation and Mortification in Religion and Folklore, trans. T. Croft-Murray. Cambridge, 1988.

(ed.), *Il libro dei vagabondi: Lo 'Speculum cerretanorum' di Teso Pini, 'Il vagabondo' di Rafaele Frianoro e altri testi di 'furfanteria'.* Turin, 1973.

La maschera di Bertoldo: G.C. Croce e la letteratura carnevalesca. Turin, 1976.

Caracciolo, F., 'Vie di comunicazione e servizio postale nel Regno di Napoli tra XVI e XVII secolo', *Ricerche di storia sociale e religiosa*, II (1972), 213–28.

Caramia, G., 'Pagine di storia martinese: il Seicento', in M. Paone (ed.) *Studi di storia pugliese in onore di Giuseppe Chiarelli*, III. Galatina, 1974, 354–98.

Castellana, M., 'Documenti inediti sulla vita del clero e sulla questione dell'indulto della "Franca Martina"', in M. Paone (ed.), *Studi di storia pugliese in onore di Giuseppe Chiarelli*, V. Galatina, 1980, 239–90.

Cazzato, M., 'Architettura e religiosità popolare: osservazioni e documenti in margine alla ricostruzione della Chiesa del Crocifisso di Galatone', *Sallentum*, VIII (1985), 33–53.

Cestaro, A., *Strutture ecclesiastiche e società nel Mezzogiorno. Studi e ricerche dal XV al XIX secolo.* Naples, 1978.

Chartier, R., 'Culture as appropriation: popular cultural uses in early modern France', in S. Kaplan (ed.), *Understanding Popular Culture.* Berlin, 1984, 229–53.

Châtellier, L., *L'Europe des dévots.* Paris, 1987. In English as *The Europe of the Devout: The Catholic Reformation and the Formation of a New Society*, trans. J. Birrell. Cambridge, 1989.

Chiarelli, G., 'Abusi feudali e un processo per magia nella "Franca Martina" del secolo XVIII', in *Studi di storia pugliese in onore di Nicola Vacca.* Galatina, 1971, 27–44.

Chorley, P., *Oil, silk and Enlightenment: Economic problems in XVIIIth-century Naples.* Naples, 1965.

Christian, W.A., *Apparitions in Late Medieval and Renaissance Spain.* Princeton, 1981.

Local Religion in Sixteenth-Century Spain. Princeton, 1981.

Ciammitti, L., 'Una santa di meno: storia di Angela Mellini, cucitrice di Bologna (1667– 17 –)', *Quaderni storici*, XIV, 41 (1979), 603–39.

Ciuffreda, A., 'I benefici di giuspatronato nella diocesi di Oria tra XVI e XVII secolo', *Quaderni storici*, XXII (1988), 37–71.

Clark, S., 'Inversion, misrule and the meaning of witchcraft', *Past and Present*, 87 (May 1980), 98–127.

Cocchiara, G., *Il linguaggio della poesia popolare.* Palermo, 1951.

Cohen, E. and T., 'Camilla the go-between: the politics of gender in a Roman household (1559)', *Continuity and Change*, IV (1989), 53–77.

Cohn, N., *Europe's Inner Demons: An Inquiry Inspired by the Great Witch Hunt.* London, 1975.

'The myth of Satan and his human servants', in M. Douglas (ed.), *Witchcraft Confessions and Accusations.* A.S.A. Monograph 9, London, 1970, 3–16.

Colucci, A., *Gli zingari: Storia di un popolo errante* . Turin, 1889.

Conci, D.A., 'Il "rimorso" perduto: Storie e note di un viaggio incompiuto nel Salento', *Religioni e società*, 9 (1990), 37–48.

Coniglio, G., *Aspetti della società meridionale nel sec. XVI.* Naples, 1978.

'Società e Inquisizione nel Regno di Napoli', *Annuario dell'Istituto italiano per l'età moderna e contemporanea* , XXXVII–XXXVIII (1985–6), 125–39.

Corrain, C. (with P. Zampini), *Documenti etnografici e folkloristici nei Sinodi Diocesani italiani.* Bologna, 1970.

Corsi, P. (et al.), *Cronotassi, iconografia ed araldica dell'Episcopato pugliese.* Unione regionale dei centri di ricerche di Puglia, Bari, 1986.

Corso, R., 'Riti e pratiche contro la siccità', *Il Folklore Italiano*, XI (1933), 1–23.

Cousin, B., 'Devotion et société en Provence: Les ex-voto de Notre-Dame-de-Lumières', *Ethnologie Française*, VII (1977), 121–42.

Da Molin, G. (with P. Stella), 'Offensiva rigoristica e comportamento demografico in Italia (1600–1860): natalità e mortalità infantile', *Salesianum* , XL (1978), 3–55.

da Nadro, S., *Sinodi diocesani italiani: Catalogo bibliografico degli atti a stampa, 1534–1878.* Vatican City, 1960.

Davidson, N.S., *The Counter-Reformation.* London, 1987.

Davis, N.Z., *Fiction in the Archives: Pardon Tales and their Tellers in Sixteenth-Century France.* Cambridge, 1987.

De' Antoni, D., 'Processi per magia e stregoneria a Chioggia nel XVI secolo', *Ricerche di storia sociale e religiosa* , II (1973), 187–228.

De Giorgi, E., *L'interdetto contro la città e la diocesi di Lecce (nelle cronache e documenti del tempo).* Lecce, 1984.

Delille, G., *Agricoltura e demografia nel Regno di Napoli nei secoli XVIII e XIX.* Naples, 1977.

'Un esempio di assistenza privata: i Monti di maritaggio nel Regno di Napoli (secoli XVI–XVIII)', in G. Politi, M. Rosa and F. della Paruta (eds.), *Timore e carità: I poveri nell'Italia moderna.* Cremona, 1982, 275–82.

Delooz, P., 'Towards a sociological study of canonised sainthood in the Catholic Church', in S. Wilson (ed.), *Saints and their Cults.* Cambridge, 1983, 189–216.

Del Re, N., 'Giuseppe da Copertino', *Biblioteca Sanctorum*, VI, Rome, 1965, columns 1300–2.

'I martiri di Otranto', *Bibliotheca Sanctorum*, IX, Rome, 1967, columns 1303–6.

De Luca, F., *La diocesi leccese nel Settecento attraverso le visite pastorali: Regesti.* Galatina, 1984.

Delumeau, J., *Catholicism between Luther and Voltaire: A New View of the Counter-Reformation*, trans. J. Moiser. London, 1977.

La Peur en Occident (XIVe – XVIIIe siècles): Une cité assiégée. Paris, 1978.

De Maio, R., 'Chiesa e vita religiosa a Napoli nel Settecento: Dal Sinodo del 1726 alla prima restaurazione borbonica del 1799', *Storia di Napoli,* VII. Naples, 1972, 793–960.

'L'ideale eroico nei processi di canonizzazione della Controriforma', in his *Riforma e miti nella Chiesa del Cinquecento.* Naples, 1973, 257–78.

de Martino, E., 'Intorno a una storia del mondo popolare subalterno', *Società* , V (1949), 411–35.

Morte e pianto rituale dal lamento funebre antico al pianto di Maria. Turin, 1975 edn.

Sud e magia. Milan, 1966 edn.

La terra del rimorso: Contributo a una storia religosa del Sud. Milan, 1968 edn.

De Rosa, G., *Chiesa e religione popolare nel Mezzogiorno.* Bari, 1979.

'La regestazione delle visite pastorali e la loro utilizzazione come fonte storica', *Archiva ecclesiae*, XXII–XXIII (1979–80), 27–52.

'Storia e visite pastorali nel Settecento italiano', in his *Feudalità, clero e popolo nel Sud attraverso le visite pastorali del '700* . Naples, 1969, 69–90.

Vescovi, popolo e magia nel Sud. Naples, 1982.

De Simone, L., 'La vita della Terra d'Otranto', *La Rivista Europea* , VII (1876), 3: 67–86 and 559–72, 3: 341–52, 4: 507–28.

De Simone, R., *S. Oronzo nelle fonti letterarie sino alla metà del Seicento.* Lecce, 1964.

'Oronzo', *Bibliotheca Sanctorum*, VIII. Rome, 1966, columns 51–3.

Devlin, J., *The Superstitious Mind: French Peasants and the Supernatural in the Nineteenth Century.* New Haven, 1987.

di Maria, V., 'Rosa Maria Serio', *Enciclopedia Cattolica* , XI. Florence, 1953, columns 388–9.

Di Molfetta, G., 'Superstizione e magia a Bisceglie nei sinodi e nelle visite pastorali dei secoli XVI e XVII', in M. Lanera and M. Paone (eds), *Momenti e figure di storia pugliese: Studi in memoria di Michele Viterbo (Peucezio).* Galatina, 1981, 273–93.

Di Nola, A.M., *Gli aspetti magico-religiosi di una cultura subalterna italiana.* Turin, 1976.

Di Stasi, L., *Mal Occhio [evil eye]: The Underside of Vision.* San Francisco, 1981.

Donno, G., 'Giovanni Presta: medico ed insigne olivicoltore del Settecento', in *Studi di storia pugliese in onore di Nicola Vacca.* Galatina, 1971, 171–97.

Dundes, A., 'Wet and dry, the evil eye: An essay in Indo-European and Semitic worldview', in Dundes (ed.), *The Evil Eye: A Folklore Casebook.* New York, 1981, 257–312.

Dupront, A. 'Antropologia del sacro e culti popolari: il pellegrinaggio', in C. Russo (ed.), *Società, Chiesa e vita religiosa nell'Ancien Régime.* Naples, 1976, 351–75.

Du sacré: Croisades et pèlerinages. Images et langages. Paris, 1987.

'Religion and religious anthropology', trans. M. Thom, in J. Le Goff and P. Nora (eds), *Constructing the Past. Essays in Historical Methodology.* Cambridge, 1985, 123–50.

Ebon, M., *Exorcism Past and Present* . London, 1974.

Eliade, M., 'Some observations on European witchcraft', in his *Occultism, Witchcraft and Cultural Fashions.* Chicago, 1976, 69–92.

Evans-Pritchard, E.E., *Witchcraft, Oracles and Magic among the Azande.* Oxford, 1976 edn.

Faralli, C., 'Le missioni dei Gesuiti in Italia (sec. XVI–XVII): problemi di una ricerca in corso', *Bollettino della Società di Studi Valdesi*, XCVI (1975), 97–116.

Farella, V., 'I decreti sinodali dell'arcivescovo Lelio Brancaccio relativi ai greco-albanesi del tarantino', in M. Paone (ed.), *Studi di storia pugliese in onore di Giuseppe Chiarelli*, II. Galatina, 1973, 659–83.

Farmer, D.H., *The Oxford Dictionary of Saints.* Oxford, 1987 edn.

Flynn, M., *Sacred Charity: Confraternities and Social Welfare in Spain, 1400–1700.* London, 1989.

Follieri, E. 'Il culto dei santi nell'Italia greca', in *La Chiesa greca in Italia dall'VIII al XV secolo*, II, *Italia Sacra* , no. 21 (Padua, 1972), 553–77.

Fonseca, C.D., 'La Terra d'Otranto da Lepanto a Masaniello', in Fonseca (et al.), *'Barocco' leccese: Arte e ambiente nel Salento da Lepanto a Masaniello.* Rome, 1979, 7–14.

Forbes, T., *The Midwife and the Witch.* New Haven, 1966.

Freedburg, D., *The Power of Images: Studies in the History and Theory of Response.* Chicago, 1989.

Froeschlé-Chopard, M.-H., *La Religion populaire en Provence orientale au XVIIIe siècle.* Paris, 1980.

Galasso, G., *L'altra Europa: Per un'antropologia storica del Mezzogiorno d'Italia.* Milan, 1982.

Croce, Gramsci e altri storici. Milan, 1978.

'Ideologia e sociologia del patronato di san Tommaso d'Aquino su Napoli', in Galasso and C. Russo (eds.), *Per la storia sociale e religiosa del Mezzogiorno d'Italia*, II. Naples, 1982, 213–49.

'La storia socio-religiosa del Mezzogiorno: problemi e prospettive', introduction to Galasso and C. Russo (eds.), *Per la storia sociale e religiosa del Mezzogiorno d'Italia*, I. Naples, 1982, XI–XXXI.

Galt, A.H., *Far From the Church Bells: Settlement and Society in an Apulian Town*. Cambridge, 1991.

García Cárcel, R., 'El modelo mediterraneo de brujería', *Annuario dell'Istituto storico italiano per l'età moderna e contemporanea*, XXXVII–XXXVIII (1985–6), 245–57.

'La stregoneria in Europa', in N. Tranfaglia and L. Firpo (eds.), *La Storia: I grandi problemi dal Medioevo all'Età Contemporanea. IV: L'Età moderna (2). La vita religiosa e la cultura*. Turin, 1986, 441–65.

Gaudioso, F., *Pietà religiosa e testamenti nel Mezzogiorno*. Naples, 1983.

Testamento e devozione: L'esempio della Terra d'Otranto tra il Cinque e l'Ottocento. Galatina, 1986.

'Tipologia e frequenza delle formule pie nei testamenti di una comunità pugliese (secoli XVII–XIX)', in M. Spedicato (ed.), *Chiesa e società a Carmiano alla fine dell'Antico Regime*. Galatina, 1985, 101–56.

Geertz, C., 'Religion as a cultural system', in his *Interpretation of Cultures*. New York, 1973, 87–125.

Gentile, E., 'Giustizia punitiva in Napoli nel sec. XVIII. Cartello infamatorio a condanna a morte', *Il Rievocatore*, December 1953, 13–20.

Gigli, G., *Superstizioni, pregiudizi e tradizioni in Terra d'Otranto*. Florence, 1893; reprinted Bologna, 1986.

Ginzburg, C. *I benandanti*. Turin, 1966. In English as *The Night Battles: Witchcraft and Agrarian Cults in the Sixteenth and Seventeenth Centuries*, trans. J. and A. Tedeschi. London, 1983.

'Folklore, magia, religione', *Storia d'Italia. I: I caratteri originali*. Turin, 1972), 603–76.

'Premessa giustificativa', introduction to *Quaderni storici*, XIV (1979), 393–7.

Storia notturna. Una decifrazione del Sabba. Turin, 1989. In English as *Ecstasies: Deciphering the Witches' Sabbath*, trans. R. Rosenthal. London, 1990.

'Stregoneria e pietà popolare. Note a proposito di un processo modenese del 1519', in his *Miti, emblemi, spie: Morfologia e storia*. Turin, 1986, 3–28.

'Stregoneria, magia e superstizione in Europa fra Medioevo ed età moderna', *Ricerche di storia sociale e religiosa*, IX (1977), 119–33.

'The witches' sabbat: popular cult or inquisitional stereotype?', in S. Kaplan (ed.) *Understanding Popular Culture*. Berlin, 1984, 39–51.

Gioia, M., 'Per una biografia di san Bernardino Realino, S.J. (1530–1616): Analisi delle fonti e cronologia critica', *Archivum Historicum Societatis Jesu*, XXXIX (1970), 3–101.

Giura, V., *Storie di minoranze: ebrei, greci, albanesi nel Regno di Napoli*. Naples, 1984.

Glick, L., 'Medicine as an ethnographic category: the Gimi of the New Guinea Highlands', in D. Landy (ed.), *Culture, Disease and Healing: Studies in Medical Anthropology*. New York, 1977, 58–70.

Gramsci, A., *Quaderni del carcere*, V. Gerretana (ed.). Turin, 1975.

Grendler, P.F., *The Roman Inquisition and the Venetian Press, 1540–1605*. Princeton, 1977.

Guasco, M., 'La formazione del clero: i seminari', in *Storia d'Italia. Annali IX: La Chiesa e il potere politico dal Medioevo all'età contemporanea*. Turin, 1986, 631–751.

Gurevich, A., *Medieval Popular Culture: Problems of Belief and Perception*, trans. J. Bak and P. Hollingsworth. Cambridge, 1988.

Harley, D., 'Historians as demonologists: the myth of the midwife–witch', *Social History*

of Medicine, III (1990), 1–26.

Henningsen, G., '"The Ladies from Outside": an archaic pattern of the witches' sabbath', in B. Ankarloo and G. Henningsen (eds.), *Early Modern European Witchcraft: Centres and Peripheries*. Oxford, 1989, 191–215.

Horsley, R., 'Who were the witches? The social roles of the accused in the European witch trials', *Journal of Interdisciplinary History*, IX (1979), 689–715.

Ingram, M., *Church Courts, Sex and Marriage in England, 1570–1640*. Cambridge, 1987.
'Ridings, rough music and mocking rhymes in early modern England', in B. Reay (ed.), *Popular Culture in Seventeenth-century England*. London, 1985, 166–97.

Ioly Zorattini, P.C., 'Per lo studio della stregoneria in Italia nell'età moderna', *Rivista di storia della Chiesa in Italia*, XXV (1971), 231–7.

Jones, C.W., *Saint Nicholas of Myra, Bari and Manhattan*. Chicago, 1978.

Jurlaro, R. (with appendix by Carmine Maci), 'Le confraternite laicali a Campi e a nord di Lecce', *Ricerche e studi in Terra d'Otranto*, II. Campi Salentina, 1987, 55–68.

Kieckhefer, R., *European Witch Trials: Their Foundations in Popular and Learned Culture, 1300–1500*. London, 1976.

Klapisch-Zuber, C., 'Villaggi abbandonati ed emigrazioni interne', in *Storia d'Italia. V: I documenti. I*. Turin, 1973, 311–64.
Women, Family and Ritual in Renaissance Italy, trans. L. Cochrane. Chicago, 1985.

Kleinman, A., *Patients and Healers in the Context of Culture: An Exploration of the Borderland between Anthropology, Medicine and Psychiatry*. Berkeley, 1980.

Kligman, G., *Calus: Symbolic Transformation in Romanian Ritual*. Chicago, 1981.

Labrot, G., *Baroni in città: Residenze e comportamenti dell'aristocrazia napoletana, 1530–1734*. Naples, 1979.

Lanternari, V. 'La politica culturale della Chiesa nelle campagne: la festa di S. Giovanni', *Società*, XI (1955), 64–95.

Larner, C., 'Crimen exceptum? The crime of witchcraft in Europe', in V.A.C. Gatrell (et al.), *Crime and the Law: The Social History of Crime in Western Europe since 1500*. London, 1980, 49–75.

La Sorsa, S., 'Prefiche e nenie in Puglia', *Archivio per la raccolta e lo studio delle tradizioni popolari italiane*, XI (1937), 162–74.

Lea, H.C., *The Inquisition in the Spanish Dependencies*. New York, 1908.
Materials toward a History of Witchcraft, three vols. Philadelphia, 1939.

Lebrun, F., *Se soigner autrefois: Médecins, saints et sorciers aux 17e et 18e siècles*. Paris, 1983.

Leucci, D., *S. Maria di Cotrino, Latiano (1607–1922)*. Galatina, 1987.

Lepre, A., *Storia del Mezzogiorno d'Italia*, two vols. Naples, 1986.

Le Roy Ladurie, E., 'History that stands still', in his *The Mind and Method of the Historian*, trans. S. and B. Reynolds. Brighton, 1981, 1–27.
The Peasants of Languedoc, trans. J. Day. Urbana, 1974.

Levack, B., *The Witch-Hunt in Early Modern Europe*. London, 1987.

Levi, C., *Christ Stopped at Eboli*, trans. F. Frenaye. London, 1948.

Levi, G., *L'eredità immateriale: Carriera di un esorcista nel Piemonte del Seicento*. Turin, 1985. English trans. L. Cochrane, *Inheriting Power: The Story of an Exorcist*. Chicago, 1988.

Lévi-Strauss, C., *Structural Anthropology*, trans. C. Jacobson and B. Grundfest Schoepf. London, 1968.

Lewis, I.M., *Ecstatic Religion: An Anthropological Study of Spirit Possession and Shamanism*, Harmonsworth, 1971.

Lopez, P., *Clero, eresia e magia nella Napoli del Viceregno*. Naples, 1984.
'Le confraternite laicali in Italia e la Riforma cattolica', *Rivista di studi salernitani*, II (1969), 153–238.

Inquisizione, stampa e censura nel Regno di Napoli tra '500 e '600. Naples, 1974.

Lützenkirchen, G., 'Il "male di San Donato"', in Lützenkirchen (et al.), *Mal di Luna. Folli, indemoniati, lupi mannari: malattie nervose e mentali nella tradizione popolare.* Roma, 1981, 28–56.

Macfarlane, A., *Witchcraft in Tudor and Stuart England: A Regional and Comparative Study.* London, 1970.

McKevitt, C., 'San Giovanni Rotondo and the shrine of Padre Pio', paper presented at the Interdisciplinary Conference on Pilgrimage, Roehampton Institute, London, 1988. Now in J. Eade and M.J. Sallnow (eds.), *Contesting the Sacred: The Anthropology of Christian Pilgrimage.* London, 1991.

McLaren, A., *A History of Contraception from Antiquity to the Present Day.* Oxford, 1990.

Macry, P., *Mercato e società nel Regno di Napoli: Commercio del grano e politica economica nel Settecento.* Naples, 1974.

Malecore, I., 'Letteratura e tradizioni religiose popolari nel Salento', *Lares*, XL, 2–4 (1974), 189–202.

Malinowski, B., *Magic, Science and Religion.* London, 1948 edn.

Marinò, A., 'Vicende urbanistiche di Martina Franca in Puglia' in R. Colapietra (ed.), *Città e territorio nel Mezzogiorno d'Italia fra Ottocento e Novecento.* Milan, 1982, 291–315.

Marino, J., *Pastoral Economics in the Kingdom of Naples.* Baltimore, 1988.

Massafra, A., 'En Italie Meridionale: Déséquilibres régionaux et réseaux de transports du milieu du XVIIIe siècle à l'unité italienne', *Annales E.S.C.*, 43 (1988), 1045–80.

Martin, R., *Witchcraft and the Inquisition in Venice, 1550–1650.* Oxford, 1989.

Martucci, R., '"De vita et honestate clericorum": La formazione del clero meridionale tra Sei e Settecento', *Archivio storico italiano*, CXLIV (1986), 423–67.

Mazzacane, L., *Struttura di festa: Forma, struttura e modello delle feste religiose meridionali.* Milan, 1985.

Mazzarella, E., 'Per la storia degli istituti di formazione per gli ecclesiastici in Puglia: il seminario di Nardò (1674)', in M. Paone (ed.), *Studi di storia pugliese in onore di Giuseppe Chiarelli*, III. Galatina, 1974, 493–525.

Mazzone, U. (with A Turchini), *Le visite pastorali: Analisi di una fonte.* Annali dell'Istituto storico italo-germanico, Bologna, 1985.

Mezzadri, L., 'Le missioni popolari della Congregazione della Missione nello Stato della Chiesa (1642–1700)', *Rivista di storia della Chiesa in Italia*, XXXIII (1979), 12–44.

Miele, M., 'Gli atti dei concili provinciali dell'Italia meridionale in epoca moderna', *Annuarium historiae conciliorum*, XVI (1984), 409–36.

'Il clero nel Regno di Napoli, 1806–1815', *Quaderni storici*, XIII (1978), 284–313.

'Malattie magiche di origine diabolica e loro terapia secondo il medico beneventano Pietro Piperno (+ 1642)', *Campania sacra*, IV (1973), 166–223.

Monter, W., *Ritual, Myth and Magic in Early Modern Europe.* Brighton, 1983.

'Toward a statistical profile of the Italian Inquisitions, sixteenth to seventeenth Centuries' (with J. Tedeschi), in G. Henningsen and J. Tedeschi (eds.), *The Inquisition in Early Modern Europe: Studies on Sources and Methods.* Dekalb, 1986, 130–57.

'Women and the Italian Inquisitions', in M. Rose (ed.), *Women in the Middle Ages and the Renaissance.* Syracuse, 1986, 73–87.

Moore, P., 'On the significance of relics in religion, with special reference to Christianity and Buddhism', unpublished paper presented at the Interdisciplinary Conference on Pilgrimage, Roehampton Institute, London, 1988.

Muchembled, R., 'Satanic myths and cultural reality', in B. Ankarloo and G.Henningsen (eds.), *Early Modern European Witchcraft: Centres and Peripheries.* Oxford, 1989, 139–60.

'The witches of the Cambrésis. The acculturation of the rural world in the sixteenth

and seventeenth centuries', in J. Obelkevich (ed.), *Religion and the People, 800–1700.* Chapel Hill, 1979, 221–76.

Muir, E., 'The Virgin on the street corner: the place of the sacred in Italian cities', in S. Ozment (ed.), *Religion and Culture in the Renaissance and Reformation.* Sixteenth Century Essays and Studies, XI, Kirksville, 1989, 25–40.

Musi, A., *La rivolta di Masaniello nella scena politica barocca.* Naples, 1989.

Muto, G., 'Forme e contenuti economici dell'assistenza nel Mezzorgiorno moderno: il caso di Napoli', in G. Politi, M. Rosa and F. della Paruta (eds.), *Timore e carità: I poveri nell'Italia moderna.* Cremona, 1982, 237–58.

Norberg, K., 'The Counter-Reformation and women: religious and lay', in J. O'Malley (ed.), *Catholicism in Early Modern History.* St Louis, 1988, 133–46.

Novi Chavarria, E., 'L'attività missionaria dei Gesuiti nel Mezzogiorno d'Italia tra XVI e XVIII secolo', in G. Galasso and C. Russo (eds.), *Per la storia sociale e religiosa del Mezzogiorno d'Italia,* II. Naples, 1982, 159–85.

Olmi, M., *Italiani dimezzati: Le minoranze etnico-linguistiche non protette.* Naples, 1986.

O'Neil, M., 'Magical healing, love magic and the Inquisition in late sixteenth-century Modena', in S. Haliczer (ed.), *Inquisition and Society in Early Modern Europe.* London, 1987, 88–114.

'*Sacerdote ovvero strione*: ecclesiastical and superstitious remedies in 16th century Italy', in S. Kaplan (ed.), *Understanding Popular Culture.* Berlin, 1984, 53–83.

'Superstition', in M. Eliade (ed.), *Encyclopedia of Religion,* XIV. New York, 1987, 163–6.

Orlando, V., *Feste, devozioni e religiosità: Ricerca socio-religiosa in alcuni santuari del Salento.* Galatina, 1981.

Palese, S., 'Le confraternite laicali della diocesi di Ugento nell'eopca moderna', *Archivio storico pugliese,* XXVIII (1975), 125–73.

'La fondazione del seminario diocesano di Ugento (1752)', *La Zagaglia,* XVIII (1975), 3–17.

'Note sulla devozione ai santi anargivi Cosma e Damiano nel Salento', *Nicolaus,* XI (1983), 133–44.

'Le relazioni per le visite "ad limina" dei vescovi ugentini del Seicento e del Settecento', *La Zagaglia,* XVI (1976), 37–49.

'Seminari di Terra d'Otranto tra rivoluzione e restaurazione', in B. Pellegrino (ed.), *Terra d'Otranto in età moderna: Fonti e ricerche di storia religiosa e sociale.* Galatina, 1984, 107–88.

'Sinodi diocesani e visite psatorali della diocesi di Alessano e di Ugento, dal Concilio di Trento al Concordato del 1818', *Archivio storico pugliese,* XXVII (1974), 451–99.

'Per la storia religiosa della diocesi di Ugento agli inizi del Settecento', in M. Paone (ed.) *Studi di storia pugliese in onore di Giuseppe Chiarelli,* IV. Galatina, 1976, 275–334.

'Vescovi di Terra d'Otranto prima e dopo il Concilio di Trento: La vicenda dei vescovi della famiglia Acquaviva di Nardò', *Rivista di scienze religiose,* I (1987), 78–187.

'Visite pastorali in Puglia: Storia religiosa e azione pastorale nel Mezzogiorno', *Archiva ecclesiae,* XXII–XXIII (1979–80), 379–410.

Pancino, C., *Il bambino e l'acqua sporca: Storia dell'assistenza al parto dalle mammane alle ostetriche (secoli XVI–XIX).* Milan, 1984.

Paone, M., 'Per la storia del barocco leccese', *Archivio storico pugliese,* XXXV (1982), 89–138.

Pazzini, A. *La medicina popolare in Italia: Storia, tradizioni, leggende.* Trieste, 1948.

Pellegrino, B. (ed.), *Terra d'Otranto in età moderna: Fonti e ricerche di storia religiosa e sociale.* Galatina, 1984.

'L'ulivo e l'aldilà: Devoti, messe e clero a Carmiano nel XVII secolo', in M. Spedicato (ed.), *Chiesa e società a Carmiano alla fine dell'antico regime.* Galatina, 1985, 87–99.

Peri, V., 'Chiesa latina e chiesa greca nell'Italia postridentina (1564–1596)', *La Chiesa greca in Italia dal'VIII al XVI secolo*, I, *Italia sacra*, no. 20 (Padua, 1973), 271–469.

Petrocchi, M., *Esorcismi e magia nell'Italia del '500 e del '600*. Naples, 1957.

Pitrè, G., 'Jettatura e malocchio: Scongiuri, antidoti ed amuleti', *Biblioteca delle tradizioni popolari siciliane*, XXV. Palermo, 1913, 193–211.

Medicina popolare siciliana. Turin, 1896.

Portelli, A., 'The peculiarities of oral history', *History Workshop*, XII (1981), 96–107.

Press, I., 'The urban Curandero', in D. Landy (ed.), *Culture, Disease and Healing. Studies in Medical Anthropology*. New York, 1977, 460–75.

Propp, V., *Morphology of the Folktale*. Austin, 1968.

Prosperi, A., 'Intellettuali e Chiesa all'inizio dell'età moderna', in *Storia d'Italia. Annali IV: Intellettuali e potere*. Turin, 1981, 159–252.

'Madonne di città e madonne di campagna: Per un'inchiesta sulle dinamiche del sacro nell'Italia post-Tridentina', in S. Boesch Gajano and L. Sebastiani (eds.), *Culto dei santi, istituzioni e classi sociali in età preindustriale*. Rome–Aquila, 1984, 615–47.

'"Otras Indias": missionari della Controriforma tra contadini e selvaggi', in *Scienze, credenze occulte, livelli di cultura: Convegno internazionale di studi*. Florence, 1982, 206–34.

Puce, A., 'Contributo psicologico-sociale allo studio del male di S. Donato nel Salento', *Studi e materiali di storia delle religioni*, IX (1985), 261–97.

Quaife, G.R., *Godly Zeal and Furious Rage: The Witch in Early Modern Europe*. London, 1987.

Rei, D., 'Note sul concetto di "religione popolare"', *Lares*, XL (1974), 264–80.

Rienzo, M.G., 'Il processo di cristianizzazione e le missioni popolari nel Mezzogiorno: Aspetti istituzionali e socio-religiosi', in G. Galasso and C. Russo (eds.), *Per la storia sociale e religiosa del Mezzogiorno d'Italia*, I. Naples, 1980, 441–81.

Righetti, M., *Manuale di storia liturgica*, four vols. Milan, 1959.

Rivera, A., *Il mago, il santo, la morte, la festa: Forme religiose nella cultura popolare*. Bari, 1988.

Rivers, W.H.R., *Medicine, Magic and Religion*. London, 1927.

Rizzo, G., *Settecento inedito fra Salento e Napoli*. Ravenna, 1978.

Rohlfs, G., 'Vocabolario dei dialetti salentini (Terra d'Otranto)', three vols., in the *Abhandlungen der Bayerischen Akademie der Wissenschaften*, Munich, 1956–61.

Romeo, G., 'Una città due Inquisizioni: L'anomalia del Sant'Ufficio a Napoli nel tardo '600', *Rivista di storia e letteratura religiosa*, XXIV (1988), 42–67.

Inquisitori, esorcisti e streghe nell'Italia della Controriforma. Florence, 1990.

'Una "simulatrice di santità" a Napoli nel '500: Alfonsina Rispola', *Campania sacra*, VIII–IX (1977–8), 159–218.

'Per la storia del Sant'Ufficio a Napoli tra '500 e '600 Documenti e problemi', *Campania sacra*, VII (1976), 5–109.

Rosa, M., 'La Chiesa meridionale nell'età della Controriforma', *Storia d'Italia. Annali IX: La Chiesa e il potere politico dal Medioevo all'età contemporanea*. Turin, 1986, 293–345.

'Diocesi e vescovi del Mezzogiorno durante il viceregno spagnolo. Capitanata, Terra di Bari and Terra d'Otranto dal 1545 al 1714', in B. Musca (ed.) *Studi storici in onore di Gabriele Pepe*. Bari, 1969, 531–80.

Religione e società nel Mezzogiorno tra Cinque e Seicento. Bari, 1976.

Rosaldo, R., 'From the door of his tent: the field worker and the inquisitor', in J. Clifford and G. Marcus (ed.), *Writing Culture: The Poetics and Politics of Ethnography*. Berkeley, 1986, 77–97.

Rossi, A., *Le feste dei poveri*. Bari, 1971.

Rowland, R., '"Fantasticall and devilishe persons": European witch-beliefs in comparative perspective', in B. Ankarloo and G. Henningsen (eds.), *Early Modern Euroepan*

Witchcraft: Centres and Peripheries. Oxford, 1989, 161–90.

Rubel, A. (et al.), *Susto, a Folk Illness.* Berkeley, 1984.

Rusconi, R., 'Confraternite, compagnie e devozioni', *Storia d'Italia. Annali IX: La Chiesa e il potere politico dal Medioevo all'età contemporanea.* Turin, 1986, 469–506.

'Predicatori e predicazione', *Storia d'Italia. Annali IV: Intellettuali e potere.* Turin, 1981, 951–1035.

Russell, J.B., *Lucifer: The Devil in the Middle Ages.* Ithaca, 1984.

Russo, C., 'La storiografia socio-religiosa e i suoi problemi', introduction to Russo (ed.), *Società, Chiesa e vita religiosa nell'Ancien Régime.* Naples, 1976.

Salimbeni, F., 'La stregoneria nel tardo Rinascimento', *Nuova rivista storica*, LX (1976), 269–334.

Sallmann, J.-M., *Chercheurs de trésors et jeteuses de sorts: La Quête du surnaturel à Naples au XVIe siècle.* Paris, 1986.

'Image et fonction du saint dans la région de Naples à la fin du XVIIIe siècle', *Mélanges de l'Ecole Française de Rome*, 91.2 (1979), 827–74.

'La sainteté mystique féminine à Naples au tournant des 16e et 17e siècles', in S. Boesch Gajano and L. Sebastiani (eds.), *Culto dei santi, istituzioni e classi sociali in età preindustriale.* Rome–Aquila, 1984, 683–702.

'Il santo patrono cittadino nel '600 nel Regno di Napoli e in Sicilia', in G. Galasso and C. Russo (eds.), *Per la storia sociale e religiosa del Mezzogiorno d'Italia*, II. Naples, 1982, 187–211.

'Il santo e le rappresentazioni della santità: Problemi di metodo', *Quaderni storici*, XIV, (1979), 584–602.

Schmitt, J.-C., 'La fabrique des saints', *Annales. E.S.C.*, 39 (1984), 286–300.

'"Religion populaire" et culture folklorique', *Annales. E.S.C.*, 31.5 (1976), 941–53.

Schoeck, H., 'The evil eye: forms and dynamics of a universal superstition', in A. Dundes (ed.), *The Evil Eye: A Folklore Casebook.* New York, 1981, 192–200.

Scribner, R.W., *Popular Culture and Popular Movements in Reformation Germany.* London, 1987.

Semeraro, M., *Le Apostoliche Missioni: Le congregazioni dei 'padri salesiani' o 'preti pietosi' nel Sette-Ottocento leccese.* Rome, 1980.

Seppilli, T. (ed.), *Le tradizioni popolari in Italia: Medicine e magia.* Milan, 1989.

Silverman, S., *Three Bells of Civilization.* New York, 1975.

Smith, B.H., 'Narrative versions, narrative theories', *Critical Inquiry*, VII (1980), 213–36.

Sodano, G., 'Miracoli e Ordini religiosi nel Mezzogiorno d'Italia (XVI–XVIII secolo)', *Archivio storico per le province napoletane*, CV (1987), 293–414.

Soman, A., 'Décriminalisation de la sorcellerie en France', *Histoire, economie et société*, IV (1985), 179–203.

Spedicato, M. (ed.), *Chiesa e società a Carmiano alla fine dell'antico regime.* Galatina, 1985.

'Indicazioni sul reclutamento del clero leccese nella seconda metà del XVIII sec. attraverso l'esame dei patrimoni sacri', *Archivio storico pugliese*, XXIX (1976), 271–9.

(ed.), *Una parrocchia salentina in epoca moderna: Magliano tra XVII e XIX secolo.* Galatina, 1986.

'Ricerca storica e storiografia religiosa in Terra d'Otranto in epoca moderna', in B. Pellegrino (ed.), *Terra d'Otranto in età moderna: Fonti e ricerche di storia sociale e religiosa.* Galatina, 1984, 13–64.

Sposato, P., 'Dati statistici sulla popolazione civile ed ecclesiastica nel Viceregno di Napoli tra la prima e la seconda metà del Seicento', *Annali della scuola speciale per archivisti e bibliotecari dell'Università di Roma*, V (1965), 115–76 and VI (1966), 33–86.

Tacchi Venturi, P., *Storia della Compagnia di Gesù in Italia, narrata con sussidio di fonti inedite.* Rome, 1950 edn.

Tedeschi, J., 'Inquisitorial law and the witch', in B. Ankarloo and G. Henningsen (eds.), *Early Modern European Witchcraft: Centres and Peripheries.* Oxford, 1989, 83–118.

'Preliminary observations on writing a history of the Roman Inquisition', in F. Church and T. George (eds.), *Continuity and Discontinuity in Church History.* Leiden, 1979, 232–49.

'The Roman Inquisition and witchcraft: An early seventeenth-century "Instruction" on correct trial procedure', *Revue de l'Histoire des Religions,* CC (1983), 163–88.

'Toward a statistical profile of the Italian Inquisitions, sixteenth to seventeenth centuries' (with W. Monter), in G. Henningsen and J. Tedeschi (eds.), *The Inquisition in Early Modern Europe: Studies on Sources and Methods.* Dekalb, 1986, 130–57.

Thomas, K., *Religion and the Decline of Magic.* Harmondsworth, 1973 edn.

Tocci, G., 'Per un nuovo studio dell'economia agricola salentina nella seconda metà del Settecento', *Critica storica,* VI (1967), 23–77.

Torre, A., 'Il consumo di devozioni: rituali e potere nelle campagne piemontesi nella prima metà del Settecento', *Quaderni storici,* XX (1985), 181–223.

Toscani, X., 'Il reclutamento del clero (secoli XVI–XIX)', *Storia d'Italia. Annali IX: La Chiesa e il potere politico dal Medioevo all'età contemporanea.* Turin, 1986, 575–628.

Tozer, H.F., 'The Greek-speaking population of southern Italy', *The Journal of Hellenic Studies,* X (1889), 11–42.

Trevor-Roper, H., *The European Witch-craze of the Sixteenth and Seventeenth Centuries.* London, 1969.

Trexler, R., 'Florentine religious experience: the sacred image', *Studies in the Renaissance,* XIX (1972), 7–41.

Public Life in Renaissance Florence. New York, 1980.

Tsirpaulis, Z., 'Memorie storiche sulle comunità e chiese greche in Terra d'Otranto (XVI sec.)', *La Chiesa greca in Italia dal'VIII al XVI secolo,* II, in *Italia sacra,* no. 21 (Padua, 1972), 845–77.

Turchini, A., *Morso, morbo, morte: La tarantola fra cultura medica e terapia popolare.* Milan, 1987.

Turner, V. and E., *Image and Pilgrimage in Christian Culture. Anthropological Perspectives.* Oxford, 1978.

Turner, V., 'Social dramas and stories about them', *Critical Inquiry,* VII (1980), 141–68.

Turrisi, C., *La diocesi di Oria nell'Ottocento: Aspetti socio-religiosi di una diocesi del Sud (1798–1888).* Rome, 1978.

Ussia, S., 'La festa delle Quarant'ore nel tardo barocco napoletano', *Rivista di storia e letteratura religiosa,* XVIII (1982), 253–65.

Vauchez, A., *La sainteté en Occident au derniers siècles du moyen age d'après les procès de canonisation et les documents hagiographiques.* Rome, 1981.

'Santità', *Enciclopedia Einaudi,* XII. Turin, 1984, 441–53.

'Il santo', in J. Le Goff (ed.), *L'uomo medievale.* Rome–Bari, 1987, 353–90.

Vecchi, A., *Il culto delle immagini nelle stampe popolari.* Florence, 1968.

Vernole, E., 'La morte nelle tradizioni popolari salentine', *Rinascenza salentina,* V (1937), 65–76.

Verucci, G., 'Chiesa e società nell'Italia della Restaurazione (1814–1830)', *Rivista di storia della Chiesa in Italia,* XXX (1976), 25–72.

Villani, P., 'Documenti e orientamenti per la storia demografica del Regno di Napoli nel Settecento', *Annuario dell'Istituto storico italiano per l'età moderna e contemporanea,* XV–XVI (1963–4), 5–145.

Villari, R., *Mezzogiorno e contadini nell'età moderna.* Bari, 1977 edn.

La rivolta antispagnola a Napoli. Bari, 1967.

Visceglia, M.A., 'Commercio e mercato in Terra d'Otranto nella seconda metà del XVIII

sec.', *Quaderni storici*, XXVII (1975), 151–98.

Territorio, feudo e potere locale: Terra d'Otranto tra Medioevo ed età moderna. Naples, 1988.

Vismara Chiappa, P., *Miracoli settecenteschi in Lombardia tra istituzione ecclesiastica e religione popolare*. Milan, 1988.

Vovelle, M., *Piété baroque et déchristianisation en Provence au XVIIIe siècle: Les attitudes devant la mort d'après les clauses des testaments*. Paris, 1973.

Walker, D.P., *Spiritual and Demonic Magic from Ficino to Campanella*. London, 1958.

Unclean Spirits: Possession and Exorcism in France and England in the late Sixteenth and early Seventeenth Centuries. Philadelphia, 1981.

Wallerstein, I., *The Modern World-System. II: Mercantilism and the Consolidation of the European World-Economy, 1600–1750*. New York, 1980.

Ward, B., *Miracles and the Medieval Mind*. London, 1982.

Warner, M., *Alone of All Her Sex: The Myth and the Cult of the Virgin Mary*. London, 1985 edn.

Weil, M.S., 'The devotion of the Forty Hours and Roman baroque illusions', *Journal of the Warburg and Courtauld Institutes*, XXXVII (1974), 218–48.

Weissman, R., *Ritual Brotherhood in Renaissance Florence*. New York, 1982.

Wrightson, K., (with D. Levine), *Poverty and Piety in an English Village: Terling, 1525–1700*. New York, 1979.

UNPUBLISHED THESES

Carrino, A., 'La diocesi di Nardò tra la fine del '600 e gli inizi del '700', unpublished *tesi di laurea*, Università degli studi di Lecce, 1967–8.

Liebreich, K., 'The contribution of the Piarist Order to popular education in the seventeenth century', unpublished doctoral dissertation, University of Cambridge, 1985–6.

Index